THE ARTIST'S COMPLETE HEALTH & SAFETY GUIDE

Second Edition

MONONA ROSSOL

ALLWORTH PRESS, NEW YORK

Published by Allworth Press, an imprint of Allworth Communications, Inc., 10 East 23rd Street, New York, NY 10010.

Book Design by Douglas Design Associates, New York.

Library of Congress Catalog Card Number: 94-70298

ISBN: 1-880559-18-8

This book was written to provide the most current and accurate information about health and safety hazards in the arts and about applicable laws and regulations. However, the author and publisher can take no responsibility for any harm or damage that might be caused by the use or misuse of any information contained herein. It is not the purpose of this book to provide medical diagnosis, suggest health treatment, or provide legal or regulatory counseling. Readers should seek advice from physicians, safety professionals, industrial hygienists, environmental health specialists, and attorneys concerning specific problems.

Dedication

To John S. Fairlie and the vast Fairlie clan to which I belong.

Acknowledgements

There are so many professional friends and colleagues I would like to thank, but the list is far too long. Instead I will mention only a crucial few. First, always, is Jack Holzhueter who labored long to "learn" me to write. Next, my thanks to Ted Rickard at the Ontario College of the Arts for his help on the Canadian regulations, to Tad Crawford who knows how to spur a writer along without puncturing the ego, and to Cathrine Jenkins for providing a technical review of data on pigments.

My deep gratitude goes also to the Board of ACTS (Arts, Crafts and Theater Safety), Susan Shaw, Eric Gertner, Nina Yahr, and Elizabeth Northrop for sharing their expertise and encouragement. And to Tom Arminio who gave me the idea of starting ACTS and served on its Board until his death in 1988.

CONTENTS

6

| SECTION III | Precautions for Individual Media |

| SECTION IV | Teaching Art |

List of Tables

List of Figures

PREFACE

T he idea for this book can be traced back to the University of Wisconsin where I earned a BS in chemistry. I was working and teaching in the chemistry department when I decided to enter the graduate art program. As I went back and forth between the chemistry and art schools, it occurred to me that many of the same acids and other chemicals were used in both places.

As a research chemist I defended myself against chemicals with goggles, gloves, fume hoods, and other safety equipment. My art colleagues and I, on the other hand, saw these same chemicals as art materials that were to be used lovingly and intimately. As I look back at our work practices now, I think we must have confused "exposure to art" with "exposure to art materials."

My first writings on art hazards were graduate school seminar and term papers in the early 60's. They were not well-received. My classmates and teachers told me bluntly that this kind of information interfered with their creativity. Unfortunately, illness and death also interfere with creativity, so I have persisted. This book is the result of that persistance.

The book's subject is necessarily technical and you may find you have questions or need additional information. For this reason, I have made arrangements for readers to be able to reach me at:

Arts, Crafts and Theater Safety (ACTS)
181 Thompson Street, #23
New York, NY l0012.
212-777-0062

ACTS is a not-for-profit corporation dedicated to providing a variety of health and safety services for artists. I already answer thousands of requests for information at ACTS every year and would be pleased to hear from you.

Monona Rossol, M.S., M.F.A., Industrial Hygienist.

Section

I

The Regulated Art World

```
┌─────────────────┐
│                 │
│  CHAPTER        │
│                 │
│                 │
│      1          │
│                 │
│                 │
└─────────────────┘
```

A s artists and teachers, most of us believe our creative work must be free, uninhibited, and independent. Actually, it is encumbered by a host of laws and regulations.
For example, fire, health, and safety laws affect how we must design our studios and what we can teach in our classrooms. And environmental protection laws limit the kinds of art materials available to us, as well as how we must store, use and dispose of them. These laws apply to us because many materials used in art contain substances which now are known to be both toxic and hazardous to the environment. By using these materials improperly, we risk our health and pollute our world just as industry does. While we each may use much smaller amounts of chemicals than industry, there are so many of us.

Today, these laws are becoming more restrictive. They not only apply to professional and industrial materials, but to many common household and hobby products. Art materials packaged for consumer use, in particular, now are regulated under a special amendment to the Toxic Substances Control Act (see page 43).

Either we can see these new laws as impositions and resist them at every turn, or we can accept change and do our share in protecting ourselves and the environment. But whether we resist or not, progressively stricter regulation and enforcement is inevitable.

Schools and universities should be in the forefront of this movement. They could encourage teachers and students to explore safer media, find substitutes for toxic materials, and research and develop alternatives to hazardous processes.

Schools that teach art also must develop curricula which include formal health and safety training. This kind of training is already mandated by law for all employed teachers using toxic art materials (see page 19-20) and it should be made available to students and self-employed artists as well.

This health and safety training for artists, teachers, students, and all users of art materials should consist of basic industrial hygiene which has been adapted for the arts.

INDUSTRIAL HYGIENE FOR THE ARTS

Industrial hygiene is the science of protecting workers' health through control of the work environment. As an artist-turned-industrial hygienist, I have spent more than a dozen years specializing in protecting artists from their environments—and themselves.

To be honest, I would not describe this work as a "glamorous career in the arts." However, my work enables me to visit each year between 80 and 100 schools, universities, museums, commercial studios, theaters, and other sites in the United States, Canada, Australia, and England. I have also been involved in developing state and federal art materials regulations, testifying as an expert witness in art-related lawsuits, and counseling literally thousands of artists, teachers, administrators, and the like.

This book is an attempt to share the prospective I have developed through these experiences and to provide a training reference to help us comply with applicable health and safety laws and regulations.

THE CARROTS (INDUCEMENT)

One of the most humbling aspects of my first few years in industrial hygiene was observing how steadfastly both artists and administrators ignored my advice. I talked enthusiastically about health and safety programs, ventilation, respiratory protection, and so on. While I was talking, there would be interest, motivation, and good intentions. But before my vocal cords cooled, people would be back to business as usual.

It wasn't that people didn't want to be safer and healthier— they did. It wasn't that they didn't understand the technical information—they did.

It wasn't even that the precautions would cost too much—they often didn't. The failure to institute proper health and safety procedures usually boiled down, in the main, to inertia and old habits.

These are formidable foes. We are all infected terminally with the desire to do the familiar—even if we know it is not in our best interest. There is an exquisite pain associated with the effort of hauling habits out of our spinal cord reflexes and putting them back into our brains to be thought through again. Confronting this resistance taught me that there is no industrial hygienist clever enough, no lecturer interesting enough, no argument convincing enough to make us change the way we make art. The lectures and training only make us feel a little more guilty as we routinely bet little bits of our life on risky familiar activities.

THE STICKS (ENFORCEMENT)

If lectures and training will not change our habits, force, in the form of our own governmental agencies, and the courts, will. Enforcement is necessary and beneficial, despite the bitter complaints we hear about excessive jury awards and restrictive Occupational Safety and Health Administration (OSHA) rules.

And certainly, enforcement works. One lawsuit improves safety practices in an entire school district overnight. One hefty OSHA fine causes shop managers for a hundred miles around to put the guards back on the saws.

Personally, I have found that juries and judges usually are fair. And complaints about the cost of complying with regulations merely reflect our difficulty in facing the fact that for far too many years we have spent far too little on health and safety.

In this case the law and the lawsuit are not our enemies. They reflect our own collective (not always perfect) wisdom in the form of our governmental servants and a jury of our peers. If you doubt this, try this exercise: imagine yourself defending your work practices, reporting your accident, or describing conditions in your studio or classroom to OSHA or a jury.

LAWS PROTECTING ART WORKERS

Both the United States and Canada have very complex regulations governing the relationship between employer and employee. However, whether the regulations are called the Occupational Safety and Health

Act (OSHAct in the United States) or Occupational Health and Safety Act (OHSAct in Canada), their main purpose is very simple—to protect workers.

The OSHAct general duty clause reads in part that the "employer shall furnish...employment and a place of employment which are free from recognized hazards." The Canadian OHSAct requires employers and supervisors to "take every precaution reasonable in the circumstances for the protection of a worker."

These brief general statements serve as the foundation for complex regulatory structures. The Acts include rules about chemical exposures, noise, ladder safety, machinery guarding, and a host of subjects. And many of these rules apply to schools, art-related businesses, etc.

All of us should be aware of these rules. In my opinion, even high schools should not graduate students who are unacquainted with their rights in the workplace. If you also are not versed in these regulations, first call your nearest department of labor and obtain a copy. Although the Acts are not reader-friendly, become as familiar with them as possible.

THE RIGHT-TO-KNOW

Certain recently instituted regulations are proving particularly useful in pressing us to upgrade our health and safety practices. These are the so-called "right-to-know" laws.

United States right-to-know laws were first passed by a number of states. Then a similar federal regulation called the OSHA Hazard Communication Standard was instituted. The result is that *all* employees in the United States now are covered by one or the other (sometimes both) of these laws. Even federal workers, so long exempt from OSHA regulations, come under this rule. There is a similar history in Canada with the resulting passage of the federal Workplace Hazardous Materials Information System (WHMIS).

For the most part, all these laws require employers to provide written hazard communication programs, give workers access to complete inventories and data sheets for all potentially hazardous chemicals in the workplace, and require formal training of all employees who potentially are exposed to toxic chemicals.

Even an ordinary office worker comes under the rule if he or she works long hours with an ozone-producing copy machine. That worker must be told of the effects of ozone, shown what kind of ventilation is necessary to reduce it to acceptable limits, given access to a data sheet de-

scribing details of the toner's hazardous ingredients, instructed formally about what to do if the toner spills, and so on.

How much more, then, should the law be applied to art teachers, craftspeople, or artists who use hazardous paints, dyes, solvents, metals, and so on.

Yet many schools and art-related businesses still do not comply with the new laws. This is partly due to a peculiar common belief that the laws do not apply to art—that art is somehow "special." Actually, producing art should more correctly be considered a "light industry" which uses toxic substances to create a product. This also is how government inspectors see artmaking.

Today, OSHA gives more citations for hazard communication violations than for any other rule infraction. Some art schools, businesses, and institutions have been cited. (I have participated in program development and training in cited schools and businesses. To illustrate that all workplaces are covered: a Broadway theater company was cited and I trained the actors and technicians between matinee and evening performances.)

WHO'S COVERED?

*Essentially, all employees** in the United States are covered by state, or federal hazard communication (right-to-know) laws. *All employees* in Canada are covered by the Workplace Hazardous Materials Information System (WHMIS). *All employers* in workplaces where hazardous materials are present, therefore, are required to develop programs and train their employees. (The employer is the person or entity that takes the deductions out of the paycheck.)

Self-employed artists/teachers are *not* covered, but may be affected by the laws. For example, if you work as an independent contractor working or teaching at a site where there are employees, all the products and materials you bring onto the premises must conform to the employer's hazard communication or Workplace Hazardous Materials Information System program labeling requirements. Your use of these products also must conform.

Teachers in the United States have a unique hazard communication obligation arising from the fact that they can be held liable for any harm classroom activities cause their students. To protect their liability, teachers should formally transmit to students hazard communication training

*A few state and municipal employees in states that do not have an accepted state OSHA plan are still exempt.

about the dangers of classroom materials and processes. They also must enforce the safety rules and act as good examples of proper precautions.

(Precautionary training need not be done by elementary school teachers since they should not use materials for which training would be required.)

Complying with the Hazard Communication Standard and Workplace Hazardous Materials Information System

1. To comply, first find out which law applies to you. Call your local department of labor and ask them to tell you whether you must comply with a state/provincial or federal right-to-know.

2. Ask for a copy of the law which applies to you. Also ask for explanatory materials. Some of the government agencies have prepared well-written guidelines to take you through compliance step by step.

General Requirements—Hazard Communication Standard and Workplace Hazardous Materials Information System

There are small differences between the United States and Canadian laws. For example, the definition of "hazardous" varies, and the Canadian law requires information in French. However, the two laws require employers to take similar steps toward compliance:

1. *Inventory all workplace chemicals.* Remember, even products such as bleach and cleaning materials may qualify as hazardous products. List everything. (This is an excellent time to cut down paper work by trimming your inventory. Dispose of old, unneeded or seldom-used products.)

2. *Identify hazardous products in your inventory.* Apply the definition of "hazardous" in the right-to-know law which applies to you.

3. *Assemble Material Safety Data Sheets (MSDSs) on all hazardous products.* Write to manufacturers, distributors, and importers of all products on hand for MSDSs. Require MSDSs as a condition of purchase for all new materials.

4. *Check all product labels to be sure they comply with the law's labeling requirements.* Products which do not comply must be eliminated or relabeled.

5. *Prepare and apply proper labels to all containers into which chemicals have been transferred.* (Chemicals in unlabeled containers that are used up within one shift need not be labeled.)

6. *Consult Material Safety Data Sheets to identify all operations which use or generate hazardous materials.* Be aware that nonhazardous materials when chemically reacted, heated, or burned may produce toxic emissions.

7. *Make all lists of hazardous materials, Material Safety Data Sheets, and other required written materials available to employees.* (The OSHA Hazard Communication Standard also requires a written Hazard Communication program which details all procedures.)

8. *Implement a training program* (see Training below).

9. *Check to see if you are responsible for additional state and provincial requirements.* In the United States, the Supreme Court recently upheld (July 3, 1989) the right of states to enforce certain amendments to the federal right-to-know law.

TRAINING

Since both laws are in effect, all employees in both the United States and Canada already should have received right-to-know training. Additional training should take place whenever new employees are hired or new materials or processes introduced. Some state laws require yearly training as well.

The amount of time the training should take is not specified. This is because the law intends the training requirements to be performance oriented--that is, the employees must be given whatever information they need to understand the hazards of their specific jobs and how to work safely. Often short quizzes are used to verify that the employees have understood the presentation.

Training for artists and art teachers usually can be accomplished in a full day. The information which must be communicated includes:

1. *The details of the hazard communication program* that the employer is conducting including an explanation of the labeling system, the Material Safety Data Sheets and how employees can obtain and use hazard information.

2. *The physical and health hazards of the chemicals in the work area.* This should include an explanation of physical hazards such as fire and explosions, and health hazards such as how the chemical enters the body and the effects of exposure.

3. *How employees can protect themselves.* This should include information on safe work practices, emergency procedures, use of personal protective equipment that the employer provides, and explanation of the ventilation system and other engineering controls that reduce exposure.

4. *How the employer and employees can detect the presence of hazardous chemicals in the work area.* This should include training about environmental and medical monitoring conducted by the employer, use of monitoring devices, the visual appearance and odor of chemicals, and any other detection or warning methods.

This book can be used to address points 2 through 4 above, providing employers, employees, and teachers with formal training materials. The lists of precautions as the ends of chapters on specific media can be used as shop safety inspection checklists.

<table>
<tr><td>CHAPTER

2</td><td>*HEALTH
HAZARDS AND
THE BODY*</td></tr>
</table>

A rt and craft workers need to understand how chemicals in their materials affect them, in order to protect their health and to meet the requirements of new occupational and environmental laws. Studying the hazards of art and craft materials is difficult because they contain so many different toxic chemicals. For example, many toxic metals, including highly toxic ones such as lead and cadmium, are still found in traditional paint and ink pigments, ceramic glazes, metal enamels, and in alloys used in sculpture, stained glass, jewelry, and other crafts. In addition, new synthetic dyes and pigments, plastics, organic chemical solvents, and a host of materials may be used.

Each of these chemicals affects the body in its own unique way. The study of these effects is called toxicology.

BASIC CONCEPTS

DOSE. Chemical toxicity is dependent on the dose—that is the amount of the chemical which enters the body. Each chemical produces harm at a different dose. Highly toxic chemicals cause serious damage in very small amounts. Moderately and slightly toxic substances are toxic at relatively higher doses. Even substances considered nontoxic can be harmful if the exposure is great enough.

TIME. Chemical toxicity is also dependent on the length of time over which exposures occur. The effects of short and long periods of exposure differ.

SHORT-TERM OR ACUTE EFFECTS. Acute illnesses are caused by large doses of toxic substances delivered in a short period of time. The symptoms usually occur during or shortly after exposure and last a short time. Depending on the dose, the outcome can vary from complete recovery, through recovery with some level of disability, to—at worst—death. Acute illnesses are the easiest to diagnose because their cause and effect are easily linked. For example, exposure to turpentine while painting can cause effects from lightheadedness to more severe effects such as headache, nausea, and loss of coordination. At even higher doses, unconsciousness and death could result.

LONG-TERM OR CHRONIC EFFECTS. These effects are caused by repeated low-dose exposures over many months or years. They are the most difficult to diagnose. Usually the symptoms are hardly noticeable until permanent damage has occurred. Symptoms appear very slowly, may vary from person to person, and may mimic other illnesses. For instance, chronic exposure to turpentine during a lifetime of painting may produce dermatitis in some individuals, chronic liver or kidney effects in other, and nervous system damage in still others.

EFFECTS BETWEEN ACUTE AND CHRONIC. There are also other effects between acute and chronic such as "sub-acute" effects produced over weeks or months at doses below those which produce acute effects. Such in between effects also are difficult to diagnose.

CUMULATIVE/NONCUMULATIVE TOXINS. Every chemical is eliminated from the body at a different rate. Cumulative toxins, such as lead, are substances which are eliminated slowly. Repeated exposure will cause them to accumulate in the body.

Noncumulative toxins, like alcohol and other solvents, leave the body very quickly. Medical tests can detect their presence only for a short time after exposure. Although they leave the body, the damage they cause may be permanent and accumulate over time.

THE TOTAL BODY BURDEN is the total amount of a chemical present in the body from all sources. For example, we all have body burdens of

lead from air, water, and food contamination. Working with lead-containing art materials can add to this body burden.

MULTIPLE EXPOSURES. We are carrying body burdens of many chemicals and are often exposed to more than one chemical at a time. Sometimes these chemicals interact in the body.

• *Additive Exposures.* Exposure to two chemicals is considered additive when one chemical contributes to or adds to the toxic effects of the other. This can occur when both chemicals affect the body in similar ways. Working with paint thinner and drinking alcohol is an example.

• *Synergistic Exposures.* These effects occur when two chemicals produce an effect greater than the total effects of each alone. Alcohol and barbiturates or smoking and asbestos are common examples.

CANCER. Occupational cancers are a special type of chronic illness. Chemicals which cause cancer are called carcinogens. Examples include asbestos and benzidine dyes and pigments. Unlike ordinary toxic substances, the effects of carcinogens are not strictly dependent on dose. No level of exposure is considered safe. However, the lower the dose, the lower the risk of developing cancer. For this reason, exposure to carcinogens should be avoided altogether or kept as low as possible.

Occupational cancers typically occur ten to forty years after exposure. This period of time, during which there are no symptoms, is referred to as a latency period. Latency usually makes diagnosis of occupational cancers very difficult.

MUTAGENICITY. Mutations (and cancer) can be caused by chemicals which alter the genetic blue print (DNA) of cells. Once altered, such cells usually die. Those few that survive will replicate themselves in a new form.

Any body cell (muscle, skin, etc.) can mutate. However, when the effected cell is the human egg or sperm cell, mutagenicity can affect future generations. Most pregnancies resulting from mutated sperm and eggs will result in spontaneous termination of the pregnancy (reabsorption, miscarriage, etc.). In other cases, inherited abnormalities may result in the offspring.

Only a handful of chemicals, pesticides, and drugs have been studied sufficiently to prove they are human mutagens. Such proof requires

that thousands of exposed individuals be studied for many decades. Since this is not practical, chemicals are considered "suspect human mutagens" if they cause mutation in bacteria or animals. Some chemicals found in arts and crafts have been shown to be suspect mutagens, including a number of pigments, synthetic dyes, and solvents. (See Tables 5 and 6, Common Solvents & Their Hazards and Pigments used in Paints & Inks, pages 89 and 102.) Both men and women should avoid exposure to suspect mutagens, since both may be affected.

TERATOGENICITY. Chemicals that affect fetal organ development—that is, cause birth defects—are called teratogens. They are hazardous primarily during the first trimester. Two proven human teratogens include the drug, Thalidomide, and grain alcohol. Chemicals which are known to cause birth defects in animals are considered "suspect teratogens." Among these are many solvents, lead, and other metals.

FETAL TOXICITY. Toxic chemicals can affect the growth and development of the fetus at any stage of development.

ALLERGENICITY. Allergies are adverse reactions of the body's immune system. Common symptoms may include dermatitis, hay fever effects, and asthma. Although a particular person can be allergic to almost anything, certain chemicals produce allergic responses in large numbers of people. Such chemicals are called "sensitizers." Some strong sensitizers include epoxy adhesives, chrome compounds, batik dyes, and many wood dusts.

The longer people work with a sensitizing chemical the greater the probability they will become allergic to it. Once developed, allergies tend to last a lifetime and symptoms may increase in severity with continued exposure. A few people even become highly sensitized—that is, develop life-threatening reactions to exceedingly small doses. This effect is caused by bee venom in some people, but industrial chemicals have produced similar effects—including death.

HOW CHEMICALS ENTER THE BODY (Routes of Entry)

In order to cause damage, toxic materials must enter the body. Entry can occur in the following ways:

SKIN CONTACT. The skin's barrier of waxes, oils, and dead cells can be destroyed by chemicals such as acids, caustics, solvents, and the like.

Once the skin's defenses are breached, some of these chemicals can damage the skin itself, the tissues beneath the skin, or even enter the blood, where they can be transported throughout the body causing damage to other organs.

Cuts, abrasions, burns, rashes, and other violations of the skin's barrier can allow chemicals to penetrate into the blood and be transported throughout the body. There are also many chemicals that can—without your knowing it—enter the blood through undamaged skin. Among these are benzene and wood alcohol.

INHALATION. Inhaled substances are capable of damaging the respiratory system acutely or chronically at any location—from the nose and sinuses, to the lungs. Examples of substances which can cause chronic and acute respiratory damage include acid gases and fumes from heating or burning plastics.

Some toxic substances are absorbed by the lungs and are transported via the blood to other organs. For example, lead in solder fumes may be carried via the blood to damage the brain and kidneys.

INGESTION. You can accidently ingest toxic materials by eating, smoking, or drinking while working, pointing brushes with your lips, touching soiled hands to your mouth, biting your nails, and similar habits. The lung's mucous also traps dusts and removes them by transporting them to your esophagus where they are swallowed.

Accidental ingestions occur when people pour chemicals into paper cups or glasses and later mistake them for beverages. Some of these accidents have even killed children who were allowed in the studio.

WHO IS AT RISK?

EVERYBODY is susceptible to occupational exposures. How they are affected will depend on the nature of the chemical, its route of entry, the degree of exposure, and, in some cases, the susceptibility of the exposed person. For example, most people's lungs will be affected equally by exposure to similar concentrations of strong acid vapors. However, someone who already has bronchitis or emphysema may be even more seriously harmed.

HIGH RISK INDIVIDUALS. Certain segments of the population—particularly the disabled, the chronically ill (especially those with preexisting

damage of organs such as the liver or lungs), pregnant women and the fetus, children, and elderly—are at especially high risk from certain art activities. For example, the hearing-impaired may risk further damage to their already defective hearing if they engage in woodworking activities that employ noisy machinery. The retarded should not be exposed to chemicals which are known to adversely affect mental acuity and behavior, such as lead and chemical solvents.

People taking certain medications are sometimes at higher risk. For example, medications (and recreational drugs) which are narcotic may potentiate the effects of solvents and metals which also are narcotic (affect the brain).

OCCUPATIONAL ILLNESSES
Any organ in the body can be affected by an occupational illness. Some occupational illnesses include the following:

SKIN DISEASES. Two types of dermatitis are among the most common occupational skin diseases.

1. Primary irritant contact dermatitis. This is a nonallergic skin reaction from exposure to irritating substances. Exposure to irritants account for 80 percent of the cases of occupational contact dermatitis. There are two major types of irritants:

- mild irritants which require repeated and/or prolonged exposure. Included in this category are soaps, detergents, and many solvents.

- strong irritants which require only short exposures to cause damage. Substances included in this category are strong acids, alkalis, and peroxides.

2. Allergic contact dermatitis (sometimes called hyper-sensitivity dermatitis) is a delayed allergic skin reaction occurring when sensitized individuals are exposed to allergens. Common allergens include epoxy adhesives, chrome and nickel compounds, and many woods.

Other occupational skin diseases include infections and skin cancer. Working with cuts, abrasions, or other kinds of skin damage may lead to infections. Lamp black pigments and ultraviolet radiation are associated with skin cancer.

EYE DISEASES. Irritating, caustic, and acid chemicals can damage the eye severely. Infrared (from glowing hot kilns) or ultraviolet light (e.g., from welding) can cause eye damage. A few chemicals, such as methanol and hexane, also can damage the eyesight when inhaled or ingested.

RESPIRATORY SYSTEM DISEASES. Any irritating airborne chemical can be potentially hazardous to the respiratory system. Damage can range from minor irritation to life-threatening chemical pneumonia, depending on how irritating the substance and how much is inhaled. Exposures to smaller amounts of irritants over years can cause chronic respiratory damage such as chronic bronchitis or emphysema.

Often the first symptom of respiratory irritation is an increased susceptibility to colds and respiratory infections. This is commonly seen among artists exposed to the small amounts of ammonia and formaldehyde released by acrylic paints.

Another factor affecting respiratory damage is the irritant's solubility in liquid and mucous. Highly soluble irritants, such as hydrochloric acid gas, produce immediate symptoms in the upper respiratory tract. These warning symptoms usually cause people to take action to avoid further exposure. Less soluble irritants such as ozone or nitric acid (from acid etching) cause delayed damage to the lower respiratory tract. In cases of heavy exposure, pulmonary edema may occur as much as twelve hours after exposure.

Some types of soluble chemicals, including lead and solvents, are absorbed by the lungs, pass into the blood stream and are transported to other organs in the body. Insoluble particles, on the other hand, may remain in the lungs for life if they are deposited deeply in the air sacs (alveoli). Some of these insoluble particles such as asbestos and silica can cause lung scarring diseases (fibroses) such as asbestosis and silicosis, and/or lung cancer.

Allergic diseases such as asthma, alveolitis, and hypersensitivity pneumonia may result from exposure to sensitizing chemicals. Smokers are at greater risk from lung cancer and almost all other diseases of lungs. Smoking inhibits the lungs' natural clearing mechanisms, leaving toxic particles in them longer and allowing them to do more damage.

HEART AND BLOOD DISEASES. Many solvents at high doses can alter heart rhythms (arrhythmia) and even cause a heart attack. Deaths related to this phenomenon have been noted among both industrial workers, and glue-sniffers whose level of exposure to solvents were very high.

Benzene, still found as a contaminant in some solvents and gasoline, can cause aplastic anemia (decreased bone marrow production of all blood cells) and leukemia.

NERVOUS SYSTEM DISEASES. Metals like lead and mercury are known to cause nervous system damage. The early symptoms of exposure often are psychological disturbances and depression.

Almost all solvents can affect the nervous system. Symptoms can vary from mild narcosis (lightheadedness, headache, dizziness) to coma and death at high doses. People exposed to small amounts of solvent daily for years often exhibit the symptoms of chronic nervous system damage such as short-term memory loss, mental confusion, sleep disturbances, hand-eye coordination difficulties, and depression.

Some chemicals such as *n*-hexane (found in rubber cements, some aerosol sprays, etc.) are particularly damaging to the nervous system and chronic exposure can result in a disease similar to multiple sclerosis.

LIVER DISEASES. Hepatitis can be caused by chemicals as well as by disease organisms. Some toxic metals and nearly all solvents, including grain alcohol, can damage the liver if the dose is high enough. Liver cancer is caused by chemicals such as carbon tetrachloride.

KIDNEY DISEASES. Kidney damage is also caused by many metals and solvents. Lead and chlorinated hydrocarbon solvents such as trichloroethylene are particularly damaging. Heat stress and accidents (damaged blood and muscle cell debris block kidney tubules) are also causes of kidney damage.

BLADDER DISEASES. Benzidine-derived pigments and dyes are documented causes of bladder cancer.

REPRODUCTIVE EFFECTS. Chemicals can affect any stage of reproduction: sexual performance, the menstrual cycle, sperm generation, all stages in organ formation and fetal growth, the health of the woman during pregnancy, and the newborn infant through chemicals secreted in breast milk. More is being learned each day regarding such effects. Prudence dictates that both men and women planning families exercise care when working with art and craft materials containing toxic chemicals. (See also the section above on mutagenicity and teratogenicity.)

CHAPTER	*CHEMICAL*
3	*HEALTH* *HAZARDS AND* *THEIR CONTROL*

H ealth-damaging chemicals can enter our body by inhalation, skin contact, and ingestion. Exposure by skin contact usually can be prevented by wearing gloves, using tools to handle materials, and the like. Ingestion can be prevented by good work habits and by not eating, smoking, or drinking in the workplace. Precautions against inhalation are more complex.

INHALATION HAZARDS

To prevent inhalation of airborne chemicals, it is first necessary to understand the nature of airborne contaminants such as gases, vapors, mists, fumes, and dust.

GASES. Scientists define gas as "a formless fluid" that can "expand to fill the space that contains it." We can picture this fluid as many molecules moving rapidly and randomly in space.

Air, for example, is a mixture of different gases—that is different kinds of molecules. Even though each different gas has a different molecular weight, the heavier gases will never settle out because the rapid molecular movement will cause them to remain mixed. In other words, once gases are mixed, they will stay mixed.

In almost all cases, gases created during art-making are mixed with air as they are released. This means that they also will not settle, but instead will "expand into the space that contains them." In most cases the gas will diffuse evenly throughout the space—the room—in time.

When the gas escapes from the room or is exhausted from the room by ventilation, expansion of the gas continues theoretically forever. It is this expansion, for example, that causes spray can propellants and Freon refrigerant gases to reach the stratospheric ozone layer.

Under certain conditions, gases will not freely mix with air. For example, carbon dioxide gas from dry ice will form a foggy layer at ground level because the cold gas is denser and heavier than air (the molecules are closer together). In another instance, gases may layer out or take a long time to mix with air in locations where there is little air movement—such as in storage areas.

Gases vary greatly in toxicity. They can be irritating, acidic, caustic, poisonous, and so on. Some gases also have dangerous physical properties such as flammability or reactivity. Toxic gases which may be encountered in art making include: hydrochloric acid gas from etching and pickling solutions; ozone and nitrogen oxides from welding; and sulfur dioxide and acetic acid gases from photographic developing baths.

Some gases are not toxic. An inert gas such as argon used in inert gas welding is an example. Such gases are dangerous only when present in such large quantities that they reduce the amount of oxygen in the air to levels insufficient to support life. These gases are called asphyxiants.

VAPORS. Vapors are the gaseous form of liquids. For example, water vapor is created when water evaporates—that is, releases water molecules into the air. Once released into the air, vapors behave like gases and expand into space. However, at high concentrations they will recondense into liquids. This is what happens when it rains.

There is a common misconception that substances do not vaporize until they reach their "vaporization point"—that is their boiling point. Although greater amounts of vapor are produced at higher temperatures, most materials begin to vaporize as soon as they are liquid.

Even some solids convert to a vapor form at room temperature. Solids that do this are said to "sublime." Mothballs are an example of a chemical solid which sublimes.

Vapors, like gases, may vary greatly in toxicity, flammability and reactivity. Among the most common toxic vapors created in art work are

organic chemical vapors from solvents such as turpentine, mineral spirits, and lacquer thinners.

MISTS. Mists are tiny liquid droplets in the air. Any liquid, water, oil, or solvent can be misted or aerosolized. The finer the size of the droplet, the more deeply the mist can be inhaled. Some mists, such as paint spray mists, also contain solid material. Paint mist can float on air currents for a time. Then the liquid portion of the droplet will vaporize—convert to a vapor—and the solid part of the paint will settle as a dust.

A mist of a substance is more toxic than the vapor of the same substance at the same concentration. This results from the fact that when inhaled, the droplets deliver the mist in little concentrated spots to the respiratory systems tissues. Vapors, on the other hand, are more evenly distributed in the respiratory tract.

FUMES. Laymen commonly use this term to mean any kind of emission from chemical processes. In this book, however, only the scientific definition will be used.

Technically, fumes are very tiny particles usually created in high heat operations such as welding, soldering, or foundry work. They are formed when hot vapors cool rapidly and condense into fine particles. For example, lead fumes are created during soldering. When solder melts, some lead vaporizes. The vapor immediately reacts with oxygen in the air and condenses into tiny lead oxide fume particles.

Fume particles are so small (0.01 to 0.5 microns in diameter)* that they tend to remain airborne for long periods of time. Eventually, however, they will settle to contaminate dust in the workplace, in the ventilation ducts, in your hair or clothing, or wherever air currents carry them. Although fume particles are too small to be seen by the naked eye, they sometimes can be perceived as a bluish haze rising like cigarette smoke from soldering or welding operations.

Fuming tends to increase the toxicity of a substance because the small particle size enables it to be inhaled deeply into the lungs and because it presents more surface area to lung fluids (is more soluble).

In addition to many metals, some organic chemicals, plastics, and silica will fume. Smoke from burning organic materials may also contain fumes.

*A micron is a metric system unit of measurement equaling one millionth of a meter. There are about 25,640 microns in an inch. Respirable fume and dust particles are in the range of 0.01 to 10 microns in diameter. Such particles are too small to be seen by the naked eye.

DUSTS. Dusts are formed when solid materials are broken down into small particles by natural or mechanical forces. Natural wind and weathering produces dusts from rocks. Sanding and sawing are examples of mechanical forces which produce dusts.

The finer the dust, the deeper it can be inhaled into the lung and the more toxic it will be. Respirable dusts—those which can be inhaled deeply into the lungs—are too small to be seen with the naked eye (0.5 to 10 microns in diameter).

SMOKE. Smoke is formed from burning organic matter. Burning wood and hot wire-cutting plastics are two smoke-producing activities. Smoke is usually a mixture of many gases, vapors, and fumes. For example, cigarette smoke contains over four thousand chemicals, including carbon monoxide gas, benzene vapor, and fume-sized particles of tar.

EXPOSURE STANDARDS

Exposure to airborne chemicals in the workplace is regulated in the United States and Canada. The United States limits are called OSHA Permissible Exposure Limits (PELs). The Canadian limits are called Occupational Exposure Limits (OELs).*

Although the levels at which various chemicals are regulated may differ occasionally, both countries' regulations are based on a concept called the Threshold Limit Value (TLV). The Permissible Exposure Limit and Occupational Exposure Limit for many substances are identical to the Threshold Limit Value.

Threshold Limit Values are airborne substance standards set by the American Conference of Governmental Industrial Hygienists (ACGIH). Copies of the Threshold Limit Values can be obtained from the ACGIH.** Threshold Limit Values are designed to protect the majority of healthy adult workers from adverse effects. There are three types:

1. *Threshold Limit Value-Time Weighted Average.* Threshold Limit Value-Time Weighted Averages are airborne concentrations of substances averaged over eight hours. They are meant to protect from adverse effects those workers who are exposed to substances at this concentration over the normal eight-hour day and a forty-hour work week.

* This book will not emphasize the PELs and OELs because they are subject to the vagaries of the regulatory process and litigation. For example, U.S. Courts struck down 416 PELs in 1992.

** ACGIH see Appendix I for address.

2. *Threshold Limit Value-Short Term Exposure Limit.* Threshold Limit Value-Short-Term Exposure Limits are fifteen minute average concentrations that should not be exceeded at any time during a work day.

3. *Threshold Limit Value-Ceiling.* Threshold Limit Value-Ceilings are concentrations that should not be exceeded during any part of the workday exposure.

Threshold Limit Values should not be considered absolute guarantees of protection. Threshold Limit Values previously thought adequate have repeatedly been revised as medical tests have become more sophisticated, and as long-term exposure studies reveal chronic diseases previously undetected.

At best, Threshold Limit Values are meant to protect most, but not all, healthy adult workers. They do not apply to children, people with chronic illnesses, and other high risk individuals.

Threshold Limit Value-Time Weighted Averages also do not apply to people who work longer than eight hours a day. This is especially true of people who live and work in the same environment, such as artists whose studios are at home. In these cases, very high exposures have been noted, since the artist is likely to be exposed to contaminants twenty-four hours a day. With no respite during which the body can detoxify, even low concentrations of contaminants become significant.

Expensive and complicated air-sampling and analysis are usually required to prove that Threshold Limit Values are exceeded. For this reason, Threshold Limit Values are primarily useful to artists as proof that a substance is considered toxic, and that measures should be taken to limit exposure to substances with Threshold Limit Values.

Artists should also be aware that many substances known to be toxic have no Threshold Limit Values. In some cases the reason is that there is insufficient data to quantify the risk from exposure.

When additional factors, such as evaporation rate, are considered, artists also can use Threshold Limit Values to compare the toxicity of various chemicals. Table 1 lists the Threshold Limit Value-Time Weighted Averages of some common air contaminants. In general, the smaller the Threshold Limit Value, the more toxic the substance. Gases and vapors with Threshold Limit Value-Time Weighted Averages 100 parts per million (ppm) or lower can be considered highly toxic. Dusts whose Threshold Limit Value-Time Weighted Averages are set at ten milligrams per cubic meter (mg/m^3) are considered only nuisance dusts. Particulates with

Threshold Limit Value-Time Weighted Averages smaller than 10 mg/m³ are more toxic.

TABLE 1	Threshold Limit Value-Time Weighted Averages* of Common Substances

Gas or Vapor	ppm**
ethanol (grain alcohol)	1000
isopropanol (rubbing alcohol)	400
VM & P naphtha (paint thinner)	300
turpentine	100
xylene and Stoddard solvent	100
n-hexane (common in rubber cement thinner)	50
ammonia	25
fluorine	1
acrolein (created when wax is burned/overheated)	0.1
MDI and TDI (from urethane casting/foaming)	0.005

Fume or Dust	mg/m³**
calcium carbonate (marble dust, whiting)	10
aluminum:	
aluminum oxide (abrasives)	10
metal dust	10
fume (welding)	5
graphite (synthetic and natural)	2
copper:	
dusts and mists	1
fume	0.2
silica:	
amorphous (unfired diatomaeous earth, silica gel)	10
crystalline (quartz, sand, flint, etc.)	0.1
calcined/fired (cristobalite, tridymite)	0.05
beryllium (metal and compounds)	0.002

* Threshold Limit Value-Time Weighted Averages taken from 1993-1994 ACGIH list.
** ppm=parts per million, mg/m³=milligrams per cubic meter.

CHAPTER	*PHYSICAL*
4	*HAZARDS AND* *THEIR* *CONTROL*

P hysical phenomena such as noise, vibration, various kinds of
light, and heat also can be damaging to the body. There are
Threshold Limit Values for these phenomenon similar to those
for chemical exposures.

NOISE

Artists perform many noise-producing tasks. Working with electrical
tools, hammering on hard surfaces, or even playing loud music can pro-
duce ear-damaging sound.

Whether caused by music or machinery, noise-induced hearing loss
is permanent and untreatable. Signs of over exposure may include a tem-
porary ringing in the ears or difficulty in hearing for a while after work.
Except for these minor symptoms, there are no obvious signs or pain to
warn artists that their hearing is being damaged. Noise may also cause
increased blood pressure and stress-related illnesses.

Threshold Limit Values for noise vary with the length of time of expo-
sure and with the intensity of the noise (sound pressure) measured in deci-
bels (dB). (See Table 2 and Figure 1, page 36.) Decibels are nonlinear,
logarithmic functions, so a doubling of noise increases the sound level
by only 3 dB. For example, if one table saw produces 105 dB, turning
on another equally noisy saw adds only 3 dB to the sound level for a
total of 108 dB.

Conversely, an increase of 3 dB corresponds to a doubling of the sound intensity. So, 108 dB is not "just a little over 105 dB," it is twice as intense and does twice as much damage. To illustrate this point, see Fig. 2.

TABLE 2	Threshold Limit Values for Noise	
Duration per Day		**Sound Level**
Hours		**dBA**
16		80
8		85
4		90
2		95
1		100
1/2		105
1/4		110
1/8		115 *

Sound level in decibels are measured on a sound level meter, conforming as a minimum to the requirements of the American National Standard Specification for Sound Level Meters, SI.4(1971) Type S2A, and set to use the A-weight network with slow meter response.

* No exposure should be allowed to continuous or intermittent in excess of 115 dBA.

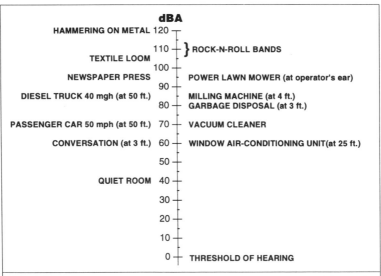

*The decibel is a logarithmic measure of sound intensity; the "A-weighted scale" is used to weight the various frequency components of the noise to approximate the response of the human ear.

Fig 1. Typical A-weighted noise levels in decibels (dBA)*

Artists should evaluate the noise-levels produced by their work. As a rule of thumb, if you must raise your voice to be heard by someone only two feet away, you probably need hearing protection. If you are not sure about the amount of noise in your workplace, you may want to call in an industrial hygienist to measure it.

To protect yourself from noise, use ear plugs. Ear plugs, particularly the foam type, provide the best and cheapest protection. Package labels on ear plugs list their attenuation or noise reduction ratings (NRR).

Intensity of Noise	dB
10,000,000,000,000	130
1,000,000,000,000	120
10,000,000,000	100
1,000,000,000	90
100,000,000	80
10,000,000	70
1,000,000	60
100,000	50
10,000	40
1,000	30
100	20
10	10
0	0

Fig.2

For example, those with a 25 dB NRR would reduce the noise level at most frequencies by about 25 dB.

Ear muffs are more expensive and not always more effective. However, muffs can be designed to attenuate specific frequencies.

Engineering methods for reducing noise include installing muffling and damping devices on machinery or mounting machines on vibration-absorbing rubber pads. When selecting new equipment, try to choose those whose manufacturers provide decibel ratings. Select machines with low dB ratings if they are available, or at least listen to equipment before purchasing.

Artists working in noisy environments also should get baseline hearing tests and yearly reexaminations to monitor any change in hearing.

VIBRATION

Hand-held tools also transfer harmful vibration to the user. It may be noticed as a tingling of the hands and arms that usually disappears within an hour. Some people, however, risk a more permanent condition known as "white hand," "dead fingers," or Raynaud's syndrome. This disease, more correctly called Vibration Syndrome, may progress in stages from intermittent tingling, numbness, and white fingertips to pain, ulcerations, and gangrene.

Recommendations to avoid this condition include using tools with low amplitudes of vibration, keeping tools in good condition, taking ten-minute work breaks for every hour of continuous exposure, maintaining normal workplace temperatures (cold weather aggravates the condition), and not grasping tools harder than needed for safe use.

IONIZING RADIATION

Radiation is either ionizing or nonionizing. Ionizing radiation can cause harmful biological effects. Sources of ionizing radiation include X-rays and radioactive metals such as uranium. Artists rarely encounter these forms of radiation unless they work with uranium-containing glass, glaze chemicals, or metal enamels (e.g., Thompson's Burnt Orange # 153 and Forsythia # 108), or work with radioactive minerals of various types. Uranium should be replaced with safer ingredients.

Conservators of art use ionizing radiation when they X-ray paintings or artifacts. They should follow all guidelines which apply to medical and dental X-ray use.

NONIONIZING RADIATION

LIGHT. Natural light contains a wide spectrum of visible, ultraviolet, and infrared rays. Artificial light contains a more limited array of light waves. It is well known that ultraviolet rays can damage the skin and eyes, and even cause skin cancer. Both sunlight and unshielded fluorescent lights have been implicated in causing cancer.

Inadequate lighting, glare, and shadow-producing direct lighting can cause eye strain and accidents. Use accepted lighting guidelines to plan lighting, especially for close work. Good diffuse overhead lighting combined with direct light on the task is a good solution for many situations.

ULTRAVIOLET (UV) AND INFRARED (IR) RADIATION. Ultraviolet and infrared radiation are produced when things burn or are heated until they glow. Hazardous ultraviolet sources include sunlight, welding, and carbon arc lamps and they can cause eye damage and skin cancer. Infrared is the primary hazard from melting metals or firing ceramics and it causes skin and eye burns. It also is suspected of causing a type of cataract after years of exposure. Whenever either type of radiation is present, protective eyewear should be worn which meets the standards of the American National Standards Institute (see figures 4 and 5, Chapter 6).

VIDEO DISPLAY TERMINALS. Video display terminals emit a number of kinds of radiation including low level pulsed electromagnetic radiation. This kind of radiation is emitted from all electrical appliances and was thought to be harmless for many years. Now clusters of abnormal pregnancies in some workers using video display terminals and increased

cancer rates in children living near power lines have cast suspicion on it. However, at this time there is no conclusive evidence that these affects are due to radiation.

To be on the safe side, pregnant Canadian government workers have been given the right to transfer from video display terminal jobs without loss of pay. Similar rights are being legislated for pregnant workers in other provinces and states.

Some new video display terminal models are being designed to shield users from all types of radiation suspected to be hazardous. When these are perfected, they may be recommended for use by pregnant women.

In addition to radiation, video display terminals are associated with eye strain, overuse injuries (see below), and stress. Artists using video display terminals should plan lighting and desk and chair arrangement carefully. Be sure your vision is checked frequently and get regular physical examinations. Take frequent work breaks.

RADIATION THRESHOLD LIMIT VALUES: There are Threshold Limit Values for the forms of ionizing and nonionizing radiation discussed above. In addition, there are Threshold Limit Values for heat stress, laser radiation, microwaves, and more. All these phenomena can be harmful. Artists exposed to such radiation should obtain appropriate guidelines, codes of practice, and other information about these hazards.

PHYSIOLOGICAL HAZARDS AND THEIR CONTROL

Artists' specialized activities often cause unusual bodily stresses and strains. Potters, glassblowers, and weavers, for example, engage in repetitive actions which cause wear and tear on their muscles and tendons. "Potter's thumb," for instance, is the term some potters have used to describe symptoms which are now associated with the early stages of carpel tunnel syndrome, a debilitating nerve problem.

In response to artists' special needs, a new field called "arts medicine" has been created. Doctors and clinics specializing in arts medicine can be located by consulting your doctor or arts organizations such as ACTS (See Preface) .

OVERUSE INJURIES

Artists doing repetitive tasks such as hand sanding and polishing are at risk from a special type of injuries called Cumulative Trauma Disorders

(CTDs). These usually affect tendons, bones, muscles, and nerves of the hands, wrists, arms, and shoulders. Examples include tendonitis, carpal tunnel syndrome, and tennis elbow.

To prevent these injuries, pay careful attention to your body for signs of fatigue, pain, changes in endurance, weakness, and the like. Try using good work habits to resolve early symptoms, including:

- good posture.
- frequent rest breaks.
- alternating tasks or varying the types of work done often.
- warming up muscles before work; moving and stretching muscles during breaks.
- easing back into heavy work schedules rather than expecting to work at full capacity immediately after holidays or periods away from work.
- modifying technique and/or equipment to avoid uncomfortable positions or movements (see Ergonomics below).

If your symptoms do not respond quickly to better work habits, seek medical attention. Early medical intervention will cause the majority of overuse injuries to resolve without expensive treatment or surgery. Delaying treatment can leave you disabled for long periods of time or even for life.

ERGONOMICS. Ergonomics is defined as designing work environments using data from engineering, anatomical, physiological, and psychological sources so that the best use is made of human capabilities.

With these principles in mind, many tools, machines, and much office and shop furniture have been redesigned. This equipment, combined with good posture, reasonable workloads, reduced levels of job stress and noise, good lighting, and other factors can prove useful to many artists.

LIFTING. Back injuries are common among artists who lift heavy objects such as sculpture and litho stones. When possible heavy objects should be lifted with mechanical devices. Manual lifting should be done with the knees bent, the back straight, and the weight held as close to your body as possible. Employers whose workers lift objects on the job must follow the guidelines in the National Institute for Occupational Safety and Health's Work Practices Guide for Manual Lifting (See Appendix I).

CHAPTER 5

IDENTIFYING HAZARDOUS MATERIALS

I Identifying potentially hazards products in the studio or work place can be accomplished most easily by the procedures outlined in the right-to-know laws. These include developing an accurate, chemical inventory, labeling materials properly, and collecting hazard information about each product in the form of material safety data sheets, fact sheets and similar materials.

INVENTORY

The first step in any program to control chemical hazards, is to make a complete inventory of all the products you use. The list also should include all ordinary consumer products—even if your right-to-know law does not require it. This is necessary because artists may use consumer products in greater amounts or in ways which are not typical. For example, a small tube of glue meant to be used a drop at a time may become hazardous when a full tube is used at once.

Be careful to include all soaps, cleansers, and maintenance products. Many of these now are known to contain toxic materials. Consumer art materials often are especially hazardous. In both the United States and Canada, artists' paints are exempt from the consumer paint lead laws and often contain lead, cadmium, and a host of toxic ingredients.

Reduce your inventory by discarding old materials for which ingredient information is no longer available. Throwing things away is often psychologically difficult for artists and teachers who have spent years existing on tight budgets. However, it is a violation of the right-to-know laws to have unlabeled or improperly labeled products, or products whose hazards and ingredients are unknown in the workplace.

READING CONSUMER PRODUCT LABELS

To identify hazardous materials in your inventory, begin by reading product labels. However, do not assume that the label will warn of all the product's potential hazards. The truth is that the hazards of many of the ingredients in consumer products have never been fully studied, especially for chronic hazards.

Evaluating label information is further complicated by the fact that many common art products are imported. By law, these products' labels are supposed to conform to standards in the United States and Canada. However, many improperly labeled products escape scrutiny and turn up in art stores.

Even if the labeling meets standards, the label terminology may be difficult to interpret. The following United States and Canadian label terms illustrate the point:

USE WITH ADEQUATE VENTILATION: Many people think this means a window or door should be kept open while using the product. It actually indicates that the product contains a toxic substance which becomes airborne during the product's use and the ventilation should be sufficient to keep the airborne substance below levels considered acceptable for industrial use (see section on industrial Threshold Limit Values). Sufficient ventilation could vary from an ordinary exhaust fan to a specially designed local exhaust system depending on the amount of the material and how it is used.

In order to plan such ventilation, you must know exactly what substance the product gives off and at what rate. Ironically, this is often precisely the information the manufacturer excludes from the label.

NONTOXIC. Both the United States Federal Hazardous Substances Act and the Canadian Federal Hazardous Products Act use short term (two week long) animal tests to define toxicity. These tests are so inadequate

that they would permit asbestos to be labeled "nontoxic" because two week tests are too short for cancer to develop. In the past, asbestos-containing clays, papier maches and other art materials were routinely labeled "nontoxic."

This began to change in the United States in 1978 when the Consumer Product Safety Commission (CPSC) warned the art industry to improve labeling or face regulation. In the early 1980's, the industry organized a subcommittee of the American Society of Testing and Materials (ASTM) to work on a voluntary chronic labeling standard called ASTM D-4236.

The ASTM D-4236 committee began modifying a 40-year-old voluntary program developed by the Arts and Crafts Materials Institute (known to many artists by their "AP," "CP," and "HL" label seals). Soon public action groups, most notably the Public Interest Research Groups, began pressuring for legislation to make ASTM D-4236 mandatory. Seven States passed such laws, but in 1988, they were preempted by a federal law called the Labeling of Hazardous Art Materials Act (LHAMA).

LHAMA requires that appropriate chronic warnings be placed on the labels of each hazardous art material after an evaluation by a Board Certified Toxicologist. The label also must state that the product "Conforms to ASTM D-4236" and it must provide a telephone number at which consumers can get further information.

NEW DEFINITION OF TOXIC. In 1992, CPSC published its final codification of LHAMA which formally changed the definition of "toxic" for all consumer products to include both the short term animal tests and new guidelines for determining when products could cause cancer, neurological, developmental and reproductive harm. There are, however, serious flaws in the guidelines:

1. Chemicals which have never been tested for toxicity may be labeled nontoxic--even if those chemicals are related to known chronically toxic substances.

2. Products containing toxic substances may be labeled "nontoxic" if toxicologists assume artists are exposed to amounts smaller than that which would make industrial workers sick. Yet artists working and living in the same studio/loft may be exposed for more hours and more intimately than workers.

3. Paints containing substances that cause cancer by inhalation such as cadmium may not be labeled with cancer warnings if the user is warned not to spray apply the paint. Actually, artists may inhale paints in many other ways such as by sanding, scraping, or heating. They need to know that the pigment must not be inhaled in any way and why.

4. Enforcement is weak and compliance is still poor especially for imported products.

LABELS FOR INDUSTRIAL / PROFESSIONAL USE ONLY.

Products carrying this label are not supposed to be readily available to general consumers and should never be used by children or untrained adults.

Rules for the types of information and warning symbols which conform to your right-to-know law can be obtained from your local department of labor. This label warns workers that they should be skilled in the use of the product and should have a Material Safety Data Sheet (see next section) as a guide to safe use of the product.

MATERIAL SAFETY DATA SHEETS

WHAT ARE THEY? Material Safety Data Sheets are forms which provide information on a product's hazards, and the precautions required for its safe use in the working environment. Material Safety Data Sheets are usually filled out by the product's maker and the quality of the information varies depending on the diligence and cooperativeness of the individual manufacturer. However, manufacturers are responsible to their respective government agencies for the accuracy of information they provide.

The Material Safety Data Sheets are essential starting points for the development of a data base for health and safety programs. They should not be considered complete sources of information on their own.

WHO NEEDS THEM? The Hazard Communications Standard, WHMIS, and right-to-know laws require that Material Safety Data Sheets be made available to all those who use or could be exposed to potentially hazardous products in the workplace. This would include not only the products' users, but those working near the material, those storing or distrib-

uting the material (in case of breakage), and anyone exposed to airborne emissions from the products use, and so on.

All employers and administrators are required by the new laws to obtain Material Safety Data Sheets and make them available to all employees. Art teachers, who are employees, must have access to Material Safety Data Sheets and should in turn make them available to all students old enough to understand them. Self-employed artists should also obtain Material Safety Data Sheets for their protection as well.

In addition, all employers and administrators are responsible for training employees to interpret and use Material Safety Data Sheet information (see TRAINING, pages 19-20).

HOW ARE THEY OBTAINED? Material Safety Data Sheets can be obtained by writing to manufacturers, distributors, or importers of the product. Schools, businesses, and institutions can require Material Safety Data Sheets as a condition of purchase. If makers or suppliers do not respond to requests for Material Safety Data Sheets, send copies of your requests and other pertinent information to the agency responsible for enforcing your federal or local right-to-know law. These agencies usually get very good results.

Products for which there are no Material Safety Data Sheets or incomplete Material Safety Data Sheets must be removed from the workplace and replaced with products for which better information is available.

WHERE SHOULD THEY BE KEPT? Material Safety Data Sheets should be filed or displayed where the products are used and stored. For schools, experience has shown that the best procedure is to have a central file for all Material Safety Data Sheets and also to have smaller files in each classroom, shop, or work area which contains copies of the Material Safety Data Sheets for products used at that location.

WHAT DO THEY LOOK LIKE? To begin with, the words "Material Safety Data Sheet" must be at the top. Some manufacturers resist sending Material Safety Data Sheets, sending instead sheets labeled "Product Data Sheet," "Hazard Data Sheet," or other titles. These forms do not satisfy the laws' requirements.

Although Material Safety Data Sheets must contain the same basic information, the actual forms may look very different. For example, some are computer generated and some are government forms.

Figure 3 is a copy of the most common United States Material Safety Data Sheet form (the OSHA 174 form).* The Canadian forms require similar information (see Figure 3A).

INFORMATION REQUIRED ON MATERIAL SAFETY DATA SHEETS. All of the information on the form in Figures 3 and 3A should be on a Material Safety Data Sheet. In general, Material Safety Data Sheets identify the product chemically (with the exception of trade secret products), identify any toxic ingredients, list its physical properties, its fire and explosion data, its acute and chronic health hazards, its reactivity (conditions which could cause the product to react or decompose dangerously), tell how to clean up large spills and dispose of the material, identify the types of first aid and protective equipment needed to use it safely, and discuss any special hazards the product might have.

Canadian Material Safety Data Sheets require the chemicals' odor threshold (OT) when known. This is a very practical piece of information. For example if the Odor Threshold of a chemical is a smaller number than the Threshold Limit Value, workers know they can detect the odor of the substance before they are overexposed.

HOW TO READ MATERIAL SAFETY DATA SHEETS. It would take a small book to explain how to interpret Material Safety Data Sheets. Fortunately there already are many small books and pamphlets on this subject. Some good ones are listed in Appendix I, The Right-To-Know Library, page 326. For definitions of common terms used on Materials Safety Data Sheets, see the Glossary, page 330. All of these materials can be used for your right-to-know program or as training aids.

Artists also should be aware of certain common errors on Material Safety Data Sheets. For example, some manufacturers send out data sheets with blank spaces. This is not allowed. If no data exists or it is not applicable, the form must state this. Other problems are addressed below by section.

Section I — THE MATERIAL SAFETY DATA SHEET must have the art material manufacturer's name, address, and emergency telephone number at the top. It is the company whose name is on the Material Safety

* A new form jointly developed by the American National Standards Institute and the Chemical Manufacturer's Association is coming into use. It has 16 categories of information and will include environmental hazards and precautions. Information about these new forms is available from ACTS (see page 9).

Data Sheet that is responsible to you for information and help.

Some art materials makers violate the law by sending out Material Safety Data Sheets from other companies--often the companies that sell them raw materials. The reason is that art materials companies do not manufacture pigments, solvents, glaze chemicals and so on. They may mix these ingredients into new products or simply relabel them. In these cases, they must put their own name at the top of the Material Safety Data Sheets and rework the information to reflect the consumer's use of the products, For example, a Material Safety Data Sheet for a paint is improper if it discusses only the hazards of the liquid if the paint also is to be sprayed or sanded.

Some suppliers send old, outdated Material Safety Data Sheets. Look for the date of preparation either in this section or at the end of the form. If there is no date or if the Material Safety Data Sheet is several years old, demand a proper one. In Canada, three-year-old Material Safety Data Sheets are automatically invalid.

Section II — HAZARDOUS INGREDIENTS. The definition of a "hazardous ingredient" varies in different state, provincial, and federal laws. But the OSHA Hazard Communication Standard defines as *hazardous* any chemical which is a physical hazard (flammable, unstable, etc.,) or a health hazard. *Health hazard* is further defined to mean any "chemical for which there is statistically significant evidence based on at least one study..."

This means that a chemical should be listed if there is even one proper animal study indicating a potential problem. On the other hand, manufacturers may decline to list chemicals which have never been studied or which are not listed by OSHA as regulated chemicals. This means there may be toxic chemicals in the product which are not listed.

Some art-materials manufacturers decline to list any of their ingredients, because they claim their products are proprietary or trade secrets. Artists should be aware that there are legal criteria for claiming trade secret status and in many states they must have a registration number. If you receive a Material Safety Data Sheet for a trade secret product, contact your department of labor to find out if these criteria were met.

Ingredient identification should include: chemical name, chemical family, synonyms, and common name(s). Good Material Safety Data Sheets also include the "CAS" number. "CAS" stands for the Chemical Abstracts Service, an organization that indexes information about chemicals. The CAS number enables users to look up information about the chemical in many sources.

Exposure limits should also be listed if they exist. For example, ACGIH-Threshold Limit Values, OSHA-Permissible Exposure Limits, and Canadian Occupational Exposure Limits (see page 32). Sometimes manufacturers will also list their own recommended limits if no others exist for the material.

The percentage of each ingredient in products that are mixtures is optional, but responsible manufacturers supply them.

Section III — PHYSICAL/CHEMICAL CHARACTERISTICS. Boiling point, evaporation rate, and other properties of the material are listed here. The description of appearance and odor can be compared to the look and smell of your product to verify that you have the right Material Safety Data Sheet.

Section IV — FIRE AND EXPLOSION HAZARD DATA. Flash point and other data are listed here along with information about the proper fire extinguisher to use and any special fire-hazard properties of the material. This section should be consulted when planning emergency procedures.

Section V — REACTIVITY DATA. Artists who experiment with their media should pay special attention to the section on reactivity. This section describes how stable the material is, under what conditions it can react dangerously, and materials with which it is incompatible. If you don't understand this section, do not experiment.

Section VI — HEALTH HAZARD DATA. Toxicological information is briefly summarized here and many manufacturers still do not include chronic hazards. You will need to investigate further and may want to use one of the resources mentioned above or the Glossary in this book to look up some of the terminology.

Cancer information which should be included on United States Material Safety Data Sheets includes whether the material is considered a cancer agent by either the National Toxicology Program (NTP), the International Agency for Research on Cancer (IARC), or OSHA. See *Cancer* in the Glossary for their criteria.

Section VII — PRECAUTIONS FOR SAFE HANDLING AND USE. Use the information in this section to plan storing and handling of the material. Waste disposal information cannot be detailed because so many different local, state, provincial, and federal regulations exist. Check regulations that apply to your location.

Section VIII — CONTROL MEASURES. Proper respiratory protection, ventilation, and other precautions should be described here. Consult the ventilation and respiratory protection chapters of this book for more detailed information.

Material Safety Data Sheet May be used to comply with OSHA's Hazard Communication Standard, 29 CFR 1910.1200. Standard must be consulted for specific requirements.	**U.S. Department of Labor** Occupational Safety and Health Administration (Non-Mandatory Form) Form Approved OMB No. 1218-0072
IDENTITY *(As Used on Label and List)*	Note: Blank spaces are not permitted. If any item is not applicable, or no information is available, the space must be marked to indicate that.

Section I

Manufacturer's Name	Emergency Telephone Number
Address *(Number, Street, City, State, and ZIP Code)*	Telephone Number for Information
	Date Prepared
	Signature of Preparer *(optional)*

Section II — Hazardous Ingredients/Identity Information

Hazardous Components (Specific Chemical Identity, Common Name(s))	OSHA PEL	ACGIH TLV	Other Limits Recommended	% *(optional)*

Section III — Physical/Chemical Characteristics

Boiling Point	Specific Gravity (H_2O = 1)
Vapor Pressure (mm Hg.)	Melting Point
Vapor Density (AIR = 1)	Evaporation Rate (Butyl Acetate = 1)
Solubility in Water	
Appearance and Odor	

Section IV — Fire and Explosion Hazard Data

Flash Point (Method Used)	Flammable Limits	LEL	UEL
Extinguishing Media			
Special Fire Fighting Procedures			
Unusual Fire and Explosion Hazards			

(Reproduce locally) OSHA 174, Sept. 1985

Fig. 3. Material Safety Data Sheet (U.S.)

Section V — Reactivity Data

Stability	Unstable		Conditions to Avoid
	Stable		

Incompatibility (*Materials to Avoid*)

Hazardous Decomposition or Byproducts

Hazardous Polymerization	May Occur		Conditions to Avoid
	Will Not Occur		

Section VI — Health Hazard Data

Route(s) of Entry:	Inhalation?	Skin?	Ingestion?

Health Hazards (*Acute and Chronic*)

Carcinogenicity:	NTP?	IARC Monographs?	OSHA Regulated?

Signs and Symptoms of Exposure

Medical Conditions
Generally Aggravated by Exposure

Emergency and First Aid Procedures

Section VII — Precautions for Safe Handling and Use

Steps to Be Taken in Case Material Is Released or Spilled

Waste Disposal Method

Precautions to Be Taken in Handling and Storing

Other Precautions

Section VIII — Control Measures

Respiratory Protection (*Specify Type*)

Ventilation	Local Exhaust		Special	
	Mechanical (*General*)		Other	

Protective Gloves		Eye Protection	

Other Protective Clothing or Equipment

Work/Hygienic Practices

Page 2 ☆ U S G P O 1986-491-529/45775

Fig. 3. (Continued)

Minimum Information Required on Canadian Material Safety Data Sheets for Controlled Products

Hazardous Ingredient Information
 I. Chemical identity and concentration
 a) of the product (if the product is a pure substance);
 b) of each controlled ingredient (if the product is a mixture);
 c) of any ingredient that the supplier/employer has reason to
 believe may be harmful; and
 d) of any ingredient whose toxic properties are unknown.
 2. The products CAS, UN and/or NA registration numbers.
 a) CAS=Chemical Abstracts Service Registration Number.
 b) UN=number assigned to hazardous materials in transit
 by the United Nations.
 c) NA=number assigned by Transport Canada and the United
 States Department of Transportation and for which a UN num-
 ber has not been assigned.
 3. The LD^{50} and LC^{50} of the ingredient(s).
 a) LD^{50}=the dose (usually by ingestion) which kills half of the
 test animals in standard acute toxicity tests.
 a) LC^{50}=the airborne concentration which when inhaled kills

 half of the test animals in standard acute toxicity tests.

Preparation Information
 1. The name and telephone number of the group, department or
 person responsible for preparing the Material Safety Data Sheet.

 2. The date the Material Safety Data Sheet was prepared.

Product Information
 1. The name, address, and emergency telephone number of the
 product's manufacturer and, if different, the supplier.
 2. The product identifier (brand name, code or trade name, etc.)

 3. The use of the product.

Physical Data
 Physical state (gas, liquid, solid), odor and appearance, odor thresh
 old (level in parts per million at which the odor becomes notice-able),
 specific gravity, vapor pressure, vapor density, evaporation rate, boil-
 ing point, freezing point, pH (degree of acidity or alkalinity), and co-
 efficient of water/oil distribution.

Fig. 3A

Fire and Explosion Hazards

Conditions under which the substance becomes a flammable hazard, means of extinguishing a fire caused by the substance, flash point, upper flammable limit, lower flammable limit, auto-ignition temperature, hazardous combustion products, explosion data including sensitivity to mechanical impact and to static discharge.

Reactivity Data

1. Conditions under which the product is chemically unstable.
2. Name(s) of any substance with which the product is chemically unstable (will react hazardously).
3. Conditions of reactivity.
4. Hazardous decomposition products.

Toxicological Data

1. Route of entry (skin contact, inhalation, ingestion, eye contact).
2. Acute effects.
3. Chronic effects.
4. Exposure limits (Occupational Exposure Limits, Threshold Limit Values, etc.).
5. Irritancy.
6. Sensitization potential (ability to cause allergies).
7. Carcinogenicity.
8. Reproductive toxicity.
9. Teratogenicity (ability to cause birth defects).
10. Mutagenicity (ability to cause mutation).
11. Synergistic effects (names of substances which may enhance toxic effects).

Preventative Measures

1. Personal protective equipment needed.
2. Specific engineering controls required (e.g. ventilation).
3. Spill or leak procedures.
4. Waste disposal methods.
5. Handling procedures and equipment.
6. Storage requirements.
7. Special shipping information.

First Aid Measures

Specific first aid measures in event of skin/eye contact, inhalation or ingestion.

Fig. 3A. (Continued)

CHAPTER

6 *GENERAL PRECAUTIONS*

I n addition to specific precautions such as ventilation and respira-
tory protection, there are several general precautions which should
be used in most situations.

SUBSTITUTION

The most effective precaution, of course, is substituting safe materials for
more hazardous ones. Material Safety Data Sheets and labels can be used
to compare products for toxicity and to identify the safest one. General
rules for substitution include the following:

1. Always choose water-based or latex paints, inks, and other products
 over solvent-containing ones whenever possible. Solvents are among
 the most hazardous chemicals used by artists. For this reason, acrylic
 or water colors are much safer to use than oils and enamels, which
 are thinned with turpentine or paint thinner.

2. If solvents must be used, Threshold Limit Values, evaporation rates,
 and other data on Material Safety Data Sheets can be used to choose
 the least toxic ones. (See also Chapter 9, Solvents, page 87, for addi-
 tional guidelines.)

3. Choose products which do not create dusts and mists. Avoid materi-

als in powdered form or aerosol products whenever possible to avoid inhalation hazards.

4. Avoid products containing known cancer-causing chemicals whenever possible, since there is no safe level of exposure.

PERSONAL HYGIENE

One of the simplest and most neglected methods of avoiding exposure to toxic substances is to practice good hygiene in the workplace. Industrial experience has taught that tiny amounts of toxic substances left on the skin, or brought home on clothing can affect even the workers' families. Some basic hygiene rules include the following:

1. Do not eat, smoke, or drink in studios, shops, or other environments where there are toxic materials. Dust, after all, settles in coffee cups, vapors can be absorbed by sandwiches, and hands can transfer substances to food and cigarettes. Smoking is especially hazardous because some substances inhaled through a cigarette can be converted by the heat to more hazardous forms.

2. Wear special work clothes and remove them after work. If possible, leave them in the workshop and wash them frequently and separately from other clothing. If the workplace is dusty, wear some form of hair covering (hair is a good dust collector). And for safety as well as hygiene, do not wear loose clothing, scarves or ties, or jewelry. Tie back long hair.

3. Wash hands carefully after work, before eating, using the bathroom, and applying make-up.

STORAGE OF MATERIALS

Many accidents, spills, and fires can be avoided by following rules for safe storage and handling of materials.

1. Clearly mark every bottle, box, or gas cylinder as to its contents, its hazards, and the date received and opened. Even containers into which materials are transferred for storage should be so labeled.

2. Use unbreakable containers whenever possible.

3. Apply good bookkeeping rules to chemical storage. Keep a current inventory of all the materials on hand and their locations. Post locations of flammable or highly toxic materials.

4. Maintain records of dates of purchase of materials in order to dispose of chemicals with limited shelf-lives properly. Some chemicals even become explosive with age.

5. Apply good housekeeping rules to chemical storage. Have cleaning supplies and facilities for handling of spills at hand. Never store any material which you are not prepared to control or clean up if it spills. If respiratory protection, gloves, or other personal protective equipment will be needed for cleaning up spills, have these in the studio at all times.

6. Organize storage wisely. For example, do not store large containers on high shelves where they are difficult to retrieve. Never store hazardous chemicals directly on the floor or above shoulder height.

7. Store reactive chemicals separately. Check each product's Material Safety Data Sheet and other technical sources for advice.

8. Keep all containers closed except when using them in order to prevent escape of dust or vapors.

9. Ventilate the storage room. Keep it cool and keep chemicals out of direct sunlight.

10. Do not allow dispensing or mixing of chemicals in or near the storage area.

11. If chemical corrosives or irritants are stored, be prepared with an eye wash station and emergency shower.

12. Storage of flammable chemicals should conform to all state/provincial fire regulations. Contact your local authorities for advice. Store large amounts of flammable solvents in metal flammable storage cabinets or specially designed storage rooms.

13. Have fire protection or extinguishers available which are approved for fires caused by the type of chemicals stored. Train personnel to use this type of extinguisher.

HANDLING/DISPOSAL OF MATERIALS

1. Check labels and Material Safety Data Sheets of your materials and have available the types of face, eye protection, gloves, wash-up facilities, and first aid equipment which are recommended.

2. When accidents occur, wash skin with lots of water and remove contaminated clothing. If eyes are affected, rinse eyes for at least fifteen minutes in an eye wash fountain and get medical advice.

3. Do not use any cleaning methods which raise dust. Wet mop floors or sponge surfaces.

4. Dispose of waste or unwanted materials safely. Check federal and local environmental protection regulations. Sometimes product labels or manufacturers can provide advice. Do not pour solvents down drains. Pour nonpolluting aqueous liquids down the sink one at a time with lots of water. For large amounts of regularly produced wastes, engage a waste disposal service.

5. Clean up spills immediately. If you use flammable or toxic liquids in the shop, stock chemical absorbants or other materials to collect spills, self-closing waste cans, and respiratory protection if needed. Empty waste cans daily.

6. When practical, dispense solvents from self-closing safety cans to reduce evaporation.

7. Do not store flammable or combustible materials near exits or entrances. Keep sources of sparks, flames, UV light, and heat as well as cigarettes away from flammable or combustible materials. (See Chapter 9, Solvents, page 87, for addition rules about flammable liquids.)

8. Have appropriate fire protection or extinguishers handy and train workers to use them.

CHOOSING PROPER PROTECTIVE EQUIPMENT

Many types of protective equipment are on the market. Some general rules for selecting appropriate equipment include:

1. Get expert advice when planning for safety and health. For example, consult an industrial hygienist (either private or governmental) to survey your facilities for hazards and recommend equipment. Some state/provincial government industrial hygiene services are free.

2. Get advice from more than one source when purchasing protective equipment, machinery, etc. Never rely solely on equipment manufacturers or distributors for information.

3. Survey personnel and students' special needs and problems regarding protective equipment. For example, people with dermatitis may need special hand protection.

4. Enforce proper use of protective equipment. Respirators are useless if they are not worn, hearing is not protected by unused ear muffs, etc.

5. Develop programs for regular repair, replacement, and maintenance of protective equipment.

WHERE TO BUY SAFETY SUPPLIES
There are several safety equipment directories available. One is *Best's Safety Directory*. It lists manufacturers and distributors of all types of safety equipment and supplies. Many technical libraries have a copy or it can be purchased for about $ 30.00 from A.M. Best Co., Ambest Road, Oldwick, NJ 08858 or call (201)439-2200.

EYE AND FACE PROTECTION
Suitable face and eye protection in the form of goggles or shields will guard against a variety of hazards, including impact (from chipping, grinding, etc.), radiation (welding, carbon arcs, lasers, etc.), and chemical splash (solvents, acids, etc.).
Only use protective equipment which conforms to American National Standards Institute (ANSI) standards. (See figures 4 and 5.)

AMERICAN NATIONAL STANDARD Z87.1-1989
SELECTION CHART

	Operation	ASSESSMENT SEE NOTE (1)	PROTECTOR TYPE	PROTECTORS	PROTECTORS LIMITATIONS	NOT RECOMMENDED
IMPACT	Chipping, grinding, machining, masonry work, riveting, and sanding.	Flying fragments, objects, large chips, particles, sand, dirt, etc.	B,C,D, E,F,G, H,I,J, K,L,N	Spectacles, goggles, faceshields SEE NOTES (1) (3) (5) (6) (10) For severe exposure add N	Protective devices do not provide unlimited protection.	Protectors that do not provide protection from side exposure. SEE NOTE (10)
					SEE NOTE (7)	Filter or tinted lenses that restrict light transmittance, unless it is determined that a glare hazard exists. Refer to OPTICAL RADIATION.
HEAT	Furnace operations, pouring, casting, hot dipping, gas cutting, and welding.	Hot sparks	B,C,D, E,F,G, H,I,J, K,L,*N	Faceshields, goggles, spectacles *For severe exposure add N SEE NOTE (2) (3)	Spectacles, cup and cover type goggles do not provide unlimited facial protection.	Protectors that do not provide protection from side exposure.
		Splash from molten metals	*N	*Faceshields worn over goggles H,K SEE NOTE (2)	SEE NOTE (2)	
		High temperature exposure	N	Screen faceshields, Reflective faceshields. SEE NOTE (2) (3)	SEE NOTE (3)	
CHEMICAL	Acid and chemicals handling, degreasing, plating	Splash	G,H,K *N	Goggles, eyecup and cover types. *For severe exposure, add N	Ventilation should be adequate but well protected from splash entry	Spectacles, welding helmets, handshields
		Irritating mists	G	Special purpose goggles	SEE NOTE (3)	

Fig. 4. ANSI Protection Standards

These materials (Fig. 4 and 5) are reproduced with permission from American National Standard "Practice for Occupational and Educational Eye and Face Protection," Z87.1-1989, copyright 1989 by the American National Standards Institute. Copies of this standard may be purchased from the American National Standards Institute at 1430 Broadway, New York, NY 10018.

	Operation	Hazard	Protectors	TYPICAL FILTER LENS SHADE	PROTECTORS	Information
				SEE NOTE (9)		
DUST	Woodworking, buffing, general dusty conditions.	Nuisance dust	G,H,K			Atmospheric conditions and the restricted ventilation of the protector can cause lenses to fog. Frequent cleaning may be required.
OPTICAL RADIATION	WELDING: Electric Arc		O,P,Q	10-14	Welding Helmets or Welding Shields	Protection from optical radiation is directly related to filter lens density. SEE NOTE (4). Select the darkest shade that allows adequate task performance.
	WELDING: Gas		J,K,L, M,N,O, P,Q	SEE NOTE (9) 4-8	Welding Goggles or Welding Faceshield	
	CUTTING			3-6		
	TORCH BRAZING		B,C,D, E,F,N	3-4		
	TORCH SOLDERING			1.5-3	Spectacles or Welding Faceshield	SEE NOTE (3)
	GLARE		A,B	Spectacle SEE NOTE (9) (10)		Shaded or Special Purpose lenses, as suitable. SEE NOTE (8)

Protectors that do not provide protection from optical radiation. SEE NOTE (4)

16

Fig. 4. ANSI Protection Standards (Continued)

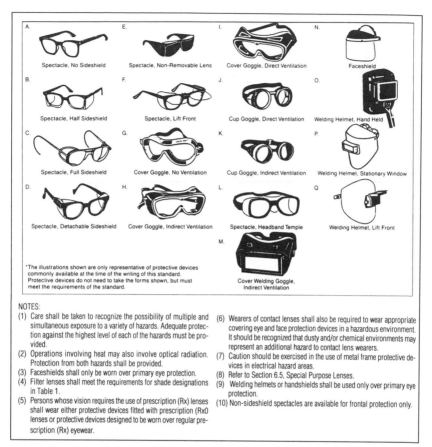

*The illustrations shown are only representative of protective devices commonly available at the time of the writing of this standard. Protective devices do not need to take the forms shown, but must meet the requirements of the standard.

NOTES:

(1) Care shall be taken to recognize the possibility of multiple and simultaneous exposure to a variety of hazards. Adequate protection against the highest level of each of the hazards must be provided.

(2) Operations involving heat may also involve optical radiation. Protection from both hazards shall be provided.

(3) Faceshields shall only be worn over primary eye protection.

(4) Filter lenses shall meet the requirements for shade designations in Table 1.

(5) Persons whose vision requires the use of prescription (Rx) lenses shall wear either protective devices fitted with prescription (RxO lenses or protective devices designed to be worn over regular prescription (Rx) eyewear.

(6) Wearers of contact lenses shall also be required to wear appropriate covering eye and face protection devices in a hazardous environment. It should be recognized that dusty and/or chemical environments may represent an additional hazard to contact lens wearers.

(7) Caution should be exercised in the use of metal frame protective devices in electrical hazard areas.

(8) Refer to Section 6.5, Special Purpose Lenses.

(9) Welding helmets or handshields shall be used only over primary eye protection.

(10) Non-sideshield spectacles are available for frontal protection only.

Fig. 5. Eye Protection Products

These standards are recognized in both the United States and Canada. Approved items will be labeled with the numbers of the standards with which they comply. Be certain to choose equipment appropriate to the hazard. A common mistake is to see chemical splash goggles used for protection against grind-wheel particles.

If you use any materials which can damage the eyes, an eye wash fountain should be a fixture in your shop. The fountain should be able to deliver at least fifteen minutes of water flow. Small eye wash bottles are not satisfactory for this purpose and also may become contaminated with bacteria.

Fountains should be activated by a foot pedal, lever or other mechanism which requires only a single movement to turn on the water and keep it running. Fountains should be flushed by running the water a few minutes once a week to keep fresh, clean water in the line.

Ordinary glasses are not proper eye protection. Do not wear contact lenses in shops where irritating liquids such as acids or solvents are used or where dusts are present.

SKIN PROTECTION

Chemical-resistant gloves have been developed for almost any use imaginable. They can be purchased in lengths up to shoulder length, in any thickness from paper thin to very thick, and in many types of plastic and rubber. However, many artists do not know that there is no single glove, no matter how expensive or thick, that will resist all chemicals.

It is necessary to find a glove supplier who provides data (usually in the form of a chart) on the length of time each type of glove material can be in contact with a chemical before it is 1) degraded and/or 2) permeated.

Degradation occurs when the glove deteriorates from the chemical's attack. Permeation occurs when molecules of the chemical squirm through the glove material. It can occur in minutes, and permeated gloves often appear unchanged, leaving users unaware they are being exposed to the chemical. Surgical or ordinary household gloves should not be expected to stand up to solvents, acids, and other strong chemicals. In addition, some people are exquisitely allergic to natural rubber.

Artists should only select gloves from the manufacturer's chart, because glove permeation is specific to glove material, thickness, and the methods of manufacture. General glove charts found in some safety publications can be misleading.

Manufacturers' catalogues often provide access to proper gloves for other purposes, such as protection from heat, radiation, and abrasion. Asbestos gloves should not be used and substitutes for them are available.

For protection from occasional splashes or very light exposure to chemicals, you may use special creams called "barrier creams." Some of these creams protect skin from solvents and oils, others from acids, and so on. Choose the right cream and use it exactly as directed.

Do not use harsh hand soap. Waterless skin cleaners are useful if their ingredients do not include solvents or other harsh chemicals. Never wash your hands with solvents. Some people find that rubbing baby oil (mineral oil) on the skin and then washing with soap and water will remove many paints and inks. Using a barrier cream should enable you to wash off paints with soap and water. After cleaning your skin, apply a good hand lotion to replace any lost skin oils.

Hands are not the only part of the body for which skin protection has

been developed. Aprons, leggings, leather or plastic clothing, shoes, and myriad special protective products are available. Remember, your skin's protective barrier is your first defense against many hazardous agents.

MEDICAL SURVEILLANCE

Artist should keep in mind that there are no tests for some types of chemical exposures, and there are no treatments for many kinds of bodily damage from workplace chemical and physical agents. Medical monitoring is never a replacement for preventing exposure to toxic substances.

Medical monitoring, however, can be a valuable tool in early recognition and prevention of occupational illnesses. Such tests can serve three purposes: 1) to identify preexisting disorders so artists can avoid media that would put them at great risk; 2) to detect early changes in performance before serious damage occurs; 3) and to detect damage that has already occurred and which may be permanent.

Examples of some types of useful medical tests might include regular (in some cases yearly) lung function tests for artists exposed to clay, stone, or wood dust, etching acid vapors, or who intend to wear a respirator (see chapter on Respiratory Protection). Artists using lead materials also should have blood tests for lead at least once a year. There are blood or urine tests for several other toxic metals as well.

Choosing the right tests and interpreting the results can be done best by doctors who are Board Certified in Occupational Medicine or Toxicology, or who have experience with occupational health problems. Such doctors may be found by contacting your state or provincial health departments or artists' advocacy organizations such as ACTS (see Preface).

Only consult physicians who explain the results of medical tests in meaningful terms so you can be an active participants in your own health care.

CHAPTER

7 *VENTILATION*

Providing proper ventilation is the single most important method of protecting artists from hazardous airborne substances. There are two basic kinds of ventilation: 1) comfort ventilation to keep people in modern buildings comfortable; and 2) industrial ventilation to keep artists and others who work with chemicals healthy.

COMFORT VENTILATION. Comfort ventilation provides sufficient air movement and fresh air to avoid buildup of humidity, heat, and air pollution in buildings. This usually is accomplished by either natural or re-circulating ventilation systems.

Natural ventilation takes advantage of rising warm air and prevailing winds to cause the air in buildings to circulate and exchange with outside air in sufficient amounts to provide comfort to those inside the building. Often chimney-like flues are constructed behind walls to draw out warm air. Such systems are found mostly in older buildings where high ceilings and open spaces enhance the system.

Some of these buildings also employ "univents" installed in rooms on outside walls. These units draw in some outside air through louvres in the wall, mix it with room air, and heat and expel the mixture. During the energy crisis, many of these units' access to outside air was cut off to save fuel. In this case, the units provide no ventilation, only heat.

Recirculating ventilation systems use fans or blowers to circulate air from room to room throughout the building. On each recirculating cycle, some fresh air from outside is added and some recirculated air is exhausted. The amount of fresh air added usually varies from 5 to 30 percent, depending on how tightly insulated the building is and the vagaries of the particular ventilation system or its operator. Building engineers who operate ventilation systems often are encouraged to add as little fresh air as possible to reduce heating and cooling costs.

People often feel ill when insufficient amounts of fresh air are added to comfort ventilation systems. They may complain of eye irritation, headaches, nausea, and other symptoms. Taken together, these sometimes are called the "sick building syndrome." The symptoms are apparently caused by the accumulation of body heat, humidity, cigarette smoke, dust, formaldehyde, and other pollutants in the air.

INDUSTRIAL VENTILATION. Processes which produce airborne toxic substances should never be done in environments employing either natural or recirculating comfort ventilation systems. All such processes require industrial ventilation.

There are two types of industrial ventilation: 1) dilution ventilation, and 2) local exhaust ventilation.

Dilution ventilation does exactly what its name implies. It dilutes or mixes contaminated workplace air with large volumes of clean air to reduce the amounts of contaminants to acceptable levels. Then the diluted mixture is exhausted (drawn by fans or other devices) from the workplace. Dilution systems usually consist of fresh air inlets (often having fans and systems for heating or cooling the air), and outlets (exhaust fans).

Although often cheap and easy to install, dilution ventilation has limits. For example, only vapors or gases of low toxicity or very small amounts of moderately toxic vapors or gases are removed sufficiently by dilution ventilation. Never use dilution ventilation to remove dusts, mists, or any highly toxic materials.

For example, dilution ventilation might be used for areas where small amounts of solvent vapors are created, such as when you paint with latex paints (which usually contain 5 to 15 percent solvents). Other good places for dilution ventilation include photographic darkrooms (black and white) and commercial art studios where small amounts of rubber cement and solvent-containing marking pens are used. Successful dilution ventilation also depends on the control and direction of air flow through the workspace. Careful positioning of the air inlets and outlets will assure that

air flow moves in the desired direction, that the whole room is ventilated (no dead air spaces), and that expelled air cannot return via an inlet.

In special cases, the exhaust fan can be positioned very close to the work station (see figure 6). In this way it is effective as a local exhaust. Do not use this system with aerosol cans, spray painting, airbrush operations, or with flammable materials unless the fan is explosion proof.

Local exhaust ventilation is the best means by which materials of moderate to high toxicity—gases, vapors, dusts, fumes, etc.—are removed from the work place. Because local exhaust ventilation captures the contaminants at their source rather than after they have escaped into the room air, local exhaust systems remove smaller amounts of air than dilution systems. Table 3, page 70 lists processes which require local exhaust ventilation.

Local exhaust systems consist of a *hood* enclosing or positioned very close to the source of the contamination to draw in the air, *ductwork* to carry away the contaminated air, possibly an *air-cleaner* on some system to filter or purify the air before it is released outside, and a *fan* to pull air through the system. (See figure 7, page 66.)

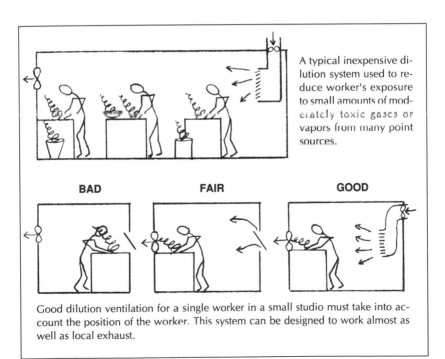

A typical inexpensive dilution system used to reduce worker's exposure to small amounts of moderately toxic gases or vapors from many point sources.

BAD FAIR GOOD

Good dilution ventilation for a single worker in a small studio must take into account the position of the worker. This system can be designed to work almost as well as local exhaust.

Fig. 6. Dilution Ventilation

Some of the rules to consider when choosing a local exhaust system include:

a. Enclose the process as much as possible by putting the hood close to the source or surrounding the process as completely as possible with the hood. The more the process is enclosed, the better the system will work.

b. Make sure the air flow is great enough to capture the contaminant. Keep in mind that dusts are heavy particles and require higher velocity air flow for capture than lighter vapors and gases.

c. Make sure that contaminated air flows away from your face, not past it.

d. Make sure that the exhausted air cannot re-enter the shop through make-up air inlets, doors, windows, or other openings.

e. Make sure enough make-up air is provided to keep the system operating efficiently.

TYPES OF HOODS. A hood is the structure through which the contaminated air first enters the system. Hoods can vary from small dust collecting types built around grind wheels to walk-in-sized spray booths. Some hoods which artists may find useful include the following:

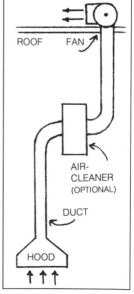

Fig. 7

Dust-collecting systems. (Fig. 8.) Most grind wheels, table saws, and other dust-producing machines sold today have dust collecting hoods built into them. Some machines need only to be connected to portable dust collectors which can be purchased off the shelf. In other cases, stationary ductwork can be used to connect machines to dust collectors such as cyclones (which settle out particles) and bag houses (which capture particles on fabric filters). Artists should not work with dust-producing machines unless they are connected to dust collectors.

Spray booths.(Fig. 9.) Spray booths from small table models to walk-in-sized or larger can be purchased or designed to fit the requirements of a particular shop. Some common uses for spray booths include spraying of paints, lacquers, adhesives and other materials, plastic resin casting, paint stripping, and solvent cleaning of silk screens. Since spray paints and other sprays are likely to contain flammable solvents, the spray booth, its ducts and fans, and the area surrounding the booth must be made safe from explosion and fire hazards.

Fig. 8.

Movable exhaust systems. (Fig. 10.) Also called "elephant trunk" systems, these flexible duct and hood arrangements are designed to remove fumes, gases, and vapors from processes such as welding, soldering, or any small table top processes which use solvents or solvent-containing products. Movable exhausts also can be equipped with pulley systems or mechanical arms designed to move hoods to almost any position.

Fig. 9.

Fig. 10.

Canopy hood systems. (Fig.11.) These hoods take advantage of the fact that hot gases rise. They are used over processes such as kilns, hot dye baths, wax and glue pots, stove ranges, and the like. Unfortunately, they often are installed above worktables where they are not only ineffective because the hood is too far from the table, but even dangerous because they draw contaminated air past the worker's face.

Fig.11.

Slot hood systems. (Fig. 12.) These systems draw gases and vapors across a work surface, away from the worker. Slot hood systems are good for any kind of bench work, including silk-screen printing, color photo developing, air brushing, and soldering. They are rather expensive to design and build, but provide a shop with surfaces on which many processes can be safely carried out.

Fig. 12.

PLANNING VENTILATION

Planning ventilation systems for large schools, studios, and shops usually requires experts for each phase of work. You should carefully apprise these experts of your special needs before they begin their work.

Ideally, you first should choose an industrial hygienist to evaluate shop and house hazards and recommend specific ventilation systems. Next select a professional engineer experienced in industrial ventilation to design both dilution and local exhaust ventilation systems. You may also want to employ a heating, ventilating, and air conditioning (HVAC) engineer to help integrate the new ventilation systems into existing ones, or to upgrade comfort ventilation systems. Once the experts have designed the systems, employ an appropriate contractor to install it. Be particularly careful to choose qualified experts. Engineering and contracting errors can result in very expensive and time-consuming problems.

Planning ventilation for small shops and individual studios is much less complicated. A good reference called *Ventilation: A Practical Guide* (Available from CSA, 5 Beekman St., New York, NY 10038) provides basic ventilation principles and calculations. Mechanically inclined artists should be able to use this manual to design and install simple systems.

Artists should be leery of salesmen who tout products which appear to solve ventilation problems cheaply by purifying contaminated air and returning it to the workplace. Some of these devices, such as the negative ion generator**, are not only useless in most studios, but they actually can be harmful if they also generate irritating ozone gas. Others, such as electrostatic precipitators, are very limited in their uses and at best can be used only as adjuncts to traditional ventilation. For example, they can successfully remove cigarette smoke fume particles, but not the gases and vapors produced by cigarettes.

CHECKING THE SYSTEM. After a ventilation system has been installed, it should be checked to see that it is operating properly. If an engineer, industrial hygienist, or contractor worked on the job, he or she should make the initial check and recommend any changes necessary to meet design specifications. If experts were not consulted, you may decide to consult one at this stage.

**These systems cannot collect gases or vapors. They only remove positive electric charges on some kinds of particles such as pollens and house dust causing them to settle temporarily on surfaces and walls. While this might be helpful to some individuals sensitive to pollens and certain dusts, it is essentially useless against toxic gases, vapors, fumes and dusts.

For example, air flow devices can be used by an expert to measure air velocity and determine how well the system is functioning.

Even without the advice of an expert, some common-sense observations can be made:

1. Can you see the system pulling dusts and mists into it? If not, you might use incense smoke or soap bubbles to check the system visually. When released in the area where the hood should be collecting, the smoke or bubbles should be drawn quickly and completely into the system.

2. Can you smell any gases or vapors? Sometimes placing inexpensive perfume near a hood can demonstrate a system's ability to collect vapors or it can show that exhausted air is returning to the workplace (or some other place where it should not be).

3. Do people working with the system complain of eye, nose, or throat irritation or have other symptoms?

4. Is the fan so noisy and irritating that people would rather endure the pollution than turn it on? Fans should not be loud, and installers should be expected to work on the system until it is satisfactory.

Check ventilation systems periodically to see that they are continuing to work properly. Maintenance schedules for changing filters, cleaning ducts, changing fan belts and the like also should be worked out and kept faithfully.

TABLE 3	Processes and Equipment Requiring Local Exhaust Ventilation

Equipment or Processes which create:

Dusts
 abrasive blasting
 dry grinding and polishing
 dry mixing of clays and glazes
 powered carving and chipping of stone, cement, etc.
 powered sanding

 woodworking machinery

Heat, Fumes, and Other Emissions
 burn-out kilns
 ceramic and glass paint kilns
 firing (all types)
 enameling and slumping kilns
 glassblowing furnaces
 foundry furnaces
 hot dye baths
 metal melting and casting
 paint-removing with torches or heat guns
 soldering

 welding

Mists
 aerosol spraying
 air-brushing

 power spraying (all types)

Solvent Vapors and/or Gases
 acid etching (all types including hydrofluoric)
 acid pickling baths
 electroplating
 paint-removing (solvent methods)
 photochemical processes:
 color processing
 toning
 photoetching
 photolithography
 plastic resin casting
 screen printing:
 printing
 print drying
 screen cleaning

CHAPTER

8 | *RESPIRATORY PROTECTION*

A dequate ventilation, not respirators, should be the primary means of controlling airborne toxic substances. United States Occupational Safety and Health Administration (OSHA) regulations restrict use of respiratory protection except: when a hazardous process is used only very occasionally (less than thirty times a year); or while ventilation is being installed, maintained, or repaired; where engineering controls result in only a negligible reduction in exposure; during emergencies; or for entry into atmospheres of unknown composition.

Most Canadian provincial regulations allow more liberal use of respiratory protection.

NIOSH APPROVAL

The National Institute for Occupational Safety and Health (NIOSH) sets standards for respirators, filters, and all respirator parts and components. Both the United States and Canada accept these standards. All approved respirators and components will carry the initials "NIOSH" and an approval number. Only NIOSH-approved products should be used.

TYPES OF RESPIRATORS

It is important to choose precisely the right type of protection for a particular task. Wearing the wrong type of respirator, a surgical mask (which is designed as protection against biological hazards, not chemical ones), or a damp handkerchief, actually may make the situation worse.

There are three basic respirator types: air-supplying, air-purifying, and powered air-purifying.

AIR-SUPPLYING RESPIRATORS bring fresh air to the wearer usually by means of pressurized gas cylinders or air compressors. They are the only respirators which can be used in oxygen-deprived atmospheres. They also are complex and expensive systems requiring special training for those using them.

AIR-PURIFYING RESPIRATORS use the wearer's breath to draw air through filters or chemical cartridges in order to purify it before it is inhaled. Most air-purifying respirators are priced in a range that artists will find practical. These respirators will be covered in detail below.

POWERED AIR-PURIFYING RESPIRATORS provide wearers with air which has been pumped (usually by a small unit attached to the wearer's belt) through filters or čartridges. This filtered air is supplied under slight pressure to a mask or shield over the wearers face. These are usually priced somewhere between the other two types of respirators.

TYPES OF AIR-PURIFYING RESPIRATORS

Artists are most likely to find the following types of air-purifying respirators useful:

1. Disposable or single-use types which often look like paper dust masks and are thrown away after use.

2. Quarter-face types which cover the mouth and nose, only and have replaceable filters and cartridges,

3. Half-face types which cover the mouth, nose, and chin, and have replaceable filters and cartridges, and

4. Full-face types which look like old-fashioned gas masks and have a replaceable canister.

RESPIRATOR PROGRAMS

Learning to select and use respirators properly is not as easy as it looks. For this reason, United States employers are required by OSHA (the Occupational Safety and Health Administration) to institute written programs for all workplaces where respirators are used. At present, Canadian regulations are not as strict, but many regulations for specific chemicals require written respirator programs. Among these substances are several used by artists and conservators including silica, lead, and ethylene oxide.

Written respirator programs should be instituted in schools, universities, businesses, museums, and all institutions whose personnel use respirators. If students are allowed to use respirators, the program should be extended to include them. Although students are not covered under occupational laws, the schools' liability will be jeopardized if students do not receive equal or better protection than staff.

The formal program requirements include fit testing to assure that contaminated air does not leak in, institution of proper procedures for cleaning, disinfecting, and storing, plus provisions for periodic inspection and repair of respirators, and for formal training of people in the use and limitations of respirators. Also included are recommendations for medical screening for users.

Medical tests or questionnaires are needed to identify users who have physical conditions which make wearing respirators dangerous. For example, heart or lung problems may be worsened by the additional breathing stress created by a respirator. Some psychological problems such as claustrophobia also preclude respirator use. Temporary conditions which curtail respirator use include head colds, skin infections, and, in come cases, pregnancy.

FIT TESTING

Fit testing is needed to identify those people who should not wear a respirator because its facepiece will not form a good seal against their skin allowing contaminants to bypass the filters. Respirators originally were designed to fit a large percentage of male caucasian faces. Some people whose faces do not conform to this shape may not find any respirator that will fit. To accommodate women, many companies now make smaller sizes. But some people simply cannot find respirators that fit them.

Other reasons respirators will not fit include the presence of facial hair (such as beards and sideburns or even a few hours growth of facial hair), facial scars, broken nose, missing dentures or very large or small faces. Fit testing should be done annually in order to catch changes in fit or physical condition. For example, losing or gaining about fifteen pounds can alter respirator fit.

FIT TESTING METHODS

There are two types of fit testing, quantitative and qualitative. Quantitative methods involve the use of equipment to measure airborne concentrations both inside and outside the respirator. This is the best method, but it is very expensive.

Qualitative fit testing involves exposing the wearer to an agent which can be detected by odor or taste if it leaks into the respirator. Isoamyl acetate (banana oil) is commonly used to test organic vapor respirators. Irritant smokes (often titanium tetrachloride) and saccharin mists can be used to test fume, dust, and mist filtered respirators and masks.

Fit tests involve placing a hood or plastic tent over the wearer, adding the testing chemical, and having the wearer report any taste or odor while he or she performs a routine series of simple tasks including deep breathing, reading/talking, and moving the head up, down, and from side to side.

Industrial hygienists or trained representatives of respirator manufacturers are usually able to perform fit tests. These people often will train selected personnel to do fit tests so that respirator programs can function without outside help.

Other simpler tests also can be done each time you wear a cartridge respirator. These include a negative pressure test (blocking cartridge air inlets with your hands, inhaling, holding your breath for fifteen to twenty seconds to see if the negative pressure remains in the facepiece), a positive pressure test (blocking the exhalation valve, exhaling gently, and seeing if you can detect air escaping around the facepiece), and a cartridge test (see the next section).

Formal fit testing is especially important when wearing paper masks since positive and negative pressure tests cannot be done.

FILTERS AND CARTRIDGES

When air is drawn through a properly fitted respirator, it passes through either a filter or a chemical material. Filters are designed to trap particles

such as dusts or metal fumes (which are fine particles created when metals are melted). Chemical air-purifying materials, on the other hand, trap vapors (such as those created when solvents evaporate) and gases (like ammonia). Different cartridges and filters are designed to trap specific gases, vapors, fumes, dusts, and mists.

No filter or cartridge can remove all of a contaminant from the air. Instead, respirators are capable of reducing the amount of a particular contaminant to an acceptable level as defined by NIOSH standards.

WHEN TO REPLACE THEM

Both filters and chemical cartridges wear out and become ineffective with use. Filters clog progressively until breathing through them becomes difficult and breathing pressure begins to draw more particles through. Spent chemical cartridges, on the other hand, will simply stop collecting the contaminant and allow it to pass through.

Chemical cartridges usually are considered spent after eight hours of use or two weeks after they have been exposed to air, which ever comes first. Chemical cartridges also wear out with time, even if they are not used. For this reason, many brands of cartridges have an expiration date stamped on them.

No filter or cartridge is designed to be effective when contaminants reach very high concentrations. At high concentrations, more contaminants pass through cartridges and filters than is desirable, and they will wear out in a shorter time—sometimes in minutes.

To be sure they are not spent, chemical cartridges should also be tested before each use. For example, a simple test for organic vapor or spray paint cartridges is to pass an open bottle of nail polish or iso-amyl acetate (banana oil) in front of the respirator when you first put it on. If you can detect the odor, replace the cartridge.

CHEMICALS AGAINST WHICH THEY ARE EFFECTIVE

Filters and cartridges are designed only for specific kinds of airborne contaminants. Table 4 lists abbreviations for some of the filters and cartridges which artists might use.

TABLE 4	Respirator Cartridges and Filters

Cartrige or Filter Use and (Abreviation)

ACID GAS **(AG)**	Acid gases rising from bleaches, etching and pickling baths, photochemicals, etc.
AMMONIA **(NH_3)**	Ammonia from diazo copiers, cleaners, etc.
ORGANIC VAPOR **(OV)**	Vapors from evaporating solvents, solvent-containing products, etc.
FORMALDEHYDE **(CH_2O or FOR)**	Formaldehyde from plywood, formalin, urea formaldehyde glues, etc.
PAINT, LACQUER, **& ENAMEL MIST (PLE)***	Sprays and aerosols from solvent-containing paints and other products.
PESTICIDES **(PEST)**	Pesticide sprays and dusts.
ASBESTOS **(A)**	Air-supplied respirators are needed.
DUSTS **(D)**	Toxic and fibrosis-producing dusts (e.g. silica) having a Threshold Limit Value of not less than 0.05 milligrams per cubic meter (mg/m^3).
MISTS **(M)**	Water-based mists having a Threshold Limit Value of not less than 0.05 mg/m^3.
FUMES **(F)**	Fumes (e.g. metal fumes) having a Threshold Limit Value of not less than 0.05 mg/m^3.
HIGH EFFICIENCY **(H)**	Dusts, mists, and fumes of highly toxic materials with Threshold Limit Values of 0.05 mg/m^3 or less such as lead, and radionuclides.

* PLE cartridges are organic vapor cartridges preceded by a spray mist prefilter to keep mists from soaking into and saturating the chemical cartridge.

WHEN THEY SHOULD NOT BE USED

Never use air-purifying respirators in oxygen-deficient atmospheres such as when gas is released in a confined space or in fire-fighting. They also should not be used for protection from cancer-causing substances since they merely reduce rather than eliminate toxic exposure.

In addition, NIOSH does not approve air-purifying respirators for use against chemicals which are of an extremely hazardous nature, or lack sufficient warning properties (smell or taste), are highly irritating, or are not effectively captured by filter or cartridge materials. Included among these are hot or burning wax vapors (acrolein and other hazardous decomposition products), carbon monoxide, methyl (wood) alcohol, isocyanates (from foaming or casting polyurethane), nitric acid, ozone, methyl ethyl ketone peroxide (used to harden polyester resins), and phosgene gas (created when chlorinated hydrocarbon solvents come into contact with heat or flame).

CHOOSING A RESPIRATOR

It is important that you know precisely what contaminant is in the air and its physical form (gas, vapor, particle, fume) before you choose filters and cartridges. (See Table 3, page 70.)

The amount of a substance in the air is also a factor affecting respirator choice. Single-use dust masks and some quarter-faced respirators are only good for low airborne concentrations of up to five times the Threshold Limit Value for the substance. Higher concentrations will require the use of those half- or full-faced respirators which are approved for concentrations up to ten times the Threshold Limit Value. Full-faced respirators also should be used when the contaminant concentration is up to 100 times the Threshold Limit Value and/or is an eye hazard or irritant.

Heavily contaminated atmospheres cannot be safely handled by air-purifying respirators at all. In this case, air-supplying respirators are needed.

Obviously it is a complicated procedure to estimate or measure airborne concentrations in order to choose a proper respirator. Such decisions will require expert advice. Consult an industrial hygienist or a technical expert associated with a reputable respirator manufacturer.

RESPIRATOR CARE

At the end of a work period, clean the respirator and store it out of sunlight in a sealable plastic bag. Respirators never should be hung on hooks in the open or left on counters in the shop. Cartridges left out will continue to capture contaminants from the air. They also should be stored in sealable plastic bags.

If a respirator is shared, it should be cleaned and disinfected between users. Most respirator manufacturers provide educational materials which describe proper break-down and cleaning procedures. Inspect respirators carefully and periodically for wear and damage.

WHERE TO BUY RESPIRATORS

Schools and businesses can easily contact their safety equipment suppliers for advice about good local sources. However, individual artists may find it more difficult.

Begin by talking to some of the safety equipment suppliers in the yellow pages of your telephone book. If this route proves unproductive, consult *Best's Safety Directory* (see page 57) or call some of the companies listed in Figure 13. Ask if they have a distributor near you.

Be sure to explain that you need a company which provides fit-testing, expert advice on matching the respirator to the hazard, and other technical services. These services are more important than the cost of the respirator.

Respiratory Protection Suppliers

Cabot Safety
90 Mechanic St., Southbridge, MA 01550. 1-800-225-9038.

Direct Safety Co.
7815 S. 46th St., Phoenix, AZ 85044. 1-800-528-7405.

Glendale Protective Technologies, Inc.
130 Crossways Park Drive, Woodbury, NY 11797. 1-516-921-5800.

Industrial Safety & Security,
1390 Neubrecht Rd., Lima, OH 45801. 1-800-537-9721.

Lab Safety Supply Co.
P.O. Box 1368, Janesville, WI 53547. 1-800-356-0783.

Mine Safety Appliances Co.
P.O. Box 426, Pittsburgh, PA 15230. 1-800-MSA-2222.

North Safety Equipment
2000 Plainfield Pike, Cranston, RI 02920. 1-401-943-4400.

Racal Health and Safety, Inc.
7305 Executive Way, Fredrick, MD 21701. 1-800-682-9500.

Safety Supply America
140 Greenwood Ave., Midland Park, NJ 07432. 1-800-SSA-ORDER

Scott Aviation
225 Erie St., Lancaster, NY 14086. 1-716-863-5100.

SURVIVAIR
3001 S. Susan St., Santa Ana, CA 92704. 1-800-821-7236.

U.S. Safety
P.O. Box 15965, Lenexa, KS 66285. 1-800-821-5218

Wilson Safety Products
P.O. Box 622, Second & Washing Sts., Reading PA 19603.
1-215-376-6161.

3M Co., Occupational Health and Safety Products Div.,
3M Center/Bldg. 220-3E-04, St. Paul, MN 55144. 1-800-328-1667.

Inclusion of a company on this list does not constitute endorsement of their products.

Fig. 13

Section

II

Artist's Raw Materials

CHAPTER 9 | SOLVENTS

Y ears ago, many art schools and universities taught highly technical courses on art materials. In these courses students learned about the chemical and physical nature of their materials, how to control their materials' properties to produce desired effects, and how to experiment with materials intelligently rather than accidently. Back then they knew that even effects achieved by accident must be understood if they are to be repeated and exploited.

Not only should these technical courses be revived and updated, but detailed information on the hazards of our raw materials should be added to them. This information could be organized by the chemical nature of the material. For instance, most of the hazardous chemicals in art materials can be organized in five groups of related materials. These are 1) solvents, 2) pigments and dyes, 3) metals and their compounds, 4) minerals, frits, and glass, and 5) plastics.

The following sections of this book will cover these groups materials in depth and provide information to be used as references for subsequent chapters on individual media.

SOLVENTS

Solvents are used in almost every kind of art material. They are found in many paints, varnishes, inks, and their thinners; in most aerosol spray products; in some leather and textile dyes; in ceramic lustre glazes, felt tip pens, glues and adhesives, some photographic chemicals, and much more.

WHAT ARE SOLVENTS?

The term "solvents" refers to liquid organic chemicals used to dissolve solid materials. Examples of solvents are turpentine, acetone, kerosene, and lacquer thinner. Solvents are used widely because they dissolve materials like resins and plastics, and because they evaporate quickly and cleanly.

SOLVENT TOXICITY

All solvents are toxic. They are hazardous in both their liquid and vapor state. There are no "safe" solvents.

In general, solvents can irritate and damage the skin, eyes, and respiratory tract, cause a narcotic effect on the nervous system, and damage internal organs such as the liver and kidneys. These kinds of damage can be acute (from single heavy exposures) or chronic (from repeated low dose exposures over months or years). In addition, some solvents are especially hazardous to specific organs or can cause specific diseases such as cancer.

SKIN DISEASE. All solvents can dissolve the skin's protective barrier of oils, drying and chapping the skin and causing a kind of dermatitis. In addition, some solvents can cause severe burning and irritation of the skin. Others may cause no symptoms, but may penetrate the skin, enter the bloodstream, travel through the body and damage other organs.

IRRITATION OF THE EYES AND RESPIRATORY TRACT. All solvent vapors can irritate and damage the sensitive membranes of the eyes, nose, and throat. Inhaled deeply, solvent vapors also can damage lungs. The airborne concentration at which irritation occurs varies from solvent to solvent. Often workers are unaware of solvents' effects at low concentrations. Their only symptoms may be increased frequency of colds and respiratory infections. Years of such exposure could lead to chronic lung diseases such as chronic bronchitis.

At higher concentrations symptoms are more severe and may include nose bleeds, running eyes, and sore throat. Inhaling very high concentrations or aspirating liquid solvents may lead to severe disorders including chemical pneumonia and death. Liquid solvents splashed in the eyes can cause severe eye damage.

EFFECT ON THE NERVOUS SYSTEM. All solvents can affect the brain or central nervous system (CNS) causing "narcosis." Immediate symptoms of this effect on the CNS may include dizziness, irritability, headaches, fatigue, and nausea. At progressively higher doses, the symptoms may proceed from drunkenness to unconsciousness and death. Years of chronic exposure to solvents can cause permanent CNS damage resulting in memory loss, apathy, depression, insomnia, and other psychological problems which are hard to distinguish from problems caused by everyday living.

Solvents also may damage the peripheral nervous system (PNS) which is the system of nerves leading from the spinal cord to the arms and legs. The symptoms caused by this PNS damage are numbness and tingling in the extremities, weakness, and paralysis. Some solvents such as n-hexane (found in rubber cement and many spray products) can cause a combination of CNS and PNS effects resulting in a disease with symptoms similar to multiple sclerosis.

DAMAGE TO INTERNAL ORGANS. There is considerable variation in the kinds and degrees of damage different solvents can do to internal organs. Many solvents can damage the liver and kidney as these organs attempt to detoxify and eliminate the solvents from the body. One solvent, carbon tetrachloride, has such a devastating effect on the liver, especially in combination with alcohol ingestion, that many deaths have resulted from its use. Many solvents also can alter heart rhythm, even causing heart attacks or sudden cardiac arrest at high doses. Methylene chloride, a solvent often found in plastics adhesives and paint strippers, is especially capable of damaging the heart because it also metabolizes (breaks down) in the bloodstream to form heart-stressing carbon monoxide.

Some solvents also are known to cause cancer in humans or animals. Benzene can cause leukemia. Carbon tetrachloride can cause liver cancer. Many experts suspect that all chlorinated solvents (those with "chloro" or "chloride" in their names) may be carcinogens. For example, methylene chloride is now considered a suspect carcinogen since it causes cancer in animals.

REPRODUCTIVE HAZARDS AND BIRTH DEFECTS. The reproductive effects of solvents are not well researched. Those studies which do exist show there is reason for concern. For example, Scandinavian studies show higher rates of miscarriages, birth defects, and other problems among workers who were exposed to solvents on their jobs. Also, two types of solvents—the glycol ethers or cellosolves (which are found in many photographic chemicals, liquid cleaning products, some paints and inks, and aerosol sprays) and the glycidyl ethers (found in epoxy resin products)—atrophy animals' testicles and cause birth defects.

In addition, recent studies of one of the least toxic solvents—grain alcohol—have shown that babies born to drinking mothers may be of low birth weight, have varying degrees of mental retardation, and suffer from other abnormalities. Cautious doctors counsel both men and women planning pregnancies to avoid both drinking alcohol and solvent exposure.

EXPLOSION AND FIRE HAZARDS. Solvents have two properties which especially influence their capacity to cause fires and explosions—evaporation rates and flashpoints. In general, the higher a solvent's evaporation rate (see definition in footnote to Table 5.) the faster it evaporates and the more readily it can create explosive or flammable air/vapor mixtures.

In addition, some solvents are more flammable than others, that is, they have a lower flash point (the temperature at which vapors can ignite in the presence of a spark or flame). Materials with flashpoints at around room temperature or lower are particularly dangerous.

The chlorinated hydrocarbons (see Chemical Classes, below) are usually not flammable and have no flash points. However, some can react explosively on contact with certain metals and heating or burning them creates highly toxic decomposition products including phosgene gas. Hazardous amounts of these toxic gases can be created even by working with chlorinated solvents in a room where a pilot light is burning.

Clearly, all solvents should be isolated from sources of heat, sparks, flame, and static electricity.

CHEMICAL CLASSES OF SOLVENTS. All solvents fall into various classes of chemicals. A class is a group of chemicals with similar molecular structures and chemical properties. Important classes of solvents are aliphatic, aromatic, and chlorinated hydrocarbons, alcohols, esters, and ketones. Table 5 shows various solvents and their properties by class.

RULES FOR CHOOSING SAFER SOLVENTS
(If solvents must be used, choose the least toxic ones.)

1. Compare Threshold Limit Values. The higher the Threshold Limit Value, the less toxic it is to inhale. (See definitions of Threshold Limit Values, page 32-33.)

2. Compare evaporation rates. The more slowly a solvent evaporates, the less vapor it creates when used, and the less hazardous it is to work with. In fact, some very toxic solvents which evaporate very slowly may not be as hazardous to use as less toxic ones that evaporates very quickly.

3. Compare flash points and evaporation rates. The higher the flashpoint, the lower its fire and explosion hazard. The more slowly it evaporates the less flammable vapor it creates. Chlorinated solvents with no flash points, however, should not be considered safe. (See Explosion and Fire Hazards section above for details.)

4. Compare toxic effects. Although all solvents are toxic, some may be especially dangerous to you. For example, if you have heart problems, it makes sense to avoid solvents known for their toxic effects on the heart.

5. Compare within classes. Often solvents in the same chemical class can be substituted for each other. Due to their similar chemical structures, many will dissolve the same materials or work the same way.

RULES FOR SOLVENT USE

1. *Try to find replacements for solvent-containing products.* New and improved water-based products are being developed. Keep abreast of developments in new materials.

2. *Use the least toxic solvent possible.* Use Table 5 to select the safest solvent in each class. Consult Material Safety Data Sheets on the products you use and choose those containing the least toxic solvents.

3. *Comply with hazard communication laws* (see pages 18-20). Make a complete inventory of solvents and label all containers, even small ones. Collect Material Safety Data Sheets on all solvents, and file them

where all users have access to them. Formally train all potentially exposed persons.

4. *Avoid breathing vapors.* Use solvents in areas where local exhaust ventilation is available. (Dilution ventilation should only be used when very small amounts of solvents or solvent-containing products are used.) Use self-closing waste cans for solvent-soaked rags, keep containers closed when not in use, and design work practices to reduce solvent evaporation. Keep a respirator with organic cartridges or an emergency air-supplying respirator at hand in case of spills or ventilation failure.

5. *Avoid skin contact.* Wear gloves for heavy solvent exposure and use barrier creams for incidental light exposures. Wash off splashes immediately with water and mild soap. Never clean hands with solvents or solvent-containing hand-cleaners. If solvents in amounts larger than a pint are used at one time, or if large spills are possible, have an emergency shower installed.

6. *Protect eyes from solvents.* Wear approved chemical splash goggles whenever solvents are poured or if there is a chance a splash may occur. Do not wear contact lenses, even under goggles. Install an eye wash fountain or other approved source of water which provides at least fifteen minutes flow. Prominently post emergency procedures (usually near telephone) for obtaining emergency medical advice and treatment if necessary.

7. *Protect against fire, explosion, and decomposition hazards.* Follow all local and federal codes for use, handling, ventilation, and storage. Never smoke or permit heat, flames, or sparks near solvents. Install sprinkler system or other proper fire-suppression system. Be sure fire extinguishers are approved for solvent and grease fires. Store amounts larger than a gallon in approved flammable storage cabinets (this recommendation exceeds requirements). Do not use heat and/or ultraviolet light sources near chlorinated hydrocarbons. Local exhaust ventilation fans for solvent vapors must be explosion-proof. Ground containers from which solvents are dispensed.

8. *Be prepared for spills.* Check all applicable local and federal regulations regarding release of solvent liquids and vapors. If spills of large

amounts are likely, use chemical solvent absorbers sold by most major chemical supply houses. Special traps to keep solvent spills out of sewers may be required by law. Release of large amounts of liquid or vapor of certain solvents must be reported to environmental protection authorities.

9. Dispose of solvents in accordance with local or federal regulations.

| **TABLE 5** | **Common Solvents and their Hazards** |

How To Use This Table

COLUMN 1 SOLVENT CLASS designates the chemical group into which solvents fall. Under each class heading are listed individual solvents and their common synonyms. Try to use the safest solvent in each class.

COLUMN 2 THRESHOLD LIMIT VALUE-TIME WEIGHTED AVERAGE (TLV-TWA). These are the ACGIH (American Conference of Governmental Industrial Hygienists) eight-hour, time-weighted Threshold Limit Values (TLV-TWA) for 1993-1994 in units of parts per million (ppm). (See pages 32-33 for definitions.) When no TLV-TWA exists, a TLV-C or a Workplace Environmental Exposure Limit (WEEL) set by the American Industrial Hygiene Association may be substituted with notation.

COLUMN 3 ODOR THRESHOLD (OT) in parts per million (ppm). Often OT's are given as range of amounts which normal people can detect. Solvents whose odor cannot be detected until the concentration is above the Threshold Limit Value are particularly hazardous.

COLUMN 4 FLASH POINT (FP) in degrees Fahrenheit (F °). The FP is the lowest temperature at which a flammable solvent gives off sufficient vapor to form an ignitable mixture with air near its surface. The lower the flash point, the more flammable the solvent. Some petroleum solvents exhibit a range of flash points.

COLUMN 5 EVAPORATION RATE (ER) categorized as FAST, MEDIUM or SLOW. See Appendix II for precise definition.

COLUMN 6 COMMENTS about the particular toxic effects of the solvent. Symptoms listed here are in addition to the general solvent hazards common to all solvents such as skin damage, narcosis, etc.

1	2	3	4	5	6
SOLVENT CLASS	TLV-TWA ppm	OT ppm	FP F°	ER	COMMENTS see also general hazards in text
ALCOHOLS					One of the safer classes.
ethyl alcohol, ethanol, grain alcohol, denatured alcohol.	1000	5-10	55	MED	Least Toxic in class. Denatured alcohol contains various toxic additives.
isopropyl alcohol, iso-propanol, rubbing alcohol	400	15-300	53	MED	One of the least toxic. Long-term hazards not fully studied.
methyl alcohol, methanol, wood alcohol	200	160-6000	52	FAST	High doses or chronic exposure causes blindness. Skin absorbs.
n-propyl alcohol, n-propanol	200	.03-41	59	MED	Causes mutation in cells. Not evaluated for cancer. Skin absorbs.
isoamyl alcohol, 3-methyl-1-butanol, fusel oil	100	.01-35	109	SLOW	Irritation begins at the TLV.
n-butyl alcohol, n-butanol	50C (ceiling)	1-11	95	SLOW	Respiratory irritation at below TLV. Lacrimator. Skin absorbs.

ALIPHATIC HYDROCARBONS

					Many of these are actually mixtures of chemicals derived from petroleum.
kerosene	none	unk	100-150	VERY SLOW	Low toxicity. Aspiration causes lung hemorrhage and chemical pneumonia.
n-heptane, normal heptane, heptanes (mixture of isomers)	400	0.5-330	25	FAST	One of the least toxic in class. Good substitute for hexane and other fast-drying solvents.
VM & P naphtha, benzine, paint thinner	300	1-40	20-40	MED	One of the least toxic in class. Good substitute for turpentine. "Odorless" thinner has aromatic hydrocarbons removed.
mineral spirits, Stoddard solvent and similar petroleum fractions	100	1-30	>100-	SLOW	Some fractions contain significant amounts of aromatic hydrocarbons.
n-hexane, normal hexane, commercial hexanes (55% n-hexane)	50	65-250	-7	FAST	Do not use. Potent nerve system toxin causing multiple sclerosis-like disease. Extremely flammable. Substitute heptane.
gasoline	300	0.3	-45	FAST	Do not use. Extremely flammable. May contain skin-absorbing benzene & organic lead compounds.

SOLVENT CLASS	TLV-TWA ppm	OT ppm	FP F°	ER	COMMENTS
AMIDES/AMINES					Many are sensitizing.
dimethyl formamide (DMF)	10	0.1-100	136	SLOW	Try to avoid. Skin absorbs.
ethanolamine	3	> 3	185	VERY SLOW	Severe skin, eye, respiratory irritant. Narcosis, liver and kidney damage reported.
diethanolamine	0.46	0.27	342	VERY SLOW	More toxic than ethanolamine. Severe skin and eye damage documented.
triethanolamine	5.0	unk	385	**	Hazards similar to ethanolamine. Avoid. An experimental carcinogen.

** hygroscopic: absorbs water and evaporates very slowly.

AROMATIC HYDROCARBONS

A hazardous class, avoid.

Name / synonyms					Notes
ethyl benzene, ethyl benzol, phenyl ethane	100	0.1-2.5	59	SLOW	Eye irritation begins at the TLV.
xylene, xylol, dimethyl benzene	100	.08-40	81-90	SLOW	Highly narcotic. Causes liver & kidney damage. Stomach pain reported.
toluene, toluol, methyl benzene, phenyl methane	50	.02-70	40	MED	Highly narcotic. Causes liver and kidney damage.
styrene, vinyl benzene, phenyl ethylene	50	.001-60	90	SLOW	Suspect cancer agent. Try to avoid. Skin absorbs.
diethylbenzenes: 1,3-DEB, 1,4-DEB	none	unk	~130	SLOW	Narcotic and irritating. Not well-studied.
trimethylbenzenes: 1,2,3-TMB, 1,2,4-TMB, 1,3,5-TMB	25	.0006-2.4	~130	MED	Strong narcotic and irritant. Not well-studied.
benzene, benzol	0.3	0 1-120	12	MED	Do not use. Cancer agent.Causes leukemia. Skin absorbs.

SOLVENT CLASS	TLV-TWA ppm	OT ppm	FP F°	ER	COMMENTS
CHLORINATED HYDROCARBONS					Experts suspect most common members of this class cause cancer. Avoid.
1,1,1-trichloro-ethane, methyl chloroform, chloroform	350	16-715	*	FAST	Causes irregular heart beat and arrest. Cancer studies underway.
methylene chloride, dichloromethane	50	160-230	*	FAST	Avoid. Suspect cancer agent. Metabolizes to carbon monoxide in blood. Stresses heart, causes irregular heart beat.
trichloroethylene	50	0.5-165	*	MED	Suspect cancer agent. Irregular heart beat.
perchloroethylene, tetrachloroethylene, perc	25	2-47	*	MED	Suspect cancer agent. Irregular heart beat, liver damage, flushing after alcohol ingestion.
chloroform	10	50-300	*	FAST	Do not use. Suspect cancer agent.
ethylene dichloride, 1,2-dichloroethane	10	6-185	56	MED	Strong intoxicant, causes liver damage, a suspect cancer agent.

carbon tetrachloride	5	2-700	*	FAST	Do not use. Cancer agent. Severe liver damage and death result when combined with alcohol. Skin absorbs.

* these solvents do not have typical flash points. They dissociate with heat or ultraviolet radiation to form toxic gases such as phosgene.

ESTERS/ACETATES

					One of least toxic classes.
ethyl acetate	400	.01-50	24	FAST	Least toxic in class.
methyl acetate	200	0.2-42	14	FAST	
isoamyl acetate, banana oil	100	.001-1	64	MED	Use for respirator fit testing.

ETHERS

					Do not use. Extremely flammable. Forms explosive peroxides with air.

GLYCOLS

					Vary greatly in toxicity. Used often as anitfreeze.
propylene glycol, 1,2-propanediol	50 (WEEL)	unk	210	**	Least toxic glycol. May cause allergies.

SOLVENT CLASS	TLV-TWA ppm	OT ppm	FP F°	ER	COMMENTS
ethylene glycol, 1,2-ethandiol	100C	0.1-40	232	**	Lung and eye irritant. Neurological damage and blindness at high doses.
diethylene glycol	none	unk	255	**	Probably more toxic than ethylene glycol, but does not cause blindness. Skin absorbs.
triethylene glycol, triglycol	none	unk	350	**	Technically, a "glycol ether" which may be reproductive hazard — see below.

** hygroscopic: absorbs water and evaporates very slowly.

GLYCOL ETHERS (CELLOSOLVES) and their acetates

SOLVENT CLASS	TLV-TWA ppm	OT ppm	FP F°	ER	COMMENTS
					Try to avoid, especially if planning a family.
butyl cellosolve, 2-butoxyethanol, ethylene glycol monobutyl ether	25	0.1-0.5	141	SLOW	Affects blood, liver, kidneys. Not as toxic to reproductive system as others. Skin absorbs.
cellosolve, 2-ethoxyethanol, ethyl cellosolve, ethylene glycol monoethyl ether	5	1.3-2.7	110	SLOW	Reproductive hazard for men and women. Affects blood, liver, kidneys. Skin absorbs.

methyl cellosolve, 2-methoxyethanol, ethylene glycol monomethyl ether	5	0.4-2.3	102	SLOW	Same as above. Skin absorbs.
di- and tri-ethylene and propylene glycol ethers and their acetates	-	--	--	--	This is a large class many of which are not well-studied. Experts suspect many harm blood & reproductive systems.

KETONES — Toxicity of this class varies widely.

acetone, dimethyl ketone, 2-propanone	750 (200)*	C.1-690	-4	FAST	Least toxic. Highly flammable. Irritating to respiratory tract.
methyl ethyl ketone, (MEK), 2-butanone	200	0.3-85	16	FAST	Causes severe nerve damage when used in combination with n-hexane.
methyl isobutyl ketone, (MIBK)	50	.01-16	64	MED	May also be more toxic in combination with n-hexane.
methyl butyl ketone, (MBK)	5	.07-.09	77	MED	Do not use. Causes permanent nerve damage.

* New TLV proposed, May 24, 1994.

SOLVENT CLASS	TLV-TWA ppm	OT ppm	FP F°	ER	COMMENTS
MISCELLANEOUS					
turpentine	100	50-200	95	SLOW	Causes allergies (dermatitis, asthma), kidney, bladder damage. Substitute odorless paint thinner.
limonene, d-limonene, citrus oil, citrus turps, menthadiene, dipentene	30 (WEEL)	unk	unk	VERY SLOW	A pesticide, cancer drug, food additive. Acutely toxic by ingestion (rats). Inhalation causes liver damage. Pleasant odor tempts children to drink it. More toxic than turpentine.
morpholine	20	.01-1	100	SLOW	Avoid. Skin absorbs.
tetrahydrofuran	200	31	1.4	VERY FAST	Becomes explosive when old or exposed to air. Highly narcotic.
dioxane, 1,4-dioxane	25	.8-172	65	FAST	Carcinogen. Skin absorbs. Avoid.
cyclohexane, hexamethylene	300	780	1.4	FAST	Not acutely toxic.Chronic effects poorly studied.

CHAPTER

10 | *PIGMENTS AND DYES*

C olor is the basic element of many arts. And in most arts, color
is obtained through the use of pigments and dyes.

WHAT ARE PIGMENTS AND DYES?

The origins of pigments and dyes are lost in antiquity, although we know
that both sprang from common natural products such as berries, roots,
minerals, and insects. When mauve, the first synthetic dye, was discov-
ered in 1856, it catalyzed the development of the whole organic chemi-
cal industry. Since then a host of synthetic chemical dyes and pigments
have been created.

Often the distinction between pigments and dyes is based on usage
and physical properties rather than on chemical constitution. The prin-
ciple characteristic of a pigment which distinguishes it from a dye is that
it is substantially insoluble in the medium in which it is used. In fact, there
are numerous instances in which the same chemical product serves as
either a dye or a pigment. Thus it is often difficult to understand how
various types of colorants are classified.

PIGMENT AND DYE CLASSIFICATION

Companies selling paints, inks, pigments and dyes list colors in many
ways, sometimes using traditional names (Prussian blue, Mars brown etc.),

simple colors (white, red, etc.), and sometimes fanciful names designed to attract customers (peacock blue). As a result, it is almost impossible to know the actual color chemicals to which these names refer.

One answer to this identification problem is to prevail upon dye and paint manufacturers and distributors to reveal their products' internationally accepted Color Index (C. I.) names and/or numbers. All but a handful of commercial pigments and dyes are assigned these identifying names and/or numbers. Many responsible manufacturers of fine arts products already provide this service for customers.

Another way to identify some dyes and pigments is by their Chemical Abstracts Service numbers (see page 47). However, not all pigments and dye have Chemical Abstracts Service numbers.

PIGMENTS AND THEIR HAZARDS

The hazards of pigments have been known since 1713 when Ramazzini described illnesses associated with pigment grinding and painting. Many of the pigments used then are still among the several hundred pigments found in art and craft products today. Table 6 lists composition, Color Index name and number, and hazard information for about 250 artists pigments. Most of the pigments you use should be listed somewhere in this table.

All of the artists' pigments in Table 6 also can be classified either as inorganic or organic chemicals.

INORGANIC PIGMENTS come from the earth (ochres, for example), or they are manufactured from metals or minerals (like lead white or cerulean blue). These pigments have been used for many years and their toxic effects are fairly well known. The lead-containing colors are especially toxic and have a long history of causing poisoning. For this reason they are banned in consumer wall paints. But artists' paints and inks, boat paints, automobile paints, and metal priming paints may still employ them.

ORGANIC PIGMENTS are either from natural sources such as Alizarin crimson from madder root, or they are synthesized from organic chemicals. Examples of synthetic pigments include phthalo blue and the fluorescent colors.

There are hundreds of organic pigments used in art materials. Most of the natural organic pigments are not particularly toxic. Only a small per-

centage of the synthetic pigments have been studied for toxicity or long-term hazards. Of those which have been studied, some have been shown to be toxic, some are not toxic, and some cause cancer in animals. Some synthetic pigments also are hazardous because they contain highly toxic impurities such as cancer-causing PCBs. (These impurities, polychlorinated biphenyls, are unwanted side-products created during manufacture.)

Some pigments are related to the chemical "benzidine" which is known to cause bladder cancer. Benzidine pigments and dyes may also cause this disease. Recent epidemiological studies of artist painters and industrial painters found elevated incidence of diseases, especially bladder cancer.*

DYES AND THEIR HAZARDS

NATURAL DYES. Some natural organic dyes such as indigo and various plant and animal extracts are still in use today. Although some natural dyes are hazardous, there are many plant and vegetable materials which are safe enough even for children to use. However, craft dyes sold today usually are synthetic chemical dyes.

SYNTHETIC DYES. The very first synthetic dyes were made from a chemical called aniline which was derived from coal tar. Some manufacturers still call their dyes "aniline" or "coal tar" dyes. However, highly toxic aniline has been replaced for the most part with safer chemicals in the manufacture of this type of dye (azine type). Still, the term "aniline" is used by some dye-sellers to refer to all dyes with some similar (azine) components, and by others to refer to all types of synthetic dyes (even nonazine types). As it is used by dye-sellers today, the term "aniline" is not very meaningful. It is more useful to refer to dyes by their class.

DYE CLASSES. Chemically, dyes can be separated into classes. Each class reacts with certain fibers in certain ways. For example, "direct dyes" are used for cotton, linen, and rayon, and they usually need to be applied using hot water baths containing salt to react properly with the fabrics.

*Miller, Barry A., Silverman, D.T., Hoover, R.N., Blair, A. "Cancer Risk among Artistic Painters." *American Journal of Industrial Medicine,* 1986; 9:281-287. See also Miller, Barry A., and Blair, Aaron. "Cancer Risks Among Artists." Submitted for publication to *Leonardo* (*Journal of the International Society for the Arts, Sciences and Technology*), New York, 1989; and "Occupational Risks of Bladder Cancer in the United States: 1. White Men," *Journal of the National Cancer Institute,* Vol. 81, No. 19, Oct. 4, 1989.

Dyes in the same class usually have some hazards in common, but in addition they may—and usually do—possess some individual hazards. This is because dyes in the same class bind themselves to fibers in the same way chemically, so the hazards related to the fiber-binding part of the dye molecule are similar within each class of dye. But the rest of the molecule may vary from dye to dye and its effects on health may vary correspondingly. Table 7 lists the hazards of some classes of dyes.

DYE HAZARDS. Industrial experience has demonstrated tragically that many dyes can harm those who use them. Some can damage the blood's ability to carry oxygen (methemoglobinemia), others cause severe allergies, produce birth defects, and so on.

One group of dyes (those related to the chemical benzidine) have been shown to cause bladder cancer (see Organic Pigments above). In order to help you avoid using these dyes, a complete list of benzidine-congener dyes by their Color Index is provided in Table 8.

The hazards of most dyes, however, are unknown because only a few of the several thousand commercial dyes have been tested for long-term effects.

Food dyes, however, have been more thoroughly tested. It is interesting that of nearly 200 food dyes provisionally listed in 1960, only 22 natural substances and six synthetic dyes are still considered safe enough for food. Prudence dictates handling all dyes cautiously.

EXPOSURE TO PIGMENTS AND DYES

Pigments or dyes are easier to use safely once they are mixed with water or oil as in paints and inks. Artists should try to avoid using pigments and dyes in the raw, powdered state because their dusts can be inhaled or they can contaminate hands and clothing. Examples of artists who may be exposed in this way include art conservators and painters who mix their own paints and textile dyers who buy dye powders and mix them into baths.

Rules for Working with Raw Pigments and Dyes

1. Try to use techniques which employ premixed paints and liquid dyes.

2. Identify your pigments and dyes. Only use materials for which Material Safety Data Sheets are available. Avoid purchasing materials from

companies which do not also provide Chemical Abstract Service numbers and/or Color Index names and numbers.

3. Never use techniques which raise dust such as sprinkling dry colors onto textiles or paper.

4. Weigh out, slurry, mix, or handle pigments and dyes only in local exhaust ventilation or in a glove box (see figure 14).

5. Avoid skin contact with pigments and dyes by wearing gloves or using barrier creams. Should skin stains occur, never use bleach or solvents to remove them. (Bleaches are especially hazardous because they may break complex colorant molecules in the skin into more toxic components.)

6. Wear protective clothing including a full length smock, shoes, and hair covering (if needed). Leave these garments in the studio to avoid bringing dusts home. Wash clothes frequently and separately from other clothes.

7. Clean the studio properly. Work on easy-to-clean surfaces and wipe up spills immediately. Wet mop or sponge surfaces and floors. Do not sweep.

8. Practice good hygiene and do not eat, smoke, or drink in the studio

9. Keep containers of pigments and dyes closed at all times when not using them.

10. If lead-containing pigments are used, blood tests for lead should be done regularly (at least once a year).

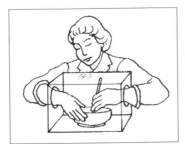

Fig. 14. Glove Box for Controlling Dust from Powdered Materials

TABLE 6	Pigments Used in Paints and Inks

Note: The pigments are listed by Color Index name because most fine art paint makers now include C.I. names on their labels in their short form (e.g. C.I. Pigment Red 5 is "PR 5"). Most common fine art pigments used today are listed. Users of inks and other art products can look for the common pigment names. However, identification can not be assured without the C.I. name.

COLOR INDEX NAME NUMBER COMMON NAMES	INGREDIENTS	TOXIC PROPERTIES
BLACK PIGMENTS (P.BLACK)		
P.BLACK 6 and 7 77266 carbon black channel black lamp black	carbon	Considered carcinogenic due to contamination with cancer-causing impurities. New manufacturing processes can eliminate contamination.
P.BLACK 8 (two types) 77268 birch black blue black soft black vegetable black vine black willow black	carbon (50-90%) and minerals	No significant hazards.
mineral black black chalk Davy's grey	carbon(15-85%) and silicates or iron oxides	No significant hazards.
P.BLACK 9 77267 animal black bone black Frankfurt black ivory black	carbon from charred animal bones	No significant hazards.
P.BLACK 10 77265 graphite plumbago stove black	graphite	Synthetic graphite can cause black lung after years of heavy inhalation. Natural graphite also may contain free silica which could cause silicosis.

P.BLACK 11 77499 black iron oxide magnetic oxide Mars black mineral black	iron oxide (Fe_3O_4) some ores contain manganese and other impurities	No significant hazards unless contaminated with toxic impurities. Often mixed with P.BLACK 14.
P.BLACK 14 77728 manganese black	manganese dioxide	See manganese in Table 10.
P. BLACK 19 77017	grey hydrated aluminum silicate	No significant hazards.
P.BLACK 26 77494 manganese ferrite black	manganese and iron spinel*	See manganese in Table 10.
P.BLACK 27 77502 iron cobalt chromite black	iron, cobalt, and chrome spinel*	See cobalt, chrome in Table 10.
P.BLACK 28 77428 copper chromite black	copper and chrome spinel*	See copper, chrome in Table 10.
P.BLACK 29 77498 iron cobalt black	iron and cobalt spinel*	See cobalt in Table 10.
77050 (no name) antimony black black lead	a black form of antimony sulfide (Sb_2S_3)	See antimony in Table 10. See sulfides in Table 11.
NATURAL BLACK 3 75290 logwood	hematoxylin from wood	Large amounts could poison.
SOLVENT BLACK 7 acid black 2 nigrosine black	a complex organic compound	Commonly contain nitro- benzene and other impuri- ties. May cause allergies and dermatitis.

*spinels are natural or synthetic oxides used as both pigments and ceramic colorants.
Most are very stable at high temperatures. Their solubility in body fluids has not been
well studied.

BLUE PIGMENTS (P.BLUE)

P.BLUE 1 42595:2 Victoria pure blue B	salt of an organic chemical dye	Low acute toxicity. Related chemically to a carcinogenic dye.
P.BLUE 2 44045:2 Victoria blue B	salt of an organic chemical dye	Unknown. Chemically related to a carcinogenic dye.
P.BLUE 3 42140:1 Peacock blue R	salt of an organic chemical dye	Unknown. Chemically related to a carcinogenic dye.
P.BLUE 10 & 11 44040:2 Victoria Blue	salt of an organic chemical dye	Unknown. Chemically related to a carcinogenic dye.
P.BLUE 15 74160 phthalocyanine blue monastral blue	copper phthalo- cyanine	May be contaminated with small amounts of PCBs* and dioxins* which cause cancer and birth defects. See also copper in Table 10.
P. BLUE 16 74100 phthalocyanine blue	metal-free phthalo- cyanine	See above.
P.BLUE 17:1 74200:1 74180:1	sulfonated phthalocyanine	See above.
P.BLUE 21 and 22 69835 & 69810 indanthrene blues	complex insoluble anthraquinone vat dyes	Low acute toxicity. Closely related to cancer-causing anthraquinones.**
P. BLUE 24 42090:1 brilliant blue erioglaucine blue peacock blue	barium precipitate (lake) of an organic chemical dye	A lake of dye that causes cancer in animals. (FD&C Blue 1). See barium in Table 10.

* Since 1982, phthalocyanine pigments with lower concentrations of PCBs (polychlorinated biphenyls) have been available. Highly contaminated pigments were being distributed as late as 1986 in the U.S. and may still be purchased, especially in imported products. Dioxins are a category of polychlorinated dioxins and dibenzoforans.

** 2-aminoanthraquinone (a precursor to Pigment Blue 22) and Disperse Blue 1 (tetraaminoanthraquinone) have been listed as carcinogens by the National Toxicology Program. Aminoanthraquinones and perhaps other anthraquinones should be considered suspect.

THE ARTIST'S COMPLETE HEALTH AND SAFETY GUIDE ..

P.BLUE 27 77510 Berlin blue Brunswick blue celestial blue Chinese blue iron blue lacquer blue Milori blue Paris blue Prussian blue Turnbull's blue	ferric ferrocyanide	Only slightly toxic, but can emit highly toxic hydrogen cyanide gas if exposed to acid, high heat, or strong ultraviolet light.
P.BLUE 28 77346 cobalt blue cobalt green cobalt ultramarine Thenard's blue	cobaltous aluminate of varying composition (blue to green)	See cobalt in Table 10.
P.BLUE 27 /28 mixture 77510, 77520, 77346 Antwerp blue cyanine blue Leitch's blue	cobaltous aluminate Prussian blue and/ or alumina (77520) mixtures	Only slightly toxic, but can emit highly toxic hydrogen cyanide gas when exposed to acid, high heat or strong ultraviolet light.
P.BLUE 29 77007 ultramarine blue ultramarine green ultramarine violet	artifical minerals of sodium, aluminum and silica. Color range: blue, green, and violet	No significant hazards.
P.BLUE 30 77420 azurite blue malachite copper blue mountain blue	azurite, a natural copper-containing mineral	See copper in Table 10.
P.BLUE 31 77437 blue frit Egyptian blue Pompeian blue	copper-calcium-silicate	See copper in Table 10.

P.BLUE 32 77365 smalt Saxon blue	potassium-cobaltous silicates of varying composition	See cobalt in Table 10.
P.BLUE 33 77112 manganese blue	barium and manganese salts	See barium and manganese in Table 10.
P.BLUE 34 77450 copper blue covellite	cupric sulfide	Irritating to skin and eyes. Highly toxic by ingestion. Can emit highly toxic hydrogen sulfide gas if exposed to high heat or acid. Also see copper in Table 10.
P.BLUE 35 77346 cerulean blue	artificial mineral of cobalt, tin, and calcium sulfate	See cobalt in Table 10.
P. BLUE 36 77343 cerulean blue chromium	oxides of cobalt and chrome	See cobalt and chrome in Table 10.
P.BLUE 60,64,65 69800, 69825, 59800 indanthrene blues	complex insoluble anthraquinone vat dyes.	Acute toxicity varies. Closely related to cancer-causing anthraquinones (see note P.BLUE 21).

BROWN PIGMENTS (P.BROWN)

P.BROWN 5 15800:2 BON browns arylide browns	copper salt of azo organic pigment made from aniline	Unknown. See copper in Table 10.
P.BROWN 6 & 7 77491,77492 Caledonian brown burnt & raw sienna burnt & raw umber burnt ochre Mars brown mineral brown Turkey umber	variety of natural and synthetic iron oxides; may contain toxic impurities	No significant hazards unless manganese or other toxic impurities present.

P. BROWN 8 77727, 77730 manganese brown	manganese minerals and/or manganese compounds	See manganese in Table 10.
P.BROWN 9 77430 Cassel's earth Cologne earth Ruben's brown Vandyke brown	treated Cassel earth containing 80-90 % organic matter plus iron, alumina and silica	No significant hazards.
NATURAL BROWN 9 (2 types) no number assigned 1) sepia	cuttle fish ink, (melanin, calcium carbonate,& other misc. chemicals)	No significant hazards.
2) sepia	mixture of burnt sienna and lampblack	See P.BROWN 6 and P.BLACK 6.

GREEN PIGMENTS (P.GREEN)

P.GREEN 1& 4 42040:1, 42000:2 brilliant green aniline green malachite green emerald green	insoluble precipi- tates of organic dyes	Low acute toxicity expected on the basis of tests on PG 1. Long term hazards unknown. Closely related to dye which causes cancer in animals.
P.GREEN 7 74260 Monastral green phthalo green phthalocyanine green Segnale light green G	polychloro copper phthalocyanine	May be contaminated with small amts of PCBs, etc. See P.BLUE 15. See copper in Table 10.
P.GREEN 8 10006 nitroso green	iron azo complex	Low acute toxicity. Chronic hazards not well studied.
P.GREEN 10 12775 green gold nickel azo green	chloroaniline/ nickel complex	Related to cancer-causing dyes. See also nickel in Table 10.
P.GREEN 12 10020:1 naphthol green B	barium precipitate of dye (Acid Green)	Low acute toxicity. Acid Green causes cancer in animals. See Barium in Table 10.

P.GREEN 15 77520 and 77600, 77601 or 77603 chrome green bronze green Prussian green Victoria green	mixture of PY 34 (lead chromate and P.BLUE 27)	See P.BLUE 27 above; lead and chrome in Table 10.
P.GREEN 17 77288 chrome oxide green emerald green emerald oxide Emeraude green	chrome oxide	See chrome in Table 10.
P.GREEN 18 77289 Emerald oxide of chromium emeraude green Guignet's green oxide of chromium, transparent Viridian	hydrated chrome oxide	See chrome in Table 10.
(permanent green deep is PG 18 precipitated with barium sulfate)		
P.GREEN 19 77335 cobalt green Rinnman's green Saxony green zinc green	calcined cobalt, zinc, and alumina	See cobalt and zinc in Table 10.
P.GREEN 20 no number verdigris	copper dibasic acetate	See copper in Table 10.
P.GREEN 21 77410 emerald green English green Paris green Schweinfurt green Veronese green	cupric aceto- arsenite	See arsenic and copper in Table 10.
P.GREEN 22 77412	same as above (historically	See Pigment Green 21.

Sheele's green	cupric arsenite)	
P.GREEN 23 77009 green earth burnt green earth terra verte Verona green	hydrous iron, magnesium, aluminum, and potassium silicates. A variety of minerals, e.g., glauconite & celedonite	No significant hazards for most of the minerals. Some forms of celedonite are in needle/fibrous form.
P.GREEN 24 77013 ultramarine green	mineral of sodium, aluminum, silica and sulfur	No significant hazards. See P.BLUE 29.
P.GREEN 26 77343 Turkish green cobalt green	chromic oxide, alumina, cobaltous oxide	See chrome and cobalt in Table 10.
P.GREEN 36 74160 yellow green Prussian green phthalocyanine green	chlorinated and brominated phthalocyanine (also may be mix of P.BLUE 15 and P.GREEN 7)	See P. BLUE 15.
P. GREEN 36 (old usage) no number assigned Prussian green	mixture of gamboge (a yellow tree resin) and various pigments.	Unknown. Not used much today.
P. GREEN 50 77377 light green oxide	oxides of nickel, cobalt, titanium	See nickel, cobalt in Table 10.
HOOKER'S GREEN	now mixtures of various pigments	Hazards depend on pigments used.

ORANGE PIGMENTS (P.ORANGE)

P.ORANGE 1, 2, & 5 11725, 12060, 12075 hansa orange dinitro- or ortho- aniline orange	insoluble azo dyes	Low acute toxicity. Long term hazards generally unstudied. PO 5 is a suspect carcinogen, a mutagen, and contains toxic impurities like those in PR4.
P.ORANGE 13 21100	insoluble azo dye (di- or dis-azo	Low acute toxicity.Diarylide pigments may be contami-

benzidine orange diarylide orange arylamide yellow segnale light	pigment)	nated with PCBs. Heating releases cancer-causing benzidine compounds.
P.ORANGE 17 & 17:1 15510:1, 15510:2 Persian orange	barium precipitate (lake) of an azo dye	Low acute toxicity. Long term hazards unknown. See barium in Table 10.
P.ORANGE 20 77202, 77199 cadmium orange cadmium yellow	cadmium sulfide and cadmium selenide, other cadmium salts	Carcinogen. Kidney damage. See cadmium and selenium in Table 10. See sulfides in Table 11.
P.ORANGE 20:1 77202:1 cadmium barium orange	cadmium sulfide, cadmium sulfoselenide, and barium sulfate	Same as above. See also barium in Table 10.
P.ORANGE 21 77601 chrome orange American vermillion Chinese red chrome red Persian red Victoria red	basic lead chromate	See lead and chrome in Table 10.
P. ORANGE 21:1 see above	basic lead chromate on a silicate base	See lead and chrome in Table 10.
P.ORANGE 23 77201 cadmium vermillion orange mercadmium colors	cadmium sulfide/ mercuric complex. Varies from orange to red (see P. Red 113)	Carcinogen. Kidney damage. See cadmium and mercury in Table 10. See sulfides in Table 11.
P.ORANGE 23:1 77201:1 cadmium barium vermillion orange	P.ORANGE 23 precipitated on barium sulfate	Same as P.Orange 23. See also barium in Table 10.
P.ORANGE 36, 60, 62 11780,11782,11775 benzimidazolone orange HL,HGL, H5G	complex organic chemical	Unknown.

P.ORANGE 43 71105 perinone orange	complex organic chemical	Unknown.
P. ORANGE 45 golden orange- yellow orange paste	basic lead chrom- ate of a different particle size than P. ORANGE 21	See P. ORANGE 21.
P.ORANGE 48 & 49 no number assigned quinacridine gold quinacridine deep gold	insoluble dye	Unknown.

See also P.RED 101, Mars orange and P.RED 104, Molybdate orange. There are other organic chemical orange pigments, most of whose hazards are unknown.

RED PIGMENTS (NATURAL RED & P.RED)

NATURAL RED 3 75460 crimson	kermesic acid from coccus ilici insect	Unknown. Not in much use today.
NATURAL RED 4 75470 crimson carmine	carminic acid from coccus cacti insect. Carmine is laked with aluminum or calcium	Unknown. Not in much use today.
NATURAL RED 6, 8-12 75330 & others alizarin	alizarin or rubie- rythric acid from certain plant roots	Low acute toxicity. Related to cancer-causing anthra quinones. May cause alizarin allergies. See also P.RED 83.
P.RED 1 12070 para red	insoluble azo dye	Ingestion can cause cyanosis (ties blood hemoglobin in methemoglobin complex). A suspect carcinogen and mutagen.
P.RED 2,5,7,9,10,14,17, 22,23,63,112,119,146, 148,170,188,63:1,63:2	azo organic pigments	Those tested show low acute toxicity. Long term hazards generally unknown.

arylide reds arylamide reds BON reds naphthol reds		PR23 is mutagenic, a suspect carcinogen, and damages kidneys in rats.
P.RED 3 12120 hansa red segnale light red toluidine red	azo pigment	Ingestion can cause cyanosis (ties blood hemoglobin in methemoglobin complex). Long term hazards being studied. Suspect carcinogen.
P.RED 4 12085 aniline red permanent red D & C Red 36	chlorinated-p- nitroaniline (monazo class)	Low acute toxicity. Ap- proved for drugs and cosmet- ics except around the eyes. May be weakly carcino- genic. May contain cancer- causing impurities.
P.RED 8,12 12335,12385 segnale reds	azo pigment	Low acute toxicity. Long term hazards unknown.
P.RED 38 & 41 21120, 21200 pyrazolone reds & maroons diarylide reds	azo pigment	Low acute toxicity. See P. ORANGE 13 for diarylide hazards.
P.RED 48,48:1,2,3&4, 52:1&2 15865,15865:1,2,3&4, 15860:1&2 BON reds, maroons lithol reds permanent reds	calcium, barium and manganese salts of beta-hydroxy- naphthanoic acid azo pigments	Low acute toxicity. See barium and manganese in Table 10.
P.RED 49,49:1&2 15630,15630:1&2 lithol reds segnale reds	sodium, barium, & calcium salts of a soluble azo pigment	Caused allergies when used in cosmetics. A suspect car- cinogen. Some grades con- tain significant amounts of soluble barium—see Table 10. May also be contami- nated with beta-naphthylam- ine which is a bladder carcinogen.
P.RED 53 15585:1&2	metal salt precipitate of an azo dye	Carcinogen. May contain some soluble barium — see

red lake C	(D & C Red 9)	Table 10.
P.RED 57,57:1 15850, 15850:1 lithol rubine segnale rubine	azo pigment and its calcium salt	Low acute toxicity. Long term hazards unknown.
P.RED 60 16105, 16105:1 acid red permanent red pigment scarlet scarlet lake	barium precipitate of azo dye, or an insoluble azo dye	Low acute toxicity. A suspect carcinogen.
P.RED 81:1 45160:1 rhodamine red	tungsten, molybde- num and phosphorus salt of Basic Red 1	Low acute toxicity. Long term hazards not well stud- ied. Some grades contain arsenic — see Table 10.
45160 day-glo red fluorescent red	a dye (Basic Red 1) in plastic resin	Same as above
P.RED 83 58000, 58000:1 alizarin alizarin crimson crimson madder madder lake rose madder	synthetic anthraquinone (1,2-dihydroxy- anthraquinone)	Low acute toxicity. Related to cancer-causing anthra- quinones (see P.Blue 21). May cause allergies.
P.RED 88 73312 thioindigoid	indigo-like dye containing sulfur and chlorine	Unknown
P.RED 90 45380:1 phloxine toner eosine	lead salt of a dye (eosine)	Eosine is known to cause dermatitis when used in cosmetics. See lead in Table 10.
P.RED 101 77015,77491,77538 Indian red light or English red oxide Mars red, violet, orange Venetian red	iron oxides	No significant hazards.

P.RED 102 77015,77491,77538 light red red ochre or bole natural red chalk Persian gulf oxide Spanish oxide	iron oxide, silica, alumina, lime, magnesia, and/or calcium sulfate	No significant hazards. If large amounts were inhaled, it could cause silicosis.
P. RED 103 77601 Derby red, Persian Vienna, Chinese or Victoria red American vermillion Australian cinnabar	Basic lead chromate. Different particle size from P. Orange 21 and 45	See lead and chrome in Table 10.
P.RED 104 77605 chrome vermillion molybdate orange moly orange	lead chromate, lead sulfate,and molybdate	See lead and chrome in Table 10.
P.RED 105 77578 minium orange lead orange mineral red lead saturn red	red lead (Pb_3O_4)	See lead in Table 10.
P.RED 106 77766 Chinese or English vermillion cinnabar vermillion	mercuric sulfide (HgS)	Can be contaminated with lead and other impurities. See mercury in Table 10. See sulfides in Table 11.
P.RED 108 77202 cadmium red light, medium, or deep selenium red	cadmium sulfo-selenide (CdS, CdSe)	Carcinogen. Kidney dam-age. See cadmium and selenium in Table 10.
P. Red 108:1 77202:1 cadmium barium red light, medium or deep	cadmium sulfo-selenide precipitated with barium sulfate	Same as above. See also barium in Table 10.

P.RED 113 77201 cadmium vermillion red	cadmium sulfide and mercuric sulfides	Carcinogen. Kidney damage. See cadmium and mercury in Table 10. See sulfides in Table 11.
P.RED 122,192,207, 209 73915,71100, others quinacridone red, magenta, scarlet, yellow-red	complex organic chemical	Low acute toxicity. Long term hazards unknown.
P.RED 123,149,179, 190 perylene vermillion perylene red, maroon, scarlet	complex organic chemicals	Low acute toxicity. Long term hazards unknown.
P.RED 144,166 20735, 20730 microlith red	azo organic pigment	Low acute toxicity. Long term hazards unknown.
P. RED 168,175,177, 178,188,194,242, and others.	complex organic chemicals	There are many organic reds.The hazards of most are unknown.

VIOLET PIGMENTS (P.VIOLET)

P.VIOLET 1 45170:1 rhodamine B	pigment based on dye below	Low acute toxicity. May cause photosensitive dermatitis. A suspected carcinogen.
45170 day-glo violet fluorescent violet	a dye (Basic violet 10, FD & C Red 19) in plastic resin	Same as above.
P.VIOLET 14 77360 cobalt violet or red	cobalt phosphate and/or cobalt arsenite	Today, PV 14 usually is all cobalt phospate—see cobalt in Table 10. Old PV 14 may contain the arsenite—see arsenic in Table 10.
P.VIOLET 15 77007 ultramarine violet	artificial mineral of sodium, silica, aluminum, and sulfur	No significant hazards. See also P.Blue 29 above.

P.VIOLET 16 77742 fast violet manganese violet mineral violet Nurnberg violet permanent mauve	manganese ammonium pyrophosphate	See manganese in Table 10.
P.VIOLET 19 46500 quinacridone red or violet	complex organic chemical	Low acute toxicity. Long term hazards unknown.
P.VIOLET 23 51319 dioxazine violet sunfast carbazole violet	complex organic chemical	May be contaminated with highly toxic dioxins (see note for P. BLUE 15).
P.VIOLET 31 60010 isoviolanthranone violet	chlorinated iso- violanthranone	Unknown.
P.VIOLET 38 73395	synthetic indigo derivative	Moderately toxic.
P.VIOLET 47 77363 cobalt lithium violet	mineral of cobalt	See cobalt and lithium in Table 10.
VIOLET 48 77352 red-blue borate cobalt-magnesium red-blue	cobalt magnesium borate	See cobalt in Table 10.
P.RED 101 mars violet	a purplish shade of iron oxide	No significant hazards.

WHITE PIGMENTS (P.WHITE)

P.WHITE 1 77597 Cremnitz white flake white silver white	basic lead carbonate and small amount of barium sulfate or other extenders	See lead in Table 10.

white lead
ceruse

P.WHITE 2 77633 basic sulfate white lead white lead	basic lead sulfate with small amount of zinc oxide	See lead in Table 10.
P.WHITE 4 (2 types) 77947 1) Chinese white permanent white zinc oxide zinc white	zinc oxide	See zinc in Table 10. Commercial pigments may contain small amounts of impurities including lead.
2) Leaded zinc oxide permanent white	zinc oxide and lead sulfate	See lead and zinc in Table 10.
P.WHITE 5 77115 Carlton white Grifith's patent zinc white Jersey Lily white lithopone Orr's zinc white ponolith	zinc sulfide and barium sulfate	Barium sulfate is insoluble, but some pigments contain soluble impurities. See zinc and barium in Table 10. See sulfide in Table 11.
P.WHITE 6 77891 titanium white titanium dioxide Titanox	titanium dioxide, usually from the mineral rutile	No significant hazards. Some grades contain large amounts of P.WHITE 4 (see above).
P.WHITE 7 77975 zinc sulfide zinc white	zinc sulfide	Highly toxic by ingestion— see sulfide in Table 11. See zinc in Table 10.
P.WHITE 10 77099 whitherite	barium carbonate	See barium in Table 10.
P.WHITE 11 77052 antimony white	antimony oxide	See antimony in Table 10.

P.WHITE 16 77625 basic lead silicate	lead silicate	See lead in Table 10.
P.WHITE 18 (2 types) 77220 chalk calcium carbonate whiting	calcium carbonate	No significant hazards.
77713 magnesium carbo- nate magnesite	magnesium carbonate	No significant hazards. In- gestion of large amounts causes purging.
P.WHITE 19 77004 aluminum silicate bentonite wilkinite alumina/china clay mixture	various aluminum silicate clays	No significant hazards.
P.WHITE 20, 26 77019, 77718 mica pumice talc	various potassium silica, alumina and magnesium- containing minerals	Historically asbestos miner- als were used. Some miner- als may still contain asbestos impurities.
P.WHITE 21,22 77120 barium sulfate barytes blanc fixe heavy spar permanent white	barium sulfate from chemical and mineral sources	May contain soluble barium and other toxic impurities. See barium in Table 10.
P.WHITE 23 77122 gloss white alumina blanc fixe	aluminum hyroxide and barium sulfate	May contain soluble barium and aluminum. See barium and aluminum in Table 10.
P.WHITE 24 77002 aluminum hydrate	aluminum hydrate	May conyain soluble alumi- num. See aluminum in Table 10.
P.WHITE 25 77231 gypsum	calcium sulfate	No significant hazards.

alabaster plaster		
P.WHITE 27 77811 quartz silica	silica	Inhalation of large amounts could cause silicosis.

YELLOW PIGMENTS (P.YELLOW)

P.YELLOW1*, 2, 3*, 4, 5, 6, 10, 60, 65, 73, 74, 75, 97, 98 *toluidine yellows hansa yellows arylide yellows	insoluble azo organic pigments	Low acute toxicity expected on basis of tests on PY 1,5, and 74. Long term hazards unknown, but some related to cancer-causing dyes.* Ingestion of some types can cause methemoglobinemia.
P.YELLOW 12,13,14, 17, 20,55,81,83 diarylide yellows arylamide yellows arylide yellows benzidine yellows	insoluble azo organic pigments	Low acute toxicity expected. PY 12 found negative on cancer tests. Others un- tested, but their relationship to bladder cancer-causing benzidine dyes causes con- cern. Some are contaminated with PCBs (see P.ORANGE 13). Heat may release cancer- causing 3,3-dichlorobenzidine from PY 12,14,17,81,83
P.YELLOW 31 77103 barium chrome barium yellow baryta yellow lemon yellow permanent yellow ultramarine yellow	barium chromate	See barium and chrome in Table 10.
P.YELLOW 32 77839 lemon yellow strontium chrome strontium yellow ultramarine yellow	strontium chromate	See chrome and strontium in Table 10. Most potent carcinogen of all chromium compounds tested.

P.YELLOW 33 77223	calcium chromate	See chrome in Table 10.
P.YELLOW 34 77600*, 77603** chrome yellow chrome lemon primrose yellow	*pure lead chromate or **mixed with lead sulfate	See lead and chrome in Table 10.
P.YELLOW 35,35:1 77117, 77205, 77205:1 cadmium yellow cadmium lithopone yellow primrose cadmium	cadmium sulfide, sometimes precipitated with barium sulfate and zinc sulfide	Carcinogen. Kidney damage. See cadmium, barium, and zinc in Table 10. See sulfide in Table 11.
P.YELLOW 36,36:1 77955,77956	zinc/potassium chromate complex	See chrome in Table 10.
P.YELLOW 37,37:1 77199 aurora yellow cadmium yellow greenockite hawleyite	pure cadmium sulfate or mixed with barium sulfate	Carcinogen. Kidney damage. See cadmium and barium in Table 10.
P.YELLOW 38 77878 mosaic gold	stannic sulfide	Toxic by ingestion — see sulfide in Table 11. See tin in Table 10.
P.YELLOW 39 (3 types) 1) 77085 arsenic orange realgar old king's gold orpiment	arsenic trisulfide (As_2S_3)	See arsenic in Table 10. See sulfide in Table 11.
2) 77086	arsenic trisulfide or P.Yellow 37 mixed with P.White 4	Formerly an arsenic pigment, but replaced by cadmium sulfide pigment
3) 77600 King's yellow	lead chromate	PY 39 also used to refer to chrome yellow. See PY 34 above.
P.YELLOW 40 77357 aureolin cobalt yellow	potassium cobaltinitrite	Ingestion can cause cyanosis due to methemoglobinemia. See also cobalt in Table 10.

123

P.YELLOW 41 77588,77589 antimony yellow Naples yellow*	pure lead antimonate or mixed with zinc and bismuth oxides	See lead and antimony in Table 10.
P.YELLOW 42,43 77492 ferrite yellow Mars yellow, orange ochre: domestic, French, yellow sienna or raw sienna yellow oxides of iron	hydrated iron oxide and other iron compounds	No significant hazards.
P.YELLOW 46 77577 lead oxide litharge yellow lead monoxide	lead oxide	See lead in Table 10.
P.YELLOW 53 77788 sun yellow nickel titanium yellow	nickel, antimony, titanium complex	See nickel and antimony in Table 10.
P.YELLOW 57 77900 primrose priderite	nickel, barium, titanium complex	See nickel and barium in Table 10.
P.YELLOW 108 68420 anthrapyrimidine yellow	complex organic chemical	Low acute toxicity. Long term hazards unknown.
P.YELLOW 109,110,112, 138,139,151,154,175, isoindolinone, flavanthrone, quinophthalone, benzimidazolone yellows	complex organic chemicals	Hazards unknown.
P.YELLOW 150, 153 12764,48545 nickel azo complex nickel dioxine yellow	organic dyes complexed with nickel	Hazards unknown. See nickel in Table 10.

| INDIAN YELLOW
NO C.I. NAME | magnesium salt of
euxaanthic acid
from mango-fed cows'
urine | No significant hazards. |

*Naples yellow today may be mixture of other less toxic and less expensive pigments.

METALLIC PIGMENTS (P.METAL)

P.METAL 1 77000	powdered aluminum	Soluble aluminum released. See Table 10.
P.METAL 2 (4 types) 77400 1) copper powder	powdered alloy of copper, zinc, aluminum, and tin.	See copper, zinc, aluminum and tin in Table 10.
2) bronze powder or copper bronze powder	powdered alloy of copper, zinc, and iron	See copper and zinc in Table 10.
3) dendritic copper	powdered alloy of copper, zinc, and traces of other metals	See above, plus any other metals present.
4) metalic copper	powdered copper	See copper in Table 10.
P.METAL 3 77480 metallic gold	gold	No significant hazards.
P.METAL 4 77575 metallic lead	lead	See lead in Table 10.
P.METAL 5 77860	tin	See tin in Table 10.
P.METAL 6 77945	zinc	See zinc in Table 10.

OTHER METAL ALLOYS can be powdered for metallic pigments and their
hazards vary with their composition.

TABLE 7	The Hazards of Dyes by Class. Dye Classifications

Using general dye chemistry as the basis for classification, the Color Index lists 14 categories or classes of textile dyes:

1. acid dyes	6. fiber reactive dyes	11. sulfur dyes
2. azoic dyes	7. vat dyes	12. pigments
3. basic dyes	8. oxidation dyes	13. optical/fluor-
4. direct dyes	9. mordant dyes	escent brighteners
5. disperse dyes	10. developed dyes	14. solvent dyes

The first seven of these classes are those most often used in textile arts. Although each individual dye is unique, some general observations can be made about their toxicity based on their class.

1. ACID DYES can be used to dye acrylics, wool, nylon, and nylon/cotton blends. They are called acid dyes because they are usually applied in acid solutions. The three most important chemical types of acid dyes are azo, anthraquinone, and triarylmethane. They appear in general to be of low acute toxicity, but the long-term hazards of many are unstudied. Some cancer-causing benzidine and food dyes have been identified in this class.

2. AZOIC DYES are used primarily on cellulosic fibers such as cotton, silk, and acetates. Allergic reactions to these dyes have been reported and some are considered carcinogens.

3. BASIC DYES can be applied to wool, silk, and some synthetics. Fluorescent dyes usually belong to this class. Allergic reactions to these dyes have been reported and some are considered carcinogens.

4. DIRECT DYES are applied from salt-containing baths to cellulosic materials such as cotton. These dyes usually present few acute hazards, but many are considered carcinogens. Most of the cancer-causing benzidine dyes are in this class. It is still possible to find benzidine dyes among direct dyes sold for art and craft purposes.

5. DISPERSE DYES are used primarily to dye water-repellant fibers such as polyester, nylon, and acetates. They are called disperse dyes because they disperse or absorb directly (colloidally) into the fiber. Some are applied at high temperatures. While many classes of dyes have caused dermatitis on direct skin contact, only disperse dyes have caused widespread dermatitis from contact with the finished product.

6. FIBER REACTIVE DYES are used most often with cellulosic fibers and wool. They can also be used with silk and nylon. The dyes derive their name from the fact that they form a chemical bond (covalent) with the fiber becoming an integral part of it. They are the fastest growing group of dyes and many are so new that they have not been assigned Color Index numbers. Industrial use has demonstrated the dyes' capacity to produce respiratory allergies and asthma. Their long term hazards are poorly studied. However, one chemical class of fiber reactive dyes (bromacrylamide) were shown to have a high percentage of positive mutagenicity tests in a 1980 study. Researchers suggested that a possible explanation may be that the small molecule size and the high reactivity of these dyes may enable them to react directly with genetic material (DNA). These tests indicate that cancer and birth defect studies should be undertaken.

7. VAT DYES are used primarily for cellulosic fibers, although some are suitable for wool and acetates. Lye or caustic soda are often used either in the bath or as a dye pretreatment. Pretreated vat dye powders are caustic and irritating to handle or inhale. Vat dyes also require an oxidation treatment after they have been applied. Some dyes oxidize in the air, but others require treatment with dichromate salts which cause allergies (see Chromium in Table 10). Some of the dyes themselves also can cause allergies. Certain vat dyes are sold as pigments. Using these is not recommended.

OTHER CLASSIFICATIONS

FOOD DYES are also a separate Color Index group, Most are acid dyes, but many other classes also are represented among Food Dyes. Most dyes in this class were selected in the 1950s because they were thought to be safe. Tests required for food additives have shown that many of these dyes cause cancer or have other toxic effects. Even dyes found safe for use in food may contain highly toxic impurities if they are not carefully manufactured. Art materials sellers who claim that their products contain "food dyes" should be required to tell customers whether the dyes are currently approved for use in food and whether they are "food grade" chemicals.

ALL-PURPOSE or UNION DYES are the common household dyes. These products contain two or more classes of dyes together with salt so that a wide variety of fabrics may be dyed. Only the dye which is specific for the material will be "taken" by the fabric. Until the early 80's, most all-purpose products contained cancer-causing benzidine dyes. Many of the new dyes are anthraquinone dyes whose hazards are not well-studied.

Table 8	Benzidine-Congener Dyes

Benzidine-Based Dyes

C.I. Acid Orange 45
C.I. Acid Orange 63
C.I. Acid Red 85
C.I. Acid Red 85, Disodium Salt
C.I. Acid Red 89
C.I. Acid Red 97, Disodium Salt
C.I. Acid Yellow 42
C.I. Acid Yellow 42, Disodium Salt
C.I. Acid Yellow 44
C.I. Acid Yellow 44, Disodium Salt
C.I. Direct Black 4
C.I. Direct Black 4, Disodium Salt
C.I. Direct Black 38
C.I. Direct Blue 2
C.I. Direct Blue 2, Trisodium Salt
C.I. Direct Blue 6
C.I. Direct Blue 6, Tetrasodium Salt
C.I. Direct Blue 158
C.I. Direct Blue 158 Tetrasodium Salt
C.I. Direct Brown
C.I. Direct Brown 1
C.I. Direct Brown 1, Disodium Salt
C.I. Direct Brown 2
C.I. Direct Brown 2, Disodium Salt
C.I. Direct Brown 6
C.I. Direct Brown 6, Disodium Salt
C.I. Direct Brown 31
C.I. Direct Brown 31, Tetrasodium Salt
C.I. Direct Brown 59
C.I. Direct Brown 74
C.I. Direct Brown 95
C.I. Direct Brown 111
C.I. Direct Brown 154
C.I. Direct Brown 154, Disodium Salt
C.I. Direct Green
C.I. Direct Green 1
C.I. Direct Green 1, Disodium Salt
C.I. Direct Green 6, Disodium Salt
C.I. Direct Green 8,
C.I. Direct Orange 1
C.I. Direct Orange 8
C.I. Direct Orange 8, Disodium Salt
C.I. Direct Red 1
C.I. Direct Red 1, Disodium Salt
C.I. Direct Red 10

C.I. Direct Red 10, Disodium Salt
C.I. Direct Red 13
C.I. Direct Red 13, Disodium Salt
C.I. Direct Red 28
C.I. Direct Red 28, Disodium Salt
C.I. Direct Red 37, Disodium Salt
C.I. Direct Red 89
C.I. Direct Violet 1
C.I. Direct Violet 1, Disodium Salt
C.I. Direct Violet 22
C.I. Direct Yellow 20
C.I. Mordant Yellow 26
C.I. Mordant Yellow 26, Tetrasodium Salt
*C.I. 22120
*C.I. 22130
C.I. 22145
C.I. 22155
C.I. 22195
*C.I. 22240
*C.I. 22245
*C.I. 22310
*C.I. 22311
C.I. 22345
C.I. 22370
C.I. 22410
C.I. 22480
C.I. 22570
*C.I. 22590
*C.I. 22610
C.I. 22870
C.I. 22880
C.I. 22890
C.I. 22910
C.I. 23900
C.I. 23910
C.I. 24555
C.I. 30045
*C.I. 30120
*C.I. 30140
*C.I. 30145
*C.I. 30235
*C.I. 30245
*C.I. 30280
*C.I. 30295
C.I. 30315
*C.I. 35660
*C.I. 36300

o-Tolidine-Based Dyes
C.I. Acid Red 114
C.I. Acid Red 167
C.I. Azoic Coupling Component 5
C.I. Azoic Orange 3
C.I. Azoic Yellow 1
C.I. Azoic Yellow 2
C.I. Azoic Yellow 3
C.I. Direct Blue 14
C.I. Direct Blue 25
C.I. Direct Blue 25, Tetrasodium Salt
C.I. Direct Blue 26
C.I. Direct Orange 6, Disodium Salt
C.I. Direct Red 2
C.I. Direct Red 2, Disodium Salt
C.I. Direct Red 39
C.I. Direct Red 39, Disodium salt
C.I. Direct Yellow 95
*C.I. 23365
*C.I. 23375
*C.I. 23500
*C.I. 23630
*C.I. 23635
*C.I. 23790
*C.I. 23850
*C.I. 31930
*C.I. 37090
*C.I. 37120
*C.I. 37610

Dianisidine-based Dyes
C.I. Azoic Black 4
C.I. Azoic Blue 2
C.I. Azoic Blue 3
C.I. Azoic Coupling component 3
C.I. Direct Black 91
C.I. Direct Black 91, Trisodium Salt
C.I. Direct Black 114
*#C.I. Direct Black 118
C.I. Direct Black 167
*C.I. Direct Blue 1

C.I. Direct Blue 1, Tetrasodium Salt
*C.I. Direct Blue 8
C.I. Direct Blue 8, Disodium Salt
*C.I. Direct Blue 15
C.I. Direct Blue 15, Tetrasodium Salt
*C.I. Direct Blue 22
C.I. Direct Blue 22, Disodium Salt
*#C.I. Direct Blue 76
*#C.I. Direct Blue 76, Tetrasodium Salt
*#C.I. Direct Blue 77
*#C.I. Direct Blue 80
*#C.I. Direct Blue 90
*#C.I. Direct Blue 98
*#C.I. Direct Blue 100
*#C.I. Direct Blue 151
C.I. Direct Blue 151, Disodium Salt
*C.I. Direct Blue 156
*C.I. Direct Blue 160
*#C.I. Direct Blue 191
*#C.I. Direct Blue 218
*#C.I. Direct Blue 224
C.I. Direct Blue 225
C.I. Direct Blue 229
*#C.I. Direct Blue 267
*C.I. Direct Blue 269
*#C.I. Direct Brown 200
*C.I. Direct Violet 93
*C.I. Direct Yellow 68
*#C.I. 23155
*C.I. 24140
*#C.I. 24175
*C.I. 24280
C.I. 24315
*C.I. 24400
*#C.I. 24401
*C.I. 24410
*#C.I. 24411
*C.I. 30400
*C.I. 37235
*C.I. 37575

*Dyes in production as of 1983.

"Metallized dyes" which have a metal ion added to their chemical structure. Industry claims these dyes are less hazardous. Since NIOSH does not now have enough information to determine whether the commercial grade metallized dyes are safer, the "#" should not be construed as NIOSH support for safety claims.

Credit: Preventing Health Hazards from Exposure to Benzidine-Congener Dyes, U.S. Department of Health and Human Services (NIOSH) Publication No. 83-105.

CHAPTER 11 | *METALS AND METAL COMPOUNDS*

Sculptors, smiths, jewelrymakers, stained-glass artists, and foundry workers use many metals. Ceramicists, glass blowers, and enamelists also use many metallic oxides and other metal compounds. Even painters and printmakers use inorganic pigments which are metallic compounds and powdered metal pigments (see Table 6, Pigments Used in Paints and Inks, page 104). Artists using these materials need to understand the nature of metals and their toxicology.

ALLOYS

Metals can be blended together into almost any combination. Sometimes nonmetallic elements such as silica and carbon are also blended with metals. These blends are called alloys. Casting metals, solders, welding and brazing rods, and sheet metals are examples of alloys. They are formulated to have certain properties such as a specific melting point, hardness, or color. In fact, almost all metals used in metalworking are alloys.

To assess metalworking hazards, then, it is necessary to know the composition of the alloys. For example, brass is an alloy which often contains lead and arsenic. Brass nonsparking tool metals contain cancer-causing beryllium. Silver solders and brazing rods often contain cadmium, antimony, and sometimes lithium.

Sometimes the common names of the products identify metals in an alloy. Examples include silicon bronze, manganese steel, or nickel sil-

ver. Never assume these names identify all the metals in the alloy. Always obtain Material Safety Data Sheets or complete ingredient information on metals.

CORROSION PRODUCTS

Metal oxides and other corrosion products are always found on metal surfaces. You can see the formation of such compounds when metals like lead are polished or cut to expose a clean shiny surface. After a few days, the metal will grow dull as a coating of lead oxide begins to form. Silver tarnishes as black silver sulfide deposits form.

This phenomenon explains why merely touching or handling some metals provides sufficient contamination of the skin to cause systemic damage if the worker transfers these contaminants to the mouth by eating or smoking before washing up.

Larger amounts of metal corrosion products are created if metals are allowed to weather (especially in polluted city air) or come in contact with acids or other chemicals which attack the metal. Cleaning or brushing corroded metal surfaces may be hazardous to workers if dust control is not provided.

The formation of a corrosion product due to contact with air is often called "oxidation." This process also occurs on the surface of particles of metal dusts and fumes.

DUSTS

Bronze powders and metal pigments are finely divided metal dusts. Some of these metal powders are explosion hazards in the presence of a spark or flame. Fireworks always contain metal powders.

Metal dusts also are created when metals are ground, polished, cut, and the like. These dusts can vary in size from large particles which drop immediately to surfaces, to fine respirable particles. In general, the smaller the particle size, the deeper the dust can be inhaled and the more toxic it is liable to be.

When inhaled, some metal dusts, such as lead and zinc, dissolve in a short time and are released into the blood stream. These metals then are free to travel throughout the body.

Other metals, such as cerium or titanium, dissolve very slowly. They will remain in the lungs a long time, perhaps a lifetime. Their effects are on the lungs themselves.

FUMES

Metal fumes are created when metal is heated to its melting point or above. Metal vapors form which oxidize and condense into tiny metal oxide particles (see page 31). Since metal fumes are exceedingly small particles, they can float for hours in the air, can settle as dust throughout a workspace, and when inhaled or ingested, they are likely to be absorbed by the body. Metal fumes are generally more toxic than metal dusts (see aluminum and manganese dust and fume Threshold Limit Values, Table 9, page 133 and Table 1, page 34).

Fumes from melting or cutting scrap or found metal may be a serious hazard if highly toxic metals are present in the alloys. In industry, many deaths from cadmium oxide fume have resulted from melting scrap.

METAL-CONTAINING GASES

Some metals, such as arsenic and antimony, emit highly toxic gases when in contact with acids. For example, this could happen when acid fluxes, cleaners, or patinas are used with arsenic/antimony contaminated metals or solders.

METAL COMPOUNDS

When metals combine with other elements, these other elements can be called "radicals." Common examples of radicals include oxides (O), carbonates (CO_2), and sulfates (SO_4).

OXIDES of metals are formed by corrosion processes or can be found in nature as metal ores. For example, iron oxidizes to form rust, but various iron oxides, from yellow ocher to red and black iron oxides, are found in nature. The toxicity of oxides will depend on the toxicity of the individual metal and how soluble the oxide is in body fluids. The effect of the oxygen molecule is negligible.

OTHER COMPOUNDS When metals combine with elements other than oxygen, these other elements may effect the toxicity of the resulting compound. For example, rust (Fe_2O_3-red iron oxide) is not very toxic, but iron arsenate ($Fe (AsO_4)^2 \cdot 6H_2O$) very toxic because it combines the hazards of iron with those of arsenic.

In some cases, combination with radicals alters the toxicity of a compound because it alters its solubility in body fluids. For example, barium carbonate ($BaCO_3$) is only slightly soluble, but releases enough highly toxic barium to be an effective rat poison. However, highly purified barium sulfate ($BaSO_4$) is so insoluble that we can swallow large amounts of it prior to X-ray studies of the digestive system.

Chemistry handbooks, artists' textbooks, and manufacturers of metallic compounds often claim many metallic compounds are safe because they are insoluble. They may even provide data on the solubility of these materials obtained from tests in solutions of acid.

However, it has been shown that some chemicals that are insoluble in acid solutions may be quite soluble in body fluids such as lung and digestive fluids. This is probably due to the combined actions of acids, bases, enzymes, and other physiological mechanisms. In addition, laboratory solubility tests are usually done on very pure chemicals. The chemicals used in art are often highly impure and contaminated.

For these reasons, it is prudent to consider all compounds containing toxic metals or radicals as potentially toxic. Table 10, Metal and Metal Compounds, page 135, lists the hazards of various metals, oxides and other compounds. Table 11 lists the hazards of common radicals.

EXPOSURE STANDARDS

The American Conference of Governmental Industrial Hygienists (ACGIH) sets Threshold Limit Values (TLVs) for exposure to airborne concentrations of metal dusts and fumes (see pages 32-33). Table 10 also lists these Threshold Limit Values when they are available.

The Threshold Limit Values for metals and metal compounds are usually expressed in milligrams per cubic meter (mg/m^3). Ten mg/m^3 is often referred to as a nuisance dust level. Even nuisance dusts may be harmful in concentrations greater than 10 mg/m^3. Threshold Limit Values which are lower than 10 mg/m^3 indicate the material is more toxic. Table 9 lists examples of Threshold Limit Value-Time Weighted Averages.

TOXICOLOGY OF METALS AND METAL COMPOUNDS

There are certain occupational illnesses which are especially associated with metals and their compounds.

TABLE 9	Examples of Threshold Limit Values For Metals
SUBSTANCE	Threshold Limit Value-Time Weighted Average (mg/m³)
calcium carbonate, whiting	10
aluminum dust	10
aluminum welding fume	5
tin metal and compounds	2
copper dust & mist	1
copper fume	0.2
arsenic metal and inorganic compounds	0.01
beryllium and its compounds	0.002

SKIN DISEASES. Handling metals usually does not harm the skin unless the metal is radioactive or unusually toxic. For example, beryllium can produce skin tumors if it penetrates broken skin, and arsenic is corrosive to the skin and causes skin cancer.

Some metals and metallic compounds also cause skin allergies. Many people are so sensitized to certain metals that even wearing metal jewelry will cause a reaction.

METAL FUME FEVER. Fumes of metals such as zinc, copper, magnesium, and iron, can cause metal fume fever. This disease resembles the flu. It usually onsets 2 to 6 hours after exposure and symptoms may include a fever, chills, and body aches. There appears to be no long term damage to the body from episodes of metal fume fever caused by metals of low toxicity. However, when toxic fumes such as cadmium are inhaled, the early symptoms may be similar, but serious consequences or even death may result.

NERVOUS SYSTEM DISEASES. A number of metals are known to affect the brain and other nervous system tissues. For example, lead, mercury, and manganese can cause effects ranging from psychological problems

at low doses, to profound retardation and paralysis at higher doses. Chronic manganese exposure can cause a disease similar to Parkinson's disease.

REPRODUCTIVE EFFECTS. A number of metals are known to affect human reproduction at various stages. For example, the ability to impregnate or conceive may be impaired, birth can be complicated, end in miscarriage, or the fetus may be affected. Metals which are known to cause such effects include antimony, arsenic, cadmium, lead, manganese, mercury, and selenium. Many other metals are suspected of causing reproductive effects or are shown to cause them in animals.

RESPIRATORY SYSTEM DISEASES. Respiratory system diseases may be caused by irritation or allergy to metals. Occasionally, lung scarring (fibrosis) or staining (benign pneumoconiosis) are associated with inhalation of metal oxides such as beryllium or aluminum (see page 153).

SYSTEMIC POISONING. Once a metal or a metal compound is absorbed into the body, a great number of organs may be affected. Each substance has its own unique behavior in the body (see Table 10).

LEAD TOXICITY — A SPECIAL PROBLEM

In recent years, research has increased our understanding of lead toxicity. It is now known that even the small amounts of lead we absorb from air pollution and contamination of food and water are causing health effects in us all and reduced mental acuity in our children.

Although lead has been used in art for hundreds of years, it is time we reconsider its use. For even if we manage to set up ventilation systems that will remove lead fumes and dust from our studios, it will contaminate the environment. The soil where your lead dust has settled will remain contaminated forever.

In addition, government regulations regarding the use and disposal of lead are incredibly strict and getting tougher. There are special standards in both the United States and Canada for workplaces where lead is used. Most studios and schools simply cannot afford to meet these standards.

As a result, schools and artists are often operating "outside" the law. Being caught could result in citations or lawsuits. The fines and damages could be especially severe because the violations are willful—that is we know that what we are doing is dangerous and illegal.

The answer is to begin immediately to seek alternatives to lead just as big business is finding substitutes for lead, for solvents which destroy the ozone layer, and for fuels which cause acid rain. Industry often resists making these changes because the substitutes will not be exactly like the old materials, will cost more, be less convenient, and so on.

Each of us must decide if we will use these same arguments to justify our use of lead.

TABLE 10	Hazards of Metals and Metal Compounds

Key

TOXICITY divided into LOCAL, and SYSTEMIC effects:

LOCAL effects are restricted to the chemical's potential for damaging the skin, eyes or respiratory system on contact through its toxic properties such as alkalinity, sensitization, or effects on surface tissues. Mechanical effects of the chemicals will not be included. IT IS ASSUMED THAT READERS KNOW THAT ALMOST ALL FINELY DIVIDED CHEMICAL POWDERS CAN CAUSE MECHANICAL DAMAGE TO LUNGS AND EYES AND CAN DRY AND ABRADE SKIN.

SYSTEMIC effects are restricted to the effects on various organ systems such as blood, kidneys, lungs, and brain. These effects are seen if elements are absorbed into the body after contacting the skin, respiratory system, or digestive tract. Only digestive tract absorption of very small amounts such as from swallowing of material cleared from the lungs or hand-to-mouth contact will be noted. EFFECTS OF MASSIVE INGESTION ARE EXCLUDED.

TVL-TWA: the American Conference of Governmental Industrial Hygienist's Threshold Limit Values which are Time Weighted Averages for the eight hour work day. They are expressed in milligrams per cubic meter (mg/m3). 10 mg/m3 is considered a nuisance dust level. TLV-TWAs lower than 10 indicate a greater toxicity. Occasionally a TLV-Ceiling will be included. This is a level which should not be exceeded even for an instant.

Table lay out:

NAME OF METAL (CHEMICAL SYMBOL)	TLV-TWA (mg/m^3)
common sources: name, (formula), synonyms	fume
LOCAL toxic hazards	dust
SYSTEMIC toxic hazards	other

ALUMINUM (Al)

Alumina (Al_2O_3), alumina hydrate, aluminum oxide, corundum, emery;
Alumina hydrate ($Al[OH]_3$), alumina trihydrate; a chemically bound, nonhazardous constituent of clays and many minerals.

Al fume: 5
Al & oxide dust: 10
soluble salts: 2

LOCAL: Inhalation of fume is associated with lung scarring disease. Inhalation of oxides is associated with a form of pneumoconiosis (Shaver's Disease).

SYSTEMIC: Generally assumed to have no significant hazards, but some experts suspect it plays role in some chronic diseases like Alzheimer's disease.

ANTIMONY (Sb)

Antimony oxide (Sb_2O_3), antimony trioxide, stibium oxide, Pigment White 11;
Antimony sulfide (Sb_2S_3), antimony black, Color Index (C I.) 77050;
Lead antimonate ($Pb_3[SbO_4]_2$), Naples Yellow, C. I. Pigment Yellow 41 (see also Lead);
Stibine gas (SbH_3), antimony hydride.

Sb & compounds: 0.5
stibine gas: 0.51

LOCAL: Fume and dust are potent irritants to skin, eyes, respiratory tract. Can cause ulcers of skin and upper respiratory tract.

SYSTEMIC: Absorption causes metallic taste, vomiting, diarrhea, irritability, fatigue, muscular pain, and may result in anemia, kidney and liver degeneration. Has adverse reproductive effects. Often contaminated with significant amounts of arsenic.

ARSENIC (As)

Arsenic oxide (As_2O_3), white oxide, arsenic trioxide, arsenous oxide;
Arsenic pentoxide (As_2O_5), arsenic acid;
Arsenic sulfide (AsS or As_2A_2), arsenic disulfide, ruby arsenic or red arsenic glass, realgar;
Arsenic trisulfide (As_2S_3), arsenious sulfide, orpiment, C. I. Pigment Yellow 39;
Copper acetoarsenite

fume, dust, compounds: 0.01
arsine gas: 0.16

$([CuO]_3As_2O_3 \bullet Cu[Cu_2H_3O_2]_2)$,
C. I. Pigment Green 21, Paris Green;
Arsine gas (AsH_3).

LOCAL: Corrosive to the skin, eyes, and respiratory tract. Can cause skin cancer.

SYSTEMIC: Absorption can cause gastrointestinal distress, kidney damage, nerve damage, cancer, and reproductive effects.

BARIUM (Ba)

Barium carbonate $(BaCO_3)$, whitherite,
 C. I. Pigment White 10;
Barium sulfate $(BaSO_4)$, barite, barytes,
 blanc fixe, C.I. Pigment White 21,
 Permanent White, Lithopone
 (with zinc compounds);
Barium chromate $(BaCrO_4)$, C.I.Pigment Yellow 31.

soluble compounds:0.5
Ba sulfate: 10

LOCAL: The fume and the carbonate are slight irritants.

SYSTEMIC: Absorption can cause muscle spasms and contractions, bladder contractions, intestinal spasms, ringing of ears, irregular heart beat, heart rate may be slowed or stopped.

BERYLLIUM (Be)

Beryllium oxide (BeO), beryllia;
Beryl $(3BeO.Al_2O_3 \bullet 6SiO_2)$, glucinum oxide.

Be & compounds: .002

LOCAL: Irritates skin and can cause swelling and ulceration of nasal passages. Penetration of broken skin (e.g., cuts from beryllium-coated glass of old fluorescent lights) has produced skin tumors.

SYSTEMIC: Inhalation can cause severe, permanent lung disease, called beryllosis, which can be fatal. This disease is often misdiagnosed as sarcoidosis. Absorption can cause liver and spleen dysfunction, and cancer.

BISMUTH (Bi)

Bismuth trioxide (Bi_2O_3), bismuth oxide;

Bismuth nitrate (Bi[NO$_3$]$_3$•5H$_2$O]);
Bismuth subnitrate.

LOCAL: No significant hazards.* (see footnote)

SYSTEMIC: Causes physiological response similar to lead, but much greater doses are required.

BORON (B)

Boric acid (H$_3$BO$_3$);
Borax (Na$_2$B$_4$O$_7$•10H$_2$O);
Boron oxide (B$_2$O$_3$), boric oxide;
 component of borosilicate frits, Colmanite,
 Gerstley borate.

borates (tetra & sodium)
 anhydrous (no H$_2$O): 1
 decahydrate (10H$_2$O): 5
 pentahydrate (5H$_2$O): 1
 boron oxide: 10

LOCAL: Irritant to skin, eyes, and respiratory tract.

SYSTEMIC: Nausea, stomach pain, vomiting, skin rash, diarrhea, liver, kidney, testicular damage, death. Lethal amounts of boric acid have been skin-absorbed from old burn treatment medications.

CADMIUM (Cd)

Cadmium sulfide (CdS), greenockite, cadmium
 yellow, C. I. Pigment Yellow 37;
Cadmium oxide (CdO);
Cadmium selenide (CdSe), (see also selenium).

total dust: 0.01
respirable dust: 0.002

LOCAL: Irritant to skin, eyes, and respiratory tract. Chronic exposure can ulcerate nasal septum and yellow the teeth.

SYSTEMIC: Acute inhalation of fumes can cause fatal illness whose early symptoms are similar to metal fume fever (flu-like symptoms). Chronic exposure can cause lung and kidney damage, anemia, and cancer. Some cadmium compounds are insoluble in acid, but solubility is not directly related to chronic toxicity. All cadmium compounds should be considered highly toxic. Has adverse reproductive effects.

CALCIUM (Ca)

Calcium carbonate (CaCO$_3$), calcite, whiting;
Calcium sulfate (CaSO$_4$ or CaSO$_4$,2H$_2$O),

Ca carbonate: 10
Ca hydroxide: 5

| plaster, gypsum, C.I Pigment White 25; common element in many ceramic chemicals. | Ca oxide: 2 |

LOCAL: No significant hazards.*

SYSTEMIC: No significant hazards.*

CERIUM (Ce)

| Cerium oxide (CeO_2), ceric oxide, cerium dioxide, ceria; component of cerite, monazite, orthite. | none |

LOCAL: No significant hazards.*
SYSTEMIC: Inhalation of fume causes a lung disease called cer-pneumoconiosis.

CHROMIUM (Cr)

| Chrome oxide (Cr_2O_3), chromium (III) oxide, chromic oxide, chrome green, C. I. Pigment Green 17; Chromium trioxide (CrO_3), chromium (VI); chromic acid; Potassium dichromate ($K_2Cr_2O_7$), potassium bichromate (chrome VI); Iron chromate ($Fe_2[CrO_4]_3$), ferric chromate, (chrome VI); Lead chromate ($PbCrO_4$), chrome yellow, C. I. Pigment Yellow 34 (chrome VI-see also Lead). | metal: 0.5 Cr (II) compounds: 0.5 Cr (III) compounds: 0.5 CR (VI) compounds: 0.05 strontium chromate (C. I. Pigment Yellow 32) : 0.0005 |

LOCAL: Irritating to skin, eyes, and respiratory system. Can cause severe skin allergies and slow-healing ulcers of skin and nasal passages.

SYSTEMIC: Moderately toxic. Cancer is associated with chrome (VI) compounds and chrome fume. Some experts think all chrome compounds can cause cancer. The chromate is a potent animal carcinogen.

COBALT (Co)

| Cobalt oxides: cobaltous oxide (CoO), black cobaltic oxide; | metal dust and fume: 0.02 |

(Co_2O_3), or cobalto-cobaltic oxide (Co_3O_4);
Cobalt carbonate (Co_2CO_3).

LOCAL: Mild skin, eye, and respiratory irritant. Can cause skin allergies.

SYSTEMIC: Inhalation causes asthma-like disease, pneumonia, heart and lung damage. Absorption causes vomiting, diarrhea, sense of hotness. An animal carcinogen.

COPPER (Cu)
Copper oxides: black copper oxide (CuO); fume: 0.2
 red copper oxide (Cu_2O); dusts & mists: 1
Copper carbonate $(CuCO_3)$, green copper
 carbonate.

LOCAL: Irritates and discolors the skin. Respiratory tract irritant. Repeated inhalation of dust can cause sinus congestion and ulceration, and perforation of the nasal septum. Contact with eyes can cause conjunctivitis and discoloration and ulcers of the cornea.

SYSTEMIC: May cause allergies in some people. Inhalation of fumes can cause metal fume fever (flu-like symptoms). Absorption can cause nausea, stomach pains.

GOLD (Au)
Metallic gold and mercury/gold amalgams none
 (in some lustres);
Gold chloride $(AuCl_3)$, gold trichloride.

LOCAL: Metallic gold has no significant hazards. Gold chloride and other gold salts may be irritating and cause allergies.

SYSTEMIC: Absorption of salts can cause anemia, liver damage, and nervous system damage.

IRON (Fe)
Iron oxides: magnetic iron oxide (FeO), fume: 5
 ferrous oxide; ferric oxide (Fe_2O_3), soluble salts: 1
 hematite, Indian red, C. I.
 Pigment Red 101; ferrosoferric oxide (Fe_3O_4),

black iron oxide, C. I. Pigment Black 11;
Yellow ochre ($2Fe_2O_3 \cdot 3H_2O$), limonite;
Iron sulfate ($FeSO_4 \cdot 7H_2O$), crocus martis.

LOCAL: No significant hazards by skin or eye contact.* Inhalation can stain lung tissues causing a disease called Siderosis. This condition is considered benign, but it can fog lung X-rays.

SYSTEMIC: Inhalation of iron fume can cause metal fume fever (flu-like symptoms). Iron sulfate is irritating and toxic due to the sulfate radical.

LEAD (Pb)

Lead monoxide (PbO), litharge, C. I. Pigment Yellow 46; Lead tetroxide (Pb_3O_4), lead oxide, red lead, mennige, minium, C. I. Pigment Red 105; Lead carbonate ($PbCO_3$), white lead, cerusite, C. I. Pigment White 1; Lead sulfate ($PbSO_4$), white lead, C. I. Pigment White 2; Lead sulfide (PbS), galena, lead glance; Lead frits, e.g. lead monosilicate, lead bisilicate, C. I. Pigment White 16; Lead chromate (also see chromium); Naples yellow (also see antimony).	dust & fume: 0.05[+] lead chromate: 0.05 OSHA Permissible Exposure Limit for all lead compounds: 0.05 Canadian standard: 0.15

LOCAL: No significant hazards.*

SYSTEMIC: Highly toxic. Acute exposure can cause colic, convulsions, coma and death. Chronic exposure can cause anemia, and brain, nervous system, and kidney damage. It accumulates in bones and tissues and may cause problems for prolonged periods of time. A hazard to the unborn fetus and to reproductive capabilities of both males and females. Children are even more seriously affected than adults and at lower doses. Probable human carcinogen.

LITHIUM (Li)

Lithium carbonate (Li_2CO_3); Lithium-containing minerals: lepidolite, petalite, spodumene, and amblygonite.	none for compounds used in art.

LOCAL: Irritating to skin, eyes, and respiratory system.

SYSTEMIC: Absorption can cause symptoms ranging from fatigue, dizziness, and gastrointestinal upset to more serious complications including tremors, kidney damage, muscular weakness, vision and hearing disturbances, coma, seizures, and death. Lithium carbonate is used medicinally to control manic depressive personality disorders which demonstrates that even milligram amounts can cause effects. Reproductive hazard.

MAGNESIUM (Mg)

Magnesium carbonate ($MgCO_3$), magnesite (mineral form of magnesium carbonate);	magnesite: 10 fume: 10
Magnesium sulfate ($MgSO_4$), epsom salt (hydrated form);	
Magnesium silicate ($MgO \bullet SiO_2$-ratio variable);	

LOCAL: No significant hazards.*

SYSTEMIC: No significant hazards except inhalation of large amounts of fume could cause metal fume fever (flu-like symptoms). Large ingestions cause laxative effect.

MANGANESE (Mn)

Manganese dioxide (MnO_2), black oxide of manganese, pyrolusite, C. I. Pigment Black 14;	fume, dust & compounds: 0.2[+]
Manganese carbonate ($MnCO_3$).	

LOCAL: Mild irritant to skin and respiratory tract.

SYSTEMIC: Chronic inhalation can produce a degenerative nervous system disease similar to Parkinsonism. Early symptoms include languor, sleeplessness, weakness, muscle spasms, headaches, and irritability. Can also cause metal fume fever. Has adverse reproductive effects.

MERCURY (Hg)

Mercuric sulfide (HgS), cinnabar, vermillion, C. I. Pigment Red 106;	inorganic compounds
Metallic mercury and amalgams.	& Hg vapor: 0.025

LOCAL: Skin irritation and occasional skin allergies have been reported.

SYSTEMIC: Mercury and some of its compounds can be absorbed through the

skin and can form vapors at fairly low temperatures which can be inhaled. Early symptoms of absorption are psychic and emotional disturbances. Symptoms can progress to tremors, kidney disease, and nerve degeneration. Has adverse reproductive effects.

MOLYBDENUM (Mo)

Molybdenum trioxide (MoO_3); molybosilicates ($Mo[SiO_2]_x$); Molybdate Orange (solution of lead molybdates, sulfates and chromates), C. I. Pigment Red 104

soluble compounds: 5
insoluble compounds: 10

LOCAL: Not well studied. Slightly irritating to skin and respiratory system.

SYSTEMIC: Appears to be of low order of toxicity.

NICKEL (Ni)

Nickel oxides: nickel monoxide (NiO), green nickel oxide; dinickel trioxide (Ni_2O_3), nickelic oxide; Nickel carbonate ($NiCO_3 \bullet 2Ni[OH]_2 \bullet 4H_2O$), green nickel carbonate; Nickel chloride ($NiCl_2$).

metal &
compounds: 0.05[+]

LOCAL: Can cause very severe skin allergies, commonly called "nickel itch," which can lead to ulceration and chronic eczema. Also irritating to eyes and mucous membranes.

SYSTEMIC: Human carcinogen. Ingestion of salts is associated with giddiness and nausea.

NIOBIUM (Nb)

Niobium metal (called "Columbium" by many metallurgists), often contaminated with tantalum; Niobium chloride ($NbCl_5$).

LOCAL: Eye and skin irritant. Effects not well-studied.

SYSTEMIC: Known to cause kidney damage. Other effects not well-studied.

PLATINUM (Pt)

Platinum chloride ($PtCl_4$), platinum tetra-chloride, chloroplatinic acid;
Platinum black (finely powdered metal).

metal: 1
soluble salts: .002

LOCAL: Skin contact with salts can cause severe allergies. Inhalation can cause nasal allergies and "platinosis," a severe type of asthma.

SYSTEMIC: Some lung scarring may occur from chronic inhalation. Ingestion hazards are unknown.

POTASSIUM (K)

Potassium carbonate (K_2CO_3), pearl ash, potash;
Potassium hydroxide (KOH), caustic potash;
A common constituent of many ceramic minerals, e.g., potash feldspars.

K hydroxide: 2
(TLV-Ceiling)

LOCAL: No significant hazards.* The hydroxide and carbonate compounds are eye, skin, and respiratory irritants.

SYSTEMIC: No significant hazards.*

PRASEODYMIUM (Pr)

Praseodymium oxide (Pr_2O_3).

LOCAL: No hazards known.

SYSTEMIC: When absorbed may depress coagulation of the blood. Not much known about toxicity.

RHODIUM (Rh)

Rhodium chloride ($RhCl_3$), rhodium trichloride.

metal: 1
insoluble compounds: 1
soluble compounds: 0.1

LOCAL: Related to platinum, but apparently not a skin sensitizer.

SYSTEMIC: Not well studied. Slightly carcinogenic in animals. $RhCl_3$ is a potent mutagen.

SELENIUM (Se)

Cadmium selenide (CdSe),	compounds: 0.2
C. I. Pigment Red 108;	
and Yellow 35 (see also Cadmium);	
Selenium photographic toners.	

LOCAL: Irritant to eyes, skin, and respiratory tract. When compounds come in contact with moisture or acid, they may release hydrogen selenide gas which is a vastly more potent irritant.

SYSTEMIC: Its toxicity is similar to that of arsenic. Symptoms of over exposure include a tell-tale garlic breath odor. Most damaging to liver, kidneys, spleen, bone marrow, and thyroid. A suspect carcinogen. Has adverse reproductive effects.

SILVER (Ag)

Metallic silver;	metal: 0.1
Silver chloride (AgCl);	soluble compounds: 0.01
Silver nitrate (AgNO$_3$);	
Silver sulfide (Ag$_2$S), niello;	
Silver/mercury amalgams (see also Mercury).	

LOCAL: Silver salts can stain skin, and irritate mucous membranes. Silver nitrate is very caustic and burns skin and has caused blindness when splashed in the eyes. Silver fume can deposit in lungs to cause a benign pneumoconiosis which can fog X-rays.

SYSTEMIC: Black silver deposits can migrate in the body to permanently stain the whites of the eye, the skin and other sites in a benign condition called "argyria."

SODIUM (Na)

Sodium carbonate (Na$_2$CO$_3$), soda ash,	Na bisulfite: 5
washing soda;	Na metabisulfite: 5
Sodium bicarbonate (NaHCO$_3$), baking soda;	Na hydroxide: 2
Sodium bisulfite (NaHSO$_3$), sodium acid sulfite;	(TLV-Ceiling)
Sodium metabisulfite (Na$_2$S$_2$O$_5$);	
Component of many ceramic chemicals and minerals.	

LOCAL: No significant hazards.* Sodium carbonate is an irritant to skin, eyes, and respiratory tract.

SYSTEMIC: No significant hazards.*

STRONTIUM (Sr)

Strontium carbonate ($SrCO_3$) strontianite;
Strontium chromate ($SrCrO_4$),
 C. I. Pigment Yellow 32;
Strontium sulfate ($SrSO_4$), celestine.

> None for Sr and
> compounds
> except for
> Sr chromate : 0.0005
> (see chromium)

LOCAL: No significant hazards.*

SYSTEMIC: No significant hazards.*

TANTALUM (Ta)

Tantalum chloride ($TaCl_5$);
Tantalum oxide (Ta_2O_5).

> metal & oxide dust: 5

LOCAL: Industrial skin injuries have been reported. Not well-studied.

SYSTEMIC: Systemic poisoning has not been demonstrated. Not well-studied.

TIN (Sn)

Tin oxides: stannous oxide (SnO); stannic
 oxide (SnO_2), cassiterite,
 white tin oxide;
Tin chloride ($SnCl_2$), stannous chloride, tin
 dichloride.

> metal, oxide &
> inorganic compounds: 2
> organic compounds: 0.1

LOCAL: No significant hazards* except the fume deposits in the lungs to produce a benign pneumoconioses which fogs X-rays. The chloride salt is a skin, eye, and respiratory irritant.

SYSTEMIC: No significant hazards* for most compounds used in art.

TITANIUM (Ti)

Titanium dioxide (TiO_2), titania,
 C. I. Pigment White 6;
minerals containing titanium: rutile, illmenite,
 ferrous titanite, perowskite;
Titanium tetrachloride ($TiCl_4$).

> titanium dioxide: 10

LOCAL: No significant hazards.* The chloride is highly irritating especially in the fume form.

SYSTEMIC: Generally thought safe, but some experts think it may cause a type of pneumoconiosis.

TUNGSTEN (W)

Tungsten carbide (WC);	insoluble compounds: 5
Tungsten trioxide (WO_3), tungstic oxide, tungstenic ochre, wolframic acid;	soluble compounds: 1
components of minerals: scheelite, wolframite; component in some ceramic frits.	

LOCAL: No significant hazards* to skin and eyes. Slightly toxic to respiratory tract.

SYSTEMIC: No significant hazards to insoluble compounds.*

URANIUM (U)

Uranium oxides: uranous oxide, UO_2; uranyl oxide, UO3; triuranium octoxide, U_3O_8; component in uranite, pitchblende;	soluble & insoluble compounds: 0.2
Uranium nitrate ($UO_2[NO_3]_2 \bullet 6H_2O$), uranyl nitrate;	
"Depleted uranium," uranium isotopes except for U^{235}.	

LOCAL: Radioactivity could effect skin to cause cancer. The nitrate is easily skin-absorbed. "Depleted uranium," is as radioactive as other uranium chemicals.

SYSTEMIC: Highly toxic, radioactive carcinogen. Absorption results in severe kidney damage.

VANADIUM (V)

Vanadium pentoxide (V_2O_5); Many mason and ceramic stains.	dust and fume: 0.05

LOCAL: Highly irritating to skin, eyes respiratory tract. Heavy exposures have caused chemical pneumonia. Can cause allergies.

SYSTEMIC: Can cause anemia, kidney disfunction, gastrointestinal disorders, nervous system damage, and cough.

ZINC (Zn)

Zinc oxide (ZnO), chinese white, C. I. Pigment White 4;	fume: 5
	Zn oxide dust: 10
Zinc chloride ($ZnCl_2$), zinc dichloride;	Zn chloride fume: 1
Zinc chromate ($ZnCrO_4 \bullet 7H_2O$).	Zn chromates: 0.01

LOCAL: No significant hazards.* The chloride is a potent irritant to skin, eyes, and respiratory tract.

SYSTEMIC: Inhalation of zinc fume can cause metal fume fever (flu-like symptoms).

ZIRCONIUM (Zr)

Zirconium oxide (ZrO_2), zirconium dioxide, baddeleyite;	Zr compounds: 5
Zirconium silicate ($ZrSiO_4$), zircon.	

LOCAL: No significant hazards.* Rare allergies to zirconium deodorant products have been reported.

SYSTEMIC: No significant hazards.*

*No significant hazards UNLESS COMBINED WITH RADICALS CONTAINING OTHER HAZARDOUS ELEMENTS. Radicals are elements or combinations of elements bound to the metal. For example, the toxicity of potassium hydroxide (KOH) is not caused by potassium (K-), but by the caustic hydroxide radical (-OH). See Table 11, hazards of Radicals.

+These are TLV published by the ACGIH in their "Notice of Intended Changes for 1994-5." They will be listed for at least one year and then adopted if no evidence comes to light that calls the values into question.

Artists may call or write ACTS for more detailed information about symptoms and diseases from exposure to particular metals.

TABLE 11	**Toxic Effects of Common Radicals**

A radical is an element or group of elements that combines with a metal to form a compound. Radicals may affect the toxicity, solubility, and other characteristics of metallic compounds.

CARBIDE radicals (-C, carbon) usually do not contribute to toxicity. Carbide radicals are found in some abrasives such as silicon carbide (SiC) and tungsten carbide (WC). Diamonds are also a form of carbon. Carbon dioxide or carbon monoxide may be given off if carbides or carbon-containing materials are heated or fired.

CARBONATE radicals (-CO_3) usually do not contribute to toxicity. Carbon dioxide and toxic carbon monoxide may be given off if compounds are heated or fired.

CHLORIDE radicals (-Cl) usually increase solubility, reactivity, and irritant qualities. Heating or firing may release highly irritating hydrochloric acid gas or chlorine.

CHROMATES (-CrO_4). See Chromium in Table 10, Hazards of Metals and Metal Compounds, page 137.

CYANIDE compounds (-CN) should be avoided because they are very soluble and toxic. When in contact with acids, heat, or gastric fluids, highly toxic hydrogen cyanide gas is formed. This gas stops the body's cells from receiving oxygen. The victim dies quickly of asphyxiation. Cyanides usually are not very irritating to the skin, but electroplaters who are repeated exposed to cyanide solutions often develop rashes and skin eruptions.

FLUORIDE radicals (-F) usually increase solubility, reactivity, and irritant qualities. Fluorides also may produce long-term toxic reactions. Chronic fluorine poisoning or "fluorosis" is seen among miners of cryolite and other fluorine-containing minerals. The disease consists of sclerosis of the bones, calcification of ligaments, mottling of the teeth, anemia, gastric, respiratory, and nervous system complaints and skin rashes.

HYDROXIDES (-OH) can vary from being very soluble to very insoluble. Soluble hydroxides are caustic and irritating to skin, eyes, digestive tract, and respiratory system.

NITRATES (-NO_3) are most often very soluble which usually makes the metals in nitrate compounds more available to the body. They are often highly toxic

by ingestion. All nitrates are powerful oxidizing agents and some can explode when exposed to heat or flame. Potassium, barium, and other nitrates are used in fireworks. May emit highly toxic nitrogen oxide gases during firing or glass-making.

NITRITES ($-NO_2$) are usually very toxic and strong oxidizers. Avoid.

OXIDE radicals (-0) usually do not contribute to toxicity.

PHOSPHATES ($-PO_4$) vary greatly in solubility and toxicity. Heating or firing phosphates may release highly toxic phosphorus oxides. Large doses of some phosphates can disturb the metabolism.

SILICATES ($-SiO_2$) usually are not very toxic. Unlike silica (free SiO_2), silicates do not cause silicosis although some silicates cause other less virulent pneumoconioses (lung diseases). Naturally occurring silicates are often contaminated with significant amounts of free silica.

SULFATE radicals ($-SO_4$) usually do not contribute to toxicity. They may emit highly irritating sulfur oxides during firing or glass making.

SULFIDES (-S) of metals are often insoluble. Many are irritating to the skin and eyes. Many sulfides are highly toxic by ingestion because they react with gastric acid to produce hydrogen sulfide gas. They emit sulfur oxides on heating or firing. If water vapor is present, hydrogen sulfide may also be released.

SULFITES ($-SO_3$) and **BISULFITES** ($-HSO_3$) usually are moderately toxic. They may emit sulfur oxides as they degrade with age, or when heated.

CHAPTER

12 | *MINERALS*

Minerals are used in almost all arts and crafts. Examples include all sculpture stones, gemstones, all clays and most ceramic chemicals, most abrasives, many paint, ink, and pastel extenders, some pigments, refractory and insulating materials for high temperature equipment, and more.

NATURAL MINERALS

It took Mother Nature ages to make our minerals. And since Mother Nature was not concerned with "quality control," she allowed inclusion of impurities in most minerals. Organic materials such as coal or asphalt contaminate some fire clay minerals. Sedimentary clays often contain a variety of organic matter deposited by ancient lakes and rivers with the clay.

Inorganic materials also may contain minerals. Trace metal impurities in gemstones, for instance, often are responsible for unique colors. Mineral talc (talcum) deposits usually contain significant amounts of other minerals such as silica and/or asbestos. Mineral impurities often must be considered when assessing the hazards of naturally occurring minerals.

SYNTHETIC MINERALS

Mother Nature is not the only mineral-maker. For thousands of years, potters have converted minerals from one form to another in their fires and kilns. Now more sophisticated equipment is used to make minerals such as synthetic gemstones and mineral fiber insulation.

Synthetic minerals can be tailored to fit our needs. Some types of synthetic gemstones can be made to possess exactly the same chemical and physical properties as pure natural gemstones. Synthetic mineral fibers can be tailored to have the same insulating properties as natural asbestos.

It should not be surprising then, that many synthetic minerals have health effects similar to those of natural minerals.

CHEMICAL VS. MINERAL HAZARDS

Like all matter, minerals are made of chemicals. In most minerals, these chemicals are arranged in a crystal structure with a definite chemical composition. Artists need information on both chemical composition (chemical analysis) and crystal structure (mineral analysis) of these materials, because both may affect health.

Some minerals contain very toxic chemicals. These toxic chemicals can affect the body if they are soluble—that is are released from the mineral into body fluids.

The mineral's crystal structure also may affect health. For example, asbestos minerals are made of harmless chemicals such as magnesium and calcium silicates. Asbestos is not soluble (inert) and does not release these chemicals in the body. But the asbestos minerals have long needle-like crystals which can penetrate tissues and cause cancer.

SOLUBILITY OF MINERALS. To find out if toxic chemicals in a particular mineral are soluble in body fluids, solubility tests are done. These tests place the mineral in contact with acid and water. Such tests do not precisely relate to body fluid solubility because body fluids contain not only acids and water, but bases, enzymes, and other materials. And solubility may differ in various body fluids such as digestive juices and lung fluids. For these reasons, the actual solubility of most minerals in various body fluids is not known precisely.

Artists also should consider that many of the minerals to which they are exposed are fine powders or dust from abrasive processes. These fine particles present a very large surface area to body fluids from which toxic

metals may be released. If these small particles are inhaled, they may be retained in the lungs for a lifetime, giving the body years to dissolve or incorporate them. In addition, natural minerals often contain some soluble impurities.

For all these reasons, minerals containing highly toxic metals such as lithium, barium, and beryllium should be treated with caution regardless of laboratory solubility data. They may be considered as metal-containing compounds and their potential hazards can be looked up in Table 10, Hazards of Metal and Metal Compounds, page 135.

INSOLUBLE OR INERT MINERALS. Certain minerals have been actually observed after years of exposure to body fluids and are known to be insoluble and inert. For example, once inhaled, asbestos fibers and silica crystals are known to remain essentially unaltered in the lungs for a lifetime. Inert minerals are often associated with specific types of illnesses.

TOXICOLOGY OF INERT MINERALS

Inert minerals usually are not very hazardous to ingest and when inhaled, they all seem to dry and irritate the lungs to some degree. Their major effects, however, usually involve chronic lung diseases.

These diseases occur precisely because the minerals do not dissolve or break down in the lungs. Instead, they begin to accumulate in the lungs. The diseases they cause fall into certain categories.

PNEUMOCONIOSES, (meaning "dusty lungs" in greek) are diseases caused by inhalation of inert materials. Each type of pneumoconiosis is identified by the name of the dust which caused it. For example, talcosis is caused by talc inhalation.

Different mineral dusts cause diseases of varying severity. There are two major categories of pneumoconiosis: fibrogenic and benign.

FIBROGENIC PNEUMOCONIOSIS. This is a disease in which the lungs are scarred by mineral dusts. Minerals such as asbestos and silica cause severe forms of the disease. It is untreatable at all phases, can progress even after exposure has ceased, and its severity can range from shortness of breath to disability or death. Typically, the disease results from small exposures to dust over many years. However, even short exposures may be hazardous. Only a few weeks of heavy exposure to silica flour (400

mesh) has caused workers to die of silicosis a couple of years later. This form of the disease is called "acute silicosis."

Dusts which cause less severe fibrotic diseases and require inhalation of greater amounts of dust include: kaolin (clay uncontaminated with silica), alumina, and talc (uncontaminated with asbestos minerals). The diseases these cause are called respectively kaolinosis, aluminosis, and talcosis.

BENIGN PNEUMOCONIOSES do not result in lung scarring. However, some will alter the appearance of diagnostic lung X-rays causing doctors to do unnecessary medical tests if the cause of the X-ray change is not known. It also may obliterate X-ray evidence of other lung diseases causing other conditions to go untreated.

Examples of minerals which can cause benign pneumoconiosis include a barium sulfate mineral, barytes (causes baritosis), and ochres and other iron oxides such as rouge and rust (causes siderosis).

LUNG CANCER AND MESOTHELIOMA (cancer of the lining of the chest, abdomen or heart) are caused by inert, microscopic, needle-shaped partices such as those of asbestos and synthetic mineral fiber insulation.

HAZARDS OF COMMON MINERALS

The type of damage a particular mineral causes depends on its unique characteristics. To complicate matters, some minerals exist in more than one crystal form. It is important to know about these forms to assess health risks and to comply with governmental exposure regulations. The minerals with which artists should be familiar include asbestos, silica, feldspars, and clays. For other minerals, See Table 13, Hazards of Common Minerals, page 159.

ASBESTOS causes asbestosis and is associated with a number of cancers including mesothelioma and lung cancer. Even ingestion of asbestos may be hazardous causing intestinal and kidney cancer as some needle-like fibers migrate through the body.

Asbestos comes in a number of mineral forms:

CHRYSOTILE—serpentine groups of mineral, white asbestos
AMOSITE—cummingtonite-grunerite minerals, brown asbestos

CROCIDOLITE—blue asbestos
AMPHIBOLE ASBESTOS—can be found in three mineral forms:
 TREMOLITE
 ANTHOPHYLLITE
 ACTINOLITE

Each of the amphibole minerals comes in two forms: fibrous and nonfibrous. The hazards of the fibrous forms are comparable with other forms of asbestos, but the hazards of the nonfibrous forms is being debated. Some people believe that these forms are not truly asbestos and their dusts are far less toxic than asbestos. Others believe that nonfibrous amphiboles mill into sharp thin cleavage fragments which cause illnesses like those caused by asbestos.

The United States Occupational Safety and Health Administration has reviewed studies of nonfibrous tremolitic talc miners and believes that this talc can be associated with increased risk of cancer. The risk appears to be less than for asbestos workers, but they have indicated that they will continue collecting data on this finding to see if regulation is needed.

Exposure to all fibrous forms of asbestos already is regulated in both Canada and the United States. The United States Permissible Exposure Limit (PEL) is .2 fibers per cubic centimeter of air (f/cc).* Canadian standards vary, with the laxest regulations being in the asbestos-mining province of Quebec. Their standard is 5 fibers per cubic centimeter of air (f/cc).

Clearly artists are not equipped to do air sampling and regulate their asbestos exposures. Until all the evidence is in, artists probably should avoid exposure to all types of asbestos, both fibrous and nonfibrous. Children certainly should never use any asbestos-contaminated materials.

SILICA, or silicon dioxide (SiO_2), is one of the earth's most common minerals. When silica is bound in compounds or minerals, it is not usually hazardous. However, inhaling unbound or "free" silica can cause a serious untreatable lung-scarring disease called "silicosis." Recently, an elevated risk of lung cancer has also been documented in people with silicosis.

* A typical male doing light work will inhale about a cubic meter of air per hour. This would mean at 0.2 f/cc a worker would inhale 1,600,000 fibers during an eight hour period. Heavy work can triple these figures because more air is inhaled. Many experts feel this standard does not provide sufficient protection for workers.

Free silica occurs in various crystalline and amorphous forms:

CRYSTALLINE SILICA—all forms are now considered probable human carcinogens. They all have the same chemical formula (SiO_2) but the crystal structures differ.

QUARTZ, common constituent of sand, flint, and other rocks.

CRISTOBALITE can be formed from heat conversion of quartz geologically or when fired. About twice as toxic as quartz.

TRIDYMITE has roughly the same origins and hazards as cristobalite above.

AMORPHOUS SILICA or NON-CRYSTALLINE SILICA—the arrangement of silicon dioxide molecules is random and unorganized, whether natural or synthetic in origin. The synthetic silicas are manufactured and promoted as "safe" silica. There is considerable debate about their safety and many experts recommend handling them with the same precautions used for free silica. A separate Threshold Limit Value is expected to be set by the ACGIH in the near future. (See pages 32-33 for definitions of Threshold Limit Values.)

TABLE 12	Current ACGIH Standards for Silica	
TYPE OF SILICA	**TLV-TWA (mg/m³*)**	
CRYSTALLINE SILICA		
quartz	0.1	respirable dust
cristobalite	0.05	" "
tridymite	0.05	" "
tripoli	0.1**	" "
AMORPHOUS SILICA		
silica fume	2.0	" "
silica, fused	0.1**	" "
silica, precipitated	10.0	total dust
diatomaceous earth (uncalcined)***	10.0	" "

> * Milligrams per cubic meter.
> ** Applies to the amount of crystalline silica contaminating the substance. Dust containing over one percent silica requires precautions.
> *** Calcined diatomaceous earth converts to cristobalite.

FELDSPARS are a group of minerals which combine silica (SiO_2) and alumina (Al_2O_3) with metal (alkali) oxides. The most common of these are sodium (in soda spars), potassium (in potash spars) and calcium (in lime spars). These metals are usually relatively insoluble and are not very toxic except for the caustic, irritating quality they may impart to the spar. Many other metals (such as magnesium [Mg], titanium [Ti], iron [Fe], barium [Ba], lithium [Li], and more) also may be present in the spar and these may be soluble to varying degrees. Analyses of spars should be obtained to estimate its health hazards and to understand its behavior in glazes or glass.

The major hazard associated with spars is the common presence of free silica contaminants.

KAOLIN AND OTHER CLAYS. "Kaolin" is a term usually used to describe white clays containing the clay mineral, kaolinite. However, the term "clay" refers to any of a number of minerals that dry to a hard form, which can be treated with heat to form a hard, waterproof material. The ones most commonly used in ceramics are minerals of various crystal structure arrangements of alumina, silica, and water. Other metals can be present in the structure of some clays.

The metal elements in clays are too well bonded to be soluble and their hazards come from their crystal structures. It is suspected that many clays can cause lung-scarring diseases after years of heavy exposure, but the disease best documented is "kaolinosis," which is seen in kaolin miners.

Since they are mined from the earth, clays usually contain many impurities. The major hazard associated with clay is the common presence of significant amounts of free silica contamination.

SYNTHETIC MINERAL FIBERS

Synthetic mineral fibers include ceramic fiber, and glass, slag, and rock wool. Research is beginning to show that microscopic needle-like inert materials whether of asbestos, glass, or ceramic origin may cause lung diseases and cancer. In June, 1987, the International Agency for Research on Cancer (IARC) recategorized glasswool, rockwool, slagwool, and ceramic fibers as being "possibly carcinogenic to humans" after evaluating data from laboratory experiments and from studies of workers in fiber-producing plants.

Ceramic fibers also have been shown to partially convert to christobalite (see Silica above) when they are heated to 870 °C (1600 °F) or above. This

means that ceramic fibers used as insulation in kilns and furnaces will convert as the equipment is used. Other man-made fibers may make similar conversions.

OSHA has proposed a Permissible Exposure Limit of one fiber per cubic centimeter (1 f/cc) for fiber glass, mineral wool and refractory ceramic fiber. If this proposal becomes law, artists using or removing ceramic fiber will have to use precautions similar to those used with asbestos which has a PEL of 0.2 f/cc.

FRITS

Frits can be thought of as amorphous or as "less structured minerals." Ground glass, glass paints, metal enamels, and commercial ceramic glazes often are made of, or contain, frits. Frits were originally developed for the British pottery industry to reduce workers' deaths from poisoning by highly soluble raw lead compounds such as litharge and white lead.

Frits are made by melting various minerals and compounds together to form a glass-like material, sintering the glass by pouring it when molten onto cold metal or into cold water, then grinding it up into a powder.

SOLUBILITY OF FRITS. Lead frits are often inaccurately touted as being nontoxic and insoluble. Frit solubility is also measured by an acid test. In preparation for the test, the finest particles are washed out of the frit. Then the washed frit is mixed with a standard amount of acid for a couple hours, and the acid solution is then tested to see how much lead it contains.

This test has shown that although some frits are acid insoluble, frit solubility varies greatly. There are even some frits which are more soluble than raw lead compounds. Acid tests also have confirmed that a frit's solubility is dependent on its chemical composition, how well it is manufactured, and its particle size.

Common acid solubility tests in which fine particles are removed prior to testing also may be misleading to glaze mixers and metal enamelists, since they may work with unwashed materials whose fine dust is more soluble.

In addition, recent studies have shown that some acid-insoluble lead frits are as soluble as raw lead compounds when ingested or inhaled by animals, or are placed in human body fluids such as lung and digestive fluids.

There is little or no data on the solubility of nonlead frits, yet these may contain barium, lithium or other toxic metals. Prudence dictates that all frits be treated with care.

GLASS

Glass can be manufactured in an infinite variety of compositions. Natural glasses, like obsidian and pumice also can vary in composition. Technically, fired ceramic glazes are also types of glass.

When powdered or ground fine, the hazards of these materials, like frits, will depend on the solubility of any toxic metals in the glass and on their ability to mechanically irritate eyes, skin and the respiratory system. Dust from grinding lead glass, for example, can be both irritating and toxic.

TABLE 13	Hazard of Common Minerals Used in Ceramics, Sculpture, Lapidary, and Abrasives

General information about common minerals is summarized in this table. Inhalation hazards are stressed since artists are most often exposed to airborne dust from these materials. Silica, asbestos, feldspars, and clays are often found in these minerals. The hazards of these materials are found in the body of the chapter. When toxic metals are present, refer to Table 10 in metals chapter.

AFRICAN WONDERSTONE (pyrophyllite, aluminum silicate) hazards are unstudied.

AGATE (chalcedony, flint, silica) see hazards of silica, pages 155-156.

ALABASTER (Calcium Sulfate) may cause eye and respiratory irritation. One of the least toxic stones. A nuisance dust.*

ALUMINUM OXIDE (see corundum).

AMBER (an organic fossil resin) no significant hazards.

AMETHYST (quartz) see silica, see pages 155-156.

AZURITE (see malachite).

CALCITE (calcium carbonate, chalk) A nuisance dust.*

CARBORUNDUM (silicon carbide) inhalation of large amounts may cause a type of pneumoconiosis. A nuisance dust.*

CERIUM OXIDE no significant hazards in dust form (fume can cause cerpneumoconiosis).

CHALCEDONY (see agate)

CORNWALL STONE a rock (feldspathoid) which contains feldspar (see page 155), quartz, kaolinite (see kaolin, page 155), mica, and a small amount of fluorspar.

CORUNDUM (aluminum oxide) inhalation of large amounts is associated with a type of lung scarring called "Shaver's disease." A nuisance dust.*

CRYOLITE natural or synthetic sodium aluminum fluoride. Used also as a pesticide. Highly toxic due to the fluorine present. A skin, eye, and lung irritant. Chronic inhalation can cause loss of appetite and weight, anemia, and bone and tooth defects.

DIABASE an igneous rock which contains various minerals. The term refers to different rocks in different countries. May contain feldspars and other minerals which are contaminated with silica.

DIAMOND (carbon) no significant hazards.

DOLOMITE (calcium magnesium carbonate) may contain some free silica.

ERIONITE a fibrous mineral unrelated to asbestos which has clearly been shown to cause the same diseases as asbestos in humans.

FLINT (quartz) see silica, pages 155-156.

FLUORSPAR (fluorite, calcium fluoride) is a skin, eye, and lung irritant. Highly toxic due to the fluorine present. See also cryolite.

GARNET (any of five different silicate minerals) may contain free silica. See silica, pages 155-156.

GLASS BEADS (various types of glass) do not cause silicosis. The dust is mechanically irritating to eyes and respiratory tract. If the glass contains toxic metals such as lead, poisoning can result from exposure to the dust.

GRANITE an igneous rock composed chiefly of feldspar and quartz with one more minerals such as mica included. Contains free silica.

GREENLAND SPAR see cryolite.

GREENSTONE a basaltic rock having green color from presence of chlorite,

epidote, or other minerals. May contain free silica. Some stones sold as greenstone may contain asbestos minerals.

GYPSUM see alabaster.

ILMENITE a titanium-containing iron ore (see titanium and iron in Table 10, page 135).

JADE Two common mineral forms of jade are: jadeite which has no significant hazards; and nephrite which is felted, intergrown, fiber-like crystals of tremolite and actinolite (forms of asbestos, see pp. 154-155). The term "jade" also may be incorrectly applied to Serpentine (see below) and certain forms of quartz (see p. 155-156).

JASPER (a black crystalline variety of quartz) see silica, pages 155-156.

LAPIS LAZULI is usually mixture of minerals with the principle mineral being lazurite which contains aluminum, silicon, sodium and sulfur. May cause skin and respiratory irritation. On ingestion, the sulfur in the mineral may be capable of forming highly toxic hydrogen sulfide gas with digestive acids.

LEPIDOLITE a lithium-containing mica. See mica, below, and lithium in Table 10, page 141.

LIMESTONE (calcium carbonate) may contain significant amounts of free silica.

MAGNESITE (magnesium carbonate) No significant hazards.

MALACHITE (hydrous copper carbonate, azurite) can irritate the eyes, nose, and throat. Known to cause nasal congestion and in severe exposure can cause ulceration and perforation of the nasal septum. Chronic exposure can cause anemia.

MARBLE (calcium carbonate) may contain some free silica. A nuisance dust if silica is not present.

MICA any of several silicates of varying chemical composition having a similar crystalline structure composed of thin sheets. Some natural micas contain free silica. Synthetic mica is also available.

NEPHELINE SYENITE a mixture of feldspars, free silica and other minerals.

OCHRES are clays containing iron oxides and occasionally manganese oxides. See kaolin, page 157, and iron and manganese in Table 10.

ONYX is a variety of quartz. See silica, pages 155-156.

OPAL (silica) is an amorphous silica which should be of low toxicity to the lungs, but large amounts may cause some lung scarring.

OPAX a frit of 92% zirconium dioxide, 6% lithium dioxide, and smaller amounts of titanium, iron, sodium, and aluminum. See zircon and lithium in Table 10, pages 141.

PEARL ASH see potash.

PERLITE a natural glass-like material which expands when heated. May contain significant amounts of free silica.

PETALITE a lithium feldspar. See feldspar, page 157, and lithium in Table 10.

PORPHYRY (conglomerate rock containing some feldspar) may contain significant amounts of free silica.

POTASH (potassium carbonate) is irritating and slightly caustic. A nuisance dust.*

PUMICE (a form of volcanic glass) may contain small amounts of free silica.

PUTTY (tin oxide) no significant hazards, inhalation of large amounts can cause benign pneumoconiosis (see page 154).

REALGAR (arsenic disulfide) is a highly toxic mineral causing skin irritation and ulceration. Inhalation can cause respiratory irritation, digestive disturbances, liver damage, peripheral nervous system damage, kidney, and blood damage.

SAND, SANDSTONE (quartz) see silica, pages 155-156.

SERPENTINE (magnesium silicate) usually is in the form of chrysotile asbestos. See asbestos, pages 154-155.

SILICON CARBIDE see carborundum, above.

SLAG (glass-like material from smelting operations) may contain small but significant amounts of highly toxic metal impurities. May be contaminated with free silica.

SLATE (a rock formed from compression of clay, shale, etc.) may contain significant amounts of free silica.

SOAPSTONE see talc.

SODA ASH (sodium carbonate) slightly irritating. No significant hazards.

SODA SPAR are sodium-containing feldspars; see feldspars, page 157.

SODIUM SILICATE or water glass is sodium silicate. Some products contain free silica.

STEATITE see talc.

TALC a magnesium silicate platy mineral responsible for the slippery feel of soapstone and steatites. Talc causes a disease called "talcosis" when inhaled in large amounts. Many talcs, soapstones, and steatites are contaminated with many other minerals including amphibole asbestos and silica.

TRIPOLI (silica) is primarily an amorphous silica which should be of low toxicity to the lungs, but most varieties contain enough quartz to cause silicosis.

TRAVERTINE (calcium carbonate, a form of limestone, see limestone above)

TURQUOISE (mineral of copper aluminum and phosphate) may cause skin allergies and irritation of the eyes, nose and throat. May be contaminated with significant amounts of free silica.

VERMICULITE a plate-like, hydrated magnesium-iron-aluminum silicate mineral capable of being expanded (puffed up) with heat. Often found contaminated with tremolite or chrysotile asbestos.

WHITING (calcium carbonate). Some natural sources contain free silica. When silica is not present, it is a nuisance dust.*

WOLLASTONITE a fibrous mineral unrelated to asbestos which may have some potential to cause cancer. Not well studied.

ZIRCON OXIDES or zirconia, see zircon in Table 10, page 148.

ZIRCONIUM SILICATE or zircon, see zircon in Table 10, page 148.

ZONOLITE see vermiculite.

*nuisance dust = 10 mg/m³, see page 132.

CHAPTER

13 | *PLASTICS*

P lastics have revolutionized art. Artists now use plastics as vehicles in paints and inks, as casting materials, adhesives, structural elements, textiles, and much more.

WHAT IS PLASTIC?

A plastic or "polymer" is created when a chemical called a "monomer" reacts with itself to form large molecules, often in long chains. This reaction is called polymerization. For example, when a monomer called methyl methacrylate is polymerized, it becomes *poly*methyl methacrylate, better known as Lucite or Plexiglas. Natural polymers such as rubber and hardened linseed oil also are created this way.

Some polymers are capable of a second reaction in which the long chains are linked together laterally (side by side). This reaction is called crosslinking. For example, liquid polyester resin becomes a solid material when it is reacted with a crosslinking agent like styrene.

These long-chain and crosslinked polymers possess different properties when exposed to heat. Heat usually will deform or mold long-chain polymers into new shapes, so they are called thermoplastics. On the other hand, heat will not deform crosslinked polymers, and these are called thermoset plastics.

Chemicals which can cause monomers and resins to react have many trade names including activators, actuators, catalysts, curing agents, hardeners, or initiators. In this book the term "initiator" will be used in most cases.

GENERAL RULES FOR USING PLASTIC RESIN SYSTEMS

1. *Use the least toxic products.* Most monomers, initiators, and crosslinkers are very toxic. Obtain Material Safety Data Sheets (MSDS) on all plastic products and compare hazard information.

Reject plastics containing chemicals which are unduly toxic. For example, one chemical found in some polyurethane foam products, epoxy hardeners, foundry core binders, and other plastics, called methylenedianiline, is so toxic that the United States Occupational Safety and Health Administration (OSHA) set a permissible exposure limit for it at 10 parts per *billion.* Replace products containing such chemicals with safer ones.

2. *Prepare precautions in advance.* Investigate the hazards of plastic resin systems before using them. Read Material Safety Data Sheet and product literature precautions and be sure your shop is equipped with necessary protective equipment and ventilation. Be prepared to deal with spills and disposal of the materials.

3. *Follow product directions precisely.* If directions are followed, the polymerization reaction should bind the hazardous chemicals into the solid plastic. Handling, machining and tooling well-made solid plastic is usually not very hazardous. Exceptions are when the reaction is not complete because mixing was not uniform, the proportions were not correct, or some other factor. In these cases, unused monomer or other chemicals may be left to off-gas or render the plastic's dust toxic.

POLYESTER RESIN CASTING SYSTEMS

Hazardous chemicals used in these systems include: the crosslinking agent which is usually styrene; ketone solvents such as acetone used to dilute the resin, or for cleanup; the initiator, which is an organic peroxide such as methyl ethyl ketone peroxide; and fiberglass used for reinforcement.

Styrene is a highly toxic aromatic hydrocarbon solvent which can cause narcosis, respiratory system irritation, liver and nerve damage, and is a

suspect carcinogen. Acetone is a less toxic solvent, but is extremely flammable. (See Table 5, Common Solvents and Their Hazards, page 89.)

Methyl ethyl ketone peroxide has caused blindness when splashed in the eyes, can form an explosive mixture with acetone, and converts to a shock-sensitive explosive material after a time. (See Organic Peroxides below for more complete discussion of hazards.)

Fiberglass dust can cause skin and respiratory irritation. There are many other compounds in polyester resin systems which initiate, promote, or accelerate the reaction. The hazards of many of these chemicals are not well-studied.

PRECAUTIONS FOR USING POLYESTER RESINS

1. Work only in local exhaust areas. Additional protection may be obtained by wearing a respirator with cartridges for organic vapors. Add a dust filter to the respirator if you use fiberglass or if you sand the finished plastic.

2. Wear gloves and chemical splash goggles when handling and pouring materials. Protection from some plastic resin chemicals requires special types of gloves. Ask the glove manufacturer for advice.

3. Wear clothing that covers your arms and legs. Remove clothes immediately if they are splashed with resins or peroxides. Always remove clothing completely after work, then take a shower.

4. Cover exposed areas of your neck and face with a barrier cream as protection in case of splashes.

5. Handle peroxides correctly by following the advice in the section on Organic Peroxides. Be especially careful to avoid splashes in the eyes, and never mix peroxides with acetone.

6. Use acetone, not styrene, for clean up. Cover your work area with disposable paper or plastic sheeting to make cleaning easier.

7. Follow all precautions for using solvents, such as cleaning up spills immediately, disposing of rags in approved, self-closing waste cans, and the like (see Chapter 9, Solvents, page 87-89).

8. When mixing small amounts of resins, use disposable containers and

agitators such as paper cups and wooden sticks. If you need reusable containers, use polyethylene or stainless steel containers.

PLASTIC MOLD MAKING MATERIALS

SILICONE. Two types of silicone resin systems commonly are used to make molds. The first is a single-component system which cures by absorbing atmospheric moisture. The second is a two-component system which cures by means of a peroxide (see section on Organic Peroxides). Both systems contain solvents such as acetone or methylene chloride.

Single-component systems may release acetic acid or methanol into the air. Acetic acid vapors are highly irritating to the eyes and respiratory tract. Methanol is a nervous system poison (see Table 5, Common Solvents and Their Hazards, page 89). Two-component systems often contain chemicals which can damage the skin. Some also contain methylene chloride which can cause narcosis and stress the heart (see Table 5, Common Solvents and Their Hazards, page 89).

RUBBER. Rubber can be considered to be a plastic-like material manufactured by nature. It contains natural proteins to which some people are so exquisitely sensitive that use of rubber latex enema tips and latex examination gloves have caused anaphylactic shock. Some have died.

Water-based rubber latex systems are commonly used to make molds. Some contain chemicals which can irritate the skin. Solvent-containing rubber products are also marketed including rubber cement. The solvent most commonly used in rubber cement, n-hexane, is a potent neurotoxin (see Table 5, Common Solvents and Their Hazards). When possible, rubber cements containing heptane should be used as substitutes.

PRECAUTIONS FOR USING SILICONE AND NATURAL RUBBER

1. Use with sufficient ventilation to remove acetic acid, solvents, and other vapors.

2. Wear protective gloves. Consult the manufacturer of the resin or latex about the proper gloves to use.

3. If any components are liquid, wear goggles when pouring or handling them.

4. Follow all solvent precautions when using products containing solvents.

5. Discontinue using rubber if rashes, breathing difficulties or other allergic symptoms develop with use.

EPOXY RESIN SYSTEMS

Epoxies are used for paint and ink vehicles, casting, laminating, and molding. They also are common adhesives and putties. Most are two-component systems. After they are mixed, the resulting epoxy gives off heat which vaporizes any solvents in it. An excess of hardener can cause the epoxy to heat to the point of decomposition and ignition.

Epoxy resins can irritate the skin. They also may contain varying amounts of solvents. Common solvents in epoxy include the glycidyl ethers which have caused reproductive and blood diseases in animals including atrophy of testicles, damage to bone marrow, and birth defects.

Epoxy hardeners are toxic and highly sensitizing to the skin and respiratory system. Almost 50 percent of industrial workers regularly exposed to epoxy develop allergies to them.

PRECAUTIONS FOR USING EPOXY RESINS

1. Wear goggles and gloves when using large amounts of epoxy. Do not mold epoxy putties by hand without wearing gloves; barrier creams do not provide sufficient protection.

2. Use large amounts of epoxy, either with local exhaust (such as a spray booth) or in front of a window exhaust fan.

3. Use liquid epoxies (those containing special solvents) in local exhaust and take special precautions to avoid skin contact. Check with glove suppliers to find which glove material will resist penetration of the particular solvent.

URETHANE RESINS

Polyurethane resin systems (do not confuse these with single-component polyurethane varnishes and paints which are safer) usually consist of a polyol polymer resin (which might also contain metal salts or amine initiators) and isocyanate crosslinkers. Foam casting systems also contain blowing agents such as freon.

Many artists, especially theatrical scene and prop makers, have used foam polyurethane casting systems. However, artists should avoid these systems for several reasons.

First, the isocyanate crosslinkers (which are related to the chemical which caused 2,000 deaths in Bhopal, India) are so irritating and sensitizing that they can cause acute asthma-like respiratory distress and other symptoms at very low levels. For this reason, the Threshold Limit Values (see pages 32-33 for definitions of Threshold Limit Values) for the crosslinkers are so low that most studios and shops cannot manage to achieve them. (For example, the Threshold Limit Value for one common isocyanate—toluene diisocyanate—is 0.005 ppm.)

Second, expensive air-supplied respirators must be used with isocyanates because there are no air-purifying respirators which provide proper protection.

Lastly, the final plastic product is still hazardous. When heated or burned can give off hydrogen cyanide, carbon monoxide, acrolein, and other toxic gases. Even cutting, sanding, and finishing the final product has been associated with skin and respiratory problems.

PRECAUTIONS FOR USING URETHANE RESINS

1. Do not allow anyone who has a history of allergies, heart problems, or respiratory difficulties to be exposed to urethane resins.

2. Use them in a local exhaust system large enough to enclose the entire project. If you also need respiratory protection, use an *air-supplied* respirator with full face mask.

3. Wear protective clothing and gloves during foaming and casting.

4. Use ventilation when sanding and cutting finished plastic, and wear protective clothing and gloves. Wear a dust mask and goggles if static electricity causes dust to cling to face and eyes.

OTHER RESIN SYSTEMS

There are a number of other resin systems but they are not used often in art. However, systems employing methyl methacrylate (MMA) alone or in combination with other monomers are used occasionally. Some of these systems need special precautions because they involve elevated pressures and/or temperatures.

Investigate the hazards of plastic resin systems before using them. Obtain Material Safety Data Sheets and other product information and be sure your shop is equipped with necessary protective equipment, spill control, and ventilation.

ORGANIC PEROXIDES

Organic peroxides (do not confuse these with hydrogen peroxide which is not as hazardous) are used to initiate many polyester, acrylic, and even some silicone polymerizations.

HAZARDS OF ORGANIC PEROXIDES. In general, organic peroxides burn vigorously and are both reactive and unstable. When heated, some are shock-sensitive and can explode. Some can burn without air because they release their own oxygen. This makes it dangerous to mix them with flammable or combustible materials. For example, if peroxides ignite after being spilled on clothing, the fire cannot be extinguished and must burn until spent.

Because of organic peroxides' fire and explosion hazard, they usually are sold mixed with inhibitors. Even so, these mixtures have been known to burn quietly until all the inhibitor is burned off; then the fire intensifies.

The toxic hazards of organic peroxides are largely unknown. In general, their vapors may cause eye and respiratory irritation, and many are sensitizers.

Organic peroxides react with oxygen in the air to form shock sensitive, explosive chemicals. Control peroxide inventories to dispose of old materials regularly.

PRECAUTIONS FOR USING PEROXIDES

1. Obtain Material Safety Data Sheets and product information on peroxides. Pay special attention to information about reactivity, fire hazards, and spill procedures.

2. Keep date of purchase and date of opening on the container label. Dispose of peroxides after six months if unopened or after three months once opened. Never purchase peroxides if containers are damaged or irregular.

3. Store peroxides separately from each other and from other combustibles. Always keep peroxides in their original containers.

4. Do not store large amounts of peroxides without consulting fire laws and OSHA standards.

5. Do not heat peroxides or store them in warm areas or sunlight.

6. Never dilute peroxides with other materials or add them to accelerators or solvents.

7. Wear protective goggles when containers are open or when pouring peroxides.

8. When mixing small amounts of resins and peroxides, use disposable containers. Soak all tools and containers in water before disposing of them.

9. Clean up spills immediately in accordance with Material Safety Data Sheet directions. Inert materials such as unmilled fire clay usually are recommended to soak them up. Clean up peroxide-soaked material with nonsparking, nonmetallic tools; do not sweep them because fires have started from the friction of sweeping itself.

10. If peroxide spills on your clothing, remove your clothes immediately and launder them separately and well before wearing them again.

11. When discarding unused peroxide or fire clay/peroxide mixtures, first react them with a 10 percent sodium hydroxide solution to prevent fires. Otherwise, unused peroxide can be reacted with resin and the solid plastic discarded safely.

FINISHED PLASTICS

Rather than working with resin systems, it is easier and safer to work with sheets, films, beads, or blocks of finished plastic. Even so, when these plastics are cut or heated, hazardous dust and decomposition products can be released. Processes during which this can occur include sawing, sanding, hot knife or wire cutting, press molding, drilling, grinding, heat shrinking, vacuum forming, plastic burnout casting, torching, and melting.

The dusts from some plastics are sensitizing. And all plastics produce hazardous gases and vapors when heated or burned. Among the most hazardous to heat are polyvinyl chloride (which releases cancer-causing

vinyl chloride and hydrochloric acid gas) and all nitrogen-containing plastics such as polyurethane, melamine resins, urea formaldehyde, and nylon (which release hydrogen cyanide gas). In general, the toxicity and amount of gas and smoke produced when plastics are heated increases with temperature.

The toxicity of gases, smoke, and cutting dusts are not dependent on the type of plastic alone, but on the many additives in the plastic such as plasticizers, stabilizers, colorants, fillers, fire retardants, inhibitors, accelerators, and more. The hazards of most of these additives are often unknown, but the most important probably are the plasticizers which keep plastics from being brittle.

PLASTICIZERS. Two common groups of plasticizers are the organic phosphates and the phthalates. Organic phosphates are skin absorbers, highly toxic, irritating, and they release toxic phosphorus oxides when heated to decomposition. The phthalate plasticizers seem to vary greatly in toxicity. One of the least toxic is DOP (dioctyl phthalate). Another called DEHP (diethylhexyl phthalate) is a probable human carcinogen. The hazards of many of the other plasticizers have not been well-studied.

ADHESIVES for finished plastics are usually solvents such as acetone or chlorinated hydrocarbons such as methylene chloride (see Table 5, Common Solvents and Their Hazards, page 89).

PRECAUTIONS FOR WORKING WITH FINISHED PLASTICS

1. Use good dilution ventilation or local exhaust ventilation. Use water-cooled or air-cooled tools, if possible, to keep decomposition to a minimum. When heat forming plastics, use the lowest possible temperature.

2. Add vacuum attachments to sanders, saws, and other electric tools to collect dust.

3. Wear dust goggles and a dust mask if static electricity causes particles to cling to face and eyes. Remember that the dust mask provides protection only against particles. No mask will protect you from all the emissions from plastics. Organic vapor respirators will trap some decomposition gases and vapors. Acid gas cartridge respirators will collect hydrochloric acid gas from decomposing polyvinyl chloride plastics. However, there are no approved cartridges or filters for emissions such as hydrogen cyanide, isocyanates, and nitrogen oxides.

4. Clean up all dust carefully by wet mopping or specially filtered vacuums. Do not sweep.

5. Use precautions for solvents (page 87) when using plastics adhesives.

GLUES AND ADHESIVES

Most glues and adhesives are either synthetic or natural polymers. Most are less hazardous than casting plastics simply because smaller amounts are used. Some common ones are in Table 14.

TABLE 14	Hazards of Common Adhesives

AIRPLANE GLUE: plastic dissolved in solvent, usually acetone. No hazards except solvents.

CYANOACRYLATE, "SUPER GLUE," "KRAZY GLUE:" plastic monomer which cures on exposure to air. Potent eye irritant. Fast curing-time can cause unplanned adhesion of body parts.

"ELMER'S," WHITE GLUE, PVA: polyvinylacetate and/or polyvinyl alcohol emulsion. May contains small amounts of vinyl acetate and acetaldehyde which are suspect carcinogens. Some responsible art materials manufacturers do not recommend white glue for young children.

EPOXIES: see above.

GLUE STICKS: plastic and/or mucilage materials. No known significant hazards.

HOT GLUE GUNS: give off small amounts of additives assumed to be primarily plasticizers (see page 173).

RUBBER CEMENT: rubber dissolved in solvents, often n-hexane. N-hexane is highly toxic (see Solvents). Many people are allergic to rubber latex.

SILICONE ADHESIVES: see page 168.

UREA FORMALDEHYDE and PHENOL FORMALDEHYDE: Resin dissolved in solvents or water-based materials. Also a plywood and pressboard adhesive. These off-gas formaldehyde. Avoid if possible.

WALLPAPER PASTE: usually wheat or methyl cellulose and preservatives. May contain large amounts of pesticides and fungicides. Use wheat or methyl cellulose paste made for children. These have no significant hazards.

WHITE PASTE, LIBRARY PASTE: no significant hazards.

Section
III

Precautions for Individual Media

<div style="border:1px solid">

CHAPTER

14
</div>

PAINTING AND DRAWING

T he diseases caused by painting and pigment grinding have been observed since Ramazini wrote about them in 1713. Back then, painters did not know about the chemical hazards in their paints as we do now.

WHAT ARE PAINTS?

Today artists use a vast array of different paints; however, these products have many properties in common because almost all of them contain pigments suspended in vehicles or bases.

Vehicles usually contain a liquid such as an oil, a solvent, or water. Cleaners and thinners for most paints are these same liquids or liquids which are compatible with them. For example, turpentine will thin and clean up oil paints.

WHAT ARE DRAWING MATERIALS?

Drawing materials also are pigments suspended in vehicles. Some drawing material vehicles include wax (crayons), inert minerals (pastels, conte crayons, chalks), and liquids (solvent and water-based inks and marking pens). Pencils contain "leads" made of graphite and clay ("lead" pencils) or pigmented clay/binder mixtures (colored pencils).

The hazards of both painting and drawing materials arise from exposure to their pigments, vehicles, and solvents.

PIGMENT HAZARDS

Artist's paints and auto, boat, metal priming, and sign paints are exempt from consumer paint lead laws. Lead and other toxic metal-containing pigments are common in oils, acrylics, alkyds, pastels, colored pencils, and all colored materials used in art products (see Pigments and Dyes, page 99-103).

There are only a few hundred pigments which are "light-fast" (resist fading) enough to be used for fine art. Paints with fugitive pigments (those which fade more rapidly with time or exposure to light than the standard alizarin crimson) can be used for work which is not expected to endure for many years, such as theatrical scenery or props, commercial art, or children's art work. Artists who use untraditional paints such as consumer wall paints also will find that the color in these paints fade. Fugitive pigments often are complex organic chemicals whose long-term hazards are not well-studied.

Inhalation is the route by which exposure is most likely. Processes during which pigments could be inhaled include: working with raw powdered pigments; using dusty chalks or pastels; sanding or chipping paints; airbrushing or spraying paints; and heating or torching paints until pigments fume.

Skin contact with pigments is less hazardous. Pigments usually are not absorbed in significant amounts by skin contact. However, some contaminants in pigments such as PCB's (polychlorinated biphenyls) could be skin absorbed. And some pigments can cause dermatitis or skin irritation. Preventing skin contact through good hygiene can prevent these problems. Good hygiene also can prevent accidental ingestion of paint pigments.

VEHICLE HAZARDS

Common vehicles include oils, wax, water, egg yolk, casein, resins, and polymer emulsions and solvent solutions. Vehicles usually also contain additives such as stabilizers (to keep ingredients in suspension), preservatives, plasticizers, antioxidants, fillers, wetting agents, retarders, and more. These additives affect paint characteristics such as drying time and workability. The hazards of many of these additives have not been well researched. And manufacturers often are reluctant to divulge the identity of these additives.

Vehicle preservatives can be especially hazardous since their purpose is to kill microorganisms. Common paint preservatives include formaldehyde (sometimes in the form of paraformaldehyde or formalin), phenol, mercury compounds, bleach, and a host of commercial fungicides and pesticides.

Even though these additives are present in small amounts, they have caused illness in artists. For example, a mural artist developed mercury poisoning some years ago from soluble mercury preservatives used in her paints.

Vehicle ingredients can be divided into volatile (will evaporate into the air) and nonvolatile components. Since nonvolatile ingredients do not become airborne, they usually present no significant hazard to artists unless they are used in techniques that make them available to be inhaled, such as spray painting. Some resins and vehicle solids are associated with allergies.

Volatile vehicle ingredients, on the other hand, can be inhaled by artists while they work or while paints or inks are drying. Acrylic paints, for example, usually contain ingredients which release ammonia and formaldehyde gases while they dry. Permanent markers contain solvents which evaporate and can be inhaled.

SOLVENT HAZARDS

Solvents may be found in paints and inks or may be used to thin and clean up materials. Solvents are also found in products used with painting and drawing such as varnishes, shellacs, lacquers, and fixatives. These products include resins such as damar, mastic, copal, lac, shellac, acrylic, and other plastic resins dissolved in solvents. (Some of these resins have been known to cause allergies.)

Solvents commonly used in paints, thinners, varnishes, etc., include turpentine, paint thinner, mineral spirits, methyl alcohol, ethyl alcohol, acetone, toluene, xylene, ethyl and other acetates, and petroleum distillates. The hazards of these and other solvents are discussed in Chapter 9, Solvents, page 83.

GENERAL PRECAUTIONS FOR PAINTING AND DRAWING MEDIA

The hazards of each type of painting or drawing will depend on the toxicity of the ingredients of the materials and how much exposure occurs

during use. The most hazardous exposure to paints will occur if they are air-brushed, sprayed, or otherwise made airborne. These processes always require local exhaust ventilation.

When paint and ink are applied by brushing, rolling, dipping and other methods which do not cause pigments and vehicles to become airborne, precautions will vary depending on the hazards of each paint or ink. See Tables 15 for precautions for specific media.

TABLE 15	Ventilation and Precautions for Painting and Drawing Media

The following hazards and precautions apply only to paint and ink techniques such as brushing, rolling, and dipping which to not cause pigments and vehicles to become airborne:

ACRYLIC PAINTS (WATER-BASED EMULSIONS) are composed of synthetic acrylic resins and pigments with many additives usually including an ammonia-containing stabilizer and formaldehyde preservative. The small amounts of ammonia and formaldehyde released during drying can cause respiratory irritation and allergies. Formaldehyde has caused cancer in animals. A low rate of dilution ventilation such as that provided by a window exhaust fan should be sufficient.

ACRYLIC PAINTS (SOLVENT-BASED) are synthetic acrylic resins and pigments dissolved in solvents. The solvents should be identified and ventilation sufficient to keep the solvent's concentration at a safe level should be provided.

ALKYD PAINTS are alkyd resins and pigments dissolved in solvents. Provide dilution ventilation at a rate sufficient to keep solvent's concentrations at safe levels.

ARTIST'S OILS are pigments mulled into waxes and oils such as a pre-polymerized linseed oil. Most contain no volatile ingredients. A few contain small amounts. OIL STICKS are similar except that they are less viscous and never contain solvents. Oils are commonly thinned and cleaned up with solvents. Dilution ventilation sufficient to control solvent exposure should be provided. Some people use oil paints and sticks without solvents and clean bushes and skin with baby oil followed by soap and water. This is a very safe way to work and requires no special ventilation.

CASEINS are made from dried milk, pigments, and preservatives. Some con-

tain ammonium hydroxide which can be irritating to the skin and eyes and dust from the powdered paint should not be inhaled. There are usually very strong preservatives added because the casein is a good source of food for microorganisms. When painting with brushes or rollers, ordinary comfort ventilation should be sufficient.

CHARCOAL has no known significant hazards.

CONSUMER OIL PAINTS AND ENAMELS contain pigments, fillers, and a variety of solvents. A common solvent for these paints is paint thinner. Sufficient dilution ventilation should be provided.

CONSUMER LATEX PAINTS are primarily pigments and water emulsions of various plastic resins. Most also contain between 5 and 15 percent solvents. On occasion, these solvents are the highly toxic glycol ethers (see Table 5, Common Solvents and Their Hazards, page 89) which can be skin-absorbed and inhaled. Dilution ventilation and proper gloves should be provided. Men and women planning families and pregnant women should avoid exposure to paints containing the glycol ethers.

CRAYONS are pigments in wax. Most have no significant hazards because the pigments are contained. Techniques which involve melting crayons may produce irritating wax decomposition products which would require exhaust ventilation.

DRAWING INKS may contain hazardous dyes and solvents. Skin contact should be avoided. Ventilation is needed only if extraordinary amounts are used or if the solvents are especially toxic.

ENCAUSTICS are dry pigments suspended in molten white refined wax such as beeswax along with drying oils, Venice turpentine, and natural resins. Working with dry pigments is very hazardous. Heating waxes can release highly irritating wax decomposition products such as acrolein and formaldehyde. Torching the wax surface also can cause pigments to fume. The solvents and wax and pigment fumes require local exhaust ventilation.

EPOXY PAINTS are two part epoxy resin systems and containing highly toxic and sensitizing organic chemicals (see Chapter 13, Plastics, page 165) and diluents (solvents). Some contain highly toxic glycidyl ether solvents. Wear gloves, goggles, and avoid inhalation with local exhaust ventilation or respiratory protection.

FRESCO consists of pigments ground in lime water (calcium hydroxide)

which is corrosive to eyes, skin, and respiratory tract. Gloves and goggles should be worn.

GOUACHE is an opaque water color which contains pigments, gums, water, preservatives, glycerin, opacifiers, and other ingredients. The opacifiers may be chalk, talc, and other substances. Formaldehyde may be used as a preservative. Ordinary comfort ventilation should be sufficient ventilation unless very large amounts are used.

MARKING PENS contain pigments or dyes in a liquid. The liquid may be water or a solvent. Water-based markers are safest. Of the solvent-based markers, those containing ethyl alcohol are the safest. Others may contain very toxic solvents. Solvent-based markers should be used with some ventilation.

PASTELS, CHALKS AND CONTE CRAYONS are pigments in binders and chalk (calcium carbonate), talc, barytes (barium sulfate mineral), or other powdered inert minerals. Oil pastels are much safer because they contain small amounts of oils and waxes which keep dust from getting airborne. "Dustless" chalks and conte crayons also are easy to use safely because they contain binders which prevent creation of respirable-sized dust particles (see page 32). Unfortunately, it is almost impossible to use dusty pastels and chalks without being exposed to pigment and vehicle dust. A dust mask and ventilation (such as working very near a window exhaust fan) may reduce exposure.

PENCIL AND GRAPHITE drawing usually exposes artists to such small amounts of dust that they are not hazardous. Very large amounts of graphite can cause black lung disease similar to that which afflicts coal miners.

TEMPERA PAINTS are pigments suspended in emulsions of substances such as oils, egg, gum casein, and wax. Preservatives are added to kill microorganisms which would feed on the vehicles. If no solvents are used in these paints, ordinary comfort ventilation should be sufficient for working with liquid paints.

WATERCOLORS (dry cakes) are composed of pigments, preservatives (often paraformaldehyde) and binders such as gum arabic or gum tragacanth. Liquid watercolors may also contain water, glycerine, glucose, and other materials. Both liquid and dry watercolors may give off small amounts of formaldehyde, but they generally need no exhaust ventilation.

RULES FOR PAINTING AND DRAWING

1. Choose studio locations with safety in mind. Floors, tables, and shelving should be made of materials which can be easily cleaned. Isolate the studio from living spaces unless you intend to use materials with no significant hazards such as watercolors and pencils. Never use toxic paints, solvents, or drawing materials in kitchens, bedrooms, living rooms, etc.

2. Obtain Material Safety Data Sheets (MSDSs) on all paints, inks, thinners, varnishes, and other products. If paint pigments are not identified by their Color Index names or numbers, ask your supplier for this information. Some suppliers' catalogs list the Color Index names of their paint pigments. These suppliers should be favored over less informative ones.

3. Use water-based products over solvent-containing ones whenever possible.

4. Buy premixed paints and avoid working with powdered pigments if possible. Pigments and paints are most hazardous and inhalable in a dry powdered state.

5. Choose brushing and dipping techniques over spray methods whenever possible.

6. Use Material Safety Data Sheets and product labels to identify the hazards of any toxic solvents, preservatives or other chemicals in paints and drawing materials. Look up the hazards of the pigments in Table 6.

7. Plan studio ventilation to control the hazards of the materials and processes you use. For example, if solvents are used, provide sufficient dilution ventilation to keep vapors below their Threshold Limit Values (see pages 32-33). If powdered paints or pigments are used, plan local exhaust ventilation (e.g., figure 6) or use a glove box (figure 14).

8. Avoid dusty procedures. Sanding dry paints, sprinkling dry pigments or dyes on wet paint or glue, and other techniques which raise dust should be discontinued or performed in a local exhaust environment or outdoors.

9. Spray or airbrush only under local exhaust conditions such as in a spray booth. A proper respirator may provide additional protection. Use a dust/mist respirator for water-based paints. Use a paint, lacquer, and enamel

mist (PLE) respirator for solvent-containing products.

10. Follow all solvent safety rules if you use solvent-containing products (see pages 87-89), and give extra attention to studio fire safety.

11. Avoid skin contact with paints and pigments by wearing gloves or using barrier creams. Use gloves with dyes. Wash off paint splashes with safe cleaners like a) baby oil followed by soap and water, b) nonirritating waterless hand cleaners, or c) plain soap and water. Never use solvents or bleaches to remove splashes from your skin.

12. Wear protective clothing, including a full-length smock or coveralls. Leave these garments in your studio to avoid bringing dusts home. Wash clothing frequently and separately from other clothing. Wear goggles if you use caustic paints or corrosive chemicals.

13. If respirators must be used, follow all rules regarding their use (see Chapter 8, Respiratory Protection, pages 71-79).

14. Avoid ingestion of materials; eat, smoke, or drink outside your workplace. Never point brushes with your lips or hold brush handles in your teeth. Wash your hands before eating, smoking, applying make-up and other personal hygiene procedures.

15. Keep containers of paint, powdered pigments, solvents, etc., closed except when you are using them.

16. Work on easy-to-clean surfaces and wipe up spills immediately. Wet mop and sponge floors and surfaces. Do not sweep.

17. Follow Material Safety Data Sheet advice and purchase a supply of materials to control spills and for chemical disposal (e.g., kitty litter, solvent spill kits).

18. Dispose of waste solvents, paints, and other materials in accordance with health, safety, and environmental protection regulations.

19. Always be prepared to provide your doctor with precise information about the chemicals you use and your work practices. Arrange for regular blood tests for lead if you use lead-containing paints or pigments.

SPECIAL PRECAUTIONS FOR PAINT REMOVING

Occasionally artists must remove paints from objects or walls. Paint removers are either highly toxic solvent mixtures or strong caustic removers. Gloves, goggles, protective clothing, and ventilation are needed. Some new methods may be less hazardous. One involves applying a caustic material, covering the material with a special cloth, and later removing the cloth and adhered paint as one flexible sheet.

Other methods of removing paint include chipping, sanding, or heating with torches or heat guns. These methods are all hazardous, especially if the paint being removed contains toxic pigments such as lead.

Dust from chipping and sanding is toxic to inhale or ingest. Torching or heat-gunning paint creates toxic paint decomposition products. Torching and heat-gunning lead paint produces a fine lead fume which has caused lead poisoning in many workers, home owners, and their children. And once lead fume is in a home, it is hard to remove and can cause health effects for years.

For these reasons, lead wall paint removal now is regulated under an OSHA standard, and in some states, only certified lead abatement contractors can do the job. The precautions used include isolating the area with taped walls of plastic sheeting and installing a specially filtered exhaust fan to draw air out of the isolated area to keep contaminated air from leaking into unisolated areas. Particular types of respiratory protection, protective clothing, and hygiene procedures are mandated for each removal method. The lead paint refuse also must be disposed of as hazardous waste.

CHAPTER 15

PRINTMAKING

All printmaking techniques rely on the use of inks of various types. There are four basic printmaking techniques: screen printing, lithography, intaglio, and relief:

SCREEN PRINTING uses a fine-meshed framed screen on which areas have been stenciled or blocked with a resist. Ink is then drawn (squeegeed) across and through the screen to the paper or other material which is being printed.

LITHOGRAPHY involves acid-etching smooth limestone surfaces on which areas have been blocked with wax pencils or crayons. Oil-based ink is rollered onto the damp stone. It adheres to the waxy areas and is repelled by the wet stone. The print is then made by running the stone through the lithographic press.

INTAGLIO is done by engraving or etching an image onto a metal plate. Ink is then forced into the grooves and depressions, the unetched areas are wiped clean, and the plate and a sheet of dampened paper are run through an etching press.

RELIEF is done by carving away parts of a materials such as wood (see Chapter 28, Woodworking, page 285) or linoleum with knives and gouges. The remaining raised surface is inked and pressed onto paper.

WHAT ARE PRINTMAKING INKS?

Traditionally, printmaking inks are oil-based or water-based materials which dry or set by evaporation, by polymerization, or by penetrating the material on which they were printed. In recent years new inks have come into use which cure with heat, infrared, or ultraviolet light. In addition special inks have been developed which glow, puff up, or sparkle.

However, both traditional and modern printmaking inks are made up of two basic components: pigments and vehicles.

PIGMENTS

Pigments used in printmaking are essentially the same as those used in painting. Artists are sometimes not aware of this because the printmakers and painters may use different names for the same pigment. For example, bone black which is made from charred animal bones is called "Frankfourt black" by printers and "ivory black" by painters.

Printmakers who make their own inks are at the greatest risk from pigments. The hazards of pigments can be found in Table 6, Pigments Used in Paints and Inks, page 104.

TRADITIONAL VEHICLES

The most common vehicles are mixtures of oils, mixtures of solvents and oils, and polymer emulsions. The oil base of lithography and etching inks are linseed oil and burnt plate oil (boiled linseed oil and driers).

Vehicles also contain additives such as stabilizers (to keep ingredients in suspension), chemical driers, preservatives, plasticizers, antioxidants, antifoaming chemicals, fillers, and more. The hazards of many of these chemicals have not been well researched.

Printmaking vehicles are quite complex because they must have exactly the right physical properties for the particular printmaking technique. The properties that must be controlled include drying time, tack, flow, stiffness, and more. For this reason, printmakers often alter their vehicles by adding oils, solvents, chemical driers, retarders, and the like to change ink performance. Printmakers usually refer to these chemicals as "modifiers."

Ink modifiers include: nontoxic tack reducers and stiffeners such as Crisco, vaseline, cup grease, magnesium carbonate, and aluminum stearate; moderately toxic tack oils such as oil of cloves and oil of lavender;

toxic solvents such as petroleum distillates; and highly toxic lead and manganese driers and aerosol anti-skinning agents.

SOLVENTS

Many solvents are used in printmaking as ink components, modifiers, and for clean-up. Included are kerosene and various petroleum distillates, gum turpentine, isopropyl alcohol, N-methyl pyrrolidone, and acetone (see Table 5, page 89). Cleaners and water-based inks also may contain glycol ether solvents which affect the reproductive system .

Cleaning presses, rollers, plates, screens, and the like can cause hazardous amounts of solvents to become airborne. It is often cheaper and safer to use inexpensive screens and discard them after use. Safer press cleaners include mineral oil and new cleaners made of modified vegetable oils.

RESISTS AND BLOCKOUT STENCILS

Both water-based and solvent-containing materials can be used to resist inks in various printmaking methods. Water-based materials usually have no significant hazards. Included are water-soluble glues, liquid wax (wax emulsions), latex rubber, and water-based friskets.

Solvent-containing resists and block outs include tusche (contains a very small amount of solvent), lacquers, shellac, polyurethane varnishes, and caustic enamels. These products all create toxic solvent vapors during use.

Stencil films may be adhered to screens or plates or removed from them with water-based or solvent-containing adhering fluids and film removers. Solvents commonly found in these materials include acetates, alcohols, and acetone.

Printmaking techniques have expanded in recent years to include photographic processes that can be used to create resists for screen printing or etching. The hazards of many of the chemicals involved in these new inks and photo chemicals are not well known. Some of them will be covered in the chapter on photography.

ACIDS AND CAUSTICS

Acids and other corrosive chemicals are used in intaglio, lithography, and some photo processes. These are very corrosive to the eyes, skin and respiratory system. They are most toxic in their concentrated form.

Hydrochloric acid, nitric acid, and Dutch mordant (potassium chlorate/water/hydrochloric acid) used in etching and lithography can cause skin and eye burns and respiratory system damage. There is no effective air-purifying respirator for nitric acid so local exhaust ventilation must be used. Hydrochloric acid can be replaced with less hazardous ferric chloride solutions in many etching processes. Ferric chloride etching usually requires no special local exhaust ventilation. Good dilution ventilation should suffice.

Phosphoric acid used for cleaning stones is highly corrosive to the skin, eyes, and respiratory tract. Caustic soda (sodium hydroxide) sometimes is used for stone cleaning. It also is highly caustic to skin and eyes.

Phenol (carbolic acid) is highly toxic by both skin absorption and inhalation. Skin contact with concentrated phenol for even several minutes can be fatal. Dilute solutions can cause severe skin burns.

MISCELLANEOUS CHEMICALS

Rosin dust can cause severe allergies. When confined in aquatint boxes, a spark, flame, or static discharge can cause rosin dust to explode (similar to grain elevator explosions).

Some kinds of French chalk (talc) are contaminated with asbestos.

PRECAUTIONS FOR PRINTMAKING

1. Plan the studio with health and safety in mind. Floors, shelving, tables, and other surfaces should be made of materials that can be easily cleaned. Floors should be capable of supporting heavy presses. Isolate studio from eating, recreation, or living areas.

2. Install ventilation which is appropriate for the processes you will do. For example, use window exhaust fans for dilution of small amounts of solvent and kerosene vapors. Install chemical fume hoods or slot hoods for acid baths.

3. Obtain Material Safety Data Sheets (MSDSs) or ingredient information on all products used. If ink pigments are not identified by their Color Index names and numbers or by Chemical Abstracts Service numbers, ask your supplier for this information.

4. Use Material Safety Data Sheets and product labels to identify the hazards of any toxic solvents, acids, or other chemicals in products and choose the least toxic materials.

5. Reduce solvent use. Use water-based inks and other products whenever possible. Use disposable screens for screen printing rather than cleaning them with solvents. Use water-based film adhering fluids or film removers when possible. Clean up with mineral oil or modified vegetable oil products.

6. Follow all solvent safety rules if you use solvent-containing products (see Chapter 9, Solvents page 87-89). Pay special attention to solvent fire safety rules in the studio.

7. If respirators are worn, follow all regulations regarding their use (see Chapter 8, Respiratory Protection, pages 71-79).

8. Protect against acids, caustics, or other irritating chemicals by wearing chemical splash goggles, gloves, aprons, and other protective clothing as needed. Use these chemicals with local exhaust systems. Install an eye wash fountain (and emergency shower if large amounts are used). Have first aid equipment on hand for chemical burns and have emergency procedures posted.

9. Keep containers of inks, pigments, solvents, acids, and other materials closed except when you are using them.

10. Avoid working with powdered materials. Buy premixed inks and other products. If toxic powders must be handled, weighed, or mixed, perform these processes where local exhaust ventilation is available or use a glove box (see figure 14).

11. Avoid dusty procedures. French chalk, wood, or rosin should be used in ways that raise as little dust as possible. If dust cannot be avoided, wear a toxic dust respirator.

12. Use aquatint processes which do not raise dust when possible. One such method uses nonaerosol, pump-sprayed rosin solution. Otherwise, construct rosin boxes with nonsparking parts to avoid dust explosions. Do not use flame or heat sources near the box.

13. Avoid aerosol spray products whenever possible. If they must be used, provide local exhaust conditions such as a spray booth and/or a proper respirator (e.g. a dust/mist respirator for water-based sprays; a paint, lacquer, and enamel mist (PLE) respirator for solvent-containing products).

14. Provide local exhaust such as slot hoods or recessed canopy hoods for heating or burning processes such as heating plate oil, wood burning tools, etc. Have first aid burn treatments handy.

15. Keep all tools sharp and all machinery in good working order. Use presses with stops to keep the beds in place. Provide local exhaust ventilation systems, guards and lockouts for table saws and other machinery. Have first aid equipment for trauma on hand. Post and practice emergency procedures.

16. Avoid ingestion of materials by eating, smoking, or drinking outside the studio. Wash your hands before eating, smoking, applying make-up, or other personal hygiene tasks.

17. Avoid skin contact with inks by wearing gloves or using barrier creams. Avoid hand wiping plates. Wipe instead with chamois, mosquito netting, or other open-weave material. Wash off ink splashes with safe cleaners like, 1) baby oil followed by soap and water, 2) nonirritating waterless hand cleaners, or 3) plain soap and water. Never use solvents or bleaches on your skin.

18. Wear protective clothing, including a full-length smock or coveralls. Leave these garments in your studio to avoid bringing dusts home.

19. Lift litho stones and other heavy items safely (see page 40).

20. Clean up spills immediately. Follow Material Safety Data Sheet advice and have handy proper materials for controlling spills and for chemical disposal, especially for acids and solvents.

21. Wet mop and sponge floors and surfaces. Do not sweep.

22. Dispose of all inks, pigments, spent acids, and other chemicals in accordance with health, safety, and environmental protection laws.

23. Always be prepared to provide your doctor with precise information about the chemicals you use and your work practices. Arrange for regular blood tests for lead if you use lead-containing paints or pigments.

CHAPTER

16 *TEXTILE ARTS*

Batik dyers, costume makers, scene painters, weavers, and other artists who work with dyes, and textiles, are at risk of exposure to dye chemicals and fiber dusts.

DYE HAZARDS

Although there are thousands of commercial dyes, only a few hundred have been studied for long term effects. Of those tested many were found to cause cancer, birth defects and other toxic effects. The chemistry and hazards of dyes are discussed In Chapter 10, pages 99-103.

Many dyes also must be used with hazardous dye-assisting or mordanting chemicals. These chemicals are added to dye baths to help dyes react with fabrics properly. A list of common dye assisting chemicals and their hazards can be found in Table 16, Hazards of Mordant and Dye Assisting Chemicals, pages 201-202.

Modern textile artists also color fabrics with paints and silk screen inks. The hazards of these materials are discussed in Chapter 14 and 15.

EXPOSURE TO DYE PRODUCTS

Dyes are most hazardous in the powdered state. Skin contact and inhalation of even very small amounts of dyes in this concentrated form should be avoided.

Dyes sold in liquid form are safer to handle. Liquid dyes still can be hazardous because they have strong preservatives and inhibitors in them to keep the dye from degrading. Some also contain solvents including acetone, toluene, xylene, carbitol (diethylene glycol ether) and other solvents.

Dyes applied in hot baths release steam which may contain small amounts of toxic chemicals from dye impurities and decomposition products. Local exhaust ventilation should be installed above hot dye baths.

DYE TECHNIQUES

Dyes are used by artists in batik, tie-dyeing, discharge dyeing and a number of other techniques.

BATIK dyeing traditionally employs fiber reactive dyes (see Table 7, The Hazards of Dyes by Class, page 125-126) on silk. However, batik techniques are now used with a number of different dye classes on many fabrics, on paper, and other materials.

The batik process uses wax (beeswax, paraffin, etc.,) as a dye resist. The wax is heated to melting and applied to the fabric. After the resisted fabric is dyed, the wax is removed by ironing the fabric between sheets of newsprint, or by applying solvents such as dry cleaning fluids, mineral spirits, etc.

Heated wax is a fire hazard. Hot wax or the vapors rising from wax pots can explode into flame easily, so open flames, gas burners, and the like should not be used to heat wax. Instead, equipment such as crock pots and electric frying pans may be used if their controls can be set accurately at the lowest temperature at which the wax remains liquid.

Heated wax also emits highly irritating chemicals, including acrolein and aldehydes such as formaldehyde. Wax emissions require exhaust ventilation because there are no suitable air-purifying respirators for acrolein. Some artists avoid using heated wax by applying cold wax emulsions which are suitable for some purposes.

Irons for pressing wax out of fabrics also should be set at the lowest temperature required for wax removal. Exhaust ventilation such as table-level window exhaust fans should be provided. If solvents are used for wax removal, all the rules for solvent use should be followed (see Chapter 9, Solvents, pages 87-89). Some artists boil fabrics to remove most of the wax and then send them to professional dry-cleaners for complete removal.

For some purposes, much safer vegetable matter batik resists which can be washed out with strong soap and water now are being developed and sold.

TIE DYEING is done by applying dyes to fabrics which have been tied tightly. Concentrated dye solutions are usually used making exposure to these solutions more hazardous by skin or eye contact.

DISCHARGE DYEING, DYE STRIPPING, AND BLEACHING involves applying chlorine bleaches or other harsh chemicals to dyed fabrics. These chemicals remove dyes by destroying their chemical bonds. In the process, dyes may be broken down into even more hazardous chemicals. For example, benzidine dyes may be broken down to free benzidine; aniline (azine) dyes may release highly toxic aniline.

Using bleach to remove dye stains from your skin would have the same effect. Bleach also irritates and damages the skin. Skin contact with dyes should be avoided, but in case of accidental contact, it is best to let stains wear off.

Some of the highly toxic break-down products of dyes are volatile and can be made airborne especially if dyeing is done in hot baths. Some of these chemicals are likely to be absorbed through the skin. Gloves and ventilation must be provided when dye stripping or discharge dyeing.

PRECAUTIONS FOR DYERS

1. Plan the dye room with health and safety in mind. Floors and surfaces should be made of materials which are easily sponged clean and which will not stain. General ventilation rates should not be so high that dusts are stirred up.

2. Install ventilation systems appropriate for the work done. For example, provide local exhaust such as slot hoods or recessed canopy hoods for

heating dye pots, reverse dyeing, wax heating and removal, and all other processes which release toxic air borne substances. Vent dryers and similar equipment.

3. Obtain Material Safety Data Sheets (MSDSs) on all dyes and textile paints. If dyes and pigments are not identified by their Color Index names and numbers or by their Chemical Abstracts Service numbers (see page 43), ask your supplier for this information. Try not to use dyes without at least knowing their classes. Look up hazards of each dye class in Table 7, page 125-126.

4. Use Material Safety Data Sheets and product labels to identify the hazards of any toxic solvents, acids, or other chemicals in dyes, paints, inks, mordants, or other materials. If solvents are used in dyes or for removal of wax, follow all precautions for solvents (see pages 87-89), and pay special attention to fire safety.

5. Choose water-based products over solvent-containing ones whenever possible.

6. Buy premixed dyes if possible. Dyes packaged in packets which dissolve when dropped unopened into hot water also can be handled safely. Dyes and pigments are most hazardous and inhalable in a dry powdered state.

7. Weigh or mix dye powders or other toxic powders where local exhaust ventilation is available or use a glove box (see fig.14, page 103).

8. Keep containers of powdered dyes and pigments, solvents, etc., closed except when you are using them.

9. Avoid procedures which raise dusts or mists. Sprinkling dry dyes or pigments on wet cloth, airbrushing, and other techniques which raise dusts or mists should be discontinued or performed in a local exhaust environment such as a spray booth.

10. Avoid skin contact with dyes by wearing gloves. If skin staining does occur, wash skin with mild cleaners and allow remainder to wear off. Never use solvents or bleaches to remove dye splashes from your skin.

11. Melt and remove wax at the lowest possible temperatures. Do not heat wax with open flames such as on gas stoves. Use devices like electric stoves or fry pans with good heat control mechanisms. Use wax emulsion products when possible. Irons used to remove wax should be set as low as possible. Sending fabrics to professional dry-cleaners is a viable, but expensive alterative. Investigate nonwax resists as substitutes.

12. Wear protective clothing, including a full-length smock or coveralls. Leave these garments in your studio to avoid bringing dusts home. Wash clothing frequently and separately from other clothes.

13. Protect eyes by wearing chemical splash goggles if you use caustic dyes or corrosive chemicals. Install an eye wash fountain (and emergency shower if large amounts are used).

14. Clean up spills immediately. Follow Material Safety Data Sheet advice and have handy proper materials to handle spills and disposal. Wet-mop and sponge floors and surfaces. Do not sweep.

15. Avoid ingestion of materials by eating, smoking, or drinking outside your workplace. Never point brushes with your lips or hold brush handles in your teeth. Never use cooking utensils for dyeing. A pot which seems clean can be porous enough to hold hazardous amounts of residual dye. Wash your hands before eating, smoking, applying make-up, or other personal hygiene procedures.

16. Dispose of dyes, mordants, and other chemicals in accordance with health, safety, and environmental protection laws.

17. Always be prepared to provide your doctor with precise information about the chemicals you use and your work habits. Arrange for regular blood tests for lead if you use lead-containing textile paints or pigments.

FIBER HAZARDS

For centuries, occupational diseases such as dermatitis, skin and pulmonary anthrax, and weaver's cough (brown lung) have been associated with exposure to some vegetable and animal textile fibers. Now new man-made fibers and chemical treatments of textiles have added some occupational hazards to the list.

VEGETABLE FIBER HAZARDS. Fiber from plants such as flax, hemp, sisal, and cotton have been associated with a debilitating disease commonly called "brown lung" or byssinosis. It is usually only seen among heavily exposed textile factory workers. Its early symptoms, including chest tightness, shortness of breath, and increased sputum flow, commonly appear when the worker returns to work after being away a few days. The condition is reversible if exposure ceases, but after ten or twenty years of exposure, the disease can progress without further exposure and may be fatal.

Long years of exposure to hemp, sisal, jute, and flax dusts is associated with chronic bronchitis, emphysema, and various allergic conditions. Some of these illnesses may be caused by mildew, fungus spores, dyes, and fiber treatments like permanent press or sizing rather than by the fiber itself. Artists noticing recurring symptoms when working with fibers should investigate the possible causes of such reactions and see their doctors.

SYNTHETIC FIBER HAZARDS. Very little is known about the hazards of synthetic fibers such as rayon, acetate, nylon, acrylics, and so on. Their dusts have been reported to cause irritation when inhaled. Fiberglass textiles, of course, will cause considerable irritation to the skin and respiratory tract. Whether more serious diseases result from exposure to synthetic fibers will not be known until years of data from industrial experience has been gathered. In the meantime, prudence dictates minimizing exposure to them.

ANIMAL FIBER HAZARDS. Fibers used by artists may include wool, silk, hair from goats, horses, rabbit, dogs, and other animals. Allergies to such fibers or animal dander are well-known and can affect fiber artists. But many reactions to animal fibers are from mold, mildew, spores, and the like which can contaminate fibers.

There are other contaminants as well. For example, greasy wool can contain sheep dip. Uncarded or dirty wool or hair can contain little twigs and grass seeds which can cause injury to weavers and spinners.

ZOONOSES—diseases which can be transmitted from animals to man—also may afflict users of animal fibers. For example, inhalation of invisible anthrax spores from wool or hair harvested from diseased animals can cause a virulent, often fatal infectious disease.

Artists also should encourage stricter government enforcement of import regulations and testing of all animal products to prevent contaminated products from entering their countries. Failure to detect a shipment of anthrax-contaminated Pakistani wool in the United States resulted in the death of an artist-weaver in 1976.

Other diseases which affect those working with animal products include Q fever, mange, lice, and more. Even working with dog hair can be hazardous since dog tapeworm larva can cause hyatids (cysts) to form in the liver, skin, and other areas of the body.

Cleaning animal fibers will remove some of these hazards, but not all. It is safer to buy pre-washed, disinfected fibers. Artists using suspect materials may wish to be immunized for anthrax, although the shots also cause side effects which must be considered.

FIBER TREATMENT HAZARDS. Many fiber treatments such as formaldehyde-emitting permanent press treatments, sizing, fire retardants, stain-guarding chemicals, mothproofing, and the like, have been shown to cause allergies and other effects. Many of these chemicals have not been well-studied. The complex organic chemical fire retardant called "tris" was not found to be a carcinogen until years after it was in common use in children's sleepwear.

Artist's who have unusual reactions to working with particular materials should also consider fiber and fabric treatment as a possible source of the difficulty. When applying fiber treatments themselves, artists should obtain as much information about the chemicals as possible.

MOTHRPOOFING chemicals are usually pesticides and require care when they are used. Two chemicals commonly used for mothproofing and mothballs are paradichlorobenzene (PDB) and naphthalene. Threshold Limit Values for both chemicals are 10 parts per million indicating that they are very toxic. PDB's primary effects are on the respiratory system and liver. PDB also is a probable human carcinogen. Naphthalene has equivocal cancer data and can cause anemia, liver and kidney damage. To certain people of Black, Mediterranean, and Semitic origins with genetic glucose-6-phosphate dehydrogenase deficiencies, naphthalene is highly toxic causing severe anemia.

WEAVING, SEWING, AND OTHER FABRICATION TECHNIQUES

Weaving, spinning, sewing, knitting, macrame, embroidery, tapestry, and similar processes involve sitting or remaining still, and using the hands in repetitive actions for long periods of time. Such tasks require careful positioning of the body. For example, looms must be properly tuned, chair heights and sewing machine foot pedals must be adjusted to fit the individual artist.

Frequent breaks should be taken and posture should be varied as often as possible. Many weavers find exercising to relieve strain is helpful.

Eyes also can be strained if lighting is not of the proper intensity and direction. Ergonomic problems, eye strain, and other health effects from exposure to Video Display Terminals may result if weavers use computers to generate patterns.

PRECAUTIONS FOR FIBER ARTISTS

1. Fibers and textiles should be purchased from reliable suppliers who will provide information about the origin of the materials, the dyes or fiber treatments which have been applied, and so on.

2. Purchase cleaned or washed fibers or textiles when possible. If raw, uncleaned materials are used, get advice on best methods for cleaning and disinfecting fibers.

3. Do not use mildewed or musty materials. Store fibers in clean dry places to avoid growth of microorganisms.

4. Avoid dust. For example, use proper-sized needles in loom shuttles. Damp mop or sponge up dusts rather than sweeping or vacuuming. Shake out fabrics away from the workplace.

5. Obtain information on moth-proofing, sizing, permanent press, and other treatments which have been applied to your materials. When applying treatment chemicals yourself, obtain Material Safety Data Sheets and/or ingredient information and follow precautionary instructions.

6. Adjust looms, chair heights, etc., for ergonomic comfort. Take breaks (perhaps five minutes each half hour), stretch and exercise to relieve strain.

7. Provide proper lighting for weaving and other work (see page 38).

8. Follow precautions for VDT use if computers are used (see page 38).

9. Artists exposed to fiber dusts should have pulmonary function tests periodically. Weavers using raw animal fibers should keep up with their tetanus shots and consult with experts about other immunizations appropriate for the raw materials used. Always be prepared to provide your doctor with precise information about the materials you use and your work practices.

TABLE 16	Hazards of Mordants and Dye Assisting Chemicals

ALUM (potassium aluminum sulfate) Some people may be allergic to it, but no special precautions are needed when using it.

AMMONIA (ammonium hydroxide)* Avoid concentrated solutions. Household strength ammonia is diluted and less hazardous. Inhalation of its vapors can cause respiratory and eye irritation. Wear gloves and avoid inhalation.

AMMONIUM ALUM (ammonium aluminum sulfate) Hazards are the same as those of alum (see above).

CAUSTIC SODA (lye, sodium hydroxide)* Very corrosive to the skin, eyes, and respiratory tract. Wear gloves and goggles.

CLOROX (household bleach, 5 percent sodium hypochlorite)* Corrosive to the skin, eyes, throat, and mucous membranes. Wear gloves and goggles. Mixing with ammonia results in the release of highly poisonous gases (nitrogen trichloride, nitrogen oxides, chlorine, etc.). Mixing with acids releases highly irritating chlorine gas.

COPPER SULFATE (blue vitriol)* May cause allergies and irritation of the skin, eyes, and upper respiratory tract. Chronic exposure to copper sulfate dust can cause ulceration of the nasal septum.

CREAM OF TARTAR (potassium acid tartrate) No significant hazards.

FERROUS SULFATE (copperas)* Slightly irritating to skin, eyes, nose, and throat. No special precautions necessary.

FORMIC ACID (methanoic acid)* Highly corrosive to eyes and mucous membranes. May cause mouth, throat, and nasal ulcerations. Wear gloves and goggles.

GLAUBER'S SALT (sodium sulfate) Slightly irritating to skin, eyes, nose, and throat.

OXALIC ACID* Skin and eye contact may cause severe corrosion and ulceration. Inhalation can cause severe respiratory irritation and damage. Wear gloves and goggles.

POTASSIUM DICHROMATE (potassium bichromate, chrome)* Skin contact may cause allergies, irritation, and ulceration. Chronic exposure can cause respiratory allergies. A suspect carcinogen. Wear gloves and goggles.

SALT (sodium chloride)* Some all-purpose dyes contain enough to be toxic to children by ingestion. No other significant hazards.

SODIUM CARBONATE * Corrosive to the skin, eyes, and respiratory tract.

SODIUM HYDROSULFITE (sodium dithionite)* Irritating to the skin and respiratory tract. Stored solutions decompose to give irritating and sensitizing sulfur dioxide gas. Mixtures with acids will release large amounts of sulfur dioxide gas. Wear gloves.

SULFURIC ACID (oleum)* Highly corrosive to the skin and eyes. Vapors can damage respiratory system. Heating generates irritating and sensitizing sulfur dioxide gas. Wear gloves and goggles.

TANNIN (tannic acid)* Slight skin irritant. Causes cancer in animals. Handle with care.

TIN CHLORIDE (tin, stannous chloride)* Irritating to the skin, eyes, and respiratory tract. Wear gloves and goggles.

UREA No significant hazards.

VINEGAR (dilute acetic acid) Glacial (pure) acetic acid is highly corrosive and the vapors are irritating. Vinegar (about 5 percent acetic acid) is safer. Mildly irritating to the skin and eyes.

* Can be poisonous if ingested. Keep out of reach of children.
credit: M. Rossol, "Fiber Arts Hazards and Precautions," Center for Occupational Hazards, New York, 1985

<table>
<tr><td>CHAPTER
17</td><td>

LEATHER AND OTHER ANIMAL PRODUCTS
</td></tr>
</table>

F or centuries, occupational diseases including zoonoses and allergies have been associated with the use of animal products such as leather, horn, bone, ivory, and shell. In recent years, statistical studies of leather workers have shown high rates of bladder and nasal sinus cancer.

HARVESTING AND TANNING

Workers harvesting leather from animals and birds are exposed to a host of zoonoses—diseases which can be transmitted from animals to man. Many of these diseases are discussed in Chapter 16, Textile Arts, pages 197-199. In the United States and Canada, rabies is also known to be transmittable during harvesting. Recently, two bushy-tailed wood rats being prepared for preservation in a Canadian museum were found to have died of bubonic plague.

Once harvested, skins are preserved with tanning chemicals. Extracts from certain plants which are natural sources of tannic acid are still used for "vegetable tanning" of sole and heavy duty leathers.

Many other leathers are tanned with minerals such as the sulfates of chromium, aluminum, or zirconium. Many synthetic chemicals are now used to tan leather. Some of these are sulfonated phenol or naphthols condensed with formaldehyde. A few special leathers and skins for taxidermy and natural history specimens also may be treated with arsenic and powerful pesticides.

HAZARDS OF TANNING CHEMICALS

Tannin is a suspect carcinogen. Chrome sulfates and some other chrome compounds are sensitizers and suspect carcinogens. Synthetic tanning chemicals such as sulfonated phenols are very toxic. The use of these toxic and sensitizing tanning chemicals may explain in part why workers exposed to leather dusts have high rates of cancer and other occupational illnesses.

Tanners should also remember that human skin can be tanned. Tanning chemicals should be kept off the skin.

LEATHER WORKING

Tools such as knives, awls, punches, and a host of specialized tools are used in each type of leather work. Care should be taken to keep these tools in good repair and sharp, and to use them safely.

Sanding of leather can be done by hand or with electric sanders. This sanding dust contains leather, tanning chemicals, dyes, and glues. Dust exposure should be prevented with local exhaust ventilation and/or respiratory protection. Goggles should be worn to prevent eye injury.

DYEING

Leather dyes, like textile dyes, tend to be hazardous chemicals (see Chapter 10, Pigments and Dyes, pages 101-102). Traditional leather dye products contain solvents from very toxic classes such as chlorinated hydrocarbons, glycol ethers, and aromatic hydrocarbons (see Table 5, Common Solvents and Their Hazards, page 89). Some leather dyes are dissolved in ethyl alcohol. These are safer to use.

Safer still are the new water-based acrylic leather dyes. Although there may be small quantities of water-miscible solvents in these products, it is assumed that these dye products are the least toxic.

CEMENTING

There are a number of leather glues on the market. Barge cement and rubber cements are the most common. Barge cement contains toluene and petroleum distillates (see Table 5, Common Solvents and Their Hazards, page 89). Rubber cements often contain normal hexane (n-hexane) which is a potent nerve toxin (see Chapter 9, Solvents, page 85.) Inha-

lation and skin contact with all solvent-containing glues should be avoided.

Some new water-emulsion glues for leather have been developed. Choose these when ever possible.

CLEANING AND FINISHING

Cleaning can be done with oxalic acid or saddle soaps. Saddle soap has no significant hazards unless it is preserved with strong pesticides. Oxalic acid is corrosive to skin, eyes, digestive, and respiratory tracts. Once absorbed, oxalic acid is damaging to the kidneys.

Finishes for leather may consist of oils such as neatsfoot oil and waxes, most of which have no significant hazards. Other types of leather finish are lacquers and resins dissolved in solvents. Skin contact and inhalation of these is hazardous.

OTHER ANIMAL PRODUCTS

BONE, ANTLER, IVORY, and HORN are used in many crafts. Toxic solvents are used to dissolve fats and oils from these materials when they are freshly harvested. Harvesting and tooling these materials also has been associated with zoonoses. There are known cases of anthrax resulting from harvesting and working with these materials, including a fatal case of anthrax contracted while tooling ivory into piano keys.

The most common diseases associated with these materials is irritation and allergic response to their dusts. Dusts from abrasives used to sand these materials may also be hazardous (see Table 13, Hazards of Common Minerals used in Ceramics, Sculpture, Lapidary, and Abrasives.

SHELLS including mother-of-pearl, abalone, and coral are commonly ground and sanded. Dust from these processes causes respiratory allergies, especially if the shell is not properly washed and contains organic matter.

Inhalation of mother-of-pearl dust can cause fevers, respiratory infections, and asthmatic reactions. Years ago, repeated inhalation of mother-of-pearl dust by adolescents working in the pearl button industry caused defects and lesions of the long bones of their arms and legs.

FEATHERS for crafts and for pillow stuffing can cause "feather-pickers disease" which is characterized by chills, fever, coughing, nausea, and

headaches. These symptoms usually abate when the individual develops a tolerance for feathers. Tolerance may take weeks or even years to develop. Some people become permanently allergic to feathers. Psittacosis, an infectious disease, also can be acquired if artists harvest feathers from live birds.

Mothproofing chemicals such as paradichlorobenzene or naphthalene are commonly applied to feathers (see Chapter 16, Textile Arts, page 199). Allow mothball odors to dissipate before working with feathers.

PRECAUTIONS FOR WORKING LEATHER AND OTHER ANIMAL PRODUCTS

1. Obtain Material Safety Data Sheets on all chemicals and choose the safest products when possible.

2. Work on easy to clean surfaces and wipe up spills and dust immediately. Follow Material Safety Data Sheet advice and have handy proper materials for controlling spills and for chemical disposal. Wet-mop and sponge floors and surfaces. Do not sweep.

3. Practice scrupulous personal hygiene. Do not eat, smoke, or drink in the workplace. Wash hands and change out of work clothing before leaving the studio. Wash work clothes frequently and separately from other clothes.

4. Avoid skin contact or inhalation of tanning chemicals by using exhaust ventilation and/or respiratory protection and gloves. Use chemical splash goggles when using corrosive chemicals. Purchase pretanned leather when possible.

5. Keep tools sharp and all machines in good repair. Prepare for accidents by having first aid materials for trauma and post emergency procedures. Keep tetanus immunization up-to-date.

6. Clean leather with saddle soaps or other detergent and soap cleaners when possible. Avoid oxalic acid cleaners.

7. Clean shell, bone, horn, antler, and other animal products well before working with them. Buy precleaned materials when possible.

8. Control sanding dusts of all leather and animal products with local exhaust ventilation and/or respiratory protection (with a dust filter or cartridge).

9. If dyes are used, follow all precautions for dyers (see Chapter 16, Textile Arts, pages 195-196). Choose acrylic water-based leather dyes or dyes dissolved in ethyl alcohol when possible.

10. Follow all rules for solvent use when working with solvent-containing dyes, glues, and finishes (see Chapter 9, Solvents, pages 87-89).

11. Always be prepared to provide your doctor with precise information about the materials you use and your work practices. Especially report signs of allergies and infections (skin lesions, respiratory infections, intestinal upsets, fevers, etc.) which may be acquired from animal products.

CHAPTER

18 | *CERAMICS*

Occupational illnesses, such as lung disease (silicosis) and lead poisoning, have been associated with pottery-making for hundreds of years. Unfortunately, these illnesses and others are still seen in ceramic artists and hobbyists and their families today. Ceramic hazards occur during three basic processes: working with clay, glazing, and firing.

CLAY HAZARDS

Most art and craft potters use one of two methods when making clay objects: manipulating wet clay by methods such as hand building or wheel throwing; and slurrying the clay into a liquid slip and casting it with molds.

HAZARDOUS INGREDIENTS. Whether hand-formed or slip cast, the term "clay" has come to mean any mineral material which can be used to make ceramic or porcelain objects. Most of these "clays" are composed of a number of mineral ingredients mixed together to produce a body which will fire at a particular temperature and have particular qualities.

Some ingredients in these "clays" include true clays (such as fire clay, china clay, and red clays), sources of silica (such as powdered flint, quartz, or sand), and many other minerals including feldspar, talc, and wollas-

tonite. Most clays will also have small amounts of additives such as: barium compounds to control scumming; bentonite to increase plasticity; grog (ground fire brick), vermiculite, or perlite to give texture; metal oxides to impart color; and the like. Slip clays additives may include stabilizers such as gum arabic to keep the mixture in suspension, and biocides to control mold and fungus.

Those clays and minerals which are mined from the earth usually contain many impurities. The actual composition of a particular ingredient may vary greatly from place to place in the mine or deposit. Researching the hazards of these ingredients usually means getting their chemical and mineral analyses. This information should be readily available from your suppliers because they need it for their right-to-know programs for their workers.

Once you have identified all the ingredients of your products, the hazards can be looked up. Almost all clays and clay mixtures contain significant amounts of silica (see pages 155-156). Hazards of other minerals, such as talc and wollastonite, can be found in Table 13, Hazards of Common Minerals used in Ceramics, Sculpture, Lapidary, and Abrasives, page 159. Metal compounds such as barium sulfate can be looked up in Table 10, Hazards of Metals and Metal Compounds, page 135.

PHYSICAL HAZARDS. In addition to toxic chemicals, there are physical hazards from the heavy work, from noise, and other hazards.

OVERUSE AND STRAIN INJURIES. There are also many overuse injuries which can occur while wedging, throwing, or hand building with clay. Many potters have acquired injuries such as carpal tunnel syndrome, a condition involving compression of the median nerve at the wrist. Often, wedging and/or throwing are the cause.

Hand, back, and wrist muscle injuries can also occur from sitting at the potters wheel for too long, especially if posture is incorrect. Injuries from lifting sacks of clay, molds, and the like are common among both potters and ceramicists (see Chapter 4, Physical Hazards and Their Control, Over-Use Injuries, page 39).

NOISE loud enough to damage hearing may be created by machinery such as pug mills and badly installed kiln ventilation. Wearing hearing protection such as ear plugs should prevent hearing loss (see Chapter 4, Physical Hazards and Their Control, pages 35-37).

OTHER PROBLEMS which are noted among clay workers include chapping and drying of the skin, and bacterial and fungal infections of the skin and nail beds.

Since wet clay commonly harbors bacteria and molds, some people may develop allergies to clay dust, and people with preexisting asthma and allergies may find their conditions worsen with exposure to clay. Avoiding dusty procedures is always advisable to prevent development of allergies. People with severe allergies would be wise to choose a different craft.

Wet clay is also a good medium of exchange for disease-causing bacteria and viruses. It is not recommended for hospital and institutional art or therapy programs if patients are carriers of infectious diseases such as hepatitis A.

GLAZE HAZARDS

Common glazes are a mixture of minerals (see Table 13, Hazards of Common Minerals Used in Ceramics, Sculpture, Lapidary, and Abrasives, page 159), metallic compounds (see Table 10, Hazards of Metals and Metal Compounds, page 135), and water. Commercial glazes usually contain frits and additives such as gum stabilizers and preservatives. Preservatives in commercial glazes are usually small amounts of toxic pesticides or bacteriocides. Gum stabilizers usually are not very toxic.

HAZARDOUS INGREDIENTS. In general, metallic elements function in glazes as fluxes (causing the glaze to melt properly) and colorants. Their toxicity varies greatly. Some very safe ones are iron, calcium, sodium, and potassium. Some low fire glazes contain very toxic fluxes and colorants including lead, cadmium, antimony, and arsenic. Middle range and high fire glazes may have large amounts of highly toxic fluxes such as barium and lithium. Toxic colorants which can be in both high- and low-fired glazes include uranium, chromium, cobalt, manganese, nickel, and vanadium. Some lustre glazes also contain highly toxic mercury and arsenic.

Lustre glazes usually contain metallic alloys and compounds, highly toxic solvents such as chloroform and other chlorinated or aromatic hydrocarbons (see Table 5, Common Solvents and Their Hazards, page 89), and tack oils such as oil of lavender. Tack oils are hazardous primarily when they decompose during firing (see Carbon Monoxide and Other Organic Decomposition Products below.)

Glazes are often used in conjunction with colorant materials such as metallic oxides, stains (e.g., Mason stains), underglazes, engobes, ceramic decals, and the like. These materials rely primarily on metallic compounds for coloring (see Table 10 Hazards of Metals and Metal Compounds, page 135).

There are also new ceramic paints on the market which look like fired ceramic glazes when dry. These usually contain plastic resins and solvents. The hazardous ingredients in these glaze paints are solvents and resins (see Chapters 9 and 10, Solvents and Pigments).

LEAD GLAZES. Those choosing to use lead glazes, should consider the health effects of lead (see pages 134-135), the solubility of lead frits (see page 158), and the leaching characteristics of lead glazes (see Finished Ware Hazards below). They also need consider the expense of compliance with (or being caught in violation of) Canadian or United States occupational and environmental lead laws. Ideally, lead glazes should be phased out of use for art and craft work.

WORKING WITH GLAZES. Glazes are potentially hazardous at all stages of use including during glaze making, application, firing, and when glazed pottery is used as food utensils.

GLAZE MAKING is one of the most hazardous tasks potters perform because it involves weighing and mixing the powdered ingredients. Methods of controlling the dust should be employed (see Chapter 7, Ventilation).

APPLICATION of glazes can be done by brushing, dipping, spraying, air brushing, and occasionally by dusting dry ingredients onto wet ware. Brushing and dipping methods are preferred because they produce less dust. Spraying, air brushing, and dusting should only be done in a spray booth or outdoors.

Many other glazing processes are potentially hazardous and should be evaluated for safety. For example, melting paraffin to use as a glaze resist can be a fire hazard and result in exposure to toxic wax decomposition products. Local exhaust ventilation should be provided for this process, direct flame should not be used to heat the wax (e.g., use an electric fry pan), and the temperature of the paraffin should be kept as low as possible. Water/wax emulsions which are applied without heat are safer.

FIRING

INFRARED RADIATION emanates from ware when it glows with heat. It can cause skin burns and eye damage.

VENTILATION. When clays and glazes are fired, they release various gases, vapors, and fumes. Some common emissions from kilns include carbon monoxide, formaldehyde and other aldehydes, sulfur dioxide, chlorine, fluorine, metal fumes, nitrogen oxides and ozone (see Table 17, Sources of Toxic Kiln Emissions, page 219).

For this reason, all firing processes require ventilation. Different types of firing need different types of ventilation. Some types can only be done safely outdoors. All indoor kilns, whether electric or fuel-fired, need exhaust ventilation. Table 18 describes proper ventilation for various types of kilns.

FIRE/ELECTRICAL SAFETY. Fire hazards should be considered when planning pottery or ceramic studios. Consult local fire officials or other experts to be sure your studio meets all local fire regulations and electrical codes.

Large kilns should be located in areas in which there are no combustible or flammable materials. Even small electric kilns should be at least three feet from combustible materials such as paper, plastic, or wood. Electric kilns also should be raised at least a foot above the floor to allow air to circulate underneath. Wooden floors under small electric kilns can be protected by asbestos-substitute fiber boards, or refractory brick.

To prevent fires and damage to ware, electric kilns should be equipped with two automatic shut-offs in case one fails. (Three types to choose from are pyrometric shut-offs, cone operated shut-offs, and timers.)

KILN BUILDING. Many potters choose to build their own kilns. This process may expose potters to many hazards including asbestos-substitutes (some are suspect carcinogens), fire brick dust (usually contains silica), heavy lifting, and noise (if hard bricks are wheel cut).

If dust-producing tasks cannot be done in local exhaust or outdoors, respiratory protection approved for toxic dusts should be used. Hearing protection should be used if brick cutting or other noisy processes are done (see Chapter 4, Physical Hazards and Their Control, section on Noise, pages 35-37).

Connecting kilns to gas or electric lines should be done or approved by licensed electricians and/or gas company employees.

FINISHED WARE HAZARDS

Potters and ceramicists often are not aware that they may be liable if the ware they sell harms someone. Potters, like commercial chinaware makers, could be held responsible for injuries or damages incurred if their ovenware shatters from heat, or if lead or other toxic metals from their glazes contaminates food.

LEACHING. The problem of glaze solubility (leaching) is particularly complex. Leaching glazes solubilize, slowly releasing all their ingredients into food (albeit sometimes at varying rates). Most glazes leach faster in acid solutions such as orange juice. Standard laboratory leaching tests are done in acid solutions. But there is reason to believe that some may solubilize faster in contact with alkaline foods such as beans or some green vegetables.

Many factors influence glaze solubility including composition of the glaze, small amounts of certain impurities, heating and cooling cycles during firing, fumes from other glazes fired in the kiln, and more. Commercial producers have found that testing programs are the only way to guarantee glaze performance. Potters should consider doing the same.

Some ceramicists have relied on premixed glazes which are sold as "lead safe," meaning that they are not expected to leach lead or cadmium into food if the firing and application of the glazes are done properly. However, over- or under-firing, application over an unsuitable underglaze (such as one containing copper), the contamination of a glaze from using an unclean brush, and many other factors can render a "lead safe" glaze dangerous.

Potters often mistakenly think that only low fire lead glazes are hazardous with food. Now it is known that some high fire glazes can leach dangerous amounts of barium, lithium, and other metals. It is true that the Canadian and the United States consumer protection laws currently only regulate lead and cadmium release from ceramics. However, in 1989, the United States Food and Drug Administration (FDA) called for data on leaching of other metals from lead-free glazes to investigate their safety. And whether regulated or not, potters are still liable for harm toxic glazes cause consumers.

Potters should consider either having reliable laboratories periodically test their ware, or to use glazes which contain no toxic metal-containing ingredients. These safer glazes would rely on glaze chemicals containing sodium, potassium, calcium, and magnesium fluxes.

Glazed ware which will not pass leaching tests should have a hole drilled in it to render it unusable or it should be labeled with a permanent fired decal. In the United States, producers of ceramic pieces that look like food ware, but which will not meet lead-leaching guidelines, are required by the FDA to comply with a newly revised regulation (21 CFR 109.16(b)(1)) which says that the piece must bear both a conspicuous stick-on label and a permanent fired or molded warning (the law specifies type size) on the base of the piece. The wording must be chosen from one of the following:

"Not for Food Use. May Poison Food;"

"Not for Food Use. Glaze contains lead. Food Use May Result in Lead Poisoning;" or

"Not for Food Use—Food Consumed from this Vessel May be Harmful."

Ceramicists do not have to comply with the rules above if they drill a hole through a food contact surface to render the object unusable.

Additional wording such as "Decorative" or "For Decorative Purposes Only," may be placed after the required statement. A one-inch diameter symbol also may be used on the temporary label or on the base of the piece:

Fig.15

Ceramicists selling wares in California have even tougher state regulations to meet (See table 17).

GLAZE TESTING. Glazes can be tested by sending pieces to certified laboratories. Usually cups are easiest to ship and test. The cost may run from as little as $ 60.00 to as high as $ 400.00 for testing six cups for two metals. Good laboratories can test for many different metals at your request.

To interpret results of laboratory tests for lead and cadmium, potters can use Table 17.

TABLE 17	Lead Glaze Regulations

**Current and Previous FDA and California Guidelines for
Maximum Lead/Cadmium Release from Ceramic Foodware in UG/L***

Category	LEAD previous	LEAD 1989	LEAD current	CALIF. current	CADMIUM current
Flatware (≤ 25 mm deep)	7.0		3.0	0.226***	0.5
Small hollowware(<1.1L)	5.0		2.0	0.1	0.5
Large hollowware(>1.1L)	2.5		1.0	0.1	0.25
cups or mugs			0.5	0.1	0.5
pitchers		0.1**	0.5	0.1	0.25
cookware	being studied by FDA				

* Ug/ml = micrograms/milliliter = milligrams/liter (mg/L) = parts per million (ppm).

** The 0.1 level was proposed for food service pitchers by FDA Jan. 1, 1989 (54 FR 23485-9), but changed.

*** Ceramicware that meets the FDA limits can be sold in California. However, special labeling is required
if the ware leaches more than California's more stringent limits.

HOME TESTS. There also are companies which market home lead
ceramic tests. These do not replace proper laboratory tests, but they can
identify excessive lead leaching. Some of these test kits are:

> **Test for Lead in Pottery** ($ 25) and the FRANDON Lead Alert Kit
> ($ 29.95), Frandon Enterprises Inc., P.O. Box 300321, Seattle,
> WA 98103. 1-800-359-9000.

> **LeadCheck Swabs** ($ 30), HybriVet Systems, Inc., P.O. Box 1210,
> Framingham, MA 01701. 1-800-262-LEAD.

> **LEADCHECK II** ($ 25), Distributed by Michigan Ceramic Sup-
> plies, 4048 Seventh St., P.O. Box 342, Wyandotte, MI 48192.
> 1-313-281-2300.

RULES FOR WORKING WITH CLAY AND GLAZES

1. Plan studios with clean up procedures in mind. Floors should be sealed
and waterproof. Tables, shelving, and equipment should be made of
materials which can be easily sponged clean. Enough space should be
left between tables and equipment to make cleaning easy.

2. Construct kilns from refractory brick and castables when possible. Avoid asbestos and ceramic fiber insulation. Wall off existing fiber insulation with brick or metal barriers. Repair or dispose of fiber insulation with precautions similar to those required for asbestos abatement. Follow all occupational and environmental regulations when disturbing, repairing, or disposing of asbestos-containing materials.

3. Install proper ventilation for the types of kilns you use (see Table 18). Install carbon monoxide detectors in rooms containing fuel fired kilns or very large electric kilns.

4. Keep all tools, machinery, and potter's wheels in good condition. Be especially vigilant about electrical condition since water is always present. Install ground fault circuit interrupters on all outlets within 10 feet of water sources or wet operations.

5. Plan fire protection carefully. Locate kilns in areas free of combustible materials. Equip electric kilns with two automatic shut-offs in case one fails. Consult fire officials or other experts for advice on proper fire-fighting systems and/or extinguishers. Do not locate water sprinkler heads above kilns or other hot and/or high voltage equipment. Hold regular fire drills.

6. Prepare for emergencies. Have a first aid kit handy. Post and practice emergency procedures.

7. Use proper personal protective equipment. Wear shade 3 or 4 welding goggles when looking into glowing kilns (see figures 4 & 5, pages 58-60), asbestos-substitute gloves when handling hot objects, impact goggles when grinding or chipping, dust masks if needed, and so on.

8. Obtain Material Safety Data Sheets on all materials used in the studio such as clays, glazes, and grind wheels. In addition, obtain mineral and chemical analyses of clays, glazes, and other minerals from suppliers. Avoid materials containing highly toxic ingredients such as lead and asbestos, and treat materials containing over one percent free silica as toxic, providing ventilation and/or respiratory protection.

9. If lead is used on the job, employers must be prepared to meet complex OSHA Lead Standard regulations in the United States or the OHSA Regulations respecting Lead in Canada.

10. Practice good hygiene. Wash hands carefully and use a nail brush after glazing. Work on surfaces that are easily cleaned with a damp sponge and wipe up spills immediately.

11. Avoid skin problems. Keep broken skin from contact with clay and glazes. Wash hands and apply a good emollient hand cream after work. People with skin problems can wear surgical or plastic gloves while working.

12. Wear protective clothing such as smocks, tightly woven coveralls, and hair covering. Avoid flammable synthetic fabrics. Change clothing when leaving the pottery rather than carrying dusts home. Wash clothing frequently and separately from other clothes.

13. Avoid repetitive strain injuries. Make repetitive and/or forceful movements of the hands and arms in short bursts and take frequent rests. Never work to the point of exhaustion or pain. Change positions frequently. When wedging, keep the wrist in a neutral or mid-joint position, and use the weight of the body rather than just the muscles of the upper limb. In general, good posture, avoidance of extreme overweight, and exercise to keep muscles strong are all useful in preventing overuse injuries.

14. Avoid lifting injuries. Store heavy bags of clay and other materials at heights (on benches or shelves) where lifting can be done without bending the back. Storage on trolleys may even avoid the need to lift. When lifting is necessary, it should be done with the legs, keeping the back straight to avoid injury.

15. Avoid dusty processes when possible. Examine all dust-producing procedures such as mixing clay and glazes, sanding greenware, and reprocessing clay. Identify procedures which can be replaced. For example, premixed clay can be purchased instead of mixing it. Buying premixed clay is usually economical if the cost of providing proper ventilation for mixing is considered.

16. Install local exhaust areas for processes that create toxic airborne materials such as glaze spraying, mixing powdered chemicals, for grind wheels, and the like. Spray booths are suitable for glaze spraying and many other processes. Some dusty tasks can be done in front of a strong

window exhaust fan or outdoors. (see Chapter 7, Ventilation).

17. If respirators must be used, they should be approved for the process (see Table 4, Respiration Filters and Cartridges, page 76) and follow all rules regarding respirator use (see Chapter 8, Respiratory Protection).

18. Clean floors without creating dust. Do not sweep. Use wet mopping and hosing methods. Ordinary household, industrial, shop, and water-filled types of vacuums will collect only large dusts while releasing the invisible respirable dusts back into the air. Proper vacuums include those which pick up wet material from the floor, or those with high efficiency (HEPA) filters.

19. Dispose of all old clays and glazes, grinding dusts, and other waste materials in accordance with occupational and environmental protection

TABLE 18	Sources of Toxic Kiln Emissions

CARBON MONOXIDE is formed when carbon-containing compounds are burned in limited oxygen atmospheres such as in electric kilns. Carbon sources include organic matter found in most clays and many glaze materials, from wax resists, stabilizers in slip clays, tack oils in lustres, and other organic additives in clays and glazes. Amounts of carbon monoxide over the Threshold Limit Value have been measured near electric kilns.

OTHER ORGANIC DECOMPOSITION PRODUCTS. When organic materials burn, large numbers of compounds in addition to carbon monoxide are created. Many of these also are toxic. Formaldehyde is one such emission which has been measured in significant amounts near electric kilns.

SULFUR OXIDES. Many clays and glaze ingredients contain significant amounts of sulfur-containing compounds. When these are fired they give off sulfur oxides which form sulfurous and sulfuric acids when they combine with water. These acids etch the metal kiln parts above ports and doors and also are highly damaging to the respiratory system.

CHLORINE AND FLUORINE. These gases are released when fluorine- and chlorine-containing clay and glaze chemicals such as fluorspar, iron chloride, and cryolite are fired. Both gases are very irritating to the respiratory tract. Fluorine also is associated with bone and tooth defects.

METAL FUMES. Fumes are formed when some metals and metal-containing compounds are fired. Complex reactions which occur during glaze firing make it difficult to predict precisely at what temperature metals will volatilize and oxidize to form a fume. Some toxic metals which commonly fume include lead, cadmium, antimony, selenium, copper, chrome, and nickel. The fumes may be inhaled or they may settle on surfaces in the studio. Some fumes can contaminate the kiln and deposit on ware in future firings.

NITROGEN OXIDES AND OZONE. These gases may be produced by decomposition of nitrogen-containing compounds or by the effect of heat and/or electricity on air in the kiln. They are strong lung irritants.

OTHER EMISSIONS. One of the strongest arguments for venting all kilns is the unpredictability of emissions. Pottery magazines and textbooks often suggest projects which result in the firing of nails, paper, plastic, wood, wire, and many other items. One magazine even suggested throwing mothballs into hot electric kilns to create reduction atmospheres. This practice would release highly toxic emissions including cancer-causing benzene. Projects such as these combined with the unpredictability of clay and glaze composition make ventilation necessary.

TABLE 19	Types of Kiln Ventilation

ELECTRIC KILNS either should be equipped with canopy hoods, negative pressure ventilation systems, or isolated in a separate room which is provided with very rapid dilution ventilation. Of these, the negative pressure system is best (see Figure 16).

FUEL-FIRED KILNS create large amounts of toxic emissions from the burning of the gas, oil, wood, or other heat sources. Most of these emissions will be drawn through the stack or chimney. The stack should be tall enough to keep emissions from drifting into areas where they are unwanted. Unless they are located outdoors, fuel-fired kilns also need a canopy hood to collect emissions which escape the stack's draw and gases generated during firing techniques such as reduction (when more fuel is introduced than the kiln can burn).

SALT FIRING probably can be done safely only outdoors. Salt firing produces gases such as highly corrosive hydrochloric acid gas. The process can be

made safer if salt is replaced with other sodium-containing compounds such as sodium bicarbonate. Kiln stacks should be placed where emissions cannot affect people. If back-up respiratory protection is needed, respirators should be full-face types with acid gas and fume cartridges. (See Chapter 8, Respiratory Protection.)

RAKU FIRING also is best done outside. Theoretically, the firing could be done indoors in almost any type of kiln, but the very smoky reduction phase of the process requires an outdoor location. Even outdoor firing will not provide sufficient ventilation if materials used for reduction release highly toxic chemicals. This can happen if sawdust from chemically treated wood or if leaf and plant materials sprayed with pesticides are accidentally used.

OTHER FIRING TECHNIQUES such as pit firing, sawdust firing, and waste-oil firing are touted in magazines and texts. The materials and methods used in these processes should be investigated and evaluated, and precautions should be planned before attempting them.

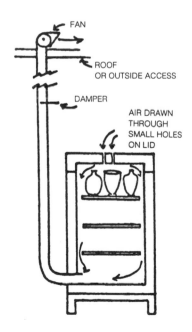

Fig. 16

CHAPTER 19 | *GLASS*

S tudies have shown that a large percentage of glassblowers develop lung problems and significantly decreased lung capacities. The cause or causes of these changes are unknown.
Glass workers also develop other physical problems for which the causes have been associated with hazardous materials or processes. These hazards are encountered during four basic stages in glassblowing: 1) making glass, 2) working (blowing) the glass, 3) annealing, and 4) finishing. The hazards of lampworking and slumping will also be discussed.

MAKING GLASS

Because glass is a "supercooled liquid" rather than a compound or mineral, there is no limit to the varieties and mixtures of glass ingredients possible. Adding a pinch or two of another ingredient to a mixture will produce a "different" glass.

However, there are several basic divisions or classifications of glass. These are usually referred to by the names of their primary fluxes (components which cause the glass to melt). For example, glasses called "borosilicates" employ boron compounds as their major fluxes.

The most common types of clear glass are lead/potash, borosilicates, and soda/lime. White or opal glasses usually come in two varieties, cal-

cium phosphate/silica and alumina/silica/ fluorine glass. Other chemicals are also added to glass melts to alter their properties.

The common glass forming chemicals are the same ingredients used in ceramics. For example, silica, feldspars, lead compounds and frits, boron, and zinc compounds are used. The hazards of these minerals and metal-containing compounds can be looked up in Table 10, Hazards of Metals and Metal Compounds, page 135, and Table 13, Hazards of Common Minerals Used in Ceramics, Sculpture, Lapidary, and Abrasives, page 159.

Glass colorants are often added to the melt. These also are generally the same chemicals used to color ceramic glazes and enamels. They may include compounds of cadmium, chrome, cobalt, copper, gold, iron, manganese, silver, and uranium. The hazards of these metals can be looked up in the Table 10, Hazards of Metals and Metal Compounds, page 135.

These glass-making and coloring compounds are weighed and put in the glass furnace to melt. The powdered chemicals can be inhaled while weighing and charging the furnace. The melting of the glass causes toxic gases and fumes to be given off. Gas furnaces also may give off carbon monoxide gas. Excellent dust control and exhaust ventilation for the furnace are needed.

A safer way to obtain glass is to purchase premixed glass or glass cullet (scrap glass) from glass factories. Some glass blowers recycle scrap glass bottles. Using glass from these sources eliminates handling toxic powders and reduces formation of toxic gases and fumes in the furnace.

Furnaces also must be vented to reduce heat in the work area. Fatigue, rashes, and stroke from heat are common problems among glassblowers. Hot glowing furnace brick and molten glass give off infrared radiation. Protective infrared goggles should be worn to prevent infrared cataract which historically has been called "glassblower's cataract."

WORKING THE GLASS

Glassblowing is heavy physical work in a hot, hazardous environment. The glass is worked while molten and glowing. Sharp glass splinters and shards are created when pieces are discarded, transferred to the pontil, or knocked off the pontil into the annealing oven. Avoiding cuts, burns, and accidents takes constant vigilance and glass workers should be prepared to treat burns and cuts. Some old-time glassblowers keep ice cubes on hand to treat small burns.

Wet wooden tools are often used to form glass and smoke from overheating these can be inhaled while working. Some practices such as marvering (rolling the hot glass on a cold surface such as metal) colorant chemicals onto the glass, will cause hot toxic gases and fumes to be created.

Work surfaces and benches often have been insulated with asbestos board. Dust raised when these surfaces are abraded has been associated with asbestos-related disease in glassblowers.

ANNEALING

Annealing is done at lower temperatures than melting. Annealing ovens add heat to the workspace, but the amount of heat should be easily dissipated by the shop's general ventilation system. However, if fuming (putting metal chlorides into the oven to create iridescent surfaces) is done in the annealing oven, the irritating fumes created require local exhaust such as a movable canopy hood.

Fiber insulation, such as asbestos or ceramic fiber (see pages 157-158), used in annealing ovens is likely to become disturbed and made airborne as glass is continually put in and removed. Refractory brick contains some free silica, but is much safer.

Annealing is done to relieve stresses in the glass. Improperly annealed glass may crack or shatter, often without warning. There are polarized lights and other instruments which can detect unrelieved stress. Having glass shatter while polishing it can be dangerous. Having it shatter in a show room is not only dangerous, it is embarrassing.

FINISHING GLASS

Dry grinding and polishing of glass can create abrasive dust. Some of the least toxic abrasives and polishing compounds are alumina, tin oxide, silicon carbide, diamond, and cerium dioxide (see Table 13, Hazards of Common Minerals Used in Ceramics, Sculpture, Lapidary, and Abrasives, page 159).

Dry grinding also produces glass dust. This dust is a mechanical irritant to the eyes and respiratory system. It also may be toxic depending on the type of glass being ground. For example, lead/potash glass dust, like a lead frit, can be a source of lead poisoning. Glass colored or opacified with highly toxic chemicals such as arsenic or antimony also can produce hazardous dust.

Wet grinding and polishing methods should be used when possible to reduce exposure to grinding dusts. Some dust will be suspended in the water mist which rises from these tools. Breathing this mist should be avoided.

Mist from these tools also may contain disease-causing microbes. Hazardous microorganisms such as those causing Legionnaires Disease have been isolated from wet grinding water reservoirs. Frequent cleaning keeps these organisms from establishing themselves in the reservoir.

Both wet and dry grinding and polishing dusts containing highly toxic components may be costly to dispose of properly. Consult local environmental protection authorities for further information.

DECORATING GLASS

Glass can also be decorated by etching, sand blasting, painting, and other techniques. These processes are discussed in Chapter 22, Ceramic, Glass, and Enamel Surface Treatments, page 245.

BUILDING/REPAIRING OVENS, FURNACES, ETC.

Furnaces, glory holes, annealing ovens, and other studio equipment are often constructed of hazardous materials. The safest materials are refractory brick and castables. A wide variety of these are on the market. High alumina refractories are extremely resistant to glass. Soft insulating brick is not, but can be protected from direct contact with a layer of hard brick or alumina refractory.

Other construction and insulation materials include asbestos, ceramic and other synthetic fiber products (see pages 157-158). Repair or disposal of equipment constructed with these fiber products can release large amounts of highly hazardous dusts. Repair and disposal of asbestos containing-materials must be done in accordance with occupational and environmental protection regulations. Complying with these regulations is usually costly, but being caught violating them can be even more costly.

LAMPWORKING AND BEADMAKING

Lampworkers use small torches (usually propane, natural gas, or acetylene) to heat glass rods and tubes to form or "blow" into objects and figures. Beadmaking is done by wrapping rods of colored glass around copper wire and dissolving the wire in acid. Hazards include thermal

and acid burns, cuts, infrared radiation, fire hazards, and toxic chemicals in some colorants and surface treatments. Precautions for using surface treatments are in Chapter 22 and for working with torches in Chapter 25, and some of the precautions at the end of this chapter.

SLUMPING AND FUSING

Glass slumping is the process of changing the shape of glass by heating it to temperatures exceeding 530 degrees Centigrade (1000 degrees Farenheit) so it will soften and bend under its own weight. Fusing is the process of heating pieces of glass together until they adhere.

These processes are usually done in electric kilns. Follow all precautions for using ceramic kilns including ventilation (see page 213).

Slumping hazards include burns and cuts, the use of colorants and surface treatments (see Chapter 22, Ceramic, Glass, and Enamel Surface Treatments), thermal shock shattering of improperly annealed glass or from fusing of incompatible glasses, and exposure to mold release powders, fiber paper, kiln washes and the like. Artists doing glass slumping may follow those Precautions for Glassworking (below) which are applicable.

The materials used for molds or to protect forms are of several types. Included are shelf primers, kiln washes, and ceramic fiber mats and papers. Most kiln washes and primers contain sources of free silica such as flint. Firing may convert the silica to more toxic cristobalite (see page 156). Obtain ingredient information and use suitable precautions. Avoid inhalation of dust from these materials and practice good dust control.

Avoid ceramic fiber mats and papers. These may be associated with asbestos-like illnesses, and after repeated firing they partially convert to crystobalite (see pages 157-158). Thin layers of refractory materials or insulating brick can be substituted in some cases.

PRECAUTIONS FOR GLASSWORKING

1. Plan studios with health and safety in mind. Floors should be cement or other noncombustible material. Walls should be fire resistant. Ceilings should be high enough to accommodate swinging blow pipes. Construct adjacent bathroom facilities and a walled-off recreation area. Artists should be able to clean up and retire to a clean room to drink fluids to replace those lost through perspiration, to rest, and the like.

2. Construct furnaces and other equipment from refractory brick and castables when possible. Avoid asbestos and ceramic fiber insulation. Wall off existing fiber insulation with brick or metal barriers. Repair or dispose of fiber-insulated equipment with precautions like those required for asbestos abatement. Follow all occupational and environmental regulations when disturbing, repairing, or disposing of asbestos-containing materials.

3. Plan fire protection carefully. Eliminate all combustibles from the area and provide a source of water on the premises. Do not install water sprinkler heads above furnaces, electric annealing ovens, and similar hot and/or high voltage equipment. Consult fire marshalls or other experts for advice on proper fire-fighting systems and/or extinguishers which meet local and federal safety codes. Post fire procedures and hold drills.

4. Provide excellent local exhaust for the furnace to remove heat and toxic gases. Gas furnaces will need both stack and canopy exhausts. Vent electric annealing ovens if fuming or lustre glazing is done in them.

5. Provide good general ventilation for the workspace to reduce heat. Follow rules to avoid heat stress and repetitive strain injuries (see page 39-40).

6. Provide local exhaust for any processes which create toxic emissions such as hot marvering of colorants, etching, or fuming (see Chapter 22, Ceramic, Glass, and Enamel Surface Treatments, page 248-249, for precautions for glass surface treatments).

7. Use cullet or second melt glass if possible to avoid the hazards of making glass. Handle shards of broken glass cullet with great care or purchase special "chain mail" types of safety gloves which protect glass handlers from cuts.

8. Obtain Material Safety Data Sheets, formulas and analyses of your glass-making and/or colorant ingredients. Look up their hazards and use the safest materials possible. Especially try to avoid highly toxic ingredients such as arsenic, antimony, cadmium, and uranium colorants, cyanide reducers, and fluorine compounds.

9. Avoid exposure to powdered glass ingredients or colorants. Weigh them

in local exhaust areas, outdoors, or use respiratory protection. Transfer them carefully to avoid creating dust. Clean up spills immediately. Prepare for spill control and chemical disposal.

10. Protect eyes by wearing infrared-blocking eyewear, which are also impact resistant, whenever looking at glowing hot materials, working with materials which might shatter, or whenever eyes are at risk. (See figures 4 and 5 pages 58-60.)

11. Wear protective clothing similar to welders'. For example, do not wear polyester or other synthetic fibers which will melt to the skin at high heat. Avoid pockets, trouser cuffs, and socks which can catch hot chips. Remove jewelry and tie back hair or wear a hair covering. Wear shoes with soles not easily penetrated by broken glass. Leave clothing in the studio to avoid tracking dusts home. Wash clothing frequently and separately from other clothes.

12. Take frequent work breaks when doing hot work and drink plenty of water (with one teaspoon of salt added per gallon if replacing water lost by perspiration). People with heart or kidney disease, who are very overweight, or who have impaired reflexes, dexterity or strength should not engage in glassblowing.

13. Avoid ingestion of materials by eating, smoking, and drinking in the separate facility outside the work area. Wash hands before eating, applying make-up, and other hygiene tasks.

14. Keep containers of cool water and/or ice handy for cooling tools and treating small burns. Have a first aid kit equipped with treatments for burns and cuts. Post and practice emergency procedures.

15. Practice constant good housekeeping to prevent cuts caused by stepping on broken glass. Never allow trip hazards in the work area.

16. Clean the studio with methods that do not raise dust such as wet mopping or hosing down.

17. Use polarized light sources or other equipment to check finished glass for stress and adjust annealing temperatures and time accordingly.

18. Dry grinding and polishing wheels also should be equipped with local exhaust. All wet and dry grinding and polishing wheels should have machine guards and face guards. Wear impact resistant eyewear when grinding.

19. Use wet grinding equipment rather than dry when ever possible. Wet grinding equipment should be cleaned while wet to avoid dust exposure. Water tanks should be cleaned often to keep microorganisms from establishing themselves.

20. Obtain Material Safety Data Sheets on grind wheels and abrasives. Avoid those containing silica and other toxic substances when possible.

21. Dispose of all grinding and polishing dusts, used chemicals, waste glass, and other materials in accordance with good hygiene and waste disposal regulations.

22. Always be prepared to provide your doctor with precise information about the chemicals you use and your work practices. Have lung function tests included in your regular physical examinations. If lead materials are used, arrange for regular blood tests for lead.

CHAPTER 20
STAINED GLASS

L ead poisoning is the major hazard in stained glass work. Lead is used in traditional stained glass to bind pieces of glass together in frames of lead came (channeled lead strips) or in lead-soldered seams coated with copper foil.

NEW MATERIALS

Traditional lead solder methods are likely be replaced in the near future. This is due to the increasing enforcement of lead laws and regulations in the United States and Canada. In the United States, the OSHA Lead Standard requires any workplace where lead is used more than thirty days per year to do air sampling. If lead found in these tests is above a certain amount (.03 milligrams per cubic meter), then regular air monitoring, medical surveillance, special ventilation, and many other costly provisions must be met.

Many glass studios could not afford to meet these standards. Fortunately, new lead-free solders developed for plumbing water pipes will work for stained glass purposes. They are not as easy to use, but more and more stained glass craftspeople are turning to them. In addition, it is likely that lead-free solders will be modified and improved in the near future.

Solders appropriate for stained glass work are made of silver, tin, copper, and zinc. Some lead-free solders contain antimony and these are too toxic. Lead- and antimony-free solders cost about twice what lead solders cost, but they are cheaper than the cost of meeting the lead laws.

Some craftspeople are also changing from lead came to channels of zinc and other metals. With these lead-free materials and certain other precautions, it even may be possible to do stained glass in schools and home workshops safely.

TRADITIONAL LEAD CAME AND SOLDER HAZARDS

Until better lead substitutes are available, traditional stained glass artists and production studio workers must consider the hazards of lead.

LEAD. Cases of lead poisoning among stained glass workers and hobbyists in the medical literature confirm the major hazard of this craft. In some cases, family members and children of stained glass hobbyists who did not work with lead were also poisoned. This phenomena is similar to that observed among the children and wives of industrial lead workers who were affected by small amounts of lead dust and fumes carried home on workclothes and shoes.

There are a number of ways stained glass workers and their families may be exposed to lead. For example, handling lead came will transfer small but significant amounts of lead oxides to the hands. This contamination can be transferred to clothing, food eaten while working, or to other people who are touched. Cutting the came and cleaning or polishing it with whiting creates tiny lead flakes and dust which can be blown or tracked into other areas.

Soldering can also result in contaminating the whole home or studio with lead. Iron soldering or torching solder seams (e.g., copper foil method) creates invisible lead fume which can remain airborne for hours and later may settle on surfaces at a considerable distance from the operation.

OTHER HAZARDOUS METALS. Traditional lead/tin solders may also be a source of other hazardous metals. A lot of these solders also contain significant amounts of highly toxic arsenic and antimony. These metals contaminate lead ore and still are present many in inexpensive solders.

Not only are the fumes of arsenic and antimony highly hazardous to inhale during soldering, but in contact with acids—such as the acid fluxes

or patina chemicals—they form extremely toxic arsine and stibine gas. Though the amounts of the metals and their gases may be small, their extreme toxicity can make exposure to them significant.

FLUXES. The solder fluxes themselves, such as zinc chloride and other acid fluxes, are skin, eye, and respiratory irritants. Rosin fluxes are not much used in stained glass work, but they can cause allergies and asthma. Fluoride fluxes are especially toxic and should be avoided if possible. For more detailed information, see Chapter 24, Metal Surface Treatments, Fluxes, page 257-261.

INSULATION. Asbestos board table tops, gloves, and other insulated materials may shed asbestos fibers during use. Replace these with asbestos substitutes such as refractory brick and polymer gloves. Do not use ceramic fiber products.

SURFACE TREATING CAME AND SOLDER

METAL COATINGS. Lead came and solder seams are often coated with other metals for the visual effect or to prepare them for treatment with patinas. Copper may be electroplated onto soldered seams from highly toxic chemical baths which may even employ cyanide (see Chapter 24, Metal Surface Treatments, Electroplating, pages 259-261). Or areas may be "tinned" to give them a coating of solder. Tinning solder fluxes usually contain fluorides and can be very hazardous to use.

Lead surfaces must be scrupulously cleaned in order to be coated with metal or patina. Some of these metal cleaners contain strong caustics, strong acids, chemicals which release hydrofluoric acid, or solvents including the glycol ethers (see Table 5, Common Solvents and Their Hazards, page 89).

PATINAS. Once the surface is prepared the patina can be applied. Patinas are generally of two types:1) those which react with the metal surface to form metal compounds such as sulfides or oxides, and 2) those which dissolve metal from the metal surface and replace it with a different metal deposited from the patina chemicals. Both types are composed of chemicals of varying toxicity and they usually produce toxic gases or vapors during application.

Common patina chemicals include copper sulfate and acid solutions which give off sulfur dioxide during use, selenium-containing patinas

which may give of highly toxic hydrogen selenide gas, patinas containing highly toxic antimony sulfide. (For further information, see Chapter 24, Metal Surface Treatments, Patinas, page 257 and Table 10, Hazards of Metals and Metal Compounds, page 135.)

WORKING WITH GLASS

Scoring and breaking glass is obviously a safety hazard. Hands and eyes are most at risk from injury. Other glass-shaping methods involve mechanical cutting and grinding for purposes such as beveling and precision cutting. Dry grinding methods produce dust which can be hazardous to inhale. Glass dust, like enamels and frits, may cause mechanical injury to tissues and may release their toxic elements in body fluids. For example, lead glass dust could be a source of lead poisoning.

Wet grinding, polishing, and cutting tools are safer. See page 245. Slumping and fusing glass also are covered in Chapter 19, Glass.

DECORATING GLASS

All glass, whether free blown, lampworked, slumped, fused, or cut for stained glass, can be decorated. There are many glass decorating methods including abrasive blasting (sand blasting), fuming, painting, hydrofluoric acid etching or frosting, and electroplating. The hazards of these procedures are described in Chapter 22.

PRECAUTIONS FOR STAINED GLASS WORK

1. Plan studios and shops with health and safety in mind. If lead will be used, the studio must be completely isolated and separate from living areas. Never allow children into areas where lead or other toxic chemicals are used. Floors and surfaces should be made of materials which are easily sponged and mopped clean.

2. Install ventilation systems appropriate for the work to be done. For example, provide local exhaust, such as slot vents or (if local codes permit) a window exhaust fan at work table level, for soldering, tinning, dry cleaning (with whiting), or polishing, applying patinas or any other operation which produces toxic emissions or dust.

3. Plan for fire safety. Install proper fire extinguishers and post and practice fire evacuation procedures.

4. Have electroplating done professionally, if possible. Otherwise have safety experts help plan and design studio equipment, ventilation, and emergency facilities.

5. If slumping and fusing are done, see Chapter 19, Glass, page 227. If glass painting is done, see Chapter 22.

6. Obtain Material Safety Data Sheets on all solders, abrasive grits and wheels, patinas and other products. Avoid solders and other products containing significant amounts of arsenic, antimony, or other highly toxic metals.

7. Substitute lead-free solders and cames whenever possible. If lead is used on the job, employers must be prepared to meet complex OSHA Lead Standard regulations in the United States or the OHSA Regulations respecting Lead in Canada.

8. Provide local exhaust ventilation for dry grinding and polishing equipment. Equip grind wheels with face guards. Remember, dust from grinding lead glass also can be a source of exposure to lead.

9. Use wet grinding, polishing and cutting methods whenever possible. Equipment should have face guards. Wet grinding equipment should be cleaned when wet to avoid dust exposure. Water reservoirs should be cleaned often to remove scum or other microbe growth.

10. Wear impact/dust goggles (see figures 4 and 5, pages 58-60) when cutting, grinding, or polishing glass.

11. Have first aid treatment handy for cuts and accidents. Post emergency procedures. Special "chain mail" types of safety gloves can be used for especially hazardous procedures.

12. Do not eat, smoke, or drink in the studio. Wash hands before eating, applying make-up, and other hygiene tasks.

13. Wear protective clothing such as a smock or coveralls, shoes and hair

covering. Leave work clothing, hair covering, and shoes in the studio to avoid taking dusts home. Wash clothing frequently and separately from other clothes.

14. Clean the studio with methods which do not raise dust such as wet mopping. Clean floors and sponge surfaces frequently. Clean up shards and scraps often.

15. Replace or encapsulate all asbestos materials and insulation. Follow all health, safety, and environmental protection regulations whenever disturbing, repairing or disposing of asbestos or asbestos-containing materials.

16. Read product literature, Material Safety Data Sheets, and other information on metal cleaners and patinas carefully. Many will require special gloves, goggles, ventilation, and respiratory protection. Follow Material Safety Data Sheet advice and have materials on hand for spill control and chemical disposal.

17. Dispose of all grinding and polishing dusts, spent or neutralized acids and other chemicals, waste glass and other materials in accordance with health, safety, and environmental protection regulations.

18. Always be prepared to provide your doctor with precise information about the chemicals you use and your work practices. If lead is used, arrange for regular blood tests for lead. Keep your tetanus immunization up-to-date.

CHAPTER 21 *ENAMELING*

Enamelers are exposed to several hazards including infrared radiation, acids, powdered glass enamels. Enameling is usually done on copper, silver, or gold. However, there are enamels for other surfaces including steel, aluminum, ceramic, and glass.

WHAT ARE ENAMELS?

Enamels are essentially powdered colored glass frits (see frits, pages 156-157). The glass-making frit ingredients may include silica, borax, lead compounds, lithium compounds, and other fluxes. The enamel colorants and opacifiers may include many different metal salts.

It is possible for artists to manufacture their own enamels from these materials. However, grinding and mixing these raw chemicals is hazardous. Commercially manufactured enamels are safer and easier to obtain and use.

The composition of the enamel will determine the material to which it can be fused (depending on its coefficients of expansion with heat). Most art and craft enamels are designed to remelt at low temperatures (730 degrees Centigrade, 1350 degrees Farenheit) and to adhere copper or silver.

LEAD-BEARING AND LEAD-FREE are the two major types of enamels. Lead-bearing types are the most common and can cause lead poisoning. Lead-free enamels are often borosilicate glass and usually only their

colorants are hazardous. However, neither type is suitable for use with children since they are both ground glass and most contain some toxic metals.

COLORANTS AND OPACIFIERS are metal compounds which usually are fused into frits during manufacture. Enamel manufacturers' rarely divulge the identity of these chemicals.

Common colorants include cadmium, cobalt, copper, manganese, antimony, selenium, chrome, and nickel. Most opaque lead enamels are opacified with arsenic. In the past, manufacturers used radioactive colorants such as uranium and thorium. Examples include Thompson's Forsythia and Burnt Orange enamels, which have been discontinued. Sale of radioactive enamels now is banned in the United States. Old stocks of such enamels should be discarded.

ENAMEL SOLUBILITY

Some enamels are so soluble in water that they dissolve (degrade) even in humid air. These enamels are easily recognized as those which must be washed before use or else they will produce cloudy or otherwise inferior results. These are the most soluble types, but all enamels are soluble in varying degrees (see Frit Solubility, page158). For this reason, all enamels that contain toxic metals should be treated as very toxic materials.

Finer particles of enamel dust present more surface area and, hence, are more soluble and toxic. Although most enamels are sieved to 40 or 80 mesh (too large to be airborne), much finer particles are also present in the enamel. These can be seen as a dust which floats up when enamels are transferred from one container to another.

Once fired, enamels usually are too soluble to be used for eating utensils. Lead, cadmium, barium, and other toxic metals can leach into food or drink. Have enameled utensils tested as you would ceramics if you wish to use or sell them (see page 215).

ENAMELING HAZARDS

Enameling is potentially hazardous during 1) application of enamels, 2) kiln firing, 3) preparation of metal to receive enamels, 4) soldering, and 5) during many specialty processes such as hydrofluoric acid etching of fired enamels, and electroplating.

These processes are used with many different enameling techniques.

Some of these include cloisonne (soldered wires separate colors), champleve (enamels fired in acid-etched depressions), basse-taille (etched, engraved, chased, or stamped metal covered with layers of transparent enamels), pallion (fusing gold or silver foil into enamel), grissalle, limoges, plique-a-jour, repouse, and sgraffito.

APPLICATION. The degree of hazard during enamel application is related to the degree to which the enamel can be inhaled or contaminate hands, hair, or clothing. Least hazardous are methods that do not raise dust such as wet charging damp enamel with spatulas, or dipping and painting enamels that are mixed with resin and solvents (here the hazards are primarily the solvent vapors). Far more hazardous methods include dusting the powder onto the metal by hand or through a screen, and spraying or air brushing enamels.

The hazards of various enamel adhesives and fixatives are related to their composition and the degree to which the user is exposed to these ingredients. Spray products containing solvents are the most hazardous and should be used with local exhaust ventilation. Obtain ingredient information and use accordingly.

Grinding and polishing of fired enamel surfaces is often done with carborundum or other abrasives under water. Such methods do not raise dust, but waste enamel material should be discarded carefully.

KILN FIRING. Toxic metal fumes from enamel ingredients may emanate from kilns, especially if enamels are over-fired or if bits of enamels flake onto kiln furniture or elements. During the firing process heat can cause burns, and long term exposure to infrared radiation can cause cataracts.

METAL PREPARATION. The metal surface that is to be enameled must be prepared to receive enamel. Metal preparation techniques include cleaning, pickling, etching, engraving, chasing, grinding, filing, and more.

CLEANING is done to prepare metal for enamels and to remove fire scale. Mechanical methods of cleaning metal can be done with pumice, steel wool, wire brushes, or buffers. These methods are the safest.

PICKLING hot metals in acid solutions is a more hazardous way of cleaning metal. Acid vapors constantly rise from acid baths. During pickling, still greater amount of vapors and mists are created.

Pickling solutions are usually dilute sulfuric acid, nitric acids, or solu-

tions of sodium bisulfate. Some commercial jewelry cleaning methods employ cyanide solutions. Cyanide solutions should never be used. Sodium bisulfate (often sold as Sparex) is the least hazardous, but it, too, releases irritating vapors.

ACID ETCHING for techniques such as champleve' is especially hazardous. Nitric acid is commonly used to etch copper. This method liberates highly dangerous nitrogen dioxide gas, which, when inhaled, can cause serious lung damage, including chemical pneumonia. Hydrochloric acid also etches copper, but can be replaced with ferric chloride solutions. Ferric chloride etching is slower, but considerably safer.

OTHER PROCESSES such as engraving, chasing, grinding, buffing, and cutting may be done. Machine tools can be purchased that have guards and exhaust ventilation connections. Cutting, engraving, and similar processes can result in cuts, eye injuries, and the like.

Further information on the hazards of these and other metal working processes may be found in the Chapter 24, Metal Surface Treatments.

SOLDERING creates metal fumes and emissions from fluxes. Lead, gold, and silver solders are commonly used in enameling. Lead fume is very hazardous. Silver and gold solders often contain cadmium, which is released as cadmium fume when heated. Cadmium in this form is associated with lung and kidney damage and lung cancer. Cadmium-free silver solders usually contain antimony, which is somewhat less toxic but still can cause serious health effects (see Table 10, Hazards of Metals and Metal Compounds, page 135).

Fluxes for soldering may be zinc chloride and other chlorides, fluoride compounds, or organic resins such as rosin. Of these, fluoride fluxes are most acutely toxic and cause long term hazards such as bone and tooth defects. Zinc and other chloride fluxes release respiratory irritants. Rosin is known to cause allergies.

OTHER TECHNIQUES such as creating matte or etched enamel surfaces with hydrofluoric (HF) acid is a occasionally done. Paste forms of HF are safer than liquid acid solutions. Follow all HF precautions (see page 247).

Electroplating of metal enamel pieces with gold, copper, and other metals is also done. Cyanide plating baths are too toxic for use by most artists. The hazards of other bath chemicals should be researched carefully before embarking on plating.

PRECAUTIONS FOR ENAMELING

1. Choose a studio location that is compatible with all necessary fire protective equipment and ventilation needed for the type of enameling you will do. Never locate studios in or near living or eating areas. Floors and surfaces should be made of materials that are fire resistant and easily mopped and sponged clean.

2. Provide all kilns with ventilation such as recessed canopy hoods, or place them near a window exhaust fan.

3. Keep areas around kilns and other hot processes free of flammable and combustible materials. Sufficient work space should be provided around kilns. Fire extinguishers or other approved fire control equipment should be installed. Post and practice emergency fire procedures.

4. Replace or encapsulate all asbestos pads, gloves, kiln insulation, and other materials. Follow all health, safety, and environmental protection regulations whenever disturbing, repairing, or disposing of asbestos or asbestos-containing materials. Do not use ceramic fiber insulation.

5. Provide sufficient space around kilns for user to work safely and comfortably.

6. Protect against burns by wearing asbestos-substitute or leather gloves. Avoid wearing synthetic clothing, loose sleeves, or other items which could melt, burn, or catch fire from radiated heat. First aid kits should be stocked with appropriate thermal burn treatments. Post emergency burn treatment procedures.

7. Wear protective clothing such as a smock or coveralls and work shoes. Leave shoes and work clothing in the studio to avoid taking dusts home. Wash work clothes frequently and separately from other clothes.

8. Protect eyes during firing with infrared-blocking goggles. Welding goggles of shades 2-6 will work but they may be too dark to see enamel fuse. Use lightly colored goggles designed specifically to block infrared. (see Figures 4 and 5, pages 58-60).

9. Do not eat, smoke, or drink in the studio. Wash hands before eating,

applying make-up, and other hygiene tasks.

10. Investigate the composition of your enamels, fixatives, and all other products you plan to use by obtaining Material Safety Data Sheets and other product information from suppliers.

11. Choose the safest enamels. Lead-free should be chosen over lead-based. Reject enamels colored with radioactive metal salts. Avoid, or handle with extra care, enamels colored with highly toxic metals such as arsenic and cadmium.

12. Examine methods of applying enamels and choose those which control dust best and employ the least toxic adhesives, fixatives, etc. Wash enamels if possible. Dusting, spraying, or air brushing methods should be avoided or only done in local exhaust.

13. Clean up enamel spills immediately. Use wet cleaning methods to avoid raising dust. Do not allow dust to remain on floors to be tracked into other areas.

14. Select metal cleaning and pickling, methods which can be done safely in your studio. Mechanical hand-rubbing with steel wool or pumice is the safest method. Never use cyanide cleaning methods. Sodium bisulfate (Sparex) is one of the least hazardous pickles. If acids or Sparex are used, follow precautions for acids (see next rule).

15. Use of acids requires installation of eye wash fountains. Emergency showers must be installed if large amounts of strong acids (more than a quart) are stored or used. Acid baths for cleaning, pickling, or etching require local exhaust (such as chemical fume hoods or placing baths in front of a window exhaust fans). Respirators equipped with acid-gas cartridges may be worn as back-up to ventilation for most acids except nitric acid. Other personal protective equipment includes chemical splash goggles, aprons, and gloves.

16. Stock first aid kit with appropriate acid burn treatments. Post first aid and emergency procedures.

17. Prepare for spills of acids and other chemicals in advance with supplies of neutralizing chemicals, absorbants, etc. Spills of some kinds of

acid and other chemicals must be reported to local environmental authorities. Check federal and local (state, provincial, municipal) regulations.

18. Have especially hazardous work such as electroplating done professionally off-site when possible. Otherwise, have safety experts help plan and design studio equipment, ventilation, and emergency facilities for hazardous processes.

19. If soldering is done, provide local exhaust ventilation—work close to a window exhaust fan or on a slot vented table. Obtain reliable ingredient information on solders and choose the safest ones. Avoid solders containing cadmium, arsenic, and antimony. Avoid fluorine fluxes when possible.

20. All dry buffing and grinding wheels require machine guards, face guards, and local exhaust ventilation. Heavy equipment also needs lock-out mechanisms. Impact resistant goggles should be worn when working.

21. Obtain Material Safety Data Sheets on abrasive grits and wheels. Choose those free of silica and other toxic minerals when possible.

22. When sawing, cutting, and doing other mechanical metal work, keep tools sharp and employ safe techniques. Stock first aid kit with supplies to treat cuts and abrasions.

23. Dispose of all spent or neutralized acids, waste enamels, and grinding, polishing dusts, and the like in accordance with health, safety, and environmental protection regulations.

24. Do not make enameled items for use with food or drink unless the piece has passed laboratory tests for release of toxic metals. Other pieces should have the warning "not for use with food, for decorative use only" fired permanently on the bottom.

25. If lead is present in solders, enamels, or any enameling materials, arrange for regular blood tests for lead. Always be prepared to provide your doctor with information about the chemicals you use and your work practices.

CHAPTER	*CERAMIC, GLASS,*
22	*AND ENAMEL SURFACE TREATMENTS*

CERAMIC, GLASS, AND ENAMEL SURFACE TREATMENTS

The surfaces of ceramics, glass, and enamels can be treated in many ways to produce artistic effects. Some of these treatments are hazardous.

CUTTING AND GRINDING

These methods can be used for purposes such as beveling, cut glass techniques, and incising. Dry grinding and cutting wheels and tools produce dust which can be hazardous to inhale. Dust from glass, enamels, and glazes may cause mechanical injury to tissues and may release their toxic elements in body fluids. For example, dust from grinding lead glass or glazes can be a source of lead poisoning. Dust from grinding fired ceramics contains silica (cristobalite-see pages 155-156).

Wet grinding, polishing, and cutting tools are safer. But some produce dust-containing water mists which are hazardous to inhale. Water reservoirs also may become contaminated with disease-causing microorganisms that can be inhaled with the mist. Running water lubrication systems are more sanitary.

ABRASIVE BLASTING

This method is currently a popular decorating technique. Hand-held blasting guns and enclosed cabinet blasting are two methods in use. Both direct a blast of abrasive material against a surface to etch it or clean it. Common abrasives include sand, metal, slag, garnet, aluminum oxide, silicon carbide, glass bead, and organic substances such as walnut shells, sawdust, apricot pits, plastic, and the like. See Table 13, Hazards of Common Minerals Used in Ceramics, Sculpture, Lapidary, and Abrasives, for the hazards of common abrasives.

Sand or other sources of free silica should not be used for abrasive blasting because it is such a serious health hazard. Abrasive blasting with sand produces large amounts of very fine silica dust that has been shown to cause a type of rapidly developing silicosis (acute silicosis), which can be contracted in as little as a few weeks of exposure and is usually fatal within a year or two. For this reason, sand blasting is outlawed in European countries (not in the United States and Canada).

Regardless of the toxicity of the abrasive, all inert dusts are hazardous in quantity. Protective measures must be devised. One method is to use blasting cabinets, which are sealed and kept under negative pressure. In this case the user needs no additional protective gear except when dust is released during processes such as changing the abrasive. However, the cabinet will only provide protection as long as it is well-maintained. Unfortunately, it is common to see blasting cabinets in schools and studios in poor repair and leaking toxic dusts.

Hand-held blasting equipment usually requires the user to wear protective gear and work in an isolated or outdoor environment. Protective gear for large work may include air-supplied respiratory protection, eye protection, gauntlet gloves, and protective clothing and shoes.

FUMING

Fuming metallic salts (usually chlorides) onto surfaces to create an iridescent look is a technique popularized by Tiffany. It is the process of depositing a thin layer (only a molecule or two) of metal on the glass surface which give an "oil on water" appearance. Different metals will produce different colors. Metals that have been used in fuming include tin, iron, titanium, vanadium, cadmium, and uranium.

Fuming can be done by introducing the metal compounds into an annealing oven or by spraying a water solution of the chlorides and ac-

ids onto surfaces when hot. Both methods cause the metal compounds to fume and to dissociate. The resulting emissions are highly irritating to the respiratory system and eyes. Cadmium and uranium are too toxic for use in this manner by studio artists. Vanadium is also very toxic and probably should not be used. Superb ventilation is needed for these processes.

PAINTING

Painting on glass and ceramic surfaces can be done with a number of materials. Some "glass paints" are really enamels fired onto glass. These paints are usually lead frits and metal colorants whose dust can be hazardous. Some are premixed in solvents and tack oils. See Chapter 21, Enameling, page 241, for precautions.

Lustres or metallic paints, which are similar to lustre glazes, contain metal alloys and compounds. Some may even contain amalgams of mercury. Often these are mixed with solvents and oils. See Chapter 18, Ceramics, page 211.

Glass stains are usually silver nitrate, gamboge, water and gum arabic. Mirroring is done with solutions containing ammonia, silver compounds, and reducing compounds such as rochelle salts.

Vapors given off during painting of solvent-containing paints and lustres are toxic. Silver nitrate can cause skin burns and can damage the eyes. The emissions during firing of paints and enamels include metal fumes and decomposition products of organic chemicals such as tack oil, gum arabic, etc.

There are also new glass and ceramic paints which do not need firing. These are polymer materials which dry to look like glazes or enamels. Most contain toxic solvents which can be inhaled during painting.

Sometimes paints and lustres are silkscreened onto surfaces. The resists can be photo etched. Many of the solvents, emulsions, and cleanup materials for these processes are toxic. See Chapter 29, Photography and Photoprinting, for the hazards of photo chemicals.

ETCHING

Etching or frosting with hydrofluoric acid (HF) is one of the most hazardous processes in surface decorating. HF is insidious because it does not cause pain on contact. Later, often hours later, severe pain onsets, indicating that the acid has penetrated the skin and is destroying tissues deep beneath the point of entry. Surgery and amputation are sometimes needed.

In addition, the absorbed fluorine from the acid can cause systemic poisoning. As little as a half cup of this acid spilled on a person has resulted in death.

Vapors rising from an HF acid bath can seriously damage lungs, causing chemical pneumonia. Long term exposure is associated with kidney, liver, bone, and tooth damage.

Etching surfaces of glazes, enamels, or glass that contains arsenic and/or antimony can result in the formation of extremely toxic arsine and stibine gases. Though the amounts of the metals and their gases may be small, their extreme toxicity can make exposure to them significant.

Etching creams which release HF on contact with the glass are less hazardous but also can cause burns. Material Safety Data Sheets for some of these products are deceptive because they list the two major ingredients without making it clear that the combined chemicals release HF.

Treatments for HF burns from either liquid or paste products should be handy and personnel taught how to use them. Recommended treatments include iced ethanol or iced Zephiran chloride. A doctor or poison control center should be contacted immediately.

Local exhaust ventilation, chemical splash goggles, gloves and other precautions are needed. However, artists planning to use liquid HF must consult experts in planning studio precautions rather than relying on this or any other book's short treatment of this subject.

ELECTROPLATING/ELECTROFORMING

Although these techniques are usually done on metals, they can also be applied to ceramics, enamels and glass under certain circumstances (see Chapter 24, Metal Surface Treatments, pages 259-260 for details)

SPECIAL PRECAUTIONS FOR SURFACE TREATMENT PROCEDURES

1. Obtain Material Safety Data Sheets and other reliable ingredient information on surface treatment chemicals. Material Safety Data Sheets often will recommend the use of special gloves, goggles, ventilation, and respiratory protection. Follow Material Safety Data Sheet advice and have handy materials for spill control and chemical disposal.

2. Use Material Safety Data Sheet information to try to avoid products containing lead, hydrofluoric acid, and other highly toxic ingredients whenever possible.

3. Also obtain detailed information about the surface to be treated. Avoid treating or acid etching surfaces of glazes, enamels, or glass containing significant amounts of arsenic, antimony, or other highly toxic metals. These metals may volatilize from the surface during some treatments. Blasting such surfaces creates highly toxic fine dust.

4. Provide excellent ventilation, such as slot vents or a window exhaust fan at work table level, for dry cleaning (with whiting), or polishing, applying acids, or any other operation that produces toxic emissions. Dry grinding and polishing equipment should have built-in local exhaust systems.

5. Use wet grinding, polishing, and cutting methods whenever possible. Wet grinding equipment should be cleaned when wet to avoid dust exposure. Water reservoirs should be cleaned often to remove scum or other microbe growth.

6. Have highly hazardous processes such as HF acid etching or electroplating done professionally, if possible. Otherwise have safety experts help plan and design studio equipment, ventilation, and emergency facilities.

7. Dispose of all neutralized acids, grinding dusts, spent abrasives and other waste materials in accordance with health, safety, and environmental protection regulations. Some wastes containing only relatively small amounts of highly toxic chemicals such as fluorides and arsenic can be very expensive to dispose of properly.

CHAPTER 23 | *SCULPTURE, LAPIDARY, AND MODELING MATERIALS*

S tone, cement, plaster, self-hardening clays, plasticine, wax, and papier mache are commonly used to sculpt and model. Most of these traditional materials can be used safely when appropriate precautions are taken.

STONES

Many stones used in sculpture and lapidary are the same minerals that are used in ceramics, glass, and as abrasives. For example, flint, steatite, dolomite, and fluorspar stones can be used for sculpture. When these same stones are ground to a powder, they can be used to make ceramic glazes and glass. For another example, garnet may is used as both a gem and a sand paper abrasive.

Artists are exposed to dust and flying chips when stones are shaped for sculpture or lapidary work by chipping, carving, grinding, and polishing. These operations can be done by hand or with electric tools. Electric tools produce large amounts of dust. Hand operations are the least hazardous, but flying chips still can damage eyes.

In addition, hand tools can slip and large stones can fall to cause injuries. Lifting heavy stones and tools can lead to strain injuries.

Electric tools also are associated with vibration syndrome or "white fingers" disease. It is a progressive circulatory system disease which constricts flow of blood to the hands (sometimes also to the feet) causing pain

and numbness (see page 37). Noise from percussive hammering, electric tools, and other equipment also can damage hearing (see page 35).

The toxicity of dust from sculpture stones varies. Some stones contain significant amounts of asbestos. These are too hazardous to use under the conditions found in craft and sculpture studios. Other stones may contain hazardous ingredients, including free silica, talc, or caustic metallic compounds.

In order to choose stones whose dust will be the least toxic, artists need both chemical and mineral analyses of the stones, including the amounts of impurities in them. Abrasives used in grinding and polishing stone may also produce hazardous dusts. The hazards of many common minerals used in sculpture, lapidary, and abrasives are listed in Table 13.

CEMENT

Cement is a mixture of fine ground lime, alumina, and silica which will set to a hard product when mixed with water. Other chemicals commonly found in cement include various iron compounds, traces of chrome, magnesia, sodium, potassium, and sulfur compounds.

In addition to these naturally occurring contaminants, there are many substances added to cement to improve adhesion, strength, flexibility, curing time, and water evaporation. Usually these are plaster, various plastic resins, and latex solids.

The primary hazards of cement are skin and respiratory irritation from the alkaline compounds. Skin burns are a common problem among cement workers and severe ulcers can develop from contact with wet cement.

Allergies to cement dust are also commonly seen in cement workers. A major cause is reaction to small amounts of chrome compounds in some cements. Some researchers also feel that the statistically significant number of cases of lung cancer seen among some workers is caused by chrome (hexavalent type) in cement.

PLASTER

Plaster or plaster of paris is calcium sulfate. It occurs in nature as gypsum and as alabaster. Plaster dust is irritating to the eyes and slightly irritating to the respiratory system. Plaster may also contain additives such as lime which make the dust more irritating. Ventilation or respiratory protection should be used to avoid exposure to excessive amounts of dust.

Heat is produced during the setting reaction. Severe burns have resulted when children and adults cast their hands in plaster.

RULES FOR WORKING WITH STONE, CEMENT, AND PLASTER

1. Wear impact/dust goggles when shaping or chipping materials. See figures 4 and 5, pages 58-60.

2. Wear steel-tipped shoes with heavy materials or equipment.

3. Move all heavy stones and objects safely (see page 40).

4. Obtain mineral and chemical analyses of sculpture stones. Good Material Safety Data Sheets will include this data. Use the least toxic varieties which meet your artistic needs. Avoid stones containing asbestos or radioactive elements.

5. Purchase electric grinding and polishing tools that are equipped with local exhaust connections for removing dust from the studio. To control other sources of dust, practice good hygiene and clean up.

6. If respiratory protection is needed, match the respirator filters to the type of dust produced. Do not expect air-purifying respirators to contend with heavy amounts of dust (over 10 times the Threshold Limit Value). For high dust level, air-supplied respirators may be needed.

7. Avoid skin contact or wear gloves when working with wet cement.

8. Purchase electric tools with low vibrations amplitude and comfortable hand grips. Do not grip tools too tightly, take frequent work breaks, and do not work in cold environments to reduce risk from vibration syndrome.

9. Purchase quiet tools and exhaust fans, or wear hearing protection (see pages 35-37).

10. Do not cast body parts in plaster unless provisions are made for dissipation of heat. There should also be a barrier of vaseline or similar material between the skin and any casting material.

MODELING MATERIALS

Modeling can be done with many products including nonhardening clays such as plasticine, air-setting and oven-setting clays, papier mache, and wax. (The hazards of sculpture clays such as terra cotta are the same as those of ceramic clays—see Chapter 18, Ceramics.)

SELF-HARDENING AND POLYMER CLAYS. The hazards of self-hardening and oven-setting polymer clays are very complex. Most manufacturers of these products will not reveal all of their contents. However it is known that most are clay mixed with plastic resin materials that contain hardening agents and plasticizers. Self-hardening clays harden in the presence of air.

Polymer clays (See Appendix I, ACTS FACTS) are designed to be cured in kitchen ovens and similar heating devices. They contain vinyl plastic and additives including about 15 percent plasticizer. For many years the plasticizer in these products was DEHP, a probable human carcinogen (see Chapter 13, page 173). In two of the popular products, DEHP was replaced by very similar chemicals which have never been tested for cancer effects. Unfortunately, labeling laws permit such products to be labeled "non-toxic."

Products containing untested chemicals should not be used by pregnant women and children. Adults who choose to use polymer clays should use them in studios which are separate from living areas. Good hygiene and hand washing should be employed. The clay should be cured in an oven or heating device which is never used for food and whose emissions are vented outside.

NONHARDENING CLAYS, such as plasticine, are usually made of clays mixed with oils and petrolatum. Other ingredients may include sulfur dioxide and other preservatives, vegetable oils, aluminum silicate, and very small amounts of turpentine. The colored clays contain pigments or dyes.

A few reports of skin allergies and respiratory symptoms have been reported among users of plasticine due to the presence of turpentine or when too much sulfur dioxide preservative has been added. In general, however, these are usually very safe materials. Discontinue use if skin or respiratory reactions occur.

WAX used for modeling is relatively safe to use unless it is heated to the point where a "hot wax" odor or smoke is noticed. This is evidence of the creation of many toxic and irritating compounds including acrolein and formaldehyde. Acrolein is an exceedingly potent lung irritant for which there is no suitable air-purifying respirator. Ventilation must be provided. Processes which require ventilation include lost wax casting, sculpting wax with hot tools, ironing out batik wax, heating wax for ceramic glaze resists, and candle making. (See Appendix I, ACTS FACTS.)

PAPIER MACHE that is formed of plain paper pieces and white glue has no significant hazards. It would only be hazardous if paper with toxic inks or an unsafe glue were used.

Powdered or instant papier maches, however, may contain very hazardous ingredients. Many paper mache powders, even those for children, used to be asbestos/glue mixtures. Some products still may be made with asbestos-contaminated talcs.

Now some papier mache powders are ground up magazines mixed with glue and fillers. The problem with these products is that slick magazine paper contains talc and other fillers, and the inks may contain lead, cadmium and a host of organic pigments of varying toxicity. Although the amounts of the toxic chemicals are fairly small the materials are usually ground so fine that considerable amounts can be inhaled.

To use papier mache safely, obtain reliable ingredient information and choose the safest product. There are good papier mache products that employ ground clean (uninked) cellulose. Avoid inhaling dust by providing ventilation for any mixing or sanding operations.

CHAPTER 24

METAL SURFACE TREATMENTS

Metals can be treated by many processes that also are used for nonmetal surfaces (see Chapter 22, Ceramic, Glass, and Enamel Surface Treatments). For example, metals can be etched and photo-etched, abraded and sandblasted, or painted. This chapter will consider procedures which are used primarily on metal surfaces including cleaning and degreasing, applying patinas, using fluxes, electroplating and annodizing, gilding, and niello work.

CLEANING AND DEGREASING

Metals must be very clean if solders are to adhere, if patinas are to take, and so on. Metals must be cleaned again after soldering, brazing, forging and similar processes, to remove flux residues, fire scale, and the like. For these purposes, many different metal cleaners are used.

Most metal cleaners and degreasers are solvents, hydroxides, ammonia, acids, or combinations of these. Other cleaners for metals include hand-rubbed abrasives such as putty and whiting, or Sparex and other acidic solutions for cleaning fire scale off hot metals. Cyanide cleaners also are used for cleaning cast metal. The hazards of these types of cleaners are listed in Table 19.

PATINAS AND METAL COLORANTS

Patinas and metal colorants usually employ very toxic chemicals. Toxic gases and vapors may be emitted during the reaction with the metal as well.

One of the most common colorants is liver of sulfur (potassium sulfide). When applied to metals this compound will darken the metal and release highly toxic hydrogen sulfide gas. This gas can be identified by its "rotten egg" odor. Many of the patinas and colorants rely on sulfides and similar reactions may occur.

When planning to use patinas, research the hazards of both the patina and the byproducts of its reaction with metals. Be aware that some patina Material Safety Data Sheets do not list the hazardous byproducts created during use of the product. The hazards of some common patinas and metal colorants are found in Table 20.

FLUXES

Many fluxes today are very complex mixtures of chemicals. Many types of chlorides, fluorides, and borates may be found in fluxes. Organic fluxes may contain a variety of organic chemicals including stearic acid, glutamic acid, oleic acid, other fatty acids, and organic amines and organic sulfates. Rosin fluxes may be "activated" with bromides and hydrochlorides. There also are other compounds which are used in vehicles such as petroleum gel, polyethylene glycol, alcohols, and water.

Some of these compounds are toxic in and of themselves. And all of them release irritating or toxic emissions when they are used. The plume of smoke rising from soldering or brazing should be considered toxic.

Fluxes can be categorized by their main ingredients into the following groups:

ACID fluxes (and acid core solders) usually are chlorides of zinc, ammonium or other matals.

BORAX fluxes containing boron compounds.

FLUORIDE fluxes containing fluoride compounds.

ORGANIC fluxes containing fatty acids.

ROSIN fluxes (and rosin core solders) contain pine rosin (colophony).

A number of the chemicals in these fluxes and their hazards are listed in Table 20. In general, acid fluxes are the safest to use for most art processes and fluoride fluxes are among the more hazardous.

RULES FOR USING DEGREASERS, PATINAS, AND FLUXES

1. Protect skin and eyes by wearing gloves, aprons and chemical splash goggles when handling acids, caustics, solvents, and other irritating chemicals. Install eye wash fountains near where they are used. If large amounts of caustics or acids are used, install emergency showers.

2. Provide local exhaust ventilation by working in front of a window exhaust fan, a slot hood, or a similar system. (Most degreasers, patinas, and fluxes give off toxic gases and vapors.)

3. Choose the safest materials by comparing Material Safety Data Sheet information. In general, acid fluxes are the least toxic. Avoid fluoride fluxes if possible. Try to avoid patinas containing sulfides (which release hydrogen sulfide gas). Avoid cleaners containing cyanides.

4. Follow directions for use carefully.

5. Never mix different types of fluxes. Some mixtures can produce especially toxic emissions and most will not perform properly. Never mix different cleaners or patinas unless you understand fully the chemical reactions which may occur.

6. Remove all residue from degreasing before soldering or heating metal (some will release highly toxic gases such as phosgene on heating).

ELECTROPLATING AND ANODIZING

Electroplating relies on depositing a metal out of an electrolyte solution by running a current from a metal anode to the object to be plated which acts as a cathode. Even materials which do not conduct electricity can be made to plate by sealing them with wax or lacquer and then coating them with a conductive material like graphite or metal paint. This process is often called "electroforming."

Anodizing is an electrolytic process in which certain metals (aluminum, magnesium, and several others) that naturally produce a film of metal oxide on their surfaces can be made to accept even thicker and more stable metal oxide coatings. A number of different metals can be employed to produce the coating including titanium and niobium. These metallic

oxides also will accept dyes and pigments making it possible to obtain finishes in many colors including black. The lustre of the underlying metal gives the coating a metallic sheen.

Many different electrolytic solutions are used in plating and anodizing. Copper can be plated from a solution of copper sulfate and sulfuric acid. Many other types of plating such as gold and silver employ cyanide solutions. Anodizing electrolytes are usually sulfuric, oxalic and chromic acids.

Sulfuric, oxalic, and chromic acid baths are highly irritating to skin, eyes, and respiratory system. Cyanide baths are moderately toxic by skin contact and highly toxic by inhalation or ingestion. Acid, heat, even carbon dioxide from the air will cause the formation of deadly hydrogen cyanide gas from cyanide solutions. Acute inhalation of either cyanide salts or hydrogen cyanide gas can be fatal.

Before being treated, metals must be scrupulously cleaned. Skin and eye damaging cleaners are used such as caustic soda and other hydroxides (see Table 19, Metal Cleaners and Degreasers). Once in the bath, large electrical currents are applied which can cause electric shocks. If lacquers or metal paints are used, these may contain toxic solvents.

PRECAUTIONS FOR ELECTROPLATING AND ANODIZING

1. Protect skin and eyes by wearing gloves, aprons and chemical splash goggles when handling acids, caustic soda, and solvents. Install eye wash fountains. If large amounts of caustics or acids are used, install emergency showers.

2. Try to avoid using cyanide salts. If they must be used, consult safety experts when designing and installing equipment and local exhaust ventilation for the baths. Train all personnel about the hazards and emergency procedures. Keep a cyanide antidote kit available (if someone on staff is qualified to use it) or notify the local hospital to be prepared for cyanide poisoning. If local hospitals are not prepared, a cyanide kit should be taken with a victim to the hospital.

3. Avoid spraying lacquers or solvent-containing paints. If they must be sprayed, use a spray booth or wear a proper respirator.

4. Instruct all personnel about electrical hazards. Install ground fault interrupters and other electrical safety features.

5. Look up the hazards of the metals and metal compounds used (see Table 10, Hazards of Metals and Metal Compounds, page 135), especially some of the rare metals employed in some anodizing procedures.

GILDING

Metal gilding (as opposed to goldleaf gilding of wood and plaster) may be done with gold and silver amalgams. The amalgams are made by mixing or heating mercury and gold or silver together. The amalgams are applied to the metal and heated until the mercury vaporizes, leaving the gold or silver on the surface.

This gilding method is not recommended for studio work. Mercury is highly toxic and can be absorbed by the skin and the vapor inhaled (see Table 10, Hazards of Metals and Metal Compounds, page 135). If the method is used, first investigate and comply with all applicable toxic substance regulations. Avoid skin contact with mercury and heat mercury amalgams only under excellent local exhaust ventilation.

Work on a tray or on a surface designed to contain spilled mercury. Since mercury vaporizes at room temperature, it must be stored in sealed containers. When in use, constant ventilation must be provided. Mercury spills must be scrupulously cleaned up. Small amounts of spilled mercury left in sink traps or floor cracks can produce significant amounts of mercury vapor.

Mercury spill kits containing ferric chloride or other chemicals which will react with mercury should be available. Do not vacuum (except with vacuums specially developed for mercury spills).

NIELLO

In this process, silver, copper, and lead are melted and poured into a crucible with sulfur. The mixture is remelted, sintered, and ground finely. Then it is mixed with ammonium chloride into a paste, applied to the metal, and heated.

Lead poisoning can result from inhaling lead fumes during heating or lead sulfide dust during grinding of the mixture. All procedures should be done in local exhaust. A proper dust mask should be worn when dealing with the powder and excellent hygiene should be practiced.

TABLE 20	Metal Cleaners and Degreasers

ACIDS such as hydrochloric, sulfuric and nitric acid are used in some metal cleaners. These are highly irritating, can damage eyes, skin, and respiratory system, and should not be mixed with other cleaners unless it is known they will not react.

AMMONIA is a respiratory irritant and may be found in both solvent and hydroxide cleaners. Ammonia can react with bleach and inorganic acids such as hydrochloric acid to release highly toxic gases. Care should be taken not to mix ammonia-containing products with acid cleaners, fluxes and acid-containing patinas, or with scouring powders that contain dry bleach.

CYANIDE cleaning mixtures are in common use in the jewelry industry for cleaning cast metal. Cleaning with a mixture of cyanide and concentrated hydrogen peroxide is called "bombing." This method produces extremely toxic hydrogen cyanide gas and should not be used.

HYDROXIDES such as potassium and sodium hydroxide (caustic soda) are very corrosive to the skin and eyes.

PUTTY (tin oxide) is sometimes used to polish or clean metal. It has no significant hazards except chronic inhalation could cause a benign pneumoconiosis (see page 154).

SOLVENTS used in cleaning are likely to be the glycol ethers (see page 94) which can penetrate the skin and rubber gloves, are toxic, and may be reproductive hazards.
 Other common cleaning solvents are the chlorinated hydrocarbons (see Table 5, Common Solvents and Their Hazards, page 89) and these are toxic and usually cancer-causing. In addition, if the chlorinated hydrocarbons are used around heat or ultraviolet light (such as is emitted during welding), they can decompose to emit highly irritating phosgene gas.

SPAREX (sodium bisulfide) is a milder acidic solution that can be used to clean fire scale off hot metal. Like acids, Sparex can damage skin and eyes on contact. Emits irritating sulfur dioxide gases on contact with hot metal.

WHITING (calcium carbonate) is a mild abrasive sometimes used to polish or clean metal. It has no significant hazards.

TABLE 21	Flux, Patina, and Metal Colorant Chemicals

ALIPHATIC AMINE HYDROGEN CHLORIDES are sensitizing and release irritating, sensitizing, and toxic emissions when heated.

AMMONIUM CHLORIDE. With heat, ammonium chloride fume will become airborne. It is moderately irritating. Some of it may break down into highly irritating ammonia and hydrochloric acid gases, especially if overheated.

ANTIMONY SULFIDE (see antimony in Table 10; sulfides below)

BORIC ACID, POTASSIUM BORATES, AND OTHER BORON-CONTAINING COMPOUNDS are moderately toxic. Boric acid and some other boron compounds can be absorbed through broken skin.

BROMIDES are moderately toxic, but highly toxic hydrogen bromide and other gases may be released when heated.

COPPER SULFATE in some patina formulas will release irritating and sensitizing sulfur dioxide gas.

FERRI- AND FERROCYANIDES are only slightly toxic, but when used with acid or heat, highly toxic cyanide gas can be released.

FLUORIDE COMPOUNDS (potassium bifluoride, boron trifluoride, etc.) are highly irritating and release highly toxic gases. Fluorides can severely damage lung tissue and can cause long-term systemic damage to bones and teeth. Fluxes and patinas containing fluorides should be avoided when possible.

HYDROCHLORIC (MURIATIC) ACID is highly irritating and can damage eyes, skin, and respiratory system.

LEAD ACETATE (see lead, Table 10, Hazards of Metals and Metal Compounds, page 135).

NITRATES (ferric, copper, etc.,) can explode under certain conditions when exposed to heat. They also emit highly toxic nitrogen oxides that can severely damage lungs.

NITRIC ACID is highly irritating and can cause severe skin and eye damage. Nitric acid releases highly irritating nitrogen oxides when it reacts with metals. These nitrogen oxides can cause severe lung damage.

OLEIC ACID AND OTHER FATTY ACIDS are not toxic, but, like all organic compounds, when decomposed by heat, they emit many irritating, sensitizing, and toxic gases and vapors.

ROSIN (colophony) is associated with respiratory allergies and asthma. When burned it releases many toxic gases such as formaldehyde.

SELENIUM COMPOUNDS (except for highly toxic selenium dioxide) are usually only slightly toxic, but in acid-containing patinas, highly toxic and irritating hydrogen selenide gas may be released. Severe lung damage, liver, and kidney damage could result. Selenium also is associated with adverse reproductive effects.

SODIUM LAURYL SULFATE is not toxic, but like all organic compounds, when decomposed by heat, it emits many irritating and toxic chemicals.

STEARIC ACID is not toxic, but, like all organic compounds, when it is decomposed by heat (as during soldering) it emits many irritating, sensitizing, and toxic gases and vapors.

SULFURIC ACID is highly irritating and, in some patinas, it also releases sulfur dioxide gas.

SULFIDES (potassium sulfide, ammonium sulfide, barium sulfide) are irritating to skin and eyes. They emit sulfur oxides when heated. When heated in the presence of water or when reacted with metal, highly toxic hydrogen sulfide gas is released.

THIOSULFATES are usually not toxic, but release highly irritating and sensitizing sulfur oxides when heated.

WETTING AGENTS, SURFACTANTS, ETC., are of varying toxicity and many have not been studied well. Like other organic compounds, they release toxic emissions when burned.

ZINC CHLORIDE. With heat, zinc chloride fume will be airborne. A moderately irritating fume. Very heavy exposures also could cause metal fume fever.

CHAPTER 25 *WELDING*

A ll methods of welding or cutting metal rely upon either heat from burning gas or from electric arc to do the job. Over eighty different types of welding exist and they use these basic heat sources in various ways. But in art, the types most commonly used are oxyacetylene welding, ordinary arc welding, gas metal arc welding (metal inert gas, MIG), and gas tungsten arc welding (tungsten inert gas, TIG). All types of welding can be extremely hazardous.

Neither this book nor any other secondary source of information should be considered inclusive of welding health and safety practices. Instead, welders and welding teachers must follow the precautions mandated by their federal, state, and provincial industry standards. They also need to follow the safety standards of three primary standard setting organizations, the American National Standards Institute (ANSI), the American Welding Society (AWS), and the National Fire Protection Association (NFPA) (addresses are in Appendix I). Readers should obtain publications lists and order applicable standards including:

ANSI 49.1: Safety in Welding and Cutting
NFPA 51: Oxygen Fuel Gas Systems for Welding, Cutting,
and Allied Processes
NFPA 51B: Cutting and Welding Processes

TRAINING

Artists often weld with old, poorly maintained equipment in unventilated spaces which are located near other activities (e.g. woodworking) which are not compatible with the fire requirements imposed by welding. In addition, many artists learned welding "by the seat of their pants," by observing other (usually equally unqualified) welders. This appalling tradition persists because universities and art schools continue to hire instructors without any professional welding qualifications to teach this hazardous craft. (Yet, these same schools wouldn't consider hiring a teacher without credentials to teach a non-hazardous subject like art history.)

The American Welding Society considers 125-150 hours of professional training necessary to qualify for oxyacetylene welding, brazing, and flame cutting. Another 250-300 hours of training are required to qualify for arc welding. Ideally, teachers should be certified in the type of welding they teach. Barring this, they should at least have taken the short AWS Health and Safety Welding course either from an AWS instructor or by correspondence (see Appendix I).

SAFETY PRECAUTIONS

Welding safety is an extraordinarily complex subject, and the safety rules differ depending on the type of welding, the kind of work, and on the shop or on-site conditions. Certain general rules, however, are basic to common types of welding.

GOOD HOUSEKEEPING. Welding shops should be kept scrupulously organized and clean. Only necessary items should be kept in the shop. Combustible materials should be eliminated from the area or covered with fire-proof tarps or other protective materials. The space should be organized to keep floors free of trip hazards because the welder's vision is often limited by face shields or goggles.

ELECTRICAL SAFETY. Most shocks caused by welding equipment are not severe. But under the right conditions they can cause injury or even death. Mild shocks can cause involuntary muscle contractions leading to accidents, and moderate amounts of current directed across the chest may stop the heart. Here are some basic ways to avoid these hazards.

1. Use only welding equipment that meets standards.
2. Follow exactly all equipment operating instructions.
3. Keep clothes dry (even from excessive perspiration) and do not work in wet conditions.
4. Maintain all electrical connections, cables, electrode holders, etc., and inspect each before starting to weld.

COMPRESSED GAS CYLINDER SAFETY. Compressed gas cylinders arepotential rockets or bombs. If mishandled, cylinders, valves, or regulators can break or rupture, causing damage as far as 100 yards away.

The different kinds of gases inside the cylinders are themselves hazards. There are three basic types of hazardous gases:

1. *Oxygen.* It will not burn by itself, but ordinary combustible materials like wood, cloth, or plastics will burn violently or even explode when ignited in the presence of oxygen. Never use oxygen as a substitute for compressed air.
2. *Fuel gases.* Acetylene, propane, and butane are some fuel gases. They are flammable and can burn and explode.
3. *Shielding gases.* These are used to shield processes such as MIG and TIG welding, include argon, carbon dioxide, helium, and nitrogen. They are inert, colorless, and tasteless. If they build up in confined spaces such as enclosed welding areas, they replace air and can asphyxiate those in the area.

Some basic rules regarding compressed gas cylinders that all art welders should know are listed below.

TABLE 22	Safety Rules for Compressed Gas Cylinders
1. Accept only cylinders approved by the Department of Transportation for use in interstate commerce. Do not remove or change any numbers or marks stamped on cylinders.	
2. Cylinders too large to carry easily may be rolled on their bottom edges, but never dragged.	
3. Protect cylinders from cuts, abrasions, drops, or striking each other. Never use cylinders for rollers, supports, or any purpose other than intended by the manufacturer.	

4. Do not tamper with safety devices in valves.

5. Return empty cylinders to the vendor. Mark them "EMPTY" or "MT" with chalk. Close the valves and replace valve protection caps.

6. Always consider cylinders as full (even when empty) and handle them with due care. Accidents have resulted when containers under partial pressure have been mishandled.

7. Secure cylinders by chaining, tying, or binding them, and always use them in an upright position.

8. Store cylinders in cool, well ventilated areas or outdoors in vertical positions (unless the manufacturer suggests otherwise). The temperature of a cylinder should never exceed 130 degrees Farenheit. Store oxygen cylinders separately from fuel cylinders or combustible materials.

FIRE SAFETY. Many fires are started by welding sparks. These "sparks" are actually molten globules of metal which can travel up to forty feet and still be hot enough to ignite combustible materials. Welding shops must be planned carefully to avoid combustible materials such as wooden floors, or any cracks or crevices into which sparks may fall and smolder.

Fire extinguishers must be on hand in welding shops because other methods—like overhead sprinkler systems--should not be used. (Imagine the results if an electric arc welder were suddenly deluged with water.) Each welder should have "hands-on" training in the use of the type of extinguishers in the shop. Emergency procedures should be posted and practiced in routine drills.

On-site welding in locations other than the shop requires extra precautions. Included among these are: giving advance notice before welding, curtailing all other activities in the area, removing all combustibles within forty feet of the operation or installing special fireproof curtains and coverings to shield combustibles which cannot be removed, clearing and dampening floors, and assigning a fire watcher with extinguisher at the ready during the welding operation. The fire watcher should remain for half an hour after welding has been completed.

ACCIDENTS. Prepare for accidents and burns by keeping first aid kits stocked with burn and trauma treatments. Post emergency procedures. Ideally, someone on site should have first aid and CPR (cardiopulmonary resuscitation) training.

HEALTH HAZARDS

Hazards to welders' health are less obvious than welding safety hazards, and they vary among different types of welding. In general, the hazards are: radiation, heat, noise, fumes, and gases from welding processes, and gases from compressed cylinders.

RADIATION generated by welding takes three forms: visible, infrared, and ultraviolet.

VISIBLE light is the least hazardous and most noticeable radiation emitted by welding. Although intense light produces only temporary visual impairment, eyes should be protected from strong light.

INFRARED (IR) radiation is produced when metal is heated until it glows. IR can cause temporary eye irritation and discomfort. Repeated exposures can cause permanent eye damage, including retinal damage and infrared cataract. These effects occur slowly, without warning.

ULTRAVIOLET (UV) is the most dangerous of the three types of radiation. All forms of arc welding produce UV radiation. Eye damage from UV, often called a "flash burn," can be caused by less than a minute's exposure. Symptoms usually do not appear until several hours after exposure. Severe burns become excruciatingly painful, and permanent damage may result.

UV also can damage exposed skin. Chronic exposure can result in dry, brown, wrinkled skin, and may progress to a hardening of the skin called keratosis. Further exposure is associated with benign and malignant skin tumors.

HEAT can harm welders by causing burns (from IR radiation to the skin or from hot metal) and by raising body temperature to hazardous levels causing "heat stress."

NOISE can damage a welder's hearing. Fortunately, most welding processes used in the arts produce noise at levels below the level at which hearing is damaged. (Air carbon arc cutting is one possible exception.) If you wear ear plugs, make sure they are fire resistant. Several cases of eardrum damage have been reported when overhead sparks fell into ear canals that were either unprotected or contained a combustible plug.

FUMES AND GASES are produced during the welding process. They sometimes can be seen as a smoky plume rising from the weld. Fumes come from the vaporized metals. Gases can come from gas cylinders or can be created when substances burn during welding. Gases also can form when some types of welding rods are being used. Material Safety Data Sheets on welding rods will identify the emissions expected during normal use.

Many occupational illnesses are associated with substances found in welding fumes and gases, including metal fume fever (see page 131), and a variety of chronic lung diseases including chronic bronchitis. Lung and respiratory system cancer are associated with metal fumes such as chrome, nickel, beryllium and cadmium. Lead poisoning from welding lead-painted metals is also well-documented.

HEALTH PRECAUTIONS
(For safety precautions, see above.)

1. *Obtain Material Safety Data Sheets on all materials* including compressed gases, and welding, and brazing rods. Obtain complete composition of metals to be welded. Avoid materials which will emit highly toxic metals such as beryllium, cadmium, antimony, etc. Never work with metals of unknown composition, painted metals, junk, or found metals unless ventilation is certain to provide total removal of the welding plume.

2. *Provide ventilation* for protection from gases, fumes, and heat buildup. Equip shops with local exhaust ventilation systems such as downdraft tables or flexible duct fume exhausters to capture welding fumes and gases at their source. These local exhaust systems should be combined with dilution systems to remove gases and fumes that escape collection and to reduce heat build up. A simple exhaust fan may suffice for open area welding, while enclosed MIG and TIG welding booths may need floor level dilution systems to prevent layering of inert gases.

Do not rely on working outdoors for protection. Many documented cases of illness have resulted from cutting and welding outdoors, even in windy conditions.

3. *Use respiratory protection if appropriate.* There are respirators sold for welding, but artists should rely primarily on ventilation. For one reason, no single air-purifying respirator will protect wearers from all the contaminants in welding plumes. Metal fume filters will stop fumes, but they offer no protection from gaseous contaminants.

Some air-supplied respirators can provide welders with fresh air, but these are complex pieces of equipment which are expensive, need constant maintenance, and their users need training to use them effectively. For these reasons, they usually are not practical for most artists.

4. *Isolate the welding area.* Isolation keeps other workers from being exposed either to direct or reflected radiation. Walls, ceilings, and other exposed surfaces should have dull finishes such as can be obtained from special nonreflective paints. Portable, fire-resistant, UV-impervious screens or curtains can be purchased to isolate welding areas and to separate individual welding stations.

5. *Use eye protection* such as goggles or face shields to protect each welder for the type of welding he or she does (see figures 4 and 5, pages 58-60). Welders who use methods that leave a slag coating on the weld should wear safety glasses under their shields. A common injury occurs when welders raise their hoods to inspect a weld and the slag pops off unexpectedly.

Face and eye protective equipment should be cleaned carefully after each use and inspected routinely for damage, especially for light shield damage. A scratched lens will permit radiation to penetrate it and it should be replaced.

Visitors and other workers nearby should avoid looking at welding and should wear safety glasses (UV weakened by distance is stopped by ordinary glass).

6. *Protect hearing* by wearing fire-resistant ear plugs, muffs, or other devices if needed.

7. *Wear protective clothing.* Pants and long-sleeved shirts can protect legs and arms. Many welders prefer wool fabrics because they insulate weld-

ers from temperature changes and because they emit a strong warning odor when heated or burned. Treat cotton clothing with a flame retardant. Never wear polyester or synthetic fabrics that melt and adhere to the skin when they burn. Pants and shirts should not have pockets, cuffs, or folds into which sparks may fall.

Shoes should have tops into which sparks cannot fall. Wear safety shoes with steel toes if heavy objects are being welded. Hair should be covered, or, at the very least, tied back. Wear gloves when arc welding. Leather aprons, leggings, spats, and arm shields may be needed for some types of welding. Do not use asbestos protective clothing.

8. *Practice good housekeeping.* Control dust by vacuuming with specially filtered vacuums that can trap fume particles or damp mop (being careful not to create an electrical hazard). Sweeping with large amounts of sweeping compound also may be acceptable.

9. *Dispose of waste* metals and other chemicals in accordance with health, safety, and environmental protection regulations.

10. *Arrange for good medical surveillance.* Always be prepared to provide your doctor with information about the materials you use and your work practices.

CHAPTER

26 *BRAZING, SOLDERING AND CASTING*

B razing is the process of filling a joint or coating a metal surface with a nonferrous metal such as silver or copper. Soldering is a method of filling a joint or seam with metal alloys which will melt at lower temperatures than the metals being soldered. Tinning is a special kind of soldering in which areas of metal are covered with a solder surface.

HAZARDS OF BRAZING AND SOLDERING

Brazing alloys can contain an array of metals, some of which are toxic. Silver and copper brazing alloys may contain cadmium, antimony and arsenic. Material Safety Data Sheets for brazing alloys should identify all the metals present in them.

Solders can contain a large number of metals including lead, tin, cadmium, zinc, arsenic, antimony, beryllium, indium, lithium and silver (see Table 10, Hazards of Metals and Metal Compounds, page 135). Solders made for use on copper water pipes and cooking utensils are safer because these alloys must not contain significant amounts of lead. Material Safety Data Sheets which identify all metal constituents should be available on solders.

Prior to soldering or brazing, the metal must be cleaned and degreased. Cleaners and degreasers usually contain toxic solvents, caustics, and/or acids (see Table 20, Metal Cleaners & Degreasers, page 262).

Fluxes are used when soldering and brazing. Inorganic acid fluxes such as those containing zinc and other chlorides are used most widely. Organic solders containing fatty acids will work well on lead and copper. Rosin solders are used primarily for copper electrical work. Rosin fluxes must be activated with toxic bromide compounds in order to work on lead, brass, or bronze (and then only if it is very clean). Fluoride fluxes work very well on many metals and are usually used with tinning solders. However, these fluxes are very toxic (see Table 21, Flux, Patina, & Metal Colorant Dyes, page 263).

During soldering a plume of "smoke" rises, and can be inhaled. The plume will contain a variety of decomposition products from materials in fluxes and metal fumes. These substances can cause eye and respiratory irritation, allergies, and, in some cases, metal poisoning.

The temperature at which brazing or soldering is done affects the amount of toxic materials in the plume. Lower temperatures vaporize less metal. Methods employing soldering guns or electric soldering irons vaporize less metal than methods using torches to heat soldering irons or to fill joints (as in the copper foil method in stained glass). Open pot tinning in which metal objects are dipped in molten solders can product very large amounts of metal fumes.

The heat created during soldering can cause burns. When the metals glow with heat they are giving off infrared radiation which can cause eye damage.

Once the metals are brazed or soldered, the seams are often cleaned of the residual flux chemicals. Cleaning products can contain toxic solvents, acids, caustics, or ammonia. Some cleaning products generate toxic gases when mixed (see Table 20, Metal Cleaners & Degreasers, page 262). Polishing soldered and brazed metals with putty (tin oxide) or whiting (calcium carbonate) is less hazardous.

PRECAUTIONS FOR SOLDERING AND BRAZING

I. Obtain Material Safety Data Sheets and complete alloy composition for all solders and brazing metals. Choose the safest ones for the work to be done. Avoid highly toxic metal-containing alloys such as those containing arsenic, cadmium, and beryllium.

2. Avoid using lead solder. If lead solders are used on the job, employers must be prepared to meet complex and expensive OSHA Lead Standard regulations in the United States or the OHSA Regulation respecting Lead in Canada.

3. Obtain ingredient information on fluxes. Choose the safest flux for the job. Avoid fluoride fluxes. Do not mix fluxes.

4. Wear goggles that will protect the eyes from infrared radiation and irritating vapors (see figures 4 and 5 pages 58-60). Use gloves when working with solvents, acids, or caustic cleaning agents. Minimize skin contact with fluxes. Wear clothing resistant to heat (see Chapter 25, Welding, pages 271-272.)

5. Have first aid treatment, cool water, and ice on hand for minor burns. Post emergency procedures.

6. Provide local exhaust ventilation for the plume.

7. Braze at the lowest temperatures at which good results are obtained. Use gun or electric soldering iron methods over open flame joining or heating of irons. Avoid open dip pot "tinning" unless excellent local exhaust can be installed.

8. Obtain ingredient information on metal cleaners and degreasers and choose the safest ones. Provide local exhaust for products which emit toxic gases and vapors. Do not mix cleaning agents unless your are sure they cannot react adversely with each other. Use putty or whiting to clean when possible.

9. Practice good housekeeping. Wet mop floors and sponge tables and surfaces to control dust, which may be contaminated with metal fume particles.

10. Dispose of all spent cleaning and polishing materials, fluxes, and metal waste in accordance with health, safety and environmental protection regulations.

11. Always be prepared to provide your doctor with information about the chemicals you use and your work practices. If lead is used, arrange for regular blood tests for lead.

METAL CASTING AND FOUNDRY

Metal casting involves forcing molten metal (by gravity or centrifugal force) into a mold. In the construction of some molds, a positive form of wax or plastic is burned out to leave room for the metal.

Metals can be cast in any size from tiny jewelry pieces to large foundry-cast sculptures. Foundry work is especially hazardous and should not be attempted unless workers are prepared to comply with all applicable occupational health and safety laws and regulations.

The hazards of all types of metal casting include exposure to mold materials, burning out patterns, and working with molten metals.

MOLD-MAKING HAZARDS

CHANNEL MOLDS are made by carving into tufa (a soft porous rock) or investment plaster mixed with pumice. Free silica can be found in investment plasters, and in some pumice and tufa.

CUTTLEBONE MOLDS are made by pressing small shapes (usually jewelry pieces) into cuttlebone (the internal shell of the cuttlefish). The mold is then painted with borax flux and water glass (sodium silicate). Cuttlebone can cause respiratory irritation and allergies; borax is moderately toxic and can be absorbed through broken skin; and some grades of sodium silicate contain some free silica. All of these dusts are eye and respiratory irritants.

SAND MOLDS are made from foundry or casting sand which is usually silica and binders. Some silica mold sands are cristobalite (see page 154). The sands are very hazardous unless they are treated with binding chemicals, which also prevent respirable dust from becoming airborne.

The binders in foundry sands can be a number of organic chemicals such as glycerine and linseed oil. These harden when heated in an oven.

Cold setting high silica sands also are used. The binders in these sands usually are synthetic resins. Many different resins now are used, including urea-formaldehyde, phenol-formaldehyde, urethanes, and other plastics. The resins and the catalysts which set them can be highly toxic and toxic gases may be emitted when the resins burn off during casting (e.g., hydrogen cyanide and isocyanates).

Mold releases may include silica flour, French chalk (talc), or graph-

ite. Some French chalk is contaminated with asbestos. Silica flour is an especially toxic source of silica because of its small particle size.

MOLDS FOR LOST WAX CASTING are made with investment plasters which contain silica flour or cristobalite, plaster, grog (fired clay), and clay. In the past, asbestos was added to this material. Asbestos or ceramic fiber may be used to line investment containers. Shell molds are made with slurries of water and silica, fused silica, or zircon, and sometimes ethyl silicate. The resulting mold is heated in a kiln to form a ceramic-like shell.

Cristobalite, silica flour, and fused silica can cause silicosis (see pages 155-156). Asbestos in any form can be a cancer hazard. Ceramic fiber also may cause asbestos-related diseases (see pages 157-158). Ethyl silicate is highly toxic by inhalation and eye contact. It is an irritant and may cause liver and kidney damage.

BURNING OUT PATTERNS. Patterns for metal casting molds can be made of wax, styrofoam, and other plastics. These materials can be burned out of the mold with a torch or a furnace. Styrofoam often is burned out when the molten metal is poured into the mold.

There are many types of wax including beeswax, carnauba, tallow, paraffin, and microcrystalline wax. When these waxes burn they release many toxic and irritating compounds including acrolein and formaldehyde. Acrolein is an exceedingly potent lung irritant, formaldehyde is a sensitizer and suspect carcinogen.

Wax additives may include rosin, petroleum jelly, mineral oil, solvents and dyes. These organic chemicals will also release carbon monoxide, and other toxic decomposition products when burned.

Burning styrofoam (polystyrene) will produce carbon monoxide and other toxic emissions. Burning out nitrogen-containing plastics such as urethane foam or urea formaldehyde will release hydrogen cyanide gas in addition to other toxic gases.

MELTING AND POURING

Small amounts of metal for centrifugal casting can be melted with torches. Centrifugal casting equipment can be dangerous. If it is unbalanced, metal can be thrown out. Most shields around centrifugal casters probably would not be able to protect bystanders if the arm should break during casting.

Furnaces are needed for larger castings. Furnaces can be heated with

278

gas, coke, coal, or electricity. Fuel-fired furnaces produce carbon monoxide and other combustion gases.

Many metal alloys may be used in casting. The composition of a few common alloys are listed in Table 22. Some of these alloys are hazardous to cast because they give off toxic fumes such as lead, arsenic, nickel, and manganese. For example, nickel fume, which is considered a carcinogen (Threshold Limit Value-Time Weighted Average of 1 milligram per cubic meter, see page 143) is given off when nickel-silver is cast.

Other highly toxic gases also can be released when mold binding chemicals are burned off when the mold is in contact with the hot metal (see above).

Heat from molten metal during pouring of large amounts can cause serious burns. Infrared radiation accidentally caused permanent scarring of an art student who was helping to pour bronze. Infrared can also cause eye damage.

TABLE 23	Composition of Common Alloys

BRASS: copper/zinc alloy with small amounts of lead, arsenic, manganese, aluminum, silicon, and/or tin.

BRITANNIA METAL, PEWTER, WHITE METAL: are of two basic types: tin/lead/copper or tin/antimony/copper.

BRONZE: copper/tin and sometimes small amounts of lead, phosphorus, aluminum, and/or silicon.

GOLD: alloyed with other metals for white, yellow, and other gold jewelry colors.

LEAD: type lead, lead pipe, battery lead, and various kinds of scrap lead have been used for sculpture.

MONEL METAL: nickel/copper alloys with small amounts of carbon, manganese, iron, sulfur, and silicon.

NICKEL SILVER: alloys of nickel/silver/zinc.

SILVER: sterling is silver alloyed with at most 7.5 percent other metals, usually copper. Other silver alloys are usually even less pure.

PRECAUTIONS

1. Be prepared to comply with all workplace occupational safety and health regulations regarding foundry work and metal casting.

2. Obtain Material Safety Data Sheets and ingredient lists for all metals, molds, and pattern materials used. Choose the least toxic products.

3. Choose foundry sands over cold setting sands and resin binders. Replace silica flours and cristobalite with nonsilica materials such as zircon when possible. Do not use asbestos.

4. If ethyl silicate is used, work with local exhaust ventilation and wear eye protection.

5. Provide dust control, ventilation and/or respiratory protection against irritating, sensitizing, and silica-containing mold materials. Dust goggles should also be worn if dust is raised.

6. Use the safest mold release agents such as graphite or asbestos-free talcs.

7. Provide local exhaust ventilation for burn out of any pattern materials. Be especially careful to exhaust the hydrogen cyanide gas generated when burning out nitrogen-containing plastic patterns.

8. Furnaces and ovens for mold-setting, burnout, and melting metal should be equipped with local exhaust ventilation such as a canopy hood. Provide exhaust ventilation for all pouring operations.

9. Avoid alloys containing significant amounts of highly toxic or carcinogenic metals such as arsenic, antimony, cadmium, nickel, or chrome when possible.

10. Avoid casting lead or lead alloys. If lead is used on the job, employers must be prepared to meet complex and expensive OSHA Lead Standard regulations in the United States or the OHSA Regulation respecting Lead in Canada.

11. Wear protective clothing appropriate to the type of casting done. For

foundry work, follow protective clothing regulations. Wear infrared goggles whenever working with glowing materials (see figures 4 and 5 pages 58-60). If molten metals may splash, wear a face shield, a long-sleeved, high-necked wool shirt, insulated leggings, jacket, apron, gloves and shoes (steel-toed if heavy materials are being lifted). Tie back hair or wear hair covering.

12. Have first aid treatment, cool water, and ice on hand for burns. Post emergency procedures.

13. Post fire emergency and evacuation procedures and train workers in use of fire extinguishers (sprinkler systems cannot be used in foundries or other places where furnaces or molten metal are used). Hold regular fire drills.

14. When centrifugal casting, make sure the equipment is well balanced and that the protective shield is in good condition.

15. Wear respiratory protection when breaking up and disposing of silica-containing molds. Practice good housekeeping. Wet mop floors and sponge tables and surfaces to control dust which may be contaminated with mold materials or metal dust.

16. Dispose of all mold materials and metal waste in accordance with health, safety, and environmental protection regulations.

17. Always be prepared to provide your doctor with information about the chemicals you use and your work practices. If lead is used, arrange for regular blood tests for lead.

CHAPTER

27 | *SMITHING*

S mithing or forging is the process of hammering hot or cold metals into shape. Blacksmiths work with iron, silversmiths forge silver, and so forth. The tools used in these processes are hammers, mallets, metal blocks, and anvils. Furnaces used for hot forging burn coal, coke, oil, or gas.

HAZARDS OF SMITHING

Percussive hammering on metal produces noise which is very destructive to hearing. Even in the 1700's Ramazini (the father of occupational medicine) observed that tinsmiths went deaf from hammering noise.

Toxic combustion products such as carbon monoxide gas are emitted by forging furnaces. Ventilation systems such as canopy hoods only can provide partial protection from these gases because the bellows used to fan the coals will also blow some emissions from the hood intake area.

Other hazards include infrared radiation given off by furnaces and hot metal, which can damage the eyes and burn the skin. Heavy work in a hot environment can cause heat stress. Some kinds of smithing also use acid pickling solutions to clean hot metal.

Fires are a constant threat. Workers should be trained in fire emergency procedures and the use of extinguishers because other controls such as overhead sprinklers cannot be used in hot forging areas.

Cold forging metals like silver and tin involve hammering metal into or over forms. Small anvils, dapping blocks, and other objects can be used to pound the metal into shapes. Repousse is a special case of shaping by hammering and chasing the metal while it is supported by a bowl of a material made of pitch, plaster of paris and tallow. When shaping is done, the pitch can be removed by a solvent or burned off in a furnace or with a torch.

PRECAUTIONS FOR SMITHING

1. Install fireproof sound-absorbing materials in floors and walls of the shop where possible.

2. Provide good stack exhausts and canopy hood ventilation for forges and furnaces. Additional general shop ventilation will be needed for blacksmithing and other hot forging to reduce heat and to exhaust toxic gases which are blown out of the hood's capture range by the bellows.

3. Plan fire protection carefully. Eliminate all combustibles from areas around forges and furnaces. Do not install sprinkler heads above hot processes. Consult fire marshalls and/or other experts for advice on appropriate fire-fighting systems and extinguishers.

4. Provide bathroom facilities and a separate clean room for work breaks. It is necessary that smiths be able to wash up and retire to a clean area to drink fluids to replace those lost through perspiration, have lunch, and the like.

5. Provide first aid supplies and cold water or ice for treatment of minor burns. Post emergency procedures. Water also should be available to drink frequently, to quench metal, etc.

6. Obtain ingredient information on all materials used in the work and use proper precautions. For example, if solvents are used, as for removal of pitch from repousse, follow all solvent safety rules (see pages 87-89).

7. Practice good housekeeping. Wet mop or sponge floors and surfaces. Never allow trip hazards in the work area.

8. Wear ear plugs or other suitable hearing protection.

9. Wear goggles to protect eyes from infrared radiation (see figures 4 and 5, pages 58-60).

10. Wear protective clothing: long-sleeved, closewoven cotton or wool shirts; leather gloves, and safety shoes. Tie back hair or wear hair covering. Leave clothing in the shop to avoid tracking dusts home. Wash clothes frequently and separately from other clothes.

11. Wear gloves and goggles when handling acids, caustics, or solvents. If hot metal is dipped or cleaned in acid or Sparex, provide gloves, goggles, protective clothing (e.g., rubber aprons), and ventilation to exhaust gases rising from the bath.

12. Dispose of all spent acids, metal waste, and other materials in accordance with good hygiene and waste disposal regulations.

13. Always be prepared to provide your doctor with information about the chemicals you use and your work practices.

CHAPTER

28 | *WOODWORKING*

V irtually any type of wood may end up in art, including hard and soft wood, exotic woods, plywood, composition board, and so on. Often art studios and school shops are filled with the sounds of noisy machines and clouds of sawdust.

WOOD DUST HAZARDS

Many artists consider wood dust as nothing more than a nuisance. It is far more than that. Wood dust has caused countless fires and explosions. A spark or static discharge is sufficient to detonate fine airborne sawdust. In addition, some wood dusts cause allergies, some are toxic, and others contain highly toxic pesticides, preservatives, flame retardants and other treatments. Some trees deposit significant amounts of toxic silica in their heartwood. It has also been established that certain types of cancer are related to wood dust exposure.

DERMATITIS. There are two common types of wood-related skin diseases. One of these is *irritant dermatitis.* It is caused most often by exposure to the sap and bark of some trees. It will affect artists if they cut trees, saw raw timber, or work with unusual woods such as cashew.

The other major wood-related skin disease is *sensitization dermatitis.* It results from an allergy to sensitizing substances present in some woods. The symptoms may start as redness or irritation, and may proceed to severe eczema, fissuring and cracking of the skin. The condition may arise anywhere on the body that the sawdust contacted.

Some exotic woods even have caused dermatitis in persons exposed only to the solid wood, not to its dust. Rosewoods are one such type. Prolonged contact with rosewood musical instruments, bracelets, or knife handles has been known to cause sensitization dermatitis. Should you suspect that a skin problem is caused by a particular wood, a doctor can conduct a patch test on your skin. Although one can become allergic to almost any wood, those woods most likely to cause this condition are shown in Table 23.

RESPIRATORY SYSTEM EFFECTS, such as damage to the mucous membranes, and dryness and soreness of the throat, larynx, and trachea can be cause by some woods, especially sequoia and western red cedar. These effects may proceed to nosebleeds, coughing blood, nausea, and headache. Eye irritation usually occurs as well.

Lung problems—like asthma, alveolitis (inflammation of the lung's air sack)—affect a minority of workers exposed to irritant sawdusts. However, these are serious diseases and a few woods, such as sequoia and cork oak can cause permanent lung damage. The symptoms may not appear until several hours after sawdust exposure, making diagnosis difficult. Any persistent or recurring lung problems should be reported to a physician familiar with wood dust hazards.

Types of wood associated with lung problems are listed in Table 23.

CANCER.The most prevalent cancer related to wood dust is cancer of the nasal cavity and nasal sinuses. Early symptoms of nasal sinus cancer may include persistent nasal dripping, stuffiness, or frequent nosebleeds.

A recent twelve-country survey showed that an astonishing 61 percent of all such cancer cases occurred among woodworkers. Hardwood dusts are definitely associated with cancer, and early results from studies on workers exposed to soft woods indicate that both woods are implicated.

Most artists are exposed to much less dust than the professional woodworkers in the study, so their risks are lower. They need not give up wood as a material, but they must reduce their sawdust exposure to a minimum.

TOXIC EFFECTS. Some woods contain small amounts of toxic chemicals that may be absorbed through the respiratory tract, intestines, or occasionally through skin abrasions. These chemicals may cause headache, salivation, thirst, nausea, giddiness, drowsiness, colic, cramps, and irregular heart beat. In exceptional cases, poisoning has occurred from food containers, spoons, or spits made from woods such as yew or oleander.

If you suspect that your symptoms are related to a particular wood, inform a physician and have the wood identified. See Table 23 for list of toxic woods.

WOOD TREATMENTS

Almost every imported wood and most domestic woods in the United States and Canada have been treated with additives, pesticides, and/or preservatives. These chemicals can vary from relatively safe to highly toxic pesticides. The most hazardous pesticides are usually applied to wood intended for use in contact with the outdoor elements.

It is usually difficult to find out exactly what chemicals had been used on wood. Three common outdoor use wood preservatives are Pentachlorophenol (PCP) and its salts, arsenic-containing compounds, and creosote. These three types of preservatives are associated with cancer, birth defects, and many other hazards. Art workers should avoid wood treated with them. There are many other more suitable preservatives on the market.

PLYWOOD AND COMPOSITION BOARDS

Many health effects also can be caused by wood glues and adhesives. Plywood, pressboards, and many other wood products contain urea-formaldehyde or phenol-formaldehyde resins. These glues release formaldehyde gas which is a strong eye and respiratory irritant and allergen. Formaldehyde is also a suspect carcinogen known to cause nasal sinus cancer in animals.

Some manufacturers are turning to other adhesives such as urethane plastics. It is hoped these binders will be more stable and less hazardous.

MEDICAL SURVEILLANCE FOR WOODWORKERS

1. Prevent wood dust-related diseases by avoiding toxic or allergy-provoking woods, or woods treated with PCP, arsenic, creosote or other highly toxic chemicals when possible.

2. For occupational health problems, consult a doctor who is board certified in occupational medicine or one who is familiar with wood-related illnesses.

3. Have base-line lung function tests done early in your woodworking career. Then have your physician compare this test with subsequent pulmonary function tests done in your regular physical examinations in order to detect lung problems early.

4. Have your physician pay special attention to your sinuses and upper respiratory tract. Report symptoms like nasal dripping, stuffiness or nose-bleeds.

5. Know the symptoms and diseases your woods can cause. If these symptoms occur, report them immediately to your physician.

6. Be able to give your doctor a good occupational history. Always be prepared to provide your doctor with information about the chemicals you use and your work practices. Keep records of recurring symptoms and chemical/wood exposures.

7. Suspect that a health problem may be related to your work if the problem improves on weekends or during vacations.

8. Should symptoms or illness occur and persist even after treatment, seek a second opinion.

WOOD SHOP REGULATIONS

EXPOSURE STANDARDS. Workplace exposure to wood dust is regulated in both the United States and Canada.The exposure limits (Permissible Exposure Limits and Occupational Exposure Limits, see pages 32-33) are 5 mg/m³ for all woods except Western red cedar which is set at 2.5 mg/m³ in recognition of the severe allergies it causes. It is expected that other sensitizing woods will be assigned this lower limit as health data accumulates.

Other chemicals present in some sawdusts also are regulated. For example, the silica standards will apply if the wood contains it. Formaldehyde exposure limits also may be enforced if plywood or other composition materials are used.

WOOD AND HAZARD COMMUNICATION. Right-to-know rules apply to substances for which there are workplace exposure limits. The labeling regulation does not apply because it is not possible to put a hazard label on every board. But the law does require employers to obtain material safety data sheets from the distributor when wood is purchased and to include the hazards of wood dust in the worker's training.

All other rules applying to conduct in the presence of a toxic substance in the workplace are triggered by wood dust. For example, it is an OSHA violation to eat, drink, or store food in a wood shop.

VENTILATION. Essentially, the wood dust regulations make it necessary to equip all woodworking machines with local exhaust. The preferred dust control method involves a central collection system to which each machine is connected. These systems work best if the air they draw from the machines is expelled from the shop (not filtered and recycled). For shops unable to afford such systems, portable collectors that can be moved from machine to machine may suffice.

Good housekeeping and hygiene also must be practiced if woodshops are to meet the regulations.

RESPIRATORY PROTECTION may be used in some cases to reduce employee exposure to wood dust. However, respirators provide very limited protection and ventilation methods are preferred. If respirators are used, follow all rules for proper use (see pages 71-79).

MACHINE GUARDS. United States and Canadian standards require guards on woodworking equipment. Yet machines in art schools and studios commonly are found unguarded.

Guards include those on blades, drive belts, and all moving parts, splitters and kickback guards on table saws and related tools, and more. People who use guarded saws for the first time may find them awkward. However, workers accustom themselves quickly, and soon would not be without them. It takes much longer for artists to adjust to using hands with less than ten fingers.

OTHER REGULATIONS include lockouts to prevent the start up or release of energy during maintenance or repair of machines, central power switches to shut down all machinery in emergencies and many other rules. Artists should get copies of applicable regulations from their local occupational health and safety offices.

OTHER WOODSHOP HAZARDS

SOLVENT-CONTAINING PRODUCTS such as finishes, adhesives, paints, paint removers, and the like may contain solvents. All solvents are toxic and most are flammable (see Chapter 9, Solvents).

GLUES AND ADHESIVES. Many skin conditions and allergies can be caused by wood glues and adhesives. See Table 14, Hazards of Common Adhesives, page 174 for hazards of these materials and precautions.

In general, polyvinyl acetate (PVA) emulsion glues or white glues are exceedingly safe in comparison to many other types of wood glue. These glues require longer setting times than some of the solvent adhesives and epoxies, but you should used them as often as possible.

Safe use of more hazardous adhesives requires avoiding skin contact, sparing and careful use, keeping containers closed as much as possible during application, and good general shop ventilation.

FIRE HAZARDS. Woodworking shops harbor many fire hazards. As previously mentioned, fine wood dust in a confined area can explode with tremendous force if ignited with a spark or match. Combining wood dust, machinery, and flammable solvents greatly increases the hazard.

Fire prevention authorities agree that adequate ventilation is the best way to curb the risk of fire. Ventilation should be combined with safe solvent handling, good housekeeping, and regular removal of dust and scraps.

VIBRATING TOOLS. A significant number of persons who use vibrating tools now are known to be at risk from a more permanent condition commonly called "white hand," "dead fingers," or Vibration syndrome. This disease can lead to severe pain, ulcerations, and even gangrene in some cases. (See page 37).

NOISE. Saws, planers, routers, sanders, and the like can easily produce a cacophony of ear-damaging sound waves. Poorly designed ventilation systems also can produce hazardous amounts of noise (see pages 35-37).

Prevent hearing loss by purchasing well-engineered machines that run quietly. Some machines also can be purchased with dampering equipment such as mufflers and other sound-absorbing mechanisms. All machines will run more quietly when they are well-oiled and carefully maintained. Mounting machinery on rubber bases will reduce vibration transmission and rattling. Hand held tools often are as damaging to hearing as stationary machinery because people work so close to them.

If noise levels are high in your shop, wear ear protection. Employers must get noise tested, obtain professional advice about appropriate ear protection, and provide hearing tests for workers. Artists who are self-employed also should get regular hearing tests and choose ear plugs or

muffs with a high attenuation rating (the higher the number, the more decibels they block).

GENERAL PRECAUTIONS FOR WOODWORKING

1. Prevent fires by providing good shop ventilation, dust collection and control, sprinkler systems or fire extinguishers, emergency procedures and drills, and by banning smoking.

2. Obtain Material Safety Data Sheets on all wood products, glues, and other materials. Choose the safest ones.
3. Try to purchase wood from suppliers who know a good deal about the kinds of wood they sell, where it is from, and how it was treated.

4. Avoid wood treated with PCP, arsenic, or creosote. Some of the arsenic-preserved woods can be identified by their greenish color and avoided.

5. Equip all woodworking machinery with local exhaust dust collection systems. Ideally, these systems should vent to the outside rather than return air to the shop.

6. Prevent hearing damage by purchasing quiet machines using dampering equipment such as mufflers or rubber mounts. Keep machines well-oiled and maintained. Use ear plugs or muffs if needed. Have a base line hearing test and periodic hearing tests as often as your doctor suggests.

7. Prevent Vibration Syndrome by using tools that are ergonomically designed and produce low amplitude vibrations, working in normal and stable temperatures (especially avoiding cold temperatures), taking ten-minute work breaks after every hour of continuous exposure, and not grasping tools too hard.

8. Wear dust goggles and a NIOSH-approved dust mask when dust cannot be controlled easily such as during hand sanding. Follow all laws and regulations regarding goggles and respirator use. Use eyewear that meets ANSI standards for impact when working with machinery. If flying particles are likely, wear a face shield over the impact glasses.

9. Wear protective clothing to keep dust off your skin. Wear gloves or barrier creams when handling woods known to be strong sensitizers.

10. Practice good hygiene. Wash and shower often. Keep the shop clean and free from sawdust. Vacuum rather than sweep dusts.

11. Follow all rules for use of solvents when using solvent-containing paints, glues, etc. (see pages 87-89).

12. Be prepared for accidents: know your blood type and keep up your tetanus shots. Keep first aid kits stocked. Post and practice emergency procedures.

13. Follow all Medical Surveillance Rules for wood dust exposure above.

TABLE 24	Some Woods and Their Health Hazards

KEY

Commercial Name(s). Different commercial names often are given to the same species or to different species within the same family. These names may be misleading. For example, redwood and California redwood are not related by family. For some woods, not every commercial name is listed.

Family and Origin. To completely identify wood, the family, origin, and exact species may be required. Scientific species names are not given in this table. Samples of wood can be completely identified by the Forest Products Research Laboratory in Madison, Wisconsin.

Health Effects

 D = Dermatitis

 C-R = Conjunctivitis-rhinitis (inflamed eyes and runny nose)

 A = Asthma (inflammation of the bronchial tubes in the lungs)

 Al = Allergic alveolitis (inflammation of the lung's air sacs)

 T = Toxic effects (systemic poisoning)

Commercial Name(s)	Family	Origin	Health Effects
Maple	Aceraceae	———	D
Cashew	Anacardiaceae	America	D
Birch	Betulaceae	———	D
Gabon mahogany	Burseraceae	———	D C-R A Al
blue wood (spruce), purple heart	Caesalpinaceae	America	T
redwood	Caesalpinaceae	America	D T
Virginian pencil cedar, eastern red cedar	Cupressaceae	America	D C-R A T
White cedar, Western red cedar	Cupressaceae	America	D C-R A T
White cypress pine	Cupressaceae	Oceana	D C-R A
Chestnut, beech, oak	Fagaceae	———	D C-R A
Walnut	Juglandaceae		D C-R A
American whitewood, tulip tree	Magnoliaceae	America	D
Red cedar, Australian cedar	Meliaceae	America/Asia/ Oceania	D C-R A
Mahogany (m), Honduras m.,Cuban m., American m., Tabasco m., baywood	Meliaceae	America	D C-R A Al T
White handlewood	Moraceae	Oceania	D T

Commercial Name(s)	Family	Origin	Health Effects
Iroko, yellowood, kambala, African teak, tatajuba	Moraceae	Africa/America	D C-R A Al
Alpine ash, yellow gum, mountain ash	Myrtaceae	Oceania	D C-R A
Ash	Oleaceae	——	D
Ebony, rosewood, blackwood, jacaranda, foxwood	Papilionaceae	Africa/Asia/ America	D C-R A T
Pine	Pinaceae	——	D C-R A
Douglas fir, red fir, Douglas spruce	Pinaceae	America	D C-R A
New Zealand white pine	Podocarpaceae	Oceania	D C-R A
Cherry, black cherry	Rosaceae	——	D C-R A
Boxwood	Rutaceae	America	D C-R A
Poplar	Salicaceae	——	D C-R A
Sequoia, California redwood	Taxodiaceae	America	D C-R A T

Footnote: This table was developed from information derived from the International Labour Organization's *Encyclopaedia of Occupational Health and Safety,* Vol. 2, third edition, Geneva, 1983. pages 2308-2316.

CHAPTER 29

PHOTOGRAPHY AND PHOTOPRINTING

U nfortunately, many art photographers work in unsafe conditions. Art schools and universities often teach photography in improperly vented areas and without proper protective equipment. And many photographers develop and print in converted bathrooms, kitchens, and other inadequate spaces in their own homes. Health and safety hazards abound in these under equipped, poorly vented darkrooms.

HEALTH HAZARDS

Vast numbers of substances, many of them very complex organic chemicals, are involved in photographic processes. Many of these are known to be hazardous, while the hazards of many others are unknown and unstudied. In addition, new photochemical products are developed frequently.

For these reasons, it is impossible in the scope of this book to discuss all photochemicals. Instead, it is easier to look at the effects of photochemical exposure.

DISEASES ASSOCIATED WITH PHOTOCHEMICALS

Photochemicals are particularly associated with skin diseases and respiratory allergies. It is not uncommon to know of photographers who have had to change careers because they have developed these occupational illnesses.

SKIN DISEASES. Many types of dermatitis have been seen in photographers including:

1. irritant contact dermatitis and chemical burns from exposure to irritating chemicals such as acids and bleaches,

2. allergic contact dermatitis from many developer chemicals such as metol and p-phenylenediamine,

3. hyper- and hypo- pigmentation (dark and light spots) from exposure to developing chemicals such as hydroquinone,

4. lichen planus (inflammatory condition characterized by tiny reddish papules that may darken and spread to form itchy, scaly patches and ulcerations) thought to be caused by some color developers, and

5. skin cancer from exposure to ultraviolet light sources such as carbon arcs. (There also is a potential for cancer to develop in lichen planus.)

RESPIRATORY DISEASES. Photochemical baths emit substances which are recognized as the typical darkroom odor. These substances also may be responsible for many of the respiratory diseases associated with darkroom work. Table 24 lists some of these airborne substances and their hazards.

TABLE 25	Common Darkroom Air Contaminants	
Chemical	Major sources	Primary hazards
acetic acid	stop baths	irritant
formaldehyde	hardeners and preservatives	sensitizer, irritant, and animal carcinogen
hydrogen sulfide	emitted by some toners	highly toxic to nervous system, irritant
sulfur dioxide	breakdown of sulfites in baths	respiratory irritant and sensitizer
various solvents	color chemistry and film cleaners	irritants, toxic to nervous system, see Table 5 hazards of specific solvents.

Darkroom chemicals can cause a variety of respiratory diseases. Low doses of irritating chemicals can cause slight damage to respiratory tissues that may leave photographers more susceptible to colds and respiratory infections.

Heavy exposures to irritating chemicals may cause acute bronchitis or chemical pneumonia. Such serious effects are most likely to occur if highly irritating substances such as concentrated acid vapors are inhaled, or if significant amounts of the dusts from dry chemicals are inhaled. Many photochemicals in the dry, concentrated form are powerful irritants and sensitizers.

Chronic diseases from years of exposure to darkroom chemicals can lead to chronic bronchitis and emphysema. In fact, these diseases are seen frequently among darkroom technicians.

Allergic diseases such as asthma and alveolitis may result from exposure to sensitizing substances such as sulfur dioxide, formaldehyde or from dust inhaled while mixing powdered developers.

Many experts believe that respiratory system cancers also may be associated with exposure to formaldehyde. Photographers who smoke are certainly at risk for lung cancer and are at greater risk for most of the other diseases associated with photochemicals.

SYSTEMIC DISEASES. Some photochemicals also are toxic to other bodily systems. For example, if significant amounts of some photochemicals are inhaled or ingested, they can cause methemoglobinemia. This is a disease in which the chemical damages the blood so that it can no longer carry sufficient oxygen. Exposure to bromide-containing chemicals and solvents may harm the developing fetus. Material Safety Data Sheets should alert users to these kinds of hazards.

Photochemical products that contain extremely toxic substances should be replaced with safer materials. Some extremely toxic chemicals include: chromic acid bleaches; lead toners; mercury vapor (Daguerreotype); mercury intensifiers and preservatives; uranium nitrate toners; and cyanide reducers and intensifiers (not ferri- or ferrocyanides, which are safer).

GENERAL PRECAUTIONS

1. Provide darkroom ventilation (at a rate of roughly twenty room exchanges per hour for small darkrooms, ten room exchanges per hour for very large gang darkrooms) for black and white developing. Provide local exhaust systems such as slot hoods or fume hoods if toners, intensifi-

ers, color process, or solvent-containing products are used. Purchase photo processors equipped with factory-built local ventilation systems.

2. Replace dry chemicals with premixed chemicals when possible. When powders must be used, handle and mix them in local exhaust ventilation such as a fume hood or with respiratory protection. Avoid skin contact and clean up dust and spills scrupulously.

3. Obtain Material Safety Data Sheets on all photochemicals and select the safest materials. Do not use extremely toxic chemicals such as those containing chromic acid, lead, mercury, uranium or cyanide.

4. Provide and use protective equipment including an eye-wash fountain, gloves, chemical splash goggles, tongs, and aprons.

5. Provide additional protection if concentrated photochemical solutions and glacial acedic acid are used including a deluge shower, and face shield. Dilute or mix these chemicals in local exhaust ventilation such as a fume hood. Always add acid to water, never the reverse.

6. Gloves and tongs always should be used to transfer prints from baths. Barrier creams can replace gloves if only occasional splashes of black and white chemicals are expected. (Note: barrier creams may smudge prints if they are handled.)

7. Store photochemicals in the original containers when possible. Never store photochemicals in glass bottles which can explode under pressure.

8. Prepare to handle spills and breakage with chemical absorbents and/ or floor drains and hose systems (if regulations permit).

9. Practice good housekeeping. Clean up all spills immediately. Never work when floors or counters are wet with water or chemicals. Eliminate trip hazards and clutter.

10. Clean up and wash off immediately all spills and splashes on the skin. Do no allow splashes on clothing or skin to remain until dry. Instead, remove contaminated clothing and flush skin with copious amounts of water. After washing off caustic materials, use an acid-type cleanser.

11. Keep first aid kits stocked and post emergency procedures.

12. Prevent electrical shocks by separating electrical equipment from sources of water and wet processes as much as possible. Install ground fault interrupters on darkroom outlets.

13. Follow manufacturer's recommendations and governmental regulations when disposing of photochemicals. If chemicals may be put down drains, dilute and flush with large amounts of water. Be sure the water treatment facility into which the chemicals will drain can handle them. Never flush into septic systems.

14. Do not allow heat or ultraviolet (UV) light (from carbon arcs or the sun) to affect photochemicals. For example, ferri- and ferrocyanides can release hydrogen cyanide gas if exposed to heat or UV.

15. Replace carbon arc light sources which emit dangerous UV, highly toxic gases and metal fumes. Use halide bulbs, quartz lamps, sunlight, or other high intensity lights. Avoid direct eye contact with all intense light sources.

16. Follow all rules for flammable and/or toxic solvents (see pages 16-19) if solvent-containing products such as film cleaners and color photochemicals are used.

17. Always be prepared to provide your doctor with information about the chemicals you use and your work environment.

PRECAUTIONS FOR SPECIFIC PHOTO PROCESSES

BLACK AND WHITE PHOTOCHEMICALS. Most common black and white photochemicals can be used safely if they are purchased premixed and diluted with care, and if the precautions above are followed. Especially provide good general dilution ventilation (see Precaution 1 above).

TONING. Almost all toners require local exhaust ventilation systems. Most of these chemicals are highly toxic and emit toxic gases during use. For example, sulfide toners produce highly toxic hydrogen sulfide gas and selenium toners produce large amounts of sulfur dioxide.

COLOR PROCESSING. Color processing employs many of the same chemicals that are used in black and white processing. In addition, they contain dye couplers which are associated with serious skin problems. Formaldehyde also is present in many color processing products and some products contain toxic solvents such as the glycol ethers (see pages 86).

Mixing of color processing chemicals and open bath color processing requires local exhaust ventilation, gloves, and goggles. Small hand tank developing can be done with dilution exhaust, gloves, and goggles.

Automatic color processing requires local exhaust ventilation. Today, most automatic color processors are made with local exhaust hoods built into them, or the manufacturers offer exhaust equipment accessories. However, many salespeople do not make it clear to buyers that these machines should be connected to exhaust fan extraction systems.

PHOTOPRINTING. Many photographic processes have been adapted to printmaking uses. Included are photo lithography, photo etching, and photo silkscreen processes. These processes use similar chemicals and require similar precautions.

High intensity light sources are needed for these processes and carbon arc lamps should be avoided (see Precaution 15 above).

Photo etching relies on solvents to etch plastic. Some of these photo etching solvents are highly toxic and may include the glycol ethers (see Table 5, Common Solvents and Their Hazards, page 89). Photolithography uses solvents and dichromate solutions.

There are two types of photo-silk screen processes: direct and indirect emulsion processes. Direct emulsions usually use ammonium dichromate as the sensitizer. Indirect emulsions use presensitized films which are developed by concentrated hydrogen peroxide and cleaned of emulsion with bleach.

The chemical ingredients used in each of these processes fall into four groups listed in Table 25.

NON-SILVER PROCESSES:

BROWN PRINTING (VAN DYKE PROCESS) employs ferric ammonium nitrate, tartaric acid (or oxalic acid), and silver nitrate. These chemicals are mixed with distilled water and applied to paper. The paper is exposed to light and developed with a water/borax mixture and fixed with sodium thiosulfate solution. Oxalic acid and silver nitrate are especially hazardous and require extra care to avoid eye and skin contact, and inhalation of the dry materials. Developing can be done with dilution ventilation.

GUM PRINTING (GUM BICHROMATE) involves coating paper with an emulsion of gum arabic, water, pigments, and ammonium dichromate. After exposure to light, it is developed in water and hung up to dry. Multiple printings can be done by changing the pigments.

Hardening and clearing are done in a solution of potassium alum and water or in a dilute solution of formaldehyde. Mercuric chloride, thymol, and other hazardous biocides may be used to preserve the solution.

Avoid solutions containing mercuric chloride or any other highly hazardous biocide. Dichromates are very toxic and are potent sensitizers. Local exhaust such as a fume hood should be used when working with powdered dichromates, dry pigments, and formaldehyde solutions.

CYANOTYPE (BLUEPRINTING) is similar to brown printing except that ferric ammonium citrate and potassium ferricyanide are used. (See Precaution 14 for hazards of these chemicals.) Ordinary dilution ventilation should suffice for cyanotype.

SALTED PAPER PRINTS use silver nitrate as the major component. Silver nitrate is especially hazardous and requires extra care to avoid eye and skin contact with the solution. Ordinary dilution ventilation should suffice.

TABLE 26	Precautions for Photoprint Chemicals

SOLVENTS used in photo printmaking have varying hazards (see Chapter 9, Solvents, pages 83-96) and ventilation requirements will depend on the toxicity of the solvent and the amount that becomes airborne. Some are the glycol ethers, which have reproductive hazards and are absorbed by skin. Provide good ventilation and avoid skin contact or use special gloves (usually nitrile gloves will provide protection).

CONCENTRATED HYDROGEN PEROXIDE AND BLEACH can cause severe eye and skin damage and gloves, goggles, and local exhaust ventilation should be used. When used to remove emulsions, bleach emits chlorine gas which also requires local exhaust ventilation.

DICHROMATES are very toxic and sensitizing. Gloves and local exhaust ventilation such as a fume hood should be used when working with powdered dichromates.

PHOTO EMULSIONS usually are sensitizers and skin contact with them should be prevented.

Section
VI

Teaching Art

CHAPTER 30

CLASSROOM SAFETY

T eaching art safely requires careful consideration of the toxicity of the materials. Students at the grade-six level or younger, and individuals with certain disabilities, simply should not be working with substances that are toxic. Suitable materials for these students will be covered in the last half of this chapter. Art projects for high school, university, and adult education students often employ toxic materials. For this reason, occupational health and safety laws usually apply to classroom activities.

ART AND OCCUPATIONAL SAFETY LAWS

Occupational health and safety laws protect employees including teachers. Students (except university students in certain states) are not covered. If teachers are injured on the job, their needs are covered by Worker's Compensation. If students are injured or made ill by classroom activities, the usual remedy is to hold the school or teacher liable.

The liability of schools and teachers can best be protected by extending to students the same rights accorded adult workers. In fact, even greater care and protection is in order since students are less trained and less educated than adult workers or teachers. This means that all occupational health or safety laws designed to protect workers doing a particular job must be complied with, and exceeded, if students are doing this work.

The types of protection which must be provided by employers for workers consist of four basic duties: to inform, to train, to enforce, and to exemplify. The duties of teachers are to meet and exceed these same duties.

1. To inform. Just as administrators are responsible for informing teachers about the hazards of their work, teachers are responsible for passing this information on to students. The information must be complete and specific. If a student is injured or made ill because a teacher neglected to inform her/him, the courts may interpret this as willful or knowing negligence on the part of the teacher and/or school.

2. To train. Teachers must ensure that each student knows how to work safely with hazardous materials or equipment. Teachers must develop mechanisms to verify their students' comprehension, and thereby avoid making incorrect assumptions. This is most often done by giving quizzes. Teachers should keep copies of these quizzes to document that their students understood the information and training.

3. To exemplify. Teachers must model safe behavior. If teachers are observed violating safety rules, they may be liable for damages caused when students also break the rules. In addition, teachers must demonstrate a proper attitude toward safety. They must make it clear that safety is more important than finishing the work, cleaning up in time, or any other objective.

4. To enforce. Teachers must be in control of their students and must enforce the safety rules. They must not tolerate improper or unsafe behavior. Teachers may be liable even when students willfully break the safety rules if it can be shown that the rules were not enforced. And courts have held that enforcement must include meaningful penalties, not wrist slapping.

ADMINISTRATOR'S ROLE

Administrators must assist and supervise teachers in the performance of these duties. Administrators are ultimately responsible for the efficacy of health and safety programs and they will share responsibility with teachers for accidents or illnesses resulting from failure to inform or train, or if there is no enforcement of the rules, or if a bad example is set.

Some administrators do not fulfill these duties under the guise of allowing teachers and students "freedom." A common example is allowing university students the freedom to work alone at night in buildings without supervision, without security, and even without ventilation if it is turned off after hours. Under these conditions, administrators have no good defense for an accident involving chemicals or machinery, an illness for which emergency services were not speedily procured, or an assault in unsecured premises.

"Freedoms" involving risks like these must be rescinded immediately and replaced with sound health and safety discipline. Administrators must administer, teachers must supervise, and students must take direction. Everyone must do their job or the safety of all, and the institution itself, are put at risk.

TRAINING SPECIAL STUDENTS.

Special training must be given students who cannot comprehend hazard information and training because they are illiterate, do not speak English, have learning disabilities, or for any other reason. Until these students can demonstrate comprehension orally, in another language, or some other way, they must not ge given access to toxic materials or dangerous machinery.

Students who will never be able to demonstrate comprehension simply must not use hazardous things. And if their judgement also is impaired, dangerous materials must be secured in their presence. A teacher has no good defense for providing access—even accidental access—to a toxic material or a dangerous machine to students who cannot protect themselves.

The above is also true for young children. For this reason, university and high school students must not be allowed bring their children into art classroom areas. And adult art classrooms must not be used by young children unless all adult art materials and equipment are secured, all waste materials are cleaned up, and the ventilation has removed any residual toxic air-contaminants.

RIGHT-TO-KNOW, HIGH SCHOOLS, AND HIGHER EDUCATION

In order to properly inform and train their students, all art teachers need specially tailored hazard communication training. Yet many schools still do not provide it. How ironic it is that educational institutions refuse to comply with a governmental mandate to educate.

Some administrators are slow to start training programs because they cost money. They also fear that after they invest in training, trained faculty members will leave for other jobs. These administrators should consider the alternative: suppose they do not train their teachers and they stay?

These are the administrators whose schools will be overtaken by increasingly complex occupational and environmental regulations and the liability they provoke. These are the schools that will graduate yet another generation of artists and teachers who are utterly ignorant of the laws that apply to their work, their materials, and their health and safety.

To correct this problem, schools must take the lead. The curriculum must include formal health and safety training at levels far above the basic information required by the law. This is not only proper, it provides an opportunity for the school to develop training materials for which there is a demand. There is good money in supplying curriculum guides, videos, and skilled trainers for business, industry, and other schools.

Hazard communication is causing an educational revolution in the workplace. Schools should be leading the revolution, not following reluctantly.

TEACHING RIGHT-TO-KNOW

The best way to accomplish good formal training and teacher preparation in art hazards is to teach courses on the subject in institutions of higher education. Short courses for teachers should also be offered for "In Service" and continuing education programs. An outline of the material which should be covered in such a course is available from ACTS (Appendix I, *ACTS FACTS*).

ART FOR GRADE SIX AND UNDER

Teachers of young children also need special training to learn how to select safe materials. Some teachers resist this idea and, instead, are waiting for a labeling system that will unequivocally identify materials that are safe for young children. In my opinion, this is a vain hope.

One reason is that the new art materials labeling law has too many flaws. Manufacturers still are allowed to label untested chemicals "non-toxic," to make estimates of "normal" use exposure which may not be applicable to your situation, to make untested assumptions about bioavailability of toxic substances, and, under some circumstances, to withhold disclosure of toxic chemicals in amounts larger than those required to be reported on Material Safety Data Sheets.

And as long as interpretation of this law is left to manufacturers and to certifiers who are paid by the manufacturers, common sense should tell us to be wary. Relying solely on these labels and certification programs is like relying only on the seller's advice when buying a car. Clearly an informed, unbiased second opinion is needed. Ideally, this opinion should that of the well-trained teacher.

HOW TO INTERPRET CURRENT LABELING

While it is not always wise to blindly trust the "non-toxic" label, it is very wise to heed any warnings. The need to consider label warnings was formalized by the Consumer Product Safety Commission (CPSC) in 1992 in an alert titled: "Never Use 'Hazard labeled' Art Materials with Elementary School Children, Nursing Home Residents, or Hospital Patients."

This alert warns that "[y]oung children, hospital patients, and others who may not be able to read and follow hazard labels might be poisoned if they misuse hazardous art materials." Examples of label warnings in the alert included "Keep out of the reach of children" or "Use only under adult supervision." Examples of warning-labeled products which should never be used by children were lead glazes and rubber cement.

Elementary school teachers who wish to ignore this advice do so at the peril of their own, and their school's, liability.

SPECIAL RISK FACTORS FOR CHILDREN

Children are at special risk from exposure to toxic art materials for a number of reasons which are psychological, physiological, and behavioral in nature.

PSYCHOLOGICAL RISK FACTORS. The age at which toxic substances can be introduced into the classroom is the age at which youngsters are able to understand the hazards, and to carry out precautions effectively and consistently. Most experts agree that children should be able to do this at about age 12 or 13 years of age. Some children must be older.

PHYSIOLOGICAL FACTORS. Children are especially sensitive to toxic substances because they are still growing and they have more rapid metabolisms than adults. They absorb and incorporate toxic materials more readily. Their brains and nervous systems are still developing and may more easily be harmed by neurotoxic chemicals. Their bodily defenses are not as developed and their lower body weight puts them at risk from smaller amounts of chemicals than if they were heavier adults.

BEHAVIORAL FACTORS. Children have behavior patterns that may put them at increased risk of exposure. For example, young children go through a stage where they put things into their mouths. Even older children may have high hand-to-mouth contact behavior or "pica," a disorder of the appetite in which nonfood substances are craved.

OTHER "HIGH RISK" STUDENTS

Certain children and adults are especially vulnerable, for various reasons, to chemical, biological, or physical agents. Some of these "high risk" groups are listed in Table 27. Special care must be extended to these individuals when selecting appropriate art projects.

TABLE 27	Who Is At Higher Risk?

ALL PEOPLE AT CERTAIN TIMES OF LIFE, SUCH AS:
* CHILDREN TWELVE AND UNDER are at greater risk. The younger the child, the greater the risk.
* PREGNANT WOMEN AND THE FETUS both are at greater risk. The fetus is at greatest risk.
* ELDERLY PEOPLE who have lost resistance to physical damage or chemical exposure with age.

PEOPLE WHO HAVE TEMPORARY IMPAIRMENTS, SUCH AS:
* SICKNESS. For example, a respiratory infection could put one at higher risk from chemicals which damage the lungs.
* CONVALESCENCE after surgery or physical injury.
* EXTREME STRESS from emotional trauma, anxiety or pressure.
* ACTIVE ADDICTION TO ALCOHOL OR DRUGS.

PEOPLE WHO HAVE CHRONIC IMPAIRMENTS, INCLUDING:
* LONG-TERM ILLNESSES such as chronic bronchitis, heart disease, liver impairment, and the like.
* MENTAL DISABILITIES.
* OTHER NEUROLOGICAL IMPAIRMENTS such as multiple sclerosis, cerebral palsy or epilepsy.
* PSYCHOLOGICAL DISTURBANCES.
* SEVERE ALLERGIES.
* VISUAL IMPAIRMENTS.
* HEARING IMPAIRMENTS.
* CERTAIN PHYSICAL DISABILITIES.
* TAKING CERTAIN MEDICATIONS.

PREGNANT WOMEN. A pregnant woman's blood volume increases by 30 to 40 percent, making her anemic. This anemia makes her more susceptible to blood-absorbed toxins such as carbon monoxide (carboxy hemoglobin) and solvents.

Pregnant women also inhale more air to provide for the increased oxygen needs of the fetus. This means that they will be more susceptible to inhaled substances. Wearing respiratory protection may not be recommended because of the breathing resistance caused by wearing a mask or respirator. Pregnant women should consult their doctors before wearing respiratory protection.

Even after pregnancy, some toxic substances are concentrated in breast milk. Examples include heavy metals, solvents, and many pesticides.

THE FETUS. Many metals such as lead, manganese, antimony, and selenium, and many pesticides, drugs, and solvents are known to affect the fetus adversely. The effect of many solvents, for instance, is similar to that of alcohol.

It is difficult for women to know when they have been exposed to amounts of chemicals that can cause harm to the fetus. This is because some toxins can cause severe damage, even fetal death, at amounts which are so small that they produce no symptoms in the mother.

Even substances to which the mother was exposed before conception may cause harm to the fetus (see cumulative toxins, page 22). For example

lead stored in the mother's body may affect the fetus months after she stopped working with it. Women working with cumulative toxins should consult their doctors when planning pregnancies.

Unfortunately, a great many chemicals used by artists have never been studied for their effects on the reproductive system. Since pregnancy is of limited duration and the outcome so important, it is prudent to avoid chemical exposure as much as possible.

PHYSIOLOGICAL LIMITATIONS. People who are physically limited in their ability to expel or resist chemicals will be more damaged by exposure than those who are unimpaired. For example, people with emphysema cannot expel toxic gases from their lungs as fast or efficiently as those without emphysema.

Similarly, people with damaged livers are more susceptible to chemicals which must be metabolized by the liver, people with dermatitis will absorb more skin-penetrating chemicals, people with anemia are more susceptible to chemicals which affect hemoglobin in the blood, heart patients may not be able to tolerate the irregular heartbeats often caused by solvent exposure, and so on.

MEDICATIONS. Some medications are known to interact adversely with chemicals in the body. For example, ingesting barbiturates and alcohol together can seriously threaten life. Similarly, barbiturates taken while inhaling alcohol vapors from shellac would have an identical interaction.

Some predictable medication/chemical interactions or additive effects might include the following:

1) medications which depress the central nervous system are likely to interact with or exacerbate the effect caused by chemicals which also are depressants, such as solvents and some toxic metals;

2) medications which interact with alcohol in ways not related to central nervous system depression;

3) medications containing catecholamines or amphetamine derivatives that could sensitize the heart (to epinephrine) making it more susceptible to solvent-induced cardiac arrhythmias (irregular heart beats);

4) medications that cause photosensitization of the skin, which could exacerbate effects of ultraviolet radiation on the skin (e.g., during welding);

5) mood-altering amine oxidase-inhibiting drugs that cause adverse reactions in individuals exposed to amine epoxy catalysts or amine solvents (e.g. ethanolamine);

6) manic depressive patients on lithium carbonate therapy are affected by additional exposure to lithium carbonate in some ceramic glazes or metal enamels.

SENSORY IMPAIRMENTS. Those who have impaired abilities to see, hear, smell, feel, or otherwise sense the presence of chemicals are also at greater risk of being over-exposed than unimpaired people. For example, visually impaired persons may paint with their faces close to their work and consequently may inhale more paint vapors than someone working at a greater distance. Visually impaired people also may not notice spills, may have more frequent accidents, or may not see well enough to clean up well.

Just as obviously, those who cannot detect odors may inhale large amounts of toxic gases and vapors without being aware, those who cannot sense pain may be injured when exposed to chemicals which burn the skin, and so on.

NEUROLOGICAL IMPAIRMENTS. People whose brains and nervous systems are damaged are likely to be more susceptible to chemicals which also damage the nervous system. For this reason, those with cerebral palsy, Parkinson's disease, multiple sclerosis, and related diseases are likely to be at greater risk from exposure to solvents and toxic metals such as mercury, lead, and manganese.

Exposure to these neurotoxic chemicals is even more devastating to people with severe mental impairments because these solvents and metals can impair their already compromised mental acuity. Further, they are even more at risk because they also 1) may not be able to understand the hazards of the chemicals, 2) may not be capable of learning to take proper precautions, 3) may have habits, such as hand-to-mouth contact, which exposes them to greater amounts, 4) they may not know when they have been over-exposed, and 5) they may not be able to clearly describe their symptoms to doctors or to others from whom they would seek help.

For these reasons, it is unconscionable to place these individuals in programs that employ toxic chemicals such as ceramics programs using lead glazes, or painting and graphic arts programs in which solvent-containing materials are used.

ALLERGIES. There are many chemicals in art and craft materials that are well-known sensitizers, such as many dyes, pigments, plastics chemicals, natural substances such as turpentine, rosin, and gum arabic, and metals like chrome and nickel. People with serious allergies such as contact dermatitis and asthma, or who have had episodes of urticaria (hives) or anaphylactic shock, should avoid exposure to sensitizers.

BIOLOGICAL HAZARDS

Microorganisms such as viruses, bacteria, rickettsia, fungus, molds, mildew, and yeasts can cause infections and allergies. There are many sources of these biological hazards in art and craft materials.

HOW PEOPLE ARE EXPOSED. In order for microorganisms to harm people they must be 1) inhaled, ingested, or skin-absorbed into the body, 2) the organisms must be of a type that can cause disease or allergy in the exposed individual, and 3) they must be present in numbers large enough to overwhelm the individual's defenses.

Most microorganisms are harmless, which is reassuring since they are everywhere including in the air, in water, and on and in people. Airborne mold, mildew, yeasts, and bacteria will contaminate any art material left uncovered. For example, diluted acrylic paints left standing at room temperature will give ample evidence of microorganism's presence by their offensive odor. Inhalation of spray or airbrush mist from these contaminated materials could cause a variety of illnesses, depending on which microorganisms were established in the material.

There are a few molds and fungi that are highly toxic. Occasionally these organisms will establish themselves in buildings or ventilation systems and cause serious illnesses in those exposed.

Even microorganisms that are considered harmless may cause allergies in some individuals, or may cause disease in individuals who are immune deficient. Table 28 lists the kinds of people who are at greater risk from biological hazards.

People can be a source of microorganisms as well. For example, United States hospitals have OSHA guidelines to prevent transference of diseases such as AIDS and hepatitis. Yet many teachers of craft and occupational therapy programs for these patients do not consider these guidelines when planning their activities, clean-up, and accident procedures. In some cases, teachers are not told of students' illnesses. In this case, both the student and the teacher may be at risk.

TABLE 28	Those at High Risk From Biological Hazards

A. People with Compromised Immune Systems Due to:

 1. Inherited or Acquired Immune Deficiencies from:
- AIDS and other diseases which affect immune response
- leukemia and other diseases affecting bone marrow
- defense systems that are engaged in fighting other diseases
- being physically run down, malnourished, etc.
- being under extreme stress

 2. Certain Chronic Illnesses (for example, people with chronic bronchitis are more susceptible to organisms that cause respiratory infections).

 3. Taking Immune-Suppressive Drugs or Treatments
- cancer patients on some types of chemotherapy and/or radiation
- organ transplant recipients

 4. Exposure to Chemicals that Affect the Immune System
- benzene and other chemicals that damage bone marrow
- other chemicals, now suspected of affecting the immune system in various ways.

B. People at Elevated Risk from Biological Allergens

 1. People who have Asthma
 2. People who have Dermatitis
 3. People who have a History of Hives or Anaphylactic Shock

CONTROLLING EXPOSURE. The ingredients necessary for microorganisms to prosper are 1) a warm temperature (those ranging from room temperature to warm tap water temperatures are optimal), 2) moisture, 3) organic matter for food (can be almost anything such as acrylic polymer in paints or minute amounts of vegetable matter in clay), and 4) introduction of the microorganisms into the system.

The ways to reduce exposure to microorganisms is: 1) to control temperature and humidity, 2) remove sources of food for microorganisms by keeping materials covered, cleaning up spills, and good housekeeping, 3) avoid practices that contaminate materials or hands with microorganisms, 4) kill microorganisms with soaps and disinfectants. This later practice requires caution, since some disinfectants and soaps also have toxic properties or cause allergies.

In other words, maintaining a comfortable environment, working neatly, and practicing good personal hygiene will go a long way toward reducing danger from microorganisms.

PHYSICAL HAZARDS

Physical hazards consist of: hazards from exposure to physical phenomena such as noise, vibration, heat, or radiation; and safety hazards such as accidents or overuse injuries.

NOISE. Noise of ear-damaging intensity is produced by many art processes (see pages 35-37). Hearing-impaired people should not be exposed to noise unless it is determined that it will not further damage their hearing. This determination should be made by an otologist since it requires understanding the exact diagnosis of the cause of each individual's hearing loss.

Some experts feel that it is not acceptable to expose hearing-impaired people to noise, even if further damage to frequency receptors will not affect their ability to hear. They reason that new methods of restoring hearing may be developed, which will rely on intact frequency receptors.

It may be possible for hearing-impaired individuals to work in noisy environments if their ears are protected from the noise. Here again, an otologist should be consulted to match the kind of protection to the type of noise in the environment and the individual's particular needs. Contrary to common opinion, merely turning down a person's hearing aid may not protect hearing. Aids with vented ear-pieces or ear-pieces which do not fit tightly may transmit significant amounts of noise.

Those planning programs that involve noise must be aware that there may be some participants who are not aware that they have hearing loss or who choose not to make their hearing loss known to others. This is especially true in programs for older people.

Noise may also cause increased blood pressure and stress-related illnesses. Elderly people and others with high blood pressure or conditions exacerbated by stress should be protected from noisy environments.

Hearing-impaired students also should not participate in activities in which hearing warning calls can be crucial to their safety, such as in theatrical rigging and lighting.

VIBRATION. Vibration, such as that transferred to users of hand held tools, can also be harmful (see pages 37). There is no data on physiological response to vibration in people whose circulation is impaired for other causes, such as aging or heart disease. However, prudence dictates exposure to vibration should be limited for such individuals.

Even less is known about whole body vibration such as that encountered on buses or trucks. Whole body vibration is suspected of causing sleep disturbances, tremors, and general nervous upset. Program planners might want to consider the possibility that whole body vibration also may affect some participants adversely.

IONIZING RADIATION. Ionizing radiation such as X-rays and radioactivity can cause harmful biological effects including cancer. These forms of radiation are rarely encountered in arts and crafts unless uranium-containing pottery glazes or metal enamels (see pages 38) are used. People who already have had X-ray therapy or radiation treatment would be at even greater risk from the additional exposure.

NONIONIZING RADIATION, including visible light and ultraviolet and infrared radiation can be hazardous to high risk individuals.

LIGHT. It is well-known that inadequate lighting, glare, and shadow-producing direct lighting can cause eye strain and accidents. Poor lighting is even more likely to be harmful to visually impaired individuals. Conversely, special lighting can be used to aid some visually impaired people to better use their limited sight. Careful attention to lighting is crucial for many art and craft programs for visually impaired individuals.

ULTRAVIOLET (UV) AND INFRARED (IR) RADIATION. UV sources include sunlight, welding, and carbon arc lamps. UV is known to cause eye damage and skin cancer in welders (see page 38).

Eye-damaging amounts of IR are produced whenever metals or ceramic materials are heated until they glow. IR radiation can cause conjunctivitis,

dry eye (decreased lacrimation), cataracts and other effects. Everyone, especially those with visual impairments, should wear protective goggles whenever IR or UV radiation is present (see Figures 4 and 5, Filter Lens Shades and Selection Chart for Eye and Face Protectors, pages 58-60).

VIDEO DISPLAY TERMINALS (VDTs). Many forms of harmful radiation are associated with these devices. It is suspected that they may be most harmful to the fetus and to young children.

In addition to radiation, VDTs are associated with eye strain, overuse injuries, and stress. When high risk individuals such as those with musculoskeletal or visual problems use these devices, lighting should be carefully planned, desk and chair arrangements should be comfortable, the users vision should be periodically checked, and frequent work breaks should be planned.

OTHER RADIATION. There are Threshold Limit Values for other forms of radiation hazards such as heat stress, cold environments, laser radiation, microwaves, and more. In general, comfortable environments, which preclude exposures to these forms of radiation, should be maintained for most high risk individuals.

ACCIDENTS. Statistics bear out the fact that accidents do not occur without a reason. This means they also can be prevented by eliminating the causes. A few common causes of accidents in the workplace that can be remedied include 1) faulty or poorly maintained equipment and tools, 2) poor condition of walking surfaces, 3) unguarded machinery, and 4) poor lighting.

When high risk individuals work where these conditions are present, accidents are even more likely. Visually impaired people are less likely to notice that equipment is damaged and hazardous; people unable to judge distances accurately would be at greater risk of accidents if lighting is inadequate; people with balance problems especially need well maintained walking surfaces; and so on.

Attention to safety hazards is especially crucial in programs for high risk individuals.

OVERUSE INJURIES. Overuse injuries are most often associated with repetitive motions or with heavy work such as lifting. While learning to lift properly and taking frequent rest breaks during repetitive tasks may be important for all people, it is crucial for many high risk individuals. In

fact, in many cases, lifting may be precluded by certain illnesses, injuries, or musculoskeletal problems. Some research indicates that older workers are more likely to sustain overuse injuries.

It is imperative that each individual be medically evaluated before placement in programs involving physical effort or repetitive tasks. Physical therapists may also be needed to help some people learn to do tasks safely.

STRESS. Stress refers to an internal response to a demanding situation. Studies show that chronic stress is the most damaging and is associated with hypertension, peptic ulcers, heart disease, and many other illnesses.

Many high risk individuals already are managing stress from dealing with their disabilities. Programs for high risk people should be designed to preclude added stress. Some strategies include placing only realistic demands on participants, providing pleasant and peaceful working conditions, and providing individuals with ways to make their needs known and met.

PLANNING PROGRAMS FOR HIGH RISK INDIVIDUALS

EMPLOY QUALIFIED TEACHERS. All too often, general teachers, volunteers, professional artists or craftspeople, and others without formal training in special education are urged to teach high risk students.

Teaching most types of high risk individuals requires special training. To protect the students, and the school's and teachers' liability, teachers should have generally accepted qualifications for teaching the kind of students in the school, or someone qualified should supervise the teachers.

RESEARCH THE LOCATION. When setting up a new program, be sure that the students have easy access to the facility. Equally important, be sure emergency egress for students with disabilities is equally accessible.

Schools and institutions must have comprehensive emergency plans and hold regular drills. Other emergency equipment that should be available includes a communication system in each activities room to summon help, first aid equipment, and fire protection equipment (extinguishers or sprinklers, smoke detectors, etc.).

In addition to emergency response equipment, it is important to see that the classroom is equipped to maintain appropriate ventilation, (see pages 63-69) temperature, and relative humidity. Higher than normal tempera-

tures may be desirable to provide comfort for elderly or ill students. Good control of humidity may be helpful in controlling biological hazards.

Sanitation and proper clean-up of materials must also be provided. Sinks and running water for washing hands and tools are a must. Custodians should provide clean-up methods appropriate to the materials used. For example, wet mopping should be used in rooms where dusts such as clay and plaster must be controlled. Carpets are never appropriate for art rooms.

CHOOSE SAFE MATERIALS AND ACTIVITIES. Know the potential hazards of the products that will be used in the activities. This will require research. Obtain Material Safety Data Sheets and any additional ingredient information possible. Table 29 lists products and activities acceptable for children and other high risk individuals.

If there is any question about the safety of a product, contact a toxicologist and/or the product's manufacturer. Some reputable manufacturers will release more complete ingredient information to teachers of high risk students.

When moderately toxic materials are used with students that are capable of handling them, follow Material Safety Data Sheet recommendations for ventilation, protective equipment, and the like. Keep in mind that the precautions listed on the Material Safety Data Sheets are for healthy adult workers. More stringent precautions are required to protect high risk individuals.

EVALUATE THE STUDENT. Secure all available background information about each student. This information may be obtained through interviews with parents or guardians, doctors, therapists, previous teachers, and when possible, the students themselves. Unfortunately, some educators feel that the students privacy is violated by such inquiries. However, the student's safety and health may be jeopardized unless teachers are familiar with their students' physical and psychological limitations, the effects of medications they are taking, the emergency procedures which would be necessary in a crisis, and the like.

Some people fear that teachers who know about their students' intellectual or psychological handicaps will treat them unfairly or will not sufficiently challenge them. If this were true, the answer would not be to know less about a student's problems, but to give the teacher more information and better training. And if there are nondisabled students in the school, it may be necessary to educate them as well.

OBTAIN ADVICE FROM OTHERS. Once the information about the student and the activity have been gathered, obtain advice from parents, therapists, physicians, previous teachers, and other interested parties. Schools and institutions often find that organizing review panels works well in coordinating such information and making decisions.

SPECIAL PROBLEMS OF HOMEBOUND PROGRAMS

Homebound art and craft programs utilize materials and equipment in the home. Homes are not proper settings for practicing some arts and crafts. Projects which create toxic solvent vapors are especially hazardous since the homebound spend long hours exposed to them. And if fine toxic dusts contaminate the home, they are likely to be a hazard to the occupants for a long time, perhaps years.

Avoid projects which employ toxic materials such as solvents, lead, other toxic metals, and two-part plastic resin systems such as polyester. Also avoid projects that create dusts or fumes such as sanding and cleaning ceramic greenware, using soft pastels, and soldering or casting metal.

Instead, select materials that do not need special ventilation, which will not cause injury on skin or eye contact, which don't involve high heat or burning processes, and which generally meet the criteria for safe materials (see Table 29).

Homebound students also must be counselled not to employ kitchen equipment for art projects. For example, kitchen ovens should not be used to harden or cure plastics, inks, clay, or similar materials. Dye pots should not later be used for food.

TABLE 29	Art Materials and Projects Suitable for Children and Other High Risk Individuals
DO NOT USE	**SUBSTITUTES**
SOLVENTS & SOLVENT-CONTAINING PRODUCTS	**WATER-BASED & SOLVENT-FREE PRODUCTS**
Alkyd, oil enamels, or other solvent-containing paints.	Use acrylics, oil sticks, colors, water containing paints, or other water-based paints containing safe pigments.
Turpentine, paint thinners, citrus turps, or other solvents for cleaning up or thinning artist's oil paints.	Mix oil-based, solvent-free paints with linseed oil only. Clean with baby oil followed by soap and water. Choose paints containing safe pigments.
Solvent-based silk screen inks and other printing inks containing solvents or requiring solvents for clean up.	Use water-based silk screen inks, block printing, or stencil inks with safe pigments.
Solvent-containing varnishes, mediums, and alcohol-containing shellacs.	Use acrylic emulsion coatings, or the teacher can apply it for students under proper conditions.
Rubber cement and thinners for paste up and mechanicals.	Use low temperature wax methods, double sided tape, glue sticks, or other solvent-free materials.
Airplane glue and other solvent-containing glues.	Use white glue, school paste, glue sticks, preservative-free wheat paste, or other solvent-free glues.
Permanent felt-tip markers, white board markers and other solvent-containing markers.	Use water-based markers.

DO NOT USE	SUBSTITUTES
POWDERED OR DUSTY MATERIALS	**DUSTLESS PRODUCTS/PROCESSES**
Clay dust from mixing dry clay, sanding greenware, and other dusty processes.	Purchase talc-free, low silica, pre-mixed clay. Trim clay when leather hard, clean up often during work, and practice good hygiene and dust control.
Ceramic glaze dust from mixing ingredients, glazing, and other processes.	Substitute with paints or buy glazes free of lead and other toxic metals which are premixed, or mix in local exhaust ventilation system. Control dust carefully.
Metal enamel dust.	Substitute with paints. Even lead-free enamels may contain other very toxic metals. Avoid enamels also because heat and acids are used.
Powdered tempera and other powdered paints.	Purchase premixed paints or have the teacher mix them. Use paints with safe ingredients.
Powdered dyes for batik, tie dyeing, and other processes.	Use vegetable and plant materials (e.g. onion skins, tea, etc.) and approved food dyes (e.g. unsweetened Kool-Aid).
Plaster dust.	Have the teacher premix the plaster outdoors or in local exhaust ventilation. Do not sand plaster or do other dusty work. Do not cast hands or other body parts to avoid burns. Cut rather than tear plaster impregnated casting cloth.
Instant papier mache dust from finely ground magazines, newspapers, etc.	Use pieces of plain paper or black and white newspaper with white glue paste, or other safe glues.

DO NOT USE	SUBSTITUTES
Pastels, chalks or dry markers which create dust.	Use oil pastels or sticks, crayons, and dustless chalks.

AEROSOLS AND SPRAY PRODUCTS	LIQUID MATERIALS
Spray paints, fixatives, etc.	Use water-based liquids which are brushed, dripped, or splattered on or have the teacher use sprays in local exhaust ventilation or out doors.
Air brushes.	Replace with other paint methods. Mist should not be inhaled and air brushes can be misused.

MISCELLANEOUS PRODUCTS	SUBSTITUTES
All types of professional artist's materials.	Use only products approved and recommended for children when teaching either children or adults who require very special protection.
Toxic metals such as arsenic, lead, cadmium, lithium, barium, chrome, nickel, vanadium, manganese, antimony, and more.	These are common ingredients in ceramic glazes, enamels, paints, and many art materials. Use only materials found free of highly toxic substances.
Epoxy resins, instant glues, and other plastic resin adhesives.	Use white glue, library paste, glue sticks or other safe adhesives.
Plastic resin casting systems or preformed plastic materials.	Do not do plastic resin casting or use any plastic material in ways that release vapors, gases, or odors.
Acid etches and pickling baths.	Do not do projects that use these.
Bleach for reverse dyeing of fabric or colored paper.	Do not do projects using bleach. Thinned white paint can be used

DO NOT USE	SUBSTITUTES
	to simulate bleach on colored paper.
Photographic chemicals.	Use blueprint paper to make sun grams or use Polaroid cameras. Be sure students do not abuse Polaroid film or pictures which contain toxic chemicals.

MISCELLANEOUS PRODUCTS	SUBSTITUTES
Stained glass projects.	Do not do projects using lead, solder or glass cutting. Use colored cellophane and black paper or tape to simulate stained glass.
Industrial talcs contaminated with asbestos or nonfibrous asbestos minerals used in many white clays, slip casting clays, glazes, French chalk, and parting powders.	Always order talc-free products.
Sculpture stones contaminated with asbestos such as some soapstones, steatites, serpentines, etc.	Always use stones found free of asbestos on analysis.
Art paints and markers used to decorate the skin (e.g., clown faces).	Always use products approved for use on the skin (e.g., cosmetics or colored zinc sun-screen creams).
Scented markers.	Do not use with children. It encourages them to sniff and taste art materials. They are acceptable for older visually impaired students for distinguishing colors.
Plants and seeds.	Check identity of all plants to be sure no toxic or sensitizing plants are used (e.g., poison oak, castor beans).

DO NOT USE	SUBSTITUTES
Donated, found, or old materials whose ingredients are unknown.	Do not use these materials unless investigation identifies the ingredients and they are found safe.
Products with possible biological hazards.	Use clean, unused materials. Products used with food or other animal or organic materials may harbor bacteria or other hazardous microbes (e.g., washed plastic meat trays may harbor salmonella).

APPENDIX I

THE RIGHT-TO-KNOW LIBRARY

The following books and periodicals are recommended for those developing a professional quality health and safety library for their Right-to-Know program. Of course, THE ARTIST'S COMPLETE HEALTH AND SAFETY GUIDE is also suggested for this purpose.

ACTS FACTS, a monthly newsletter from Arts, Crafts and Theater Safety (ACTS), updates health and safety regulations and research affecting the arts ($10/year for 12 issues). ACTS also distributes data sheets on various subjects. Those referred to in this book include "All about Wax," "Understanding the MSDS," "Polymer Clays," and a "Curriculum Guide for a Course on Art Hazards." Write or call ACTS, Attn: M. Rossol, 181 Thompson St., #23, New York, NY 10012. 212-777-0062.

Art Hazards News, Center for Safety in the Arts (CSA). A newsletter published 6 times a year on various topics related to health and safety in the arts ($21/year for 6 issues). CSA is also a source of data sheets on many subjects. CSA, 5 Beekman St., 10 floor, New York, NY l0038. 212-227-6220.

American Conference of Governmental Industrial Hygienists, (ACGIH), 6500 Glenway Ave., Bldg. D-7, Cincinnati, OH 45211-4438. 513-661-7881. publications 1 and 2 updated yearly.
 1.Threshold Limit Values and Biological Exposure Indices.
 2.Industrial Ventilation:A manual of Recommended Practice.
 3.The Documentation of TLVs and BEIs.

American National Standards Institute, (ANSI) standards for performance of safety and protective equipment. For Example, ANSI Z358.1-1990 for eye wash fountains and emergency showers, ANSI Z87.1-1989 for face and eye protection, or ANSI Z49.1 Safety in Welding and Cutting. Available from ANSI, 1430 Broadway, New York, NY 10018. 212-642-4900.

American Society of Heating, Refrigerating and Air-conditioning Engineers' ASHRAE 62-1989, "Ventilation for Acceptable Indoor Air Quality." Can be obtained from ASHRAE, 1791 Tullie Circle, N.E., Atlanta, GA 30329. 404-636-8400.

American Welding Society (AWS), a source of welding standards, a journal, a welding health and safety course, and welding certification programs. Contact AWS, 550 N. W. LeJeune Road, Miami, FL 33126.

Best's Safety Directory, A.M. Best Company, 2 Volumes, Ambest Road, Oldwick, NJ 08858. (201)439-2200. Sources safety equipment and supplies. Updated yearly.

Clark, Nancy; Cutter, Thomas; McGrane, Jean-Ann. *Ventilation: A Practical Guide,* Center for Safety in the Arts, New York, 1980. Available from CSA, 5 Beekman St., New York, NY l0038.

Colour Index International, Society of Dyers and Colourists (P.O. Box 244 Perkin House, 82 Grattan Road, Bradford West Yorkshire BD1 2JB England), and the American Association of Textile Chemists and Colorists (One Davis Drive, P.O. Box 12215, Research Triangle Park, NC 27709-2215, U.S.A.), Volumes 1-4 and 6-9 (Cost about $ 900). Lists all commercially available dyes and pigments and their intermediates. Every degree program that involves use of paints, dyes, pigments or colorants should include instruction on how to use this reference and the C.I. identification system.

Hawley, Gessner, *Hawley's Condensed Chemical Dictionary,* 11th Ed., revised by Sax, N. Irving and Lewis, Sr., Richard, Van Nostrand Reinhold Co., New York, 1987. (Also available from the ACGIH. Call (513)661-7881 for publications catalog.)

National Fire Protection Association, Batterymarch Park, Quincy, MA 02169. 800-344-3555. Obtain catalog of the 270 codes. Choose pertinent codes such as NFPA #30. Flammable and Combustible Liquids Code.

National Institute of Occupational Safety and Health (NIOSH) has many health and safety publications and standards including *Work Practices Guide for Manual Lifting* (revised 1991). Available from NIOSH Publication Office, 4676 Columbia Parkway, Cincinnati, OH 45226-1998.

New Jersey Department of Health, Right-to-Know program, CN 360, Trenton, NJ 08625. (609)984-2202. This health department sells (for about $1.00 apiece) excellent "Hazardous Substance Fact Sheets" on

around 900 different chemicals.

Patty's Industrial Hygiene and Toxicology, Vol. II, 4rd edition, Part A-D, (1993-4), Interscience Publishers, John Wiley & Sons, New York. Covers detailed toxicology of many types of substances, very technical, and expensive ($1000).

Sax, N. Irving and Lewis, Richard J. Sr., ***Dangerous Properties of Industrial Materials,*** 8th Edition, Van Nostrand-Reinhold Co., New York, 1992 and 1993 update. (Also available from the ACGIH. Call (513)661-7881.)

"The MSDS Pocket Dictionary," Genium Publishing Corporation, Revised yearly. A dictionary of terms used on Material Safety Data Sheets. Contact Genium Publishing at 1145 Catalyn Street, Schenectady, NY 12303-1836. (518)377-8854.

The WHMIS Handbook, Corpus Information Services, 1450 Don Mills Road, Don Mills, Ontario M3B 2X7. (416)445-6641. A well-written, page-tabbed guide to WHMIS.

GOVERNMENT PUBLICATIONS U.S.

First determine if you are regulated under state or federal OSHA rules. State regulated people should contact their state OSHA for publications and compliance materials. Those under the federal law should have a copy of the sections of the Code of Federal Regulations (CFR) that applies to their work. These are 29 CFR 1900-1910 (General Industry Standards) and 29 CFR 1926 (Construction Standards). Call your local OSHA office for information on obtaining copies.

For extra help in complying with the Hazard Communication Standard (federal Right-to-Know) the following publications are available free from OSHA's Publications Office, Room N-3101, 200 Constitution Ave., N.W., Washington, DC 20210; (202)219-4667:

1. "Chemical Hazard Communication" OSHA 3084, a booklet describing the rule's requirements;
2. "Hazard Communication Guidelines for Compliance", OSHA 3117, a booklet to help employers comply with the rule;
3. "Hazard Communication Guidelines for Compliance, OSHA 3111;

Also available for $18.00 from the Superintendent of Documents, U.S. Government Printing Office, Washington, D.C. 20210; (202) 783-3238:

"Hazard Communication — A Compliance Kit" OSHA 3104, GPO order No. 929-022-00000-9, a step-by-step guide to compliance.

CANADA

WHMIS Core Material: A Resource Manual for the Application and Implementation of WHMIS. Contact the Community Relations Department, Worker's Compensation Board of BC, 6951 Westminster Highway, Richmond, British Columbia V7C 1C6.

APPENDIX II

GLOSSARY

ACUTE TOXICITY. Adverse health effects resulting from brief exposure to a chemical. Data commonly includes LD50s and LC50s. One LC50 is the concentration in the air that will kill 50 % of the test animals when administered in a single exposure in a specific time period, usually 1 hour. The LD50 is the single dose that will kill 50 % of the test animals by any route other than inhalation such as by ingestion or skin contact. These tests establish the degree to which a chemical is acutely hazardous and determine if it will be designated "non-toxic," "toxic," or "highly toxic."

LABEL DEFINITIONS OF TOXICITY IN THE U.S. AND CANADA

Label term	LD_{50}		LC_{50}	
Nontoxic	> 5.0	g/kg*	>20,000	ppm**
toxic	0.05-5.0	"	200-20,000	"
highly toxic	< 0.05	"	< 200	"

 * grams per kilogram of body weight of test animal.
 ** parts per million: parts of substance in 1 million parts of air.

As defined by the Federal Hazardous Substances Act (FHSA) in the U.S., and the Federal Hazardous Products Act in Canada, "non-toxic" means anything that passes the LD50 and LC50 animal tests. Workers need to know that long term damage such as cancer and birth defects are not detected by these tests. This is one reason that the FHSA has been amended to provide chronic hazard labeling for consumer product art materials. (This definition has now been extended to all U.S. consumer products, but as yet there is poor compliance.)

ALKALI. An inorganic or organic chemical that is corrosive, has a pH of more than 7.0, neutralizes acids to form salts and turns litmus paper blue. Also called a base or caustic.

ATROPHY. Reduction in size or function of tissue or organs.

331

AUTOIGNITION TEMPERATURE. The minimum temperature at which a substance ignites without application of a flame or spark.

BOILING POINT (BP). The BP is the temperature at which the substance changes rapidly, usually with bubbling, from a liquid to a vapor. Sometimes called the "vaporization point," liquids with low BPs usually expose workers to large amounts of the vapor. If the vapor is also flammable, liquids with low BPs are also fire hazards. A common error is the assumption that no vapor is formed (e.g. from metals) until the BP is reached. However, vapor is formed at far lower temperatures, just as water which boils at 212° F evaporates at room temperature.

CANCER. There are three agencies whose reviews of carcinogenicity must be reported on MSDSs: NTP (the National Toxicology Program); IARC (the International Agency for Research on Cancer); and OSHA. They categorize carcinogens as follows:

AGENCY CATEGORY AND EXPLANATION

IARC: 1 — Carcinogenic to humans: sufficient evidence of carcinogenicity.
 2A— Probably carcinogenic to humans; limited human evidence; sufficient evidence in experimental animals.
 2B— Possibly carcinogenic to humans; limited human evidence in the absence of sufficient evidence in experimental animals.
 3 — Not classifiable as to carcinogenicity to humans.
 4 — Probably not carcinogenic to humans.
NTP: 1 — Known to be carcinogenic, with evidence from human studies.
 2 — Reasonably anticipated to be a carcinogen, with limited evidence in humans or sufficient evidence in experimental animals.
OSHA: X — Carcinogen defined with no further categorization.

Statements such as "this chemical is not considered to be a carcinogen by NTP, IARC, or OSHA" make it appear that the chemical has been evaluated by these agencies and found safe. Instead it is more likely that the agencies have never evaluated the chemical.

CAS NUMBER or CHEMICAL ABSTRACTS SERVICE REGISTRY NUMBER is a number assigned by the Chemical Abstract Service, an organization that indexes information published by the American Chemical Society. It is a unique identification number.

CAUSTIC. See Alkali.

CHRONIC. Adverse health effects resulting from long-term exposure. Included are cancer, reproductive or developmental damage, neurological or other organ damage to animals or humans related to repeated or long term exposure.

COMBUSTIBLE LIQUIDS. Defined by the U.S. Federal Hazardous Substances Act and the Canadian Federal Hazardous Products Act, combustible liquids have flash points between 100 and 150° F.

EVAPORATION RATE. This is the rate at which a material will vaporize (volatilize, evaporate) from the liquid or solid state when compared to another material. The two common liquids used for comparison are butyl acetate and ethyl ether.

WHEN BUTYL ACETATE = 1.0			WHEN ETHYL ETHER = 1.0		
> 3.0	=	FAST	< 3.0	=	FAST
0.8 - 3.0	=	MEDIUM	3.0 - 9.0	=	MEDIUM
< 0.8	=	SLOW	> 9.0	=	SLOW

FLAMMABLE LIMITS. Only applicable to flammable liquids and gases, these are the minimum and maximum concentrations in air between which ignition can occur. Concentrations below the lower flammable limit (LFL) are too lean to burn, while concentrations above the upper flammable limit (UFL) are too rich. All concentrations in between can burn or explode. (Sometimes called lower and upper explosion limits— LEL and UEL.)

FLAMMABLE LIQUIDS. Defined by the U.S. Federal Hazardous Substances Act and the Canadian Federal Hazardous Products Act, Flammable liquids have flash points between 20 and 100° F. Flash points of extremely flammable liquids are less than 20° F.

FLASH POINT. The lowest temperature at which a flammable liquid gives

off sufficient vapor to form an ignitable mixture with air near its surface or within a vessel. Combustion does not follow ignition.

GRAS. Generally Recognized as Safe. A phrase applied to FDA-approved food additives. Many GRAS additives were accepted without testing because they have been used in food for many years. Unless GRAS status has been recently "reaffirmed," and unless you plan to eat the chemical, GRAS status is irrelevant to art material safety.

HAZARDOUS DECOMPOSITION PRODUCTS. This section should list any hazardous chemicals given off when the product burns or when it degrades or decomposes without burning. However, manufacturers often only report the results of high temperature incineration with all the oxygen necessary for complete combustion. Under these conditions, most organic chemicals will give off carbon dioxide, water, and a few other low molecular weight chemicals. Actual burning in open air, heating with torches, hot wire cutting, or other methods of rapid decomposition usually will produce very different results. Workers should be aware that this section may not be relevant to the way in which the product is actually burned or decomposed.

HAZARDOUS POLYMERIZATION. Polymerization is the process by which the molecules of a chemical can combine to form larger molecules. Examples include the setting up of epoxy or polyester resins. Polymerization is hazardous if during the reaction excessive heat, gases, or some other byproduct is given off in amounts sufficient to cause fires, burst containers, or cause some other kind of harm.

HEPA. High-efficiency particulate air filter which is certified to capture 99.97 % of particles 0.3 microns in diameter.

HMIS. The hazardous materials identification system developed by the National Paint and Coatings Association to provide product information on acute health, reactivity and flammability. A zero to 4 rating system is used with 4 the most severe.

INCOMPATIBILITY. Incompatible substances are those which will react dangerously with the product. Workers should also use this to determine which substances also should not be stored in proximity to the product.

IRRITANT. A substance which can cause an inflammatory effect on living tissue. Irritant effects are usually reversible.

MELTING POINT. The melting point is the temperature at which a solid changes to a liquid. It only applies to solid materials.

METHEMOGLOBINEMIA. Cyanosis due to the oxidization of the iron molecule in the blood's hemoglobin into a brown pigment which is incapable of carrying oxygen. Can be caused by ingestion of nitrites, nitrobenzene solvents and pigments, and certain other oxidizers.

NECROSIS. Localized death of tissue.

ODOR THRESHOLD (OT). OTs are the concentrations in air at which most people can smell the chemicals. If the OT is smaller than the TLV, then the chemical provides warning before adverse health effects are expected. If the OT is larger than the TLV, one is already at risk by the time the odor can be detected.

OXIDIZER. A substance that yields oxygen readily or brings about an oxidation reaction which causes or enhances combustion of materials. Examples are chlorates, permanganates, organic peroxides, and nitrates.

SENSITIZER. A material that causes little or no reaction on first exposure, but on repeated exposure will cause allergies in significant numbers of people or test animals.

SOLUBILITY IN WATER. This term represents the amount by weight that will dissolve in water at ambient temperature. Solubility is important in determining suitable clean up and extinguishing methods. Solubility is usually reported in grams per liter (g/l) or general categories such as:

negligible or insoluble	=	< 0.1 percent
slight	=	0.1 - 1.0 percent
moderate	=	1 - 10 percent
appreciable	=	> 10 percent
complete	=	soluble in all proportions

SPECIFIC GRAVITY (SG). The SG describes the heaviness of a material compared to a reference substance. When the reference substance is water ($H_2O = 1$), it indicates whether it will float or sink in water. SG for

solids and liquids compared to water numerically equals density (see above). SG for gases does not equal density because the density of air is not 1.0, but 1.29.

STABILITY: STABLE OR UNSTABLE. Stability is the ability of the material to remain unchanged under reasonable conditions of storage and use.

TRADE SECRET EXEMPTIONS. Information on the identity of hazardous ingredients can be withheld by the manufacturer if they are trade secrets or proprietary. The MSDS should state by whose authority (usually the state health department) the product's identity can be withheld. Trade secret products should be avoided whenever possible since it is very difficult and time-consuming for medical personnel to get this data if there is an accident or illness. Even then, the medical person must withhold from the victim the name of the chemical that caused his/her problem.

UNUSUAL FIRE AND EXPLOSION HAZARD. Unusual hazards such as those of some organic peroxides that ignite spontaneously under certain conditions or that become explosive when old.

VAPOR DENSITY (AIR = 1). VD is the weight of a vapor or gas compared to an equal volume of air. Materials with a VD less than 1.0 are lighter than air. Materials with a VD greater than 1.0 are heavier than air. While all vapors and gases will mix with air and disperse, large quantities of unmixed vapor or gas in locations without much air movement such as storage rooms will tend to rise or sink depending on their VD. Flammable vapors that are heavier than air can spread to sources of ignition and flash back to the source.

VAPOR PRESSURE (mm Hg). VP is the pressure exerted by a saturated vapor above its own liquid in a closed container. VPs combined with evaporation rates are useful in determining how quickly a material becomes airborne, and thus how quickly a worker is exposed to it. They are usually reported in millimeters of mercury (mm Hg) at 68° F (20°C) unless otherwise stated. Substances with VPs above 20mm Hg may present a hazard due to their extreme volatility.

WATER-BASED. An unregulated product label term which may mean that water is an ingredient or that water can be used to dilute or clean up the product. Water-based products often contain organic chemical solvents.

INDEX

ALLWORTH BOOKS